The Unbroken Thread

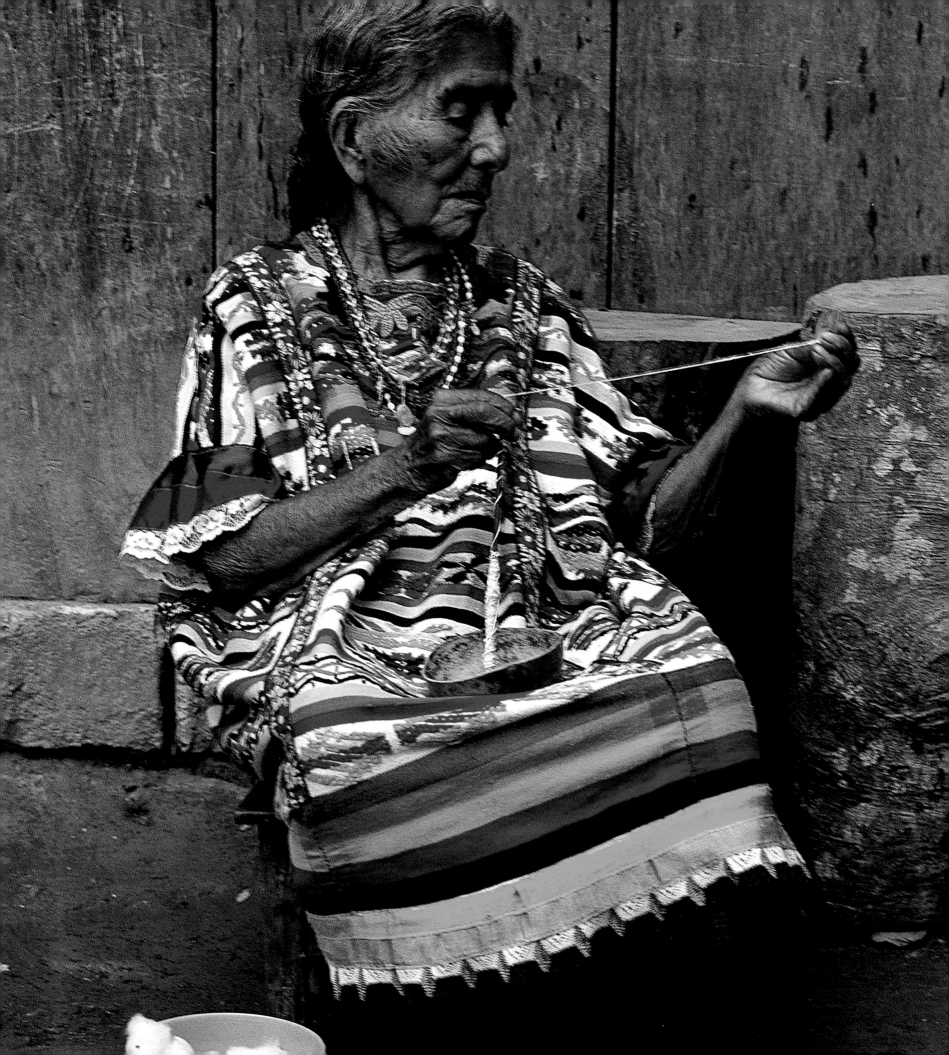

The Unbroken Thread

Conserving the

Textile Traditions

of Oaxaca

Edited by
Kathryn Klein

The Getty Conservation Institute · Los Angeles

Miguel Angel Corzo, *Executive Editor*
Dinah Berland, *Publication Coordinator*
Sylvia Tidwell, *Manuscript Editor*
Anita Keys, *Production Coordinator*
Vickie Sawyer Karten, *Designer*
Theresa Velázquez, *Typographer*

Printed in Singapore
10 9 8 7 6 5 4 3 2 1

Front cover: San Felipe Usila, Oaxaca, 1995.
Guadalupe García, nearly one hundred years
old, spinning cotton into thread. As a young
woman, she may have worn an earlier style
of huipil from Usila, such as the one found
in the collection at the Regional Museum
of Oaxaca. Here she wears a current style
of huipil from her community, a garment of
brightly colored industrially spun and dyed
thread, handwoven on a backstrap loom.
Photo by J. López.

Back cover: Weavers in Usila, Oaxaca, walk-
ing along the road. Photo by J. López.

The Getty Conservation Institute works internationally to further the appreciation and preservation of the world's cultural heritage for the enrichment and use of present and future generations. The Institute is an operating program of the J. Paul Getty Trust.

The Getty Conservation Institute gratefully acknowledges Ma. Teresa Franco y González Salas, general director of the Instituto Nacional de Antropología e Historia (INAH); Eduardo López Calzada, director of the INAH Center of Oaxaca; and Manuel Velasco López, director of the INAH Regional Museum of Oaxaca, for their participation in making this project possible.

Library of Congress Cataloging-in-Publication Data

The unbroken thread : conserving the textile traditions of Oaxaca / edited by Kathryn Klein.
 p. cm.
 Includes bibliographical references.
 ISBN 0-89236-380-0 (cloth). — ISBN 0-89236-381-9 (paper)
 1. Indian textile fabrics—Mexico—Oaxaca. 2. Indian textile fabrics—Conservation and restoration—Mexico—
Oaxaca. 3. Museo Regional de Oaxaca. I. Klein, Kathryn, 1958–
II. Getty Conservation Institute.
F1219.1.O11U53 1997
746' .0972' 740747274—dc21
97-15961
CIP

Contents

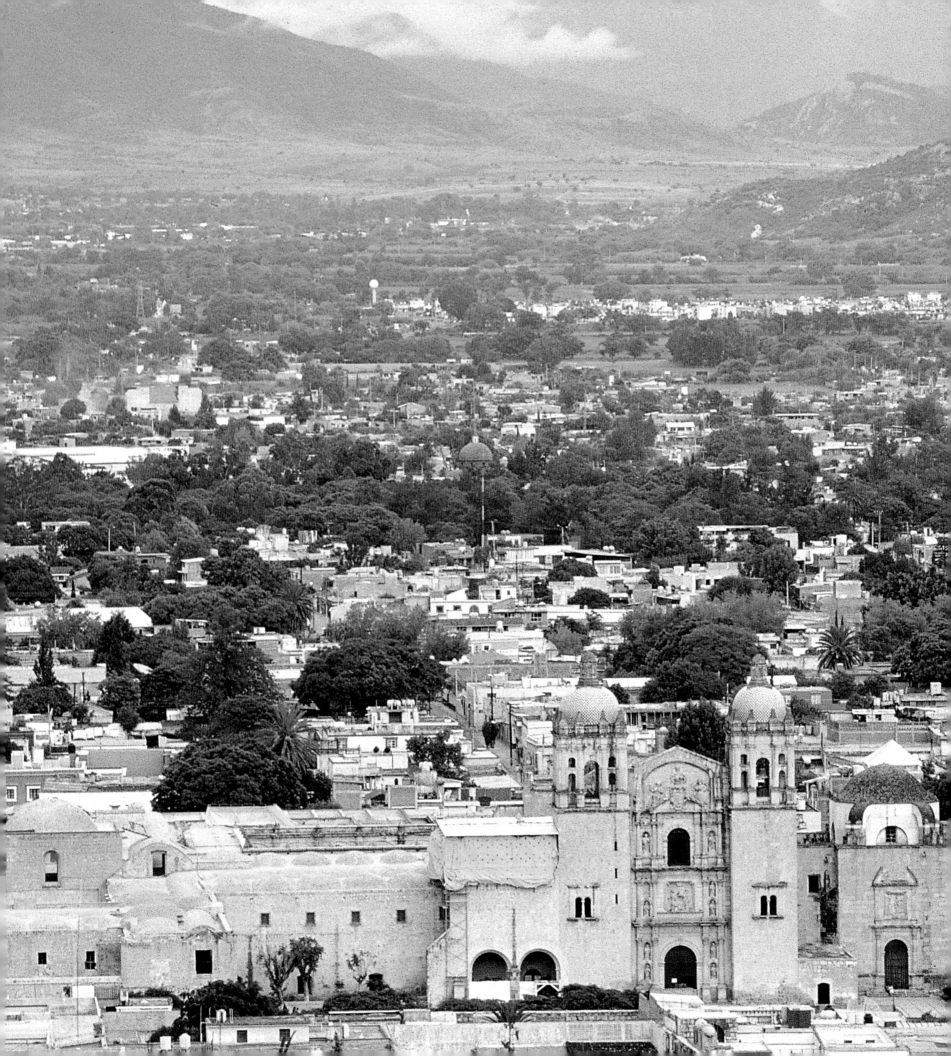

Tenía una camisa azul muy labrada de flores tegidas y plumería con unas naguas de muchos colores: en ambas manos tenía dos rosas labradas de plumas con muchas estampitas de oro como piujantes por todas ellas, y tenía los brazos abiertos como mujer que bailaba.

She wore a finely worked blue tunic decorated with beautifully woven flowers formed of feathers with many little plaques of gold pendants all over them. She was represented with her arms open like a woman who is dancing.

—Friar Diego Durán, 16th century
Translated by Fernando Horcasitas and Doris Heyden

The Valley of Oaxaca behind the massive buildings of the former convent of Santo Domingo de Gúzman, where the INAH Regional Museum of Oaxaca is located. The construction of the convent and church were initiated by the Dominican order in 1572. Encompassing forty thousand square meters, the buildings of Santo Domingo were situated north of the city of Antequera, in what is today the center of Oaxaca City. Photo by J. López.

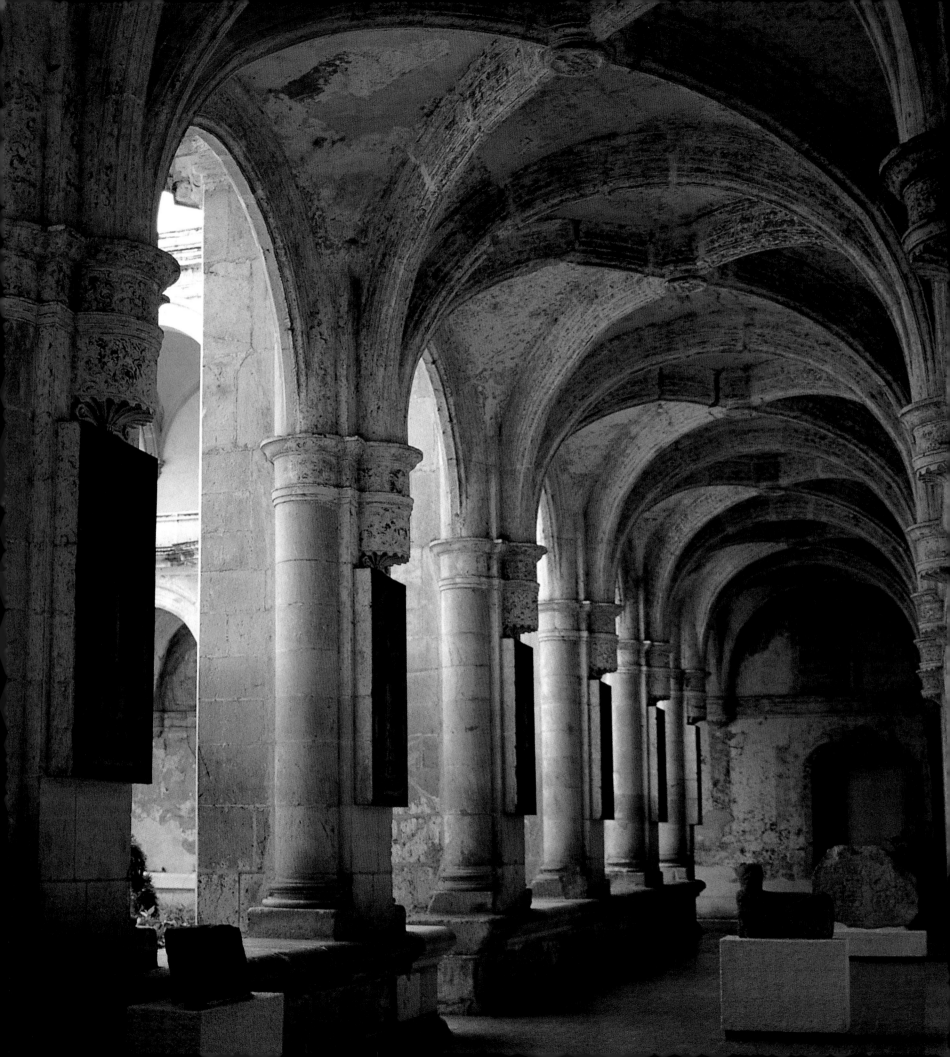

Foreword

A partial view of a seventeenth-century wall painting inside the convent. Even though the structures of the convent and church were finished in 1608, it took nearly a century to complete the decorative elements, including hand-carved stone, plaster, and wood; gilded surfaces; and interior wall paintings. Photo by K. Klein.

The interior of the former convent of Santo Domingo, where the Regional Museum of Oaxaca is located. In 1972, INAH, a federally funded program, secured a section of the convent for use as a museum; for the following twenty-two years, both the Mexican military and the museum shared the convent facility. When the military left in 1994, an ambitious restoration of the entire convent was begun. With specific sections of the convent now available for use by the national, state, and city governments, the former convent of Santo Domingo is a significant cultural center of Mexico. Photo by K. Klein.

In December 1972, the Regional Museum of Oaxaca was opened under the auspices of the Instituto Nacional de Antropología e Historia (INAH) in its present facilities in the former convent of Santo Domingo de Gúzman. This architectural complex was the work of the Dominicans, assisted by the invaluable labor of the indigenous people of Oaxaca. Occupying an area of more than 43 hectares, the original convent was completed in 1608. The complex has Gothic, Renaissance, and Baroque elements that architecturally reflect the merging of the diverse styles that came and went over time. Santo Domingo is characterized by its solid, sturdy construction, having been designed to take into account the frequent earthquakes that affect the area. The convent of Santo Domingo is one of the most outstanding architectural works in southern Mexico and one of the finest examples of Mexican colonial architecture.

Of special interest to the INAH is the ethnography collection, because it connects us directly with the living cultures of the state of Oaxaca. For this reason a gallery in the museum is dedicated to the exhibition of objects, tools, artifacts, textiles, and other items related to the uses, customs, and traditions of the indigenous groups of the state of Oaxaca. The importance of this gallery lies in the fact that through these objects, the original cultural elements of the different groups are seen. As a result of contact with Western cultures, there has been a gradual transformation of the cultural values of these peoples, and the objects on display are a priceless heritage for these indigenous groups, as well as for the rest of the world.

The Regional Museum of Oaxaca has a unique collection of traditional textiles that originated from the different indigenous communities. It is currently in the process of conservation, thanks to the invaluable support of the Getty Conservation Institute and its much appreciated representatives. The beauty of each of these items is outstanding. Because the material with which they are made requires continual special care and handling, the Getty Conservation Institute has sent specialists who not only have worked toward the preservation of the textiles but have also seen to it that the physical space where the collections are kept is in the best possible condition. In addition, they are training the custodial personnel of the museum to carry on that important work.

This type of project between cultural institutions like the Regional Museum of Oaxaca and the Getty Conservation Institute, which has enormous international prestige, is an example of cooperation in the field of cultural heritage—a heritage that belongs to all of humanity. For this reason, the authorities of Mexico's Instituto Nacional de Antropología e Historia are pleased to participate in and to strengthen relationships with agencies and institutions that share an interest in projects such as these—ones that preserve and disseminate the material and spiritual heritage of the Mexican people.

Eduardo López Calzada
Anthropologist
Director of the INAH Center
of Oaxaca

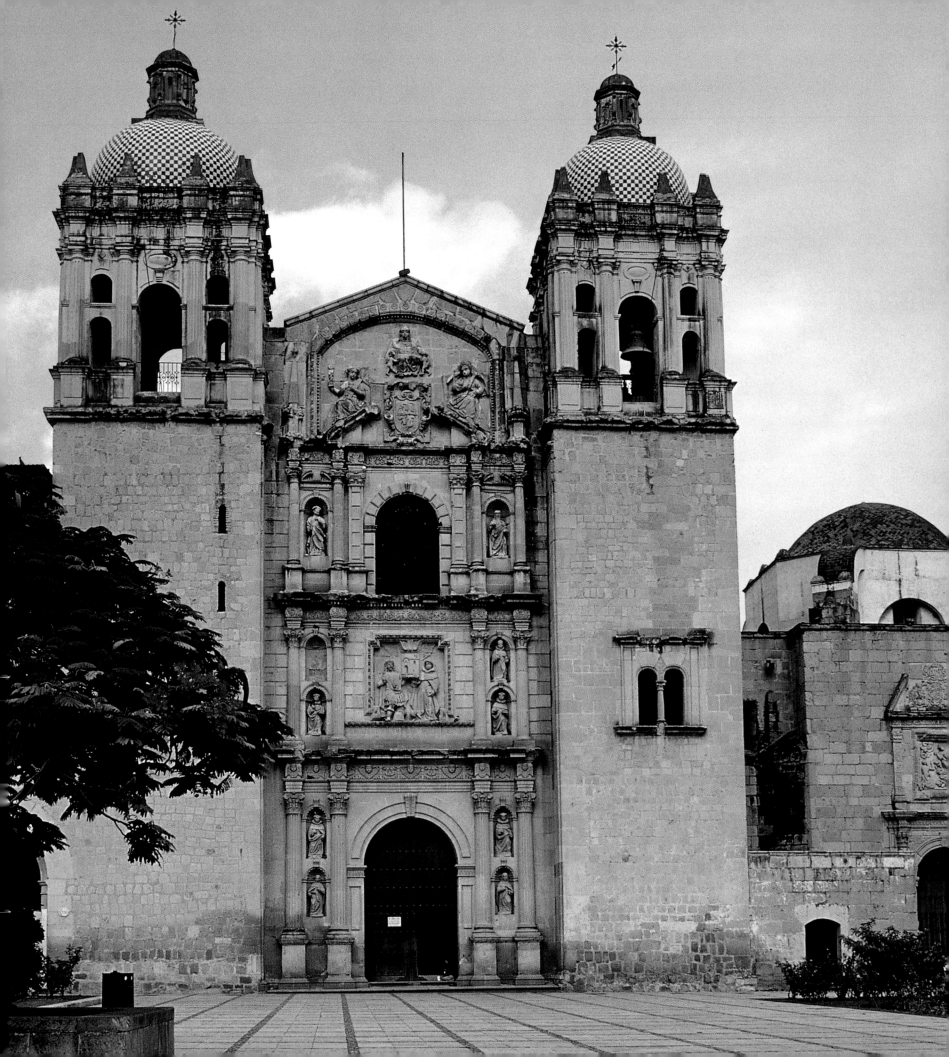

Preface

Exterior view of Santo Domingo church. The buildings were constructed of massive, hand-carved blocks made of a locally quarried greenish stone known as *cantera verde*, a zeolite used by indigenous people since precolumbian times. Because the archaeological site of Monte Albán is located just outside of Oaxaca City and was accessible to the Dominican architects, they most likely had recognized the potential of this soft stone. It has both the strength for massive construction and a consistency suitable for decorative, carved facades. Photo by J. López.

The Unbroken Thread: Conserving the Textile Traditions of Oaxaca is somewhat of a departure for a publication of the Getty Conservation Institute. This book is the result of a research and conservation project undertaken by Institute consultants and staff in collaboration with our partners at the Instituto Nacional de Antropología e Historia's Regional Museum of Oaxaca.

The project grew out of an interest in looking at living traditions in cultural heritage within our rapidly changing and evolving contemporary world. There can be no doubt about the importance of textiles as a reflection of past and present cultures. Archaeological textiles and depictions of them in ancient art provide a wealth of information about the materials used by ancient cultures, the technology of textile weaving, and the relationship of these objects to their ceremonial and everyday use. In many parts of the world, textile traditions have been transmitted to sons and daughters over the millenia. The examination of contemporary textiles offers insights into the past on a continuum that amazes anyone who explores it.

Just as fascinating as the use of the textiles and the technology of their manufacture are their beauty and the exquisite pleasures that they provide to the eye and the mind. Oaxaca was an appropriately exciting place to undertake this project. The rugged mountains of the Oaxaca region have given rise to isolated settlements where a wide variety of weaving techniques flourished in the past and survive well into the twentieth century. The pride of the artists and craftpersons who produced these materials in the past and continue to do so today is brought to the forefront in the quality of the objects and elegance of their designs.

The collaborative endeavor between Mexico's Regional Museum of Oaxaca and the Getty Conservation Institute was based on the concern of finding an appropriate mechanism to conserve textiles in the museum's collection in a sustainable and appropriate manner, linked to the existing resources of the museum. Training in the preventive care and management of the textile collection became the first of many steps that are detailed in this publication. This was followed by field work, traveling deep into the Sierra to interview

weavers, collect natural sources of dyes for further analysis, and identify the textiles within their cultural contexts.

The textiles of Oaxaca, like those of many other places in Mexico and other countries in Latin America, as well as other parts of the world, represent living traditions that have undergone many influences. In the case of Oaxaca, these traditions have evolved through many changes reflected in the uses of dyes and fibers and in the motifs of textiles created by contemporary cultures. As the reader will discover on the pages that follow, some of these motifs are symbolic, and a strong case is made for their relation to folklore in stories that are still told today.

The uses and functions of textiles have also evolved. Many garments were used in the past for ceremonial purposes; these are often depicted in precolumbian pottery, painted manuscripts, wall paintings, and carved stone reliefs. In Oaxaca today, similar garments are used in ceremonies. In the past, of course, hand-woven garments were used in daily life, whereas the demands of modern life have modified their use.

A section of the convent once occupied by the Mexican military. By 1859, under the laws of the Reform promulgated by Benito Juárez, the few friars remaining at the convent were forced to leave. Because of its solid and impenetrable structure, the convent was converted into a military garrison, serving as a prison, a stable, and a depot for military equipment. For many years the convent was occupied by the militaries of either the liberal or the conservative governments of Mexico. Through the mediations of the archbishop of Oaxaca, in 1895 the church and a small annex of the convent were returned to the Dominicans. Photo by K. Klein.

The onslaught of mass tourism also has brought many changes to the textile traditions of Oaxaca. The influx of avid tourists, justifiably eager to take home souvenirs of their visits, creates tremendous pressure on the weavers who offer their products in the tourist markets—a pressure that brings a concomitant drop in the quality of the textiles. This publication, as well as the museum exhibition mounted in conjunction with it, may help to counteract the erroneous perception that all textiles are similar to those available in the tourist markets. This information may also contribute to create a greater awareness of the exceptional care and skill of the weavers, who not only produce the textiles but also employ them for daily and ceremonial purposes.

The conservation project encompassed a systematic search for the sources of original, natural dyes. Analysis of the colorants introduced some surprising results, including the fact that the use of synthetic dyes appeared earlier than had been supposed and that natural and synthetic dyes had been mixed to produce new, innovative colorants for threads. Not many scientific studies of colorants have focused on textiles in Mesoamerica; uses of these dyes may, in fact, be related to archaeological objects. Further research is necessary, and this is certainly an exciting path to follow.

This project also pointed out the importance of establishing a collaboration between the weavers and museum authorities. From a conservation perspective, the preservation of a material object as an artist's work is as important as the information the object can provide to present and future generations. The conservation of the textile collection translates into a resource for the conservation of a living tradition; the collection is irreplaceable because traditions and technology change. Conserving the collection offers scholars the possibility of referring to previous motifs and techniques, but it also gives present-day weavers the opportunity of working within the museum setting to study past patterns and techniques, thus helping to keep the traditions alive.

As a consequence of this project, the future for this textile collection looks brighter. The collection will be available for view and study in newly reconditioned facilities that the Regional Museum of Oaxaca is preparing in the former convent of Santo Domingo. A total program of conservation that encompasses preventive care and management has been put in place. The active participation of weavers and museum curators in their joint study of Oaxaca textiles will help to ensure that these vibrant, centuries-old traditions of skill and artistry will remain for generations to come, thus helping to maintain the unbroken thread of cultural heritage.

As with all projects of the Getty Conservation Institute, this has been a team effort, and all the participants are appropriately credited here. I must nonetheless make special mention of Kathryn Klein. Her knowledge and scholarship, added to her commitment, enthusiasm, and determination to bring the conservation project to conclusion and the publication to light, are highly recognized and commended. To her and to all project participants go my sincere gratitude and appreciation. It is my fervent hope that, through this book, the reader will share in the enjoyment of the complexity and beauty of the textile traditions of Oaxaca.

Miguel Angel Corzo
Director
The Getty Conservation Institute

Oaxaca Textile Project

Project Participants

June 1993 – January 1995

INAH Regional Museum of Oaxaca

Eduardo López Calzada
Director of the INAH Center of Oaxaca

Manuel Velasco
Director of the Regional Museum of Oaxaca

Gisèle Pérez-Moreno
former Coordinator for INAH, Oaxaca

Museum Staff

Enrique Bautista Sánchez

Auria Jimenez Chavez

Paula Irma García

Ricardo León Martínez

Rosalba Sánchez Nuñez

María Angeles Velasco Crespo

GCI Conservation Consultants

Kathryn Klein
Project Leader

Sharon K. Shore
Textile Conservator

Weavers

Guadalupe García

Adela García de Jesús

Josefina Jacinto Toribio

Maura de Jesús López

Giselda F. Jiménez

Florentina López de Jesús

Elvira Martínez López

Teófila Palafox

Nicolasa Reyes Marín

Juan Sánchez Rodriguez

María del Socorro
 Agustina García

GCI Fieldwork

Alejandro de Avila B.

Kathryn Klein

Marilurdes Navarro

Rosalía B. Navarro

Gisèle Pérez-Moreno

Sharon K. Shore

Arie Wallert

Photographers

Guillermo Aldana
Oaxaca fieldwork, 1994

Kathryn Klein
project documentation

Jesús López
Oaxaca fieldwork, 1995

Michel Zabé
photography of textiles at the Regional Museum of Oaxaca, assisted by Gerardo Luna

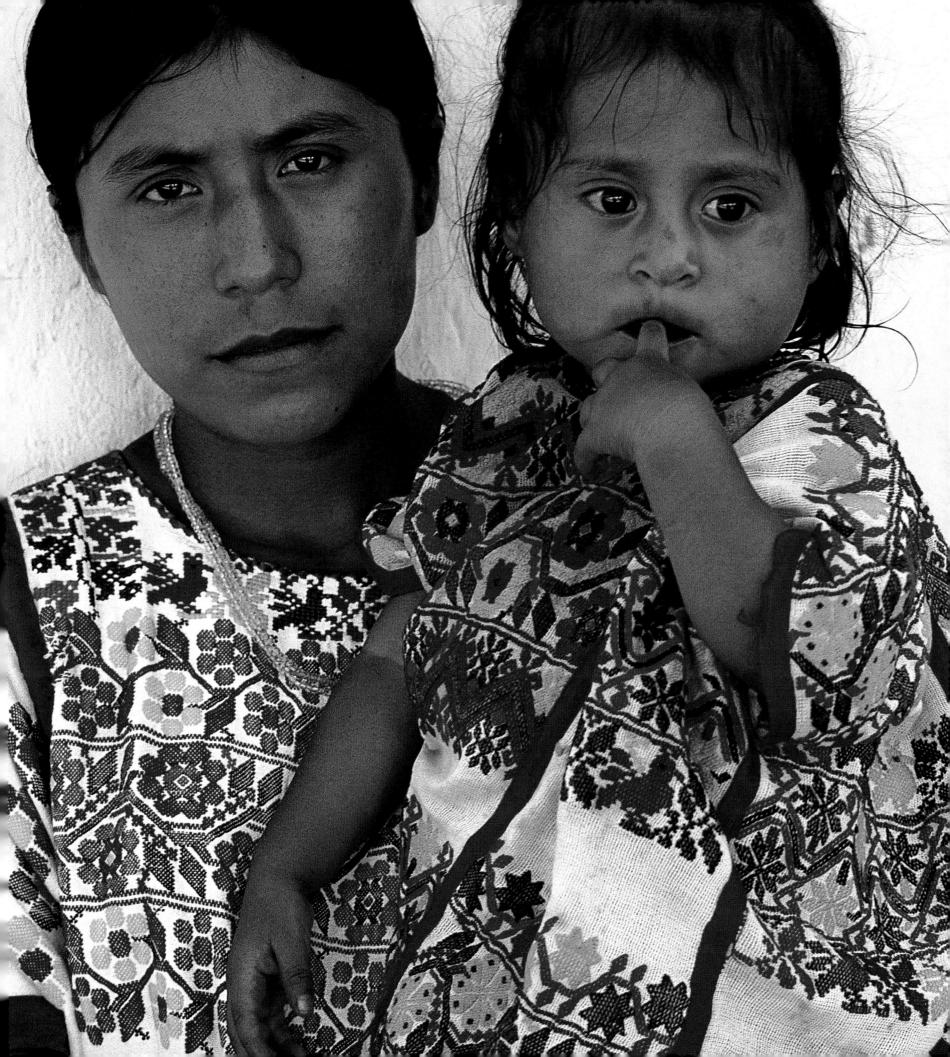

Conservation and Cultural Identity

Kathryn Klein

THROUGH the investigation of Mesoamerican material culture, the modern scholar is attempting to understand the distinctive ideologies of precolumbian Mesoamerican people. While scholars have made significant strides toward a greater comprehension of ancient and historical Mesoamerican life, there remains much to be investigated. Through anthropological and art-historical studies, a chronological structure that outlines the development, florescence, and demise of indigenous Mesoamerican civilizations has been formed; but it continues to be reconstructed and revised according to newly found archaeological evidence, ethnohistorical data, and present-day ethnographies, as well as iconographic and epigraphic analyses. Presently, scholars may understand ancient Mesoamerican life perhaps only as much as European Renaissance scholars once understood Greek antiquity.

The additional application of art conservation within Mesoamerican studies not only contributes to the conservation of cultural heritage but also to a deeper understanding of Mesoamerican material culture and the people who made its objects. Mesoamerican textile weaving reflects a continuous history of interpretation based on ancient, historic, and modern ideologies and techniques. The textiles that are found in museums and private collections and among the indigenous people of Mesoamerica, where the ancient art of weaving continues today, are significant resources of information.

A weaver and her daughter from Xochistlahuaca, Guerrero, wearing flowery huipils. The conservation of the textile traditions of living cultures includes an understanding of the past and present cultural contexts of the people who maintain those traditions. Photo by J. López.

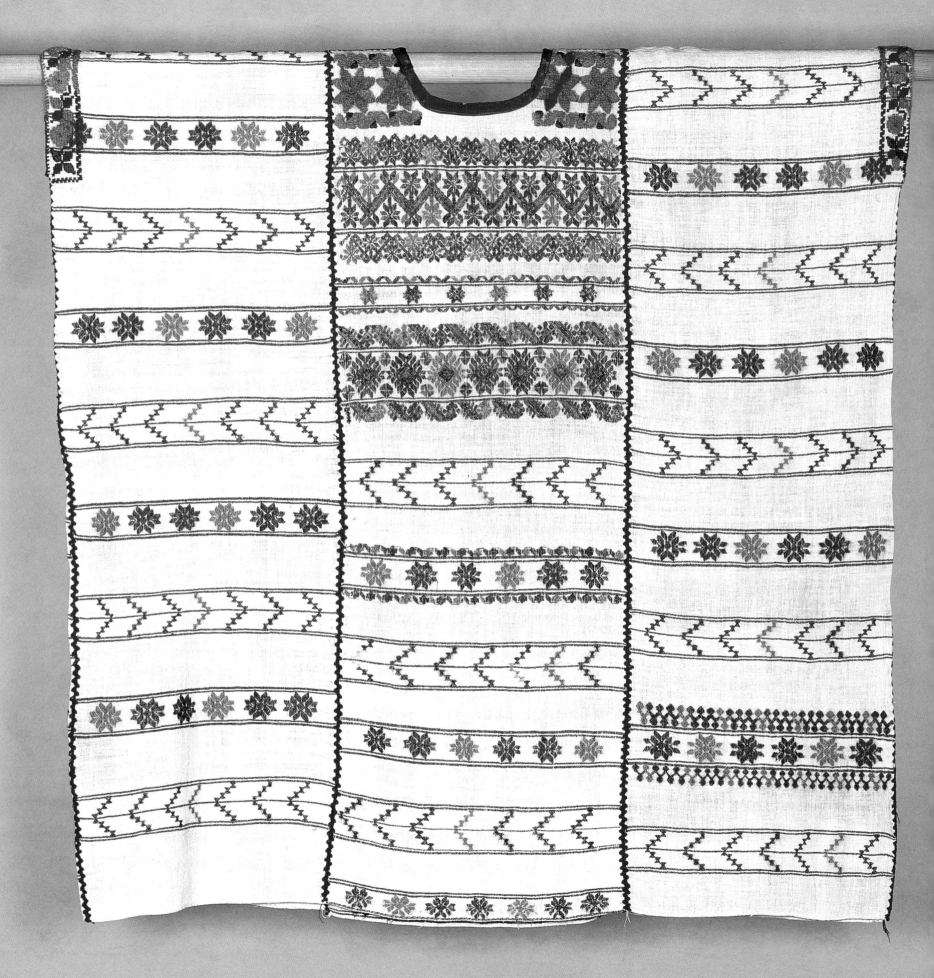

Cultural Traditions in Transition

Cultural traditions expressed through ritual enactments, symbols and myth, and the aesthetic qualities of art are in a state of transition and change according to what best reflects the identity and belief systems of a culture within a particular time and context. While these changes are usually subtle and often happen slowly, this universal feature of human beings—to create, maintain, and create continually—is exemplified by Mesoamerican people (Graburn 1976:30).

The creative application of new ideas and techniques in textile weaving is based on the maintenance of cultural foundations of tradition. For instance, although a weaver today may want to incorporate a new brocaded motif or perhaps even copy an old one into a weaving, if the weaver does not know how to make the structure for the backstrap loom, it will not be possible to materially produce this type of textile—let alone an innovative motif. Archaeological evidence suggests that loom weaving may have developed as early as 1500 B.C.E. in Mesoamerica (Sayer 1985:17). If an ancient technology such as backstrap weaving is not maintained or is replaced by something else, such as factory-made reproductions of indigenous fabrics, then not only does the material culture or object itself disappear but the entire foundation for a cultural tradition disappears along with it.

Of course, the impact of nineteenth- and twentieth-century technologies makes the picture even more complex. Some modern technologies incorporated into present-day textile traditions are valid and should be considered part of a continuous history. Synthetic as well as natural dyes, for example, are found in present-day weaving, yet many of the color symbolisms and geometric brocaded motifs have remained unchanged. Traditional foundations of expressive culture are not static but are maintained while in various states of transition. Where there are radical changes to expressive culture that completely deviate from the original functions, materials, aesthetic appearances, or symbolism, bits and pieces of cultural identity are lost (Asturias de Barrios 1991:134).[1]

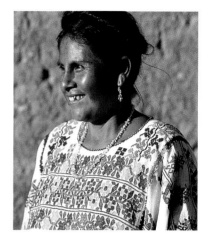

Maura de Jesús López, a weaver from Xochistlahuaca, wearing a huipil that connects her to her ancient heritage. Amuzgo weavers create distinctly lively looking huipils due to their vivacious color sense and the use of brocaded patterning in flowers. In the Náhuatl language, *xochi* means flower, and the members of this community refer to themselves as flower people. Photo by J. López.

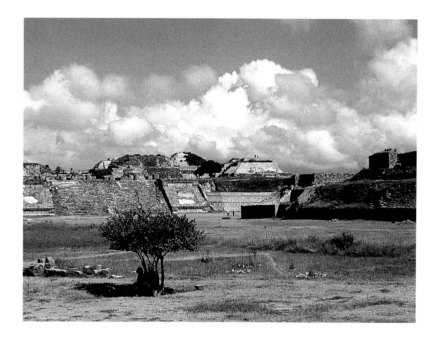

The Zapotec archaeological site of Monte Albán. Extensive religious ceremonies were once performed here by an elite class of rulers—lords and ladies who wore ceremonial costumes made of finely handwoven cotton, feathers, animal skins, wood, and plant materials. Photo by K. Klein.

A huipil from the Ometepec region of Guerrero. Mixtec and Amuzgo communities in eastern Guerrero are culturally and linguistically related to communities in Oaxaca. The brocaded patterns of flowers on the huipil recall a sixteenth-century description of a garment worn by an effigy of a Mesoamerican goddess of flowers named Xochiquetzal. "This goddess was the patroness of painters, embroiderers, weavers, silversmiths, sculptors, and all those whose profession was to imitate nature in crafts and drawing. . . . She wore a finely worked blue tunic decorated with beautifully woven flowers" (Durán 1971:239). Regional Museum of Oaxaca (154616). Photo by M. Zabé.

The Ceremonial Center

The development of the great civilizations of Mesoamerica was not based on massive technological or mechanical innovations but rather drew its power from a cultural propensity to elaborate on religious and aesthetic convictions. Located on the mountaintops overlooking the valley of Oaxaca, the buildings at the Zapotec archaeological site of Monte Albán were built without the use of domesticated draft animals, with no practical application of the wheel or even a source of water (Paddock 1966:152). Monumental buildings were erected and embellished by means of the pure physical strength, imagination, and craftsmanship of human beings propelled by belief.

In the world of the ancient Mesoamerican people, gods and deities were held to be an intrinsic part of nature and the key to well-being. The people of these ancient civilizations expressed their knowledge and beliefs through religious ceremonies and through the depiction of ceremonies in their art. The art of ceremonial dress developed simultaneously with the development of architecture, wall paintings, and objects such as ceramics and stone reliefs.

In the Valley of Oaxaca, the Zapotec-speaking people flourished from about 300 B.C.E., during the Formative period, until the infiltration of the Mixtec people into the area during the end of the Late Classic (ca. 900 C.E.). The opulence of the Zapotec ceremonial center, Monte Albán, rivaled even the contemporary Classic ceremonial center of Teotihuacán in the Valley of Mexico (ca. 600 C.E.).

At ceremonial centers such as Monte Albán, a "stage" was set for grandiose and extensive religious ceremonies performed by an elite class of rulers—lords, ladies, and priests dressed in ceremonial costumes made of finely handwoven cotton cloth, feathers, animal skins, wood, and plant material. Costumes were embellished with paint and jewelry of ceramic, bone, stone, and shell. Gold, silver, and copper were not used until the development of metallurgy in Mesoamerica, around 900 C.E. Religious ceremonies took place within the hidden chambers of the temple, as well as outside, in public view. Elaborate religious ceremonies not only venerated the gods for the masses but also rationalized the existence of an elite class of people and the labor-intensive construction of monumental buildings.

Archaeological evidence indicates that within the more humble domains of common homes, smaller ritual enactments took place. Even though most commoners did not wear the exquisite costuming of the elite, they may have embellished themselves as well as their own sacred spaces with what they had—flowers and food, body painting and tattooing, painted bark cloth, ceramic vessels, and small clay figurines. Through ceremony, the people affirmed their connectedness to gods, deities, and ancestors in order to perpetuate both the earthly and spiritual realms of their existence—which, in their reality, were one and the same.

The arts of weaving and ceremonial dress can be viewed as pervasive forces that link present-day indigenous people to their ancient and historical past. In the present-day weaving of Oaxaca, many abstract geometric brocaded motifs may be attributed to ancient ceremonial rites related to fertility and the personification of the feminine earth. In ancient Mesoamerican pictorial art, the gender of humans wearing ceremonial dress is not always clear, since both women and men dressed as female deities during ceremonial enactments—a practice that affirms the importance of feminine attributes. In many areas of Mesoamerica today, men continue to wear feminine costumes during religious ceremonies.

Before ceremonial costume can be examined, it is necessary to turn to some of the cultural contexts in which it was created and revised.

The Roots of Invention

The multitude of miniature, clay female figurines found buried at many Formative sites in Central Mexico (1500 B.C.E.–150 C.E.) points to the importance of feminine imagery. As in many "folk" arts, the repetition of the image gives its meaning. The large number of figurines, when viewed together, make a statement: Creation is important. And in this case, more is more.

At less than 10 cm in height, a standing female figurine from the Museum of Anthropology in Mexico City is typical of the D4, or "pretty lady," type, found at Tlatilco. This solid ceramic figurine was hand modeled with decorative elements of applied strips of clay and with incised indentations that indicate the details of her face and body. The figure's face and body are painted with red and yellow earth pigments that perhaps indicate decorative body painting or a textile costume. Her body has an hourglass shape with a tapering waist; a small, round belly; and youthful breasts. Her short arms are upraised and float in space—perhaps a dance gesture. D4-type figurines that are nude usually have large, rounded thighs, so that one may assume that the shape of this particular figurine indicates what would have been the ideal shape for the female body.

"Styles" of this type of figurine have been distinguished one from the other, but it is not clear whether these are from local centers of manufacture, each of which made a particular type, or the

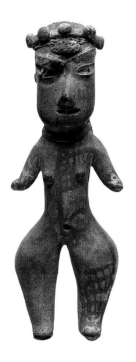

A standing female figurine from the archae-ological site of Tlatilco. The multitude of clay female figurines found buried at many Formative sites of Central Mexico (1500 B.C.E.–150 C.E.) points to the impor-tance of feminine imagery. The preponder-ance of female figurines of Tlatilco are depicted as young, voluptuous givers of life. In the present-day textiles of Mexico, many abstract geometric patterns may be attributed to ancient ceremonial rites related to fertility and the personification of the earth as female. CNCA-INAH-MEX. Reproduced by permission of the Instituto Nacional de Antropología e Historia. Photo by M. Zabé.

result of a broad development of style over time. Though there are representations of males, female figurines make up the majority. It has been proposed that the wide range of human activities sug-gested by these sculptures in clay—mothers with children, dancers, ball players, musicians—implies that the Tlatilco figurines are representative of secular life (Coe 1965:25). This may be true, but everyday life has a way of penetrating into the creative aspects of the mind. The female body, within many cultures, symbolically rep-resents fertility and creation. If the Tlatilco figurines represented only secular life, one would expect to find a more-or-less even ratio of male to female figurines. Yet the preponderance of the figurines of Tlatilco are depicted as young, voluptuous givers of life.

In his writing about Mesoamerican mythology, John Bierhorst points out that since these were agrarian societies, the typical gods of Mesoamerica were rain and earth spirits.

> Invariably the rain spirit is male, though he may have a wife who shares dominion over the waters. The spirit of the earth, on the other hand, is often feminine. Among the Aztecs she was to have been a hungry woman with mouths at every joint of her body. According to the modern Jicaque, the cracks of the earth's surface are her thirsty mouths. These ideas, however, often amount to per-sonifications rather than actual deities. (Bierhorst 1990:144)

When one considers the large quantity of female clay figurines that were purposely buried in the ground before the advent of known deities, it seems as if the idea of a personified feminine earth was being demonstrated literally.

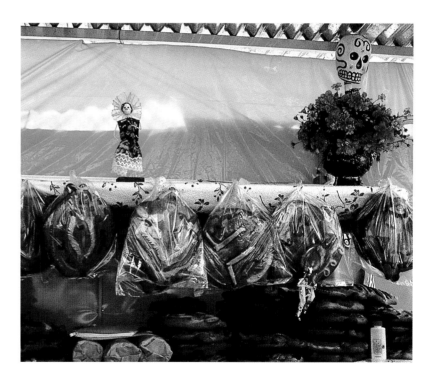

Day of the Dead items for sale in a market of Oaxaca City today. As in the ancient past, bread is shaped into forms that represent the flesh and bones of deities and ancestors. Bones, most particularly skulls, are associated with fertility, as they are perceived to contain the life force of human beings and animals. Photo by K. Klein.

While female representations found in Mesoamerican art do not determine the cultural value of women in those societies, they do bring us closer to recognizing how important a role feminine attributes played in the development of the area's mythology. Whether the use of feminine imagery was originated by men or by women is not important here; what is clear is that the marriage of the feminine and masculine aspects of the mind in any human being sparks creativity. This precept is best exemplified by Mesoamerican personifications of the earth and sky as fertility and creation. Pantheons of deities and variations on themes were created from these basic components. There were many different Formative cultures throughout Mesoamerica, and the deification of the physical world was to become shaped into many artistic forms.

A History of Reinterpretation

During the late Postclassic period (ca. 1300–1550 C.E.), the Aztec of Tenochtitlán, a militaristic civilization of the Valley of Mexico, utilized and elaborated on various representations of older Mesoamerican gods and deities. For example, the iconography of one of these gods, a fertility goddess named Xochiquetzal (Flowery Plumed) in the Náhuatl language, can be traced back through various Mesoamerican cultures and may have originated among the ancient Mixtec of what is now Oaxaca. Since Xochiquetzal was also a patron of the arts—which included weaving—it seems appropriate to include her here.

During the sixteenth century, the Spanish Dominican Friar Diego Durán wrote lengthy and detailed descriptions to chronicle the sacred world of the Aztec people of the Valley of Mexico. A description of a religious ceremony that honored the goddess Xochiquetzal follows. Ceremonies such as this one took place at the Templo Mayor of Tenochtitlán, at what is now the center of Mexico City (Durán 1971:72):

> On this day their persons, temples, houses, and streets were adorned with flowers, similar to the custom of the Christians early on Saint John's Day. Thus decorated with flowers, they engaged in different dances, merrymaking, festivities, and farces, all filled with gladness and cheer. All this was in honor and reverence for flowers. This day was called Xochilhuitl, which means Feast of Flowers, and no other finery—gold, silver, stones, feathers—was worn on this day—only flowers. Besides being the day of the flowers it was the day of the goddess, who, as I have said, was called Xochiquetzal. This goddess was the patroness of painters, embroiderers, weavers, silversmiths, sculptors, and all those whose profession it was to imitate nature in crafts and drawing. All held this goddess to be their patroness, and her feast was specially solemnized by them.

> The image of the divinity Xochiquetzal was of wood in the form of a young woman, with a queue hanging to the shoulders and bangs over the forehead. She wore golden earplugs and in her nose a golden ornament which hung over her mouth. She was crowned with a garland of red leather woven like a braid. From its sides emerged splendid green feather ornaments that were round and looked like horns. She wore a finely worked blue tunic decorated with beautifully woven flowers formed of feathers with many little plaques of gold pendants all over them. She was represented with her arms open like a woman who is dancing. (Durán 1971:239)

Durán further describes Xochiquetzal as a "patroness" of pleasurable activities and of love. The description also defines her as being "whorish," but it is doubtful that she was perceived in this way by the Aztec people. Her associations were more likely related to the fertility and abundance of the earth and the beauty and fecundity of nature.

Sacred quetzal feathers and flowers, both real and woven, adorned her. The use of flowers in religious ceremony is common throughout the world (including in Christianity, as Durán points out). In nature, the ephemeral qualities of flowers contribute to their beauty; their varieties of form, color, texture, and fragrance give evanescent pleasure to the beholder. They represent not only life but also, because of their transitory nature, death. The unknown or the sacred realm is metaphorically symbolized by flowers associated with god(s).

Later in his account of the ceremony, Durán described how the effigy of Xochiquetzal was placed inside the temple, at the Templo Mayor, on an altar next to an effigy of Huitzilopochtli (Hummingbird on the Left), who represented the warrior god of the sun requiring sacrifice for sustenance (Coe 1984:152; Baird 1993:108). The effigies were ritually purified with the smoke of burning copal incense.

Before the altar, the participants in the ceremony made the dough for a bread that would give a "signal," in the form of an impression, of the birth and arrival of Huitzilopochtli from heaven to earth. The *tzoalli* (bread) was made into various shapes, including forms that represented "the flesh and bones of deities" (Durán

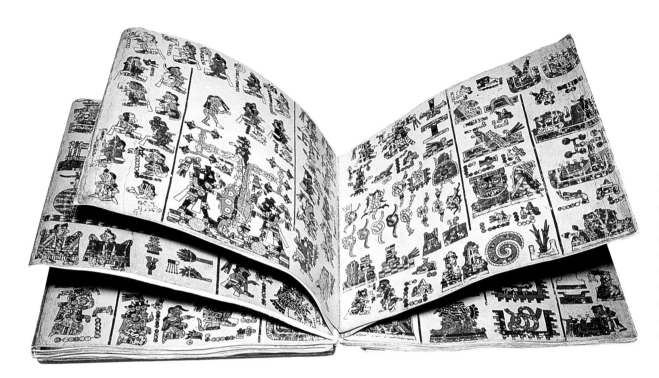

Facsimile of the Codex Vindobonensis, a precolumbian Mixtec screenfold manuscript. The figures painted on deer hide illustrate both historical and mythological events. On its obverse, it displays a creation myth with depictions of deities and/or people impersonating deities by use of ceremonial costumes. Reproduced courtesy of Peter T. Furst and Akademische Druck- und Verlagsanstalt, Graz, Austria. Photo by Peter T. Furst.

1971:203). Later the bread was ritually eaten. The practice of making shaped bread for festive occasions continues in Oaxaca today.

Durán went on to describe the ritual dancing of priests who had in their possession four colors of corn carried in gourd bowls. The priests wore ceremonial costumes—"brief shirts reaching to the waist and short skirts or aprons decorated with numerous hearts and hands," which would indicate that they were dressed as the god Xochipilli (Flower Prince), who is the masculine counterpart to Xochiquetzal (Durán 1971:243).

Two young noblewomen then entered "handsomely dressed in new clothing, with jewels at the neck . . . their faces made up with color on their cheeks and lips, while on their heads they wore elaborate tiaras."[2] The noblewomen and priests ascended the stairs "as if in procession . . . to a round [disk-shaped] stone . . . called the Cuauhxicalli." The priests "faced the mountains" and dipped the noblewomen's hands into the bowls of corn to scatter each color in a specific direction. The women were then held down by the priests and ritually slain upon the flat surface of the stone. Their hearts were removed and their bodies rolled down the stairs.

A woman dressed as Xochiquetzal was then presented. "She represented the goddess alive." She also was sacrificed, and her skin was flayed.

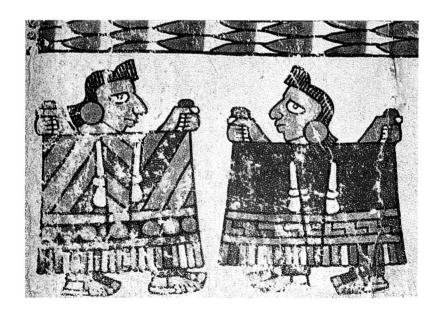

The Codex Vindobonensis. The mythological depictions shown here may represent the participants of ceremonies using specific costumes they believed allowed them to "become" the gods and deities. A detail shows two men holding textiles. The depiction of ceremonial objects and textiles demonstrates that these materials were not merely accoutrements to religious events but integral parts of these ceremonies. Reproduced courtesy of Peter T. Furst and Akademische Druck- und Verlagsanstalt. Photo by Peter T. Furst.

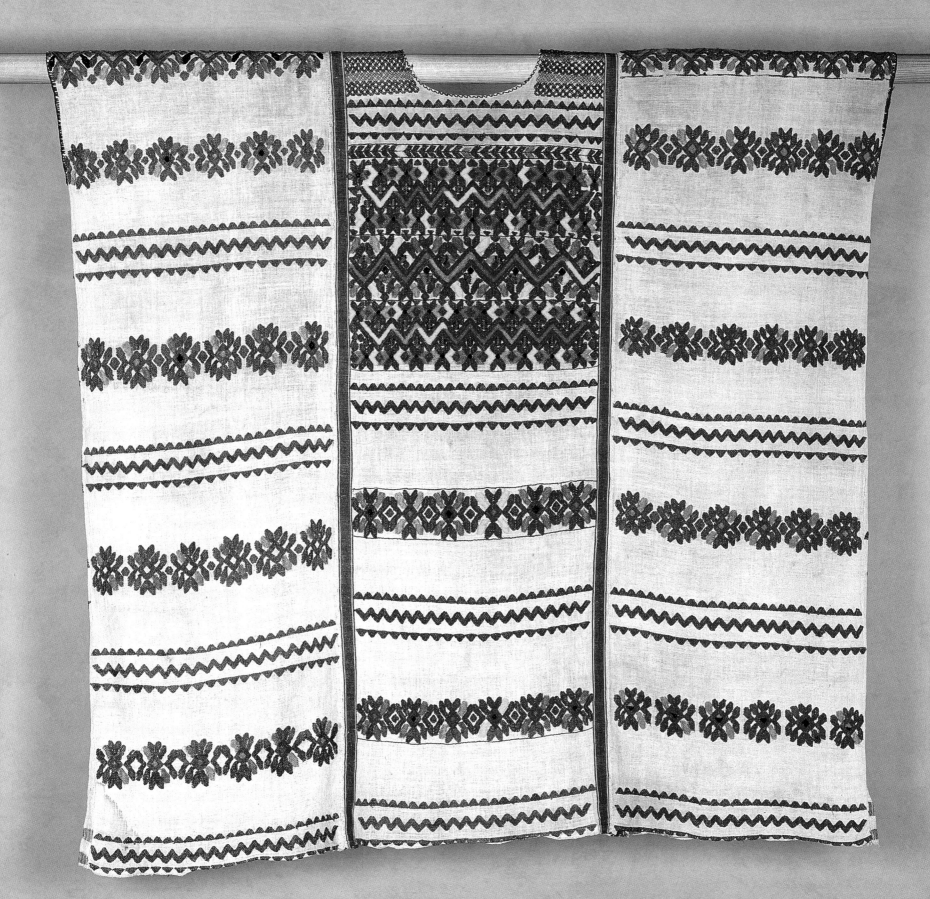

Then one of the men donned her skin and all her refinery. This man was made to sit next to the steps of the temple, where a woman's loom was placed in his hands. They made him weave as the Indian women weave: thus the man pretended to be weaving. While he feigned to be weaving, all the master craftsmen—disguised as monkeys, ocelots, dogs, coyotes, mountain lions, jaguars—reveled in a jubilant dance. Each carried in his hands the insignia of his craft: the metalworker carried his tools, the painter his brushes and paint pots. (Durán 1971:244)

During the fifteenth century, the influence of the militaristic Aztec empire was far reaching and was felt throughout much of Mesoamerica (Baird 1993:4). The development of the Aztec society in the Valley of Mexico was directly related to the revitalization and worship of many older deities and myths from other previous cultures of Mesoamerica (Townsend 1992:171). The revitalization of gods, deities, and older religious concepts proliferated, as extensive religious ceremonies and human sacrifices were taken to a fundamental extreme.

Previous to the fifteenth century, within many areas of Mesoamerica, periodic human sacrifice of captives, as well as autosacrifice by the elite, did take place. But because other Mesoamerican cultures were undoubtedly influenced by the Aztec empire during the late Postclassic, and vice versa, the practice of multiple human sacrifices in conjunction with the revitalization of myths and deities expanded into many areas, such as among the Toltec-Maya of the Yucatán and the Mixtec in the Valley of Oaxaca. Periodic human sacrifice continued to take place throughout the conquest, well past the sixteenth century (Tozzer 1941).

Cultural Florescence

Before the Late Classic Mixtec invasion into the Zapotec-populated Valley of Oaxaca, the Mixtec had been scattered in small communities throughout what is now northwest Oaxaca, Puebla, and southern Veracruz (200 B.C.E. to 700 C.E.). Archaeological excavations indicate that the Mixtec people did not build monumental temples but that their artistic endeavors focused more on portable objects such as polychrome painted ceramics, painted pictorial manuscripts, jewelry, and textile weaving. Because they had been located between the Valley of Mexico and the Valley of Oaxaca, Mixtec-Puebla artists not only created magnificent stylistic forms that were distinctly their own but also made objects that expressed earlier underlying themes based on a combination of Classic period styles: Teotihuacán, Monte Albán, and Veracruz iconography (Nicholson 1973:73).

The Codex Vindobonensis (or Codex Vienna), a pictorial manuscript of the late Postclassic Mixtec period painted on deerskin screenfold, illustrates both historical and mythological events. This codex has been interpreted as a document that determines the genealogies of various Mixtec rulers back to 1000 C.E., shows geographic locations within the Mixtec region, and, on its obverse, primarily displays a creation myth with depictions of deities and/or people impersonating deities through the use of ceremonial costume (Anawalt 1981:98).

Since the ancient Mesoamerican people perceived time as unfolding in a cyclical manner, with similar events happening over and over again, this codex (along with other codices and perhaps Mesoamerican pictorial art in general) may represent a mixture of both mythical and historical events expressed simultaneously. Because the concepts of the "real," or historical, world and the spiritual world were not viewed as separate, the composition on the obverse of this codex may not have been purely conceptual but may have been a stylized expression of how the participants in a religious ceremony visually arranged themselves.

Many sixteenth-century Spanish friars alluded to the codices as "pagan" manuals of divination and, unfortunately, burned thousands of indigenous manuscripts. Indigenous people had referred to the calendrical codices for information regarding daily life, such as the auspiciousness of planting on a certain day or the dates for religious occasions. Some of these codices may also have provided "recipes" for how to perform specific ceremonies. The mythological depictions may represent the participants of ceremonies wearing particular costumes in order to "become" the gods and deities. If the obverse of the Codex Vindobonensis depicts religious enactments, it demonstrates that ceremonial textiles and objects were not just the accoutrements applied to a religious event but were instead an integral part of the ceremony itself.

A Metlatónoc huipil from Guerrero. The confines set forth by the horizontal and vertical structures of backstrap looms imposed geometric limitations on the brocaded designs of the motifs. Within the warp and weft boundaries, however, creative imagination prevailed, as abstract geometric forms were used to represent a rich symbology. Regional Museum of Oaxaca (154576). Photo by M. Zabé.

Past and Present Ceremonial Practices

Jill Furst's complex examination of the Codex Vindobonensis focuses on the Mixtec old gods, in order to determine their identities, attributes, functions, and roles in Mixtec cosmology, as well as in the physical world. In this codex, the old gods functioned as perpetuators of the universe and performed various rituals that demonstrated the creation and birth of the gods. It has been determined that many of these Mixtec old gods were associated with the fertility of the earth and the nourishment of cultivatable maize with water and/or blood.

For example, one such fertility goddess, named Female 9 Grass, is most often depicted wearing a distinctive *quechquemitl.* *Quechquemitl* are garments that consist of two loom webs sewn together at their top and bottom ends and folded in various ways to form triangular or rounded short "ponchos" worn over the shoulders. Along the borders of Female 9 Grass's *quechquemitl* are depictions of *ilhuitl* forms—S-scroll motifs that may symbolically indicate day/sun together with ceremony. She is depicted wearing a mask-like skull headdress. Bones, most particularly skulls, are associated with fertility, as they were perceived to contain the souls or life force of human beings and animals (Furst 1994). The presence of Female 9 Grass often indicates the *initiation* of the ceremonies associated with fertility rites, as depicted in the codex (Furst 1977:7, 237; 1978:165).

While the Codex Vindobonensis has yet to be completely interpreted, certain components of the depicted rituals are particularly analogous to a present-day ceremony of the highland Maya people. Ancient indigenous ceremonies and Spanish colonial customs fused to form many traditions found in most of Mesoamerica today. In many present-day highland Maya communities, garments of the effigies of the saints are washed in an elaborate ceremony called, in the Tzotzil Maya language, *chuc nichim* ([place of] washing of the flowers). Through ceremony and tradition the Maya have maintained their rituals while simultaneously conserving their material culture by virtue of caring for the textiles in a systematic manner (Klein 1992).

This ceremony can be characterized as a traditional "conservation" practice that is enacted in preparation for the procession of the effigies on the feast day of the local patron saint. The caretakers of the saints and the churches, called *mayordomos,* hold prestigious positions within a complex hierarchical arrangement of religious and civil officials, known as a *cargo system.* Both men and

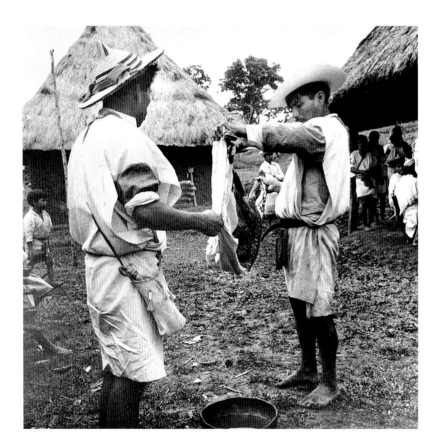

Two men from a highland Maya community participating in a ceremony called *chuc nichim* (washing of the flowers), ca. 1950. Garments worn by the effigies of Catholic saints are ritually washed and cared for in a manner that conserves the materials of which they are made while, at the same time, maintaining a precolumbian tradition of sacred textiles, which is a focus of the ceremony. Reproduced courtesy of the Na Bolom Museum, San Cristóbal de las Casas, Chiapas, Collection of Gertrude Duby Blom photographs.

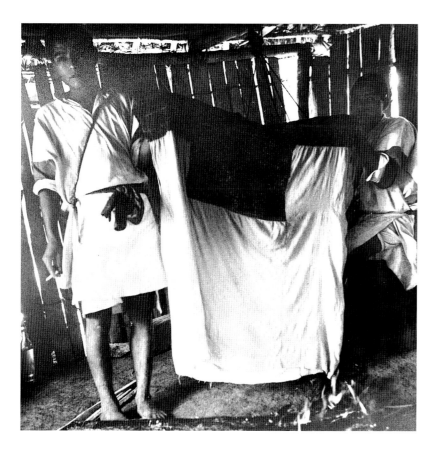

Two men holding a saint's huipil between them, ca. 1950, an image that recalls the Codex Vindobonensis depiction. Reproduced courtesy of the Na Bolom Museum, Collection of Gertrude Duby Blom photographs.

Overview of a *chuc nichim* ceremony, ca. 1950. Saints' garments hang on a clothesline to dry while the participants of the ceremony recite prayers, play music, and serve food and beverages. When the garments are dry, they are packed into wooden boxes and carried back to the church. Reproduced courtesy of the Na Bolom Museum, Collection of Gertrude Duby Blom photographs.

Participants venerating the saints, which are clothed in the washed textiles, ca. 1950. The preparation of the textiles takes place two to three days before the final event—the *muk ta' kin*, or grand day, on which the effigies of the saints are carried in a procession. Reproduced courtesy of the Na Bolom Museum, Collection of Gertrude Duby Blom photographs.

women mayordomos wear specific ceremonial dress while performing the ceremony.

During the Maya washing of the flowers ceremony, the clothes of the effigies of the saints, along with a variety of religious objects, are carefully washed in sacred water to which flowers and herbs have been added. In 1992, in the Tzotzil highland Maya community of San Juan Chamula, the women stood in sacred springwater up to their waists and washed the garments for an entire night and most of the following morning. The men received the wet garments from the women and hung them on a clothesline to dry. Hundreds of textiles were washed in this manner. Once the garments were dry, they were "purified" with the smoke of copal incense and carefully folded into wooden boxes.

Other duties performed by the mayordomos were to count and keep track of all the garments and objects for each saint. The mayordomos garnered prestige when they acquired additional objects and money for the saints and the church. In a later, equally elaborate part of this ceremony, the garments were carefully placed back onto the effigies inside the church. At specific times during the ceremony, participants of the ceremony recited prayers, played music, sang songs, and consumed food and beverages (Klein 1994).

Since the author's previous research has emphasized the conservation aspects of this Maya ceremony, the following observations do not constitute an in-depth investigation of the codices. For comparative purposes, however, a few of the similarities between Mixtec codices and the present-day Maya ceremony will be described.

Furst describes depictions in the Codex Vindobonensis of "preparatory" rituals, the function of which is to initiate the ceremonies to be performed. These are often indicated by depictions of groups of ritual objects and by the depiction of two men who hold *xicolli* (tunic-like garments) upright by the two top corners, as if the textiles are being offered (Furst 1977:195). The Maya washing of the flowers ceremony takes place two to three days before the actual "event," the *muk ta' kin* (grand day), in preparation for the effigies of the saints to be carried in procession. Ritual objects and textiles are "prepared" for the final event.

As depicted in the codex, the Mixtec men who hold garments are in a position similar to that of the present-day highland Maya men receiving the washed garments from the women, as shown in a Gertrude Blom photograph (ca. 1950) of this particular Maya ceremony. In the Maya ritual the garments are hung on a clothesline to dry and later purified with the smoke of copal incense. In another Mixtec codex (Becker I), a seated man is shown playing music over a textile that appears to be draped over a small, freestanding (wooden?) structure. As shown in the Blom photographs of 1950, in the highland Maya community of Santa Magdalenas, the wet garments of the saints were turned inside out and hung on a clothesline. Three-dimensional wooden structures made of lashed branches—similar to those depicted in the codex—had been fitted inside the garments, perhaps allowing them to dry into the shape of the effigies. Once dry, the textiles were purified with burning incense.

Although women are not depicted in the Codex Vindobonensis as ritually washing textiles, the garments *are* shown hanging between two wooden poles, as if on a clothesline, connected to a small architectural structure, which Furst indicates is a steam bath. The Mixtec steam bath is one of several "place signs" associated with water that designate where ceremonies are to be performed. Maya washing of the flowers ceremonies often take place at sacred springs that have been designated as locations for the ritual washing of the garments and religious objects of the saints.

In the Codex Vindobonensis, along with depictions of ritual objects and textiles, men are shown wrapping ropes around (wooden?) boxes, or boxes are shown with garments partially protruding from under their lids, indicating the contents. Currently, as in the past, cargo boxes are an important aspect of the highland Maya ceremony, as the textiles and ritual objects for the saints are carried in boxes to the sacred spring, then back again to the church. Textile fragments, ritual objects, and money are stored in these boxes between ceremonies as well, and the boxes are often held in the mayordomos' homes between ceremonies. The boxes function as containers while the textiles and objects are being counted during the ceremony; the depiction of wooden boxes in the Mixtec codex may also suggest the ritual counting of objects. Since ceremonial textiles and objects are depicted stored within boxes, the codex may indicate not only that ceremonial objects were saved and reused within ancient rituals but that they were stored and "conserved" in priests' dwellings between ceremonies as well.

The codex also shows pairs of men holding ropes stretched out between them, perhaps in a ritual act of making a clothesline. Along with the codex's depictions of groups of ceremonial objects, various elements of ceremonial costumes, including a mask and perhaps four headdresses, are shown tied with rope onto upright bundles of wooden(?) staffs. In the Maya ceremony, great lengths of ropes for clotheslines are ritually placed onto numerous wooden poles. At the end of the washing portion of the ceremony, the ropes for the clotheslines are ritually removed in an elaborately organized fashion by the saints' attendants. As the clotheslines and poles are being removed, the saints' cargo boxes are carried out while the participants depart in a procession to the church. A few days later, on the Grand Day, all of the saints' attendants, incense bearers, and musicians walk in procession, carrying the effigies of the saints and the cargo boxes.

In the codex, the depiction of boxes of ritual textiles and objects also functioned to designate sacred spaces. The ritual participants

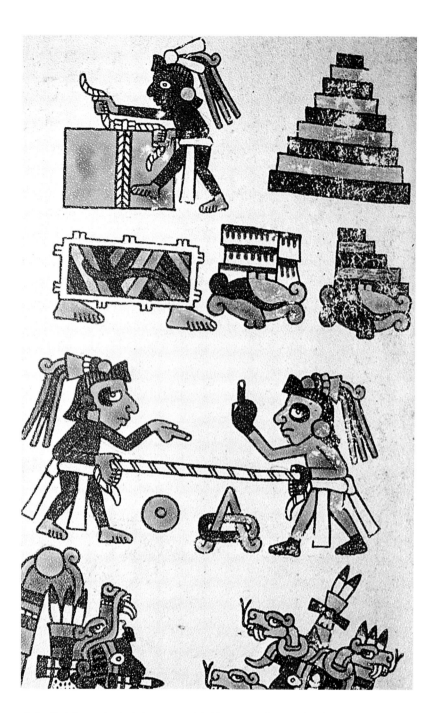

Codex Vindobonensis, depicting ceremonial objects, as well as men holding a rope between them and a man wrapping a rope around a box. As in the present-day Maya ceremony, the depiction of boxes in the late Postclassic Mixtec codex may indicate that sacred objects had been stored in boxes during periods between ceremonies as well. Reproduced courtesy of Peter T. Furst and Akademische Druck- und Verlagsanstalt. Photo by Peter T. Furst.

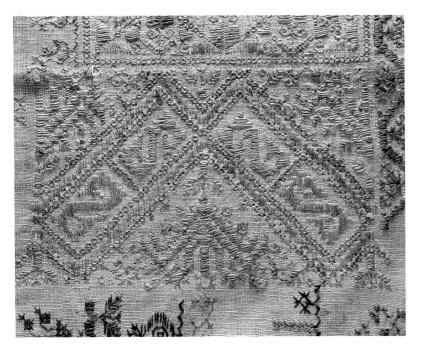

Full view and detail of a colonial embroidered sampler from Oaxaca. Even with the addition of various European embroidery techniques, which do not impose the same design limitations as does backstrap loom weaving, indigenous people continued to embroider geometric motifs onto textiles. Here, the S shape is an ancient form (*ilhuitl*) associated with the sun, feast day, and ceremony. Regional Museum of Oaxaca (131074.3). Photos by M. Zabé.

measured and secured the land by tying ropes around the boxes (Andres et al. 1992). The acquisition of land and/or the designation of sacred spaces are metaphorically demonstrated through the depiction of men tying ropes around boxes. Interestingly enough, the sacred space where the *chuc nichim* ceremony takes place is designated by rope clotheslines held on poles within that space. Usually the mayordomos sit within the confines set forth by the rope clotheslines and the textiles that are hanging on them. Furthermore, traditionally, when Maya women wash everyday clothing next to a river or washbasin, they allow their everyday clothing to dry flat on the ground or on top of small bushes, rather than setting up any sort of clothesline system.

Both the Mixtec Codex Vindobonensis and the present-day Maya washing of the flowers ceremony indicate that ceremonial textiles and religious objects—whether worn by people impersonating gods within a ceremony, by the depictions of gods, by Catholic effigies of saints, or by people who attend the saints within a ceremony—are ritually prepared, honored, and used in order to initiate a ceremonial transformation of the earthly realm into the spiritual realm.

Further investigation of current ethnological accounts of these types of Mesoamerican ceremonies, and of Mesoamerican codices, when combined with sixteenth-century Spanish descriptions, may indicate that many ceremonies that utilize ceremonial textiles to penetrate the sacred world are interpretations of ancient Mesoamerican ceremonial practices that have continued to take place within certain areas at least since the late Postclassic period. While more ethnological data about this particular ceremony need to be gathered for the Oaxaca region, it would not be surprising to find that rituals similar to the Maya washing of the flowers ceremony continue to exist within some churches of the indigenous people of Oaxaca.

The universal Mesoamerican use of the word *flower* in association with textiles—albeit in different Mesoamerican languages—symbolically refers to fertility, beauty and divinity, life, and the regenerative properties of death. The fact that most of the physical components of precolumbian Mesoamerican textiles (i.e., fibers and dyestuffs) were made of plant materials also indicates their natural connection to flowers. Further research along these lines may indicate the varying interpretations and routes of diffusion of many indigenous textile-ceremonial traditions since the late Postclassic period, and possibly before. Analyses will obviously need to include European contact and the subsequent conversion of

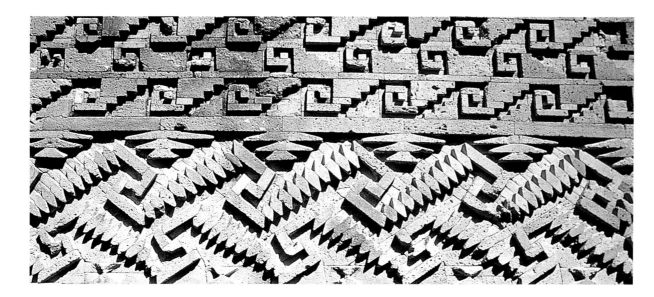

Detail of the mosaic stonework at Mitla. An aesthetic ideal was formed within textile weaving and may have been reproduced in the geometrically carved stonework of architecture. Photo by J. López.

Mesoamerican indigenous people to Christianity, as well as the impact of nineteenth- and twentieth-century technologies on Mesoamerican textile traditions.

Cultural Heritage and Conservation

In 1976 James R. Ramsey surveyed hundreds of Mixtec-style portable objects from more than eighty collections. He concluded that the most predominant Mixtec-style motifs—as opposed to the Mixtec-Puebla-style motifs—were "the celestial band [indicating a transformation into the spiritual realm], a composition comprised of the butterfly, flower forms, volute [step-fret] shapes (*xonecuilli*) [caterpillar], and the S scroll form (*ilhuitl*) [feast day and day/sun]; the human hand; the skull; and two related motifs—crosses and crossbones [symbols of fertility]." Many of these motifs were found on ceramic figurines that depict Xochipilli-Xochiquetzal (fertility) deities. Many of the same motifs are painted on depictions of textiles and ceramics in the pictorial Mixtec codices, and many had Mixtec-style origin and were not the invention of the "Aztec theologians" (Ramsey 1982:33, 39).

In the textile collection at the Regional Museum of Oaxaca, many similar motifs are found in handwoven brocaded garments. In the light of Ramsey's iconographic survey, which has significantly added to the understanding of ancient Mixtec symbolism, it would be interesting to implement comprehensive iconographic surveys of textile motifs according to the various cultural regions of Oaxaca. Mesoamerican textile collections and the textiles that various indigenous cultures have continued to make, represent

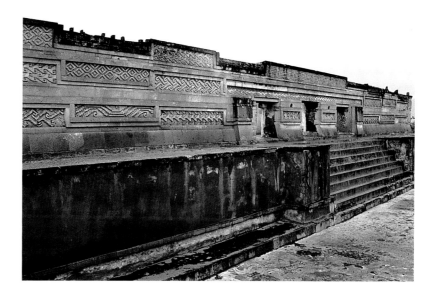

Mitla, an early Postclassic site located in the Valley of Oaxaca. The civilizations of Mesoamerica were not based on massive technological or mechanical innovations but rather drew power from a cultural propensity to elaborate on religious and aesthetic convictions. Photo by K. Klein.

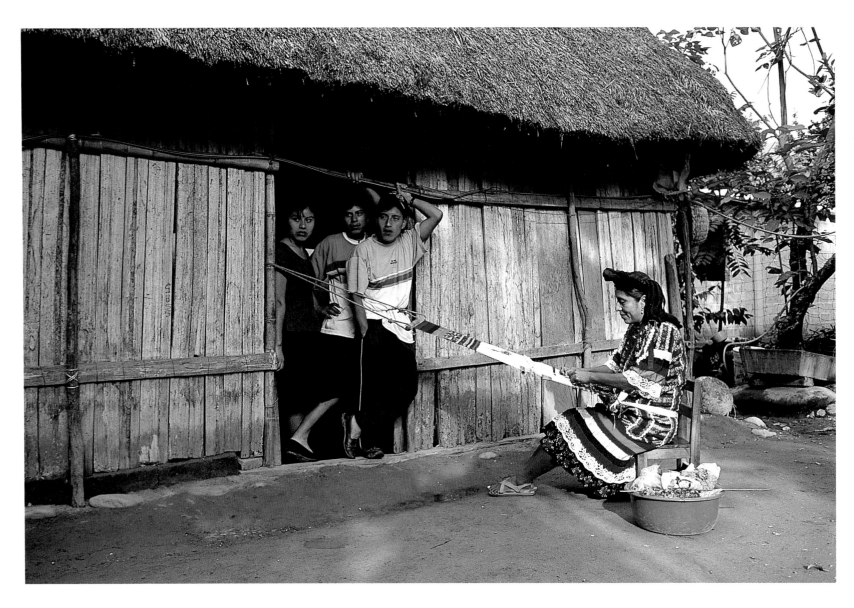

Josefina Jacinto Toribio of Usila, Oaxaca, wearing a huipil and demonstrating back-strap loom weaving. Other members of her family wear Western-style clothing. Young people prefer to wear Western clothes in many indigenous communities of Mesoamerica. Photo by J. López.

specific textile techniques and ideologies developed over time. The combination of ancient and historical iconography in the woven brocaded motifs reflects the layers of an enduring universe (Morris 1987).

The confines set forth by the horizontal and vertical structures of backstrap loom weaving imposed geometric limitations on the brocaded designs of the motifs (Cordry and Cordry 1968:172). Imagination and creativity were applied within the warp and weft boundaries of loom weaving, as symbolic meanings came to be represented in abstract, geometric brocaded forms. Even after the introduction of various European embroidery techniques, which do not impose the same limitations on design, many weavers today will carefully embroider traditional geometric motifs onto textiles. An aesthetic ideal was formed within textile weaving and may have been reproduced in the geometrically carved mosaic stonework of architecture (rather than the other way around). This is best exemplified at the Postclassic site of Mitla, located in the Valley of Oaxaca.

Additional scientific investigations into the material properties of historical and present-day textiles will further understanding of the development and use of dyestuffs and natural colorants found in Mesoamerica. It also may be possible to apply this knowledge to Mesoamerican archaeological objects, since both mineral and organic materials were utilized as colorants on painted objects and architecture (Tagle et al. 1990; Hansen et al. 1995).

A hand-spun thread connects Mesoamerican people to their ancient past. The tradition of ceremonial dress has changed in its form and function over time, but beneath the woven layers of interpretation, many cultural traditions remain. Through ceremony in conjunction with the continuance of textile traditions, the cultural heritage of Mesoamerican indigenous people is sustained for the time being.

Many of the indigenous people of Oaxaca no longer wear their traditional dress every day, although traditional dress is often worn on ceremonial occasions. In 1994, an older Zapotec woman of the village of San Pedro Cajonos, Oaxaca, exclaimed to the author that she did not want to see the loss of traditional weaving and dress, lamenting that young women of her village even wear trousers. In many indigenous cultures throughout Mesoamerica, young people want to wear Western clothes.

The young people of San Juan Chamula, Chiapas, came up with one solution in 1992: to wear Western clothes to a high school dance and then, after the dance, change back into traditional clothing.

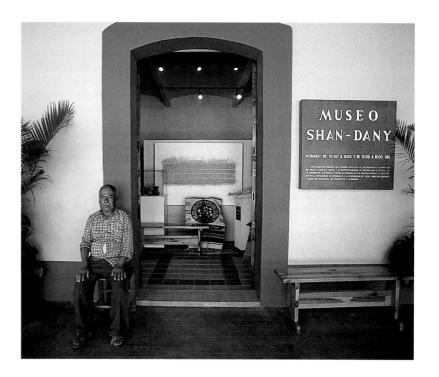

Juan Sánchez Rodriguez greeting visitors at the Community Museum of Shan-Dany in Santa Ana del Valle, Oaxaca. Shan-Dany is the Zapotec name of Santa Ana, meaning foot of the mountain. The community museums of Mexico provide opportunities for indigenous people to become involved with the conservation of their own material culture. Photo by J. López.

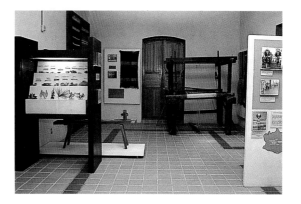

Inside the gallery at the Museum Shan-Dany. The goal of these types of community museums is to conserve at their original sites elements of local culture, archaeology, and history and to support local identity and culture. Photo by J. López.

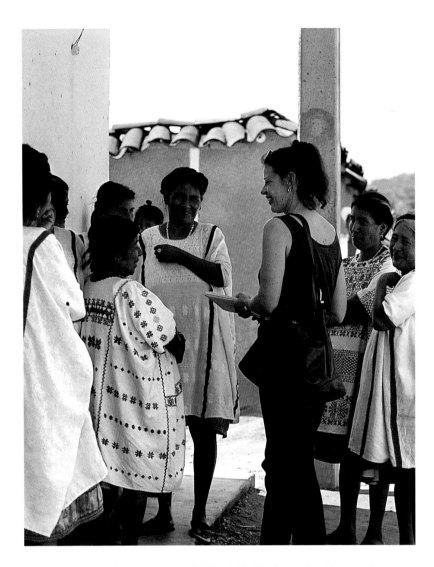

Members of the weaving cooperative called Flor de Xochi — Casa de los Artesanos de Xochistlahuaca, discussing weaving traditions with the author. Collaborative fieldwork contributes to the conservation of textile traditions. Photo by J. López.

In a sense, the Western clothing became the "costume," so that they maintained their identity, through traditional dress, as members of the community. Even though many young people are encouraged by the demonstration of their elders to continue the Mesoamerican traditions of weaving, dress, and ceremony, the quality of weaving is diminishing because of the massive quantities of textiles being woven exclusively for tourist markets.

There is not a single traditional culture in the world that has not somehow been affected both positively and negatively by Western technologies and ideologies. Western technologies infiltrated many traditional cultures at a rolling pace during the nineteenth century, picked up speed during the twentieth, and have accelerated during the last twenty years. It may not be too late to bolster the quality of weaving in Oaxaca, but it will take considerable effort. It will require the support of museums, governmental agencies, and international cultural institutions to conserve the Mesoamerican textile collections that remain, with the view to maintaining textile traditions. Such efforts may provide the opportunity for indigenous people to participate in museum programs, to study textiles, and to make copies and interpretations of textiles found in collections. These activities may also instill a heightened sense of pride in the indigenous cultures.

Though many ancient motifs continue to be utilized, in many areas of Oaxaca, exact symbolic meanings have been lost. Through conservation, documentation, and investigation of Mesoamerican textile collections, art conservators may partake in the future reintroduction of knowledge about symbolic meanings of textile motifs, as well as of weaving techniques and materials such as natural dyestuffs and colorants. This complex undertaking will also need to involve thorough investigations into the economic factors and organization of work within indigenous communities (Waterbury 1989:243–69). Many of the traditional textile techniques are labor intensive and therefore not conducive to economic growth.

The development of weaving cooperatives and stores, perhaps in conjunction with development of small local museums, will enable weavers, rather than wholesale buyers—who now take the major profit from textile sales—to profit directly. Marketing projects that raise the textile buyer's awareness, encouraging the purchase of a more expensive, higher-quality textile from these types of sources could be a means for indigenous people to benefit culturally and economically from the reintroduction of traditional textile techniques—while at the same time facilitating the survival of Mesoamerican cultural heritage.

The conservation of textile traditions may also be furthered through collaborative conservation work in the field. Collaborative projects that spark the interest of indigenous communities will aid in this endeavor (Camarena Ocampo and Morales Lersch 1994:17–21). Projects that teach conservation methods to indigenous people for collections located in small textile museums and weaving cooperatives have proved to be a viable means for the conservation of textile (and archaeological) collections in remote areas (Cohen 1989).[3] Yet, while museum workshops involve indigenous people in the conservation of their own collections, they do not necessarily change the way they care for the material culture in their own communities and ceremonies.

The conservation of the material culture of living people must also include the search for a deeper understanding of the past and present cultural contexts of the people who continue to make these objects (Klein 1997:20). Art conservators need to recognize that many living cultures—as demonstrated by their continuing existence—are vigorous and already possess inherent qualities necessary for survival. Art conservators need to know where to draw the line between useful intervention and damaging intrusion. They must be willing to make compromises—sometimes even to the detriment of the art object; objects designated as sacred may fall into this category. It is of utmost importance for conservators not only to continue to stabilize art objects and monuments but also to broaden their scope to include the conservation of present-day, living cultures.

The conservation of the textile collection at the Regional Museum of Oaxaca reveals that the textile traditions created by the indigenous people of Mesoamerica provide significant avenues of understanding into the vast complexity of their ancient, historical, and present-day life. Art conservators have the opportunity to contribute to the conservation of Mesoamerican cultural heritage through involvement in the maintenance and preventive care of textile collections and through collaboration with local communities. This approach to conservation also includes working with scholars of various disciplines through anthropological, art-historical, and scientific investigations. Conservators are equipped to carry out detailed documentation of materials and techniques and, while they are at it, surveys of iconographic descriptions. When possible, they may further the means for materials research through scientific analytic applications. Since many textile collections found in Latin America are in desperate need of attention and are *not* replaceable, the conservation of these collections offers challenging and exciting

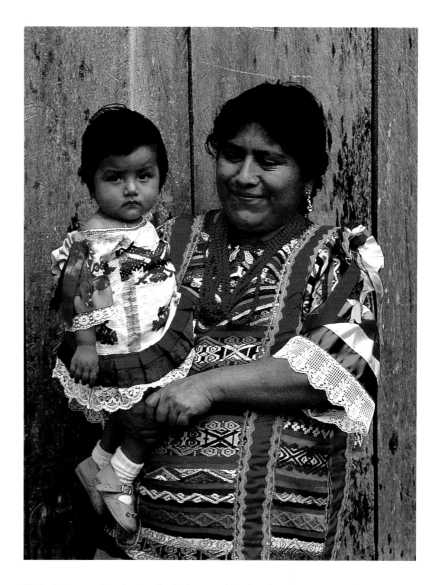

Maria del Socorro Agustina García with her granddaughter in Usila, Oaxaca. Traditional foundations of expressive culture are not static but are maintained while in various states of transition. Where there are radical changes to expressive culture, bits and pieces of cultural identity are lost. Photo by J. López.

possibilities. At the same time, such conservation serves the endeavors of individual cultures to maintain their identity.

Notes

1. Asturias de Barrios discusses Maya Guatemalan huipils in terms of the following socially relevant considerations: ethnic identity, geographic origin, economic level, matrilineal tradition, prestige of the weaver, occasion in which the weaver is participating, and personal identity.

2. The color on the noblewomen's cheeks and lips may have been an organic red colorant called cochineal, used for body painting.

3. Local community museums within Oaxaca have been established by the Instituto Nacional de Anthropología e Historia, the Dirección General de Culturas Populares, and the Programa de Museos Comunitarios y Ecomuseos. The mission statement for the Zapotec Community Museum of Santa Ana del Valle, Oaxaca, reads, "Within the national museum program, INAH has established as one of its priorities the formation of new centers for the conservation of regional patrimony. These have the goal of conserving in their original sites elements of local culture, archaeology, and history and of supporting local identity and education" (Cohen 1989:19). In Chiapas, Mexico, a project to conserve the Pellizzi Collection of highland Maya Textiles incorporated the teaching of conservation methods to the Maya staff members of the weaving cooperative called Sna Jolobil (House of the Weaver). Support for this three-year project (1991–94) was provided by the University of New Mexico's Latin American Institute and the Getty Conservation Institute.

References

Anawalt, Patricia Rieff
1981 *Indian Clothing before Cortez: Mesoamerican Costumes from the Codices.* Norman: University of Oklahoma Press.

Andres, F., M. Jansen, and G. A. Perez Jimenez
1992 *Origen e Historia de los Reyes Mixtecos, Codex Vindobonensis.* Mexico City: Fondo Cultura Económica.

Asturias de Barrios, Linda
1991 Woman's clothing as a code in Comalapa, Guatemala. In *Textile Traditions of Mesoamerica and the Andes: An Anthology.* New York: Garland Publishing.

Baird, Ellen T.
1993 *The Drawings of Sahagún's Primerios Memoriales—Structure and Style.* Norman: University of Oklahoma Press.

Bierhorst, John
1990 *The Mythology of Mexico and Central America.* New York: William Morrow.

Camarena Ocampo, Cuauhtémoc, and Teresa Morales Lersch
1994 Diálogo entre comunidades y profesionistas: El caso de los museos comunitarios de Oaxaca, 1985–1993. *IV Semana cultural de la Deas, 17–21 octubre, 1994.*

Coe, Michael D.
1965 *The Jaguar's Children: Preclassic Central Mexico.* New York: Museum of Primitive Art.
1984 *Mexico.* London: Thames and Hudson.

Cohen, Jeffrey H.
1989 Museo Shan-Dany: Packaging the past to promote the future. *Folklore Forum* 22(1–2):15–26.

Cordry, Donald, and Dorothy Cordry
1968 *Mexican Indian Costumes.* Austin: University of Texas Press.

Durán, Diego
1971 *Book of the Gods and Rites and the Ancient Calendar.* Trans. and ed. Fernando Horcasitas and Doris Heyden. Norman: University of Oklahoma Press.

Furst, Jill Leslie
1977 The old gods on the obverse of the Codex Vindobonensis Mexicanus I. Ph.D. diss., University of New Mexico, Albuquerque.
1978 *Codex Vindobonensis Mexicanus I: A Commentary.* Albany: Institute for Mesoamerican Studies, State University of New York.
1994 Conversation with the author, Santa Fe, N.M., October 15.

Graburn, Nelson
1976 Arts of the fourth world. Introduction to *Ethnic and Tourist Arts: Cultural Expressions from the Fourth World.* Berkeley: University of California Press.

Hansen, Eric F., Richard D. Hansen, and Michele R. Derrick
1995 Los análisis de los estucos y pinturas arquitectónicos de Nakbé:
 Resultados preliminares de los estudios de los métodos y materiales
 de producción. In *Octavo Simposio de Investigaciones Arqueológicas en
 Guatemala (1994), Museo Nacional de Arqueología y Etnología*, 543–60.
 Guatemala: Ministerio de Cultura y Deportes, Instituto de
 Antropología e Historia, Asociación Tikal.

Klein, Kathryn
1992 Chuc Nichim, the washing of the flowers—A look at traditional
 conservation practices. In *Proceedings of the 16th Congress, Interna-
 tional Institute for Conservation of Historic and Artistic Works, 81–83*.
 London: International Institute for Conservation of Historic and
 Artistic Works.
1994 Collections, cultural contexts, and conservation: Collaborative
 Methods for the conservation of the cultural heritage of the Maya
 people of highland Chiapas, Mexico. Master's thesis, University
 of New Mexico, Albuquerque.
1997 Collaborative conservation projects in the arts: Case studies
 in Oaxaca, Mexico. Ph.D. diss., University of New Mexico,
 Albuquerque.

Landa, Diego de
1941 *Landa's "Relación de las cosas de Yucatán."* Trans. A. M. Tozzer.
 Papers of the Peabody Museum of Archaeology and Ethnology,
 vol. 18. Cambridge, Mass.: [Peabody Museum].

Morris, Walter F., Jr.
1987 *Living Maya.* New York: Harry Abrams.

Nicholson, H. B.
1973 The Late Pre-Hispanic Central Mexican (Aztec) iconographic
 system. In *The Iconography of Middle American Sculpture.* New York:
 Metropolitan Museum of Art.

Paddock, John
1966 Oaxaca in Ancient Mesoamerica. In *Ancient Oaxaca: Discoveries
 in Mexican Archaeology and History.* Stanford, Calif.: Stanford
 University Press.

Ramsey, James R.
1982 An examination of Mixtec iconography. In *Aspects of the Mixteca-
 Puebla Style and Central Mexican Culture in Southern Mesoamerica.*
 New Orleans: Middle American Research Institute, Tulane
 University of Louisiana.

Sayer, Chloë
1985 *Costumes of Mexico.* Austin: University of Texas Press.

Tagle, Alberto A., Hubert Paschinger, Helmut Richard, and Guillermo Infante.
1990 Maya blue: Its presence in Cuban colonial wall paintings. *Studies in
 Conservation* 35:156–59.

Townsend, Richard F.
1992 The renewal of nature at the Temple of Tlaloc. In *The Ancient Art
 of the Americas: Art from the Sacred Landscapes.* Chicago: Art Institute
 of Chicago.

Waterbury, Ronald
1989 Embroidery for tourists: A contemporary putting-out system in
 Oaxaca, Mexico. In *Cloth and the Human Experience.* Washington, D.C.:
 Smithsonian Institution Press.

Preventative Textile Conservation in Latin America

Kathryn Klein

IN JUNE 1993, a conservation assessment of the condition of the textile collection at the Regional Museum of Oaxaca was undertaken for the Getty Conservation Institute (GCI). From the assessment, a GCI project was developed that would best facilitate the stabilization of this textile collection while at the same time incorporate teaching preventive conservation techniques to the museum staff. A goal of the GCI project was to create and apply practical solutions for the conservation of a textile collection located in a Latin American country.

As a U.S. conservation consultant for the GCI, the author found it necessary to establish an amiable working relationship with the staff members at the museum in Oaxaca. It was equally important to work within the goals of the museum, as set and funded by the Mexican government's Instituto Nacional de Antropología e Historia (INAH), which oversees most of the major museums in Mexico. The staff members at the Regional Museum of Oaxaca are deeply concerned for the collections, dedicated, and extremely enthusiastic about learning additional conservation techniques. Not only did the author and museum staff all work well together, but, as a bonus, new friendships were established as well.

Many of the Getty Conservation Institute's projects bring together people from diverse backgrounds and cultures who share the same vocation and dedication to the conservation of cultural heritage. The international quality of these projects helps to conserve cultural property and, at the same time, creates an atmosphere

Detail of a huipil from the Chinantla area of northern Oaxaca. Because the weaving techniques that it demonstrates are rare and the quality of its original fabrication is exceptional, this huipil is one of the designated priority textiles in the textile collection at the Regional Museum of Oaxaca. Photo by M. Zabé.

of scholarly exchange. As the work in Oaxaca continued, it became apparent that a publication about the project would provide useful information for conservators and staff members of museums in Latin American countries, as well as for foreign conservators interested in working in Latin America.

Assessment of the Textile Collection

In 1964, INAH initiated a restoration of the church and former convent of Santo Domingo. The Regional Museum of Oaxaca was established there in 1972. The cloister of the building consists of a two-story arcade that encloses a central open-air patio and fountain. Most of the collections are exhibited in the interior rooms adjacent to the open arcades on the first and second floors of the cloister.

The ethnographic collection at the Regional Museum of Oaxaca comprises a large grouping of textiles and related objects representing the rich and varied cultural traditions of the indigenous people of Oaxaca. The area culturally includes part of the western portion of the state of Guerrero. While seemingly separate, the archaeological, colonial, and ethnographic collections together form a unified history of this area of Mesoamerica. The accumulation of history is found within the ethnographic collection, where ancient Mesoamerican traditions of textile weaving have continued into the twentieth century.

The largest portion of the textile collection at the Regional Museum of Oaxaca represents the material culture of indigenous people of the region from the 1950s and 1960s, but there are a number of textiles that date from the late nineteenth and early twentieth centuries. In recent years, there has been a dramatic drop in the use and fabrication of traditional textiles and dress within the Oaxaca area. Many textile types seen in this collection currently are no longer being made or worn within their original communities. Yet there is substantial interest in revitalizing the textile traditions of Oaxaca, and the conservation of this collection will provide an important study resource for local weavers, as well as for scholars of Mesoamerican studies.

The staff at the Regional Museum of Oaxaca had been aware of the poor textile exhibition and storage conditions, and the director of the museum expressed interest in additional assistance to upgrade the existing conditions. During the 1970s, at the time of the original installation of the ethnographic collection, it had been a modern and technically sophisticated exhibit. Over the last ten years, however, the lack of funding for many regional museums of

Mexico has affected the condition of their collections—and, in fact, many U.S. museums as well have had very similar funding problems. Funding cuts unfortunately often lead to a lack of staff able to maintain large collections, a factor that contributes to the eventual degradation of collections.

Since the museum is located in a historic building, climate control is not readily feasible, although the thickness of the colonial stone walls helps maintain a somewhat consistent temperature and humidity. Most of the galleries had doors and windows open to the outside, which, on the one hand, kept air circulating but, on the other hand, allowed the entry of dust and sunlight. The relative humidity levels were not monitored as of 1993, because the museum did not own hygrothermographs. Outdoors, the humidity in Oaxaca City fluctuates between a high level of greater than 80% for four months of the year (the rainy season) and a lower humidity of 60% for eight months. There was no evidence of mold growth in the exhibit areas, even though the temperatures in Oaxaca are usually quite high. Some evidence of mold was, however, found on a few of the textiles kept in the former storage room on the first floor of the museum. More investigation would be necessary to gain conclusive data about the effects of temperature and relative humidity on the textile collection.

A preliminary estimate of the number of textiles in the ethnographic collection indicated that there were just over one thousand. Later, however, the total number was found to exceed two thousand. It was difficult to determine the exact number, since most of them were accessioned according to costume rather than as individual pieces, and single costumes may have as many as five textile components. There is a record of inventory for the textile collection, made during the 1970s, which includes small black-and-white (contact sheet) photographs of entire costumes along with short descriptions, but it is not clear that the inventory is complete. Many accession numbers were written either in ink directly on the inside of the textiles or on cotton tags stapled through the textiles.

Full view of the huipil shown in detail on page 22. Measuring 94 × 88 cm, it is dated to the beginning of the twentieth century and is in excellent condition. Although this huipil is rare, all of the nearly two thousand textiles from the textile collection were subject to the same conservation problems — light, humidity, insects, and dust. The goal of preventive conservation is to mitigate the sources of problems that affect objects collectively rather than to focus on the restoration of single objects. Regional Museum of Oaxaca (154602). Photo by M. Zabé.

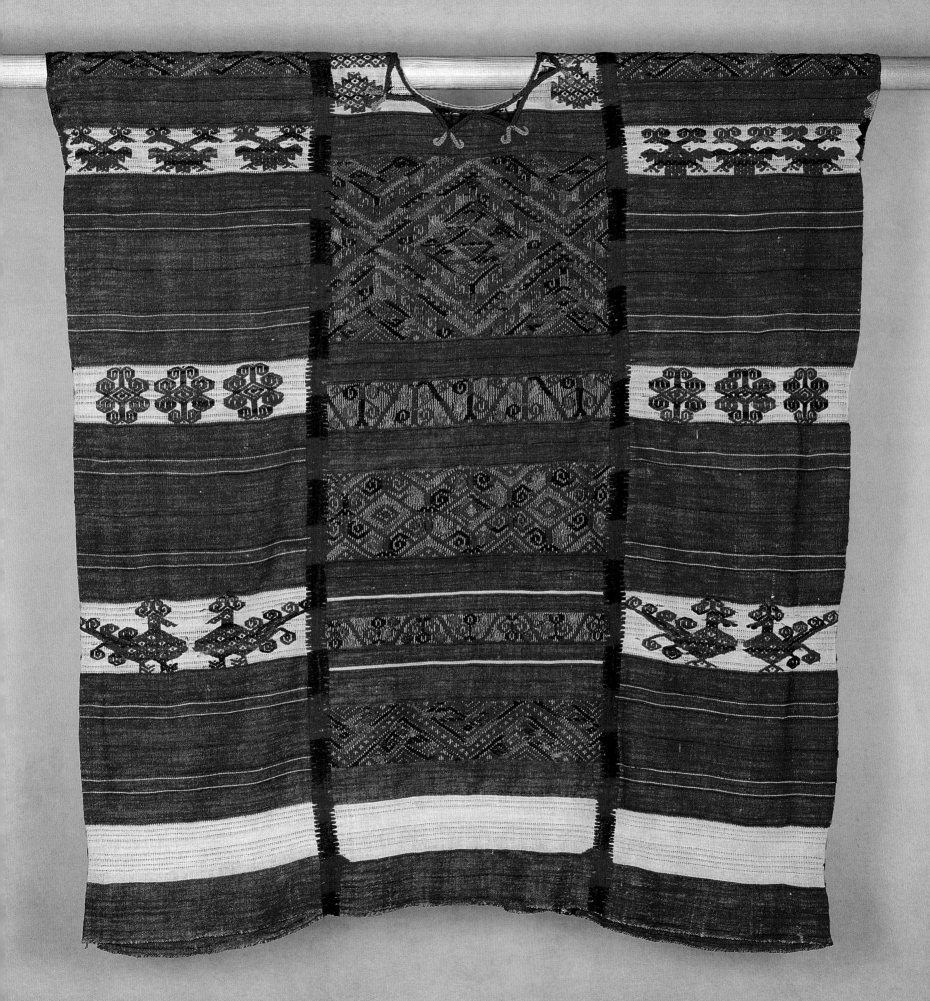

Damage to a textile caused by the accession number having been written in permanent ink directly onto the textile (top). This type of damage to a museum textile can be avoided by writing the accession number onto a cotton twill tape and then hand sewing it onto the textile with a few fine stitches, as shown above. When necessary, the cotton tape can be removed — an example of the basic conservation ethic of reversibility. Photo at top by K. Klein. Photo above by J. López.

Since the ethnographic exhibit was originally installed in 1972, most of the textiles had been on continuous display for over twenty years. Many had been displayed on mannequins on wooden platforms, while others were in glass wall cases. All the displayed textiles had remained in the same folded and draped positions for many years. Some of the mannequins were too short, and the garments had drooped, their hems resting crumpled on the floor. Heavy accumulations of dust covered much of everything, including the textiles in the wall cases. Some of those had been folded to fit and were held against the back wall without sufficient mounts.

In November 1993, the ethnographic collection was removed for the current INAH renovation of all the museum galleries. Prior to the renovation, incandescent and fluorescent lighting had been used in the galleries. Many textiles in wall cases were showing signs of photochemical degradation because of their proximity to unfiltered fluorescent light, which is high in ultraviolet radiation. Even though the overall light levels in the galleries were low, irreparable fading had been caused by heat from focal points of incandescent lighting, from exposure to ultraviolet light, and from sunlight. To correct these problems, in August 1993 INAH installed quartz-halogen lights with ultraviolet filters throughout the museum.

Evidence of insect and rodent activity in galleries and the storage area was also apparent. As part of the ethnographic display of a market scene, foodstuffs—including dried herbs, maize, and beans—and little piles of wool had attracted pests and had provided inviting nests for rodents.

Fumigation takes place in the museum every six months to a year; it was not reported what specific chemical fumigants are used. Respirators are used during fumigation, and INAH has provided information for the staffs of regional museums regarding health and safety measures.

The former storage area for the textiles consisted of one large room in which all the museum collections were stored. Textiles had been folded and stacked on open metal-shelving units. Some had been stored in plastic bags inside cardboard boxes stacked on the floor. There was very little space to move about, so it was particularly difficult to examine textiles without endangering other objects; there was certainly no room for an examination table. This storage room is located on the ground floor; because it is most often kept closed, it is damp, stuffy, and uncomfortable to work in—ambient conditions that are also particularly detrimental to textiles.

In terms of appropriate protection for the collection, smoke detectors and halon fire extinguishers are located in the storage room as well as throughout the museum. Moreover, the museum maintains an organized security system: everyone—including staff—is required to sign in and out, and a security guard is present while anyone is working in the storage room.

Overall, it appeared that the situation for the textile collection at the museum needed improvement. And, through the enthusiasm and hard work of the staff, combined with the joint support of the GCI and INAH, solutions to many of the conservation problems for the textile collection were found.

Preventive Conservation of the Textile Collection

The inherent qualities of the organic materials found within most ethnographic collections make them sensitive to the environment and susceptible to degradation. In tropical climates most particularly, ethnographic collections often fall victim to insect infestation. Many types of insects, including the ubiquitous clothes moth, feed on proteinaceous materials of wool, silk, hair, feathers, leather, and fur. They may also consume in an exploratory manner and damage cellulosic materials—such as cotton, hemp, wood, and basketry made of plant materials—and feed on the proteinaceous components of dust and stains on artifacts. Many insects are especially attracted to particulate dust, as it includes the proteinaceous debris of human skin. Much insect activity can be alleviated by a maintenance program that eliminates large accumulations of dust on which insects thrive. Because museums are intended to have many visitors, periodic vacuuming of textiles and dusting of objects are especially important.

At many institutions in both the United States and Mexico, ethnographic collections are stored and exhibited for long periods without adequate attention. Failure to review the condition of objects on a regular basis contributes to their deterioration. By the time an object is discovered to be in extremely poor condition, it is often too late for stabilization. For these reasons, rotating exhibits and accessible study collections are intrinsic parts of ethnographic conservation.

At the Regional Museum of Oaxaca, preventive conservation was a relatively new concept when the project began. There, as in many museums of the world, restoration—rather than conservation—continues to be applied to art objects. In this approach, the care of museum collections is considered in terms of restoration of

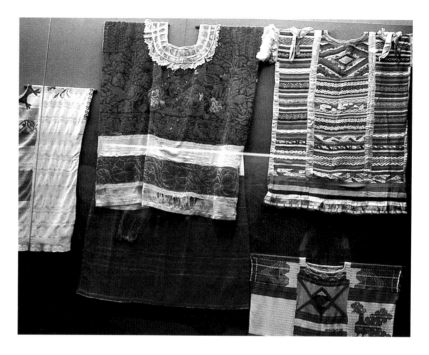

The former ethnographic exhibit at the Regional Museum of Oaxaca in June 1993. Since this exhibit was originally installed in 1972, most of the textiles had been on continuous display for about twenty years. In November 1993, this exhibit was dismantled for the INAH renovation of the entire museum. Photo by K. Klein.

Photochemical degradation to a cotton textile dyed with shellfish *Purpura* colorant. Due to the textile's proximity to fluorescent lighting, the colorant has significantly faded over time from the exposure to ultraviolet light. Regional Museum of Oaxaca, June 1993. Photo by K. Klein.

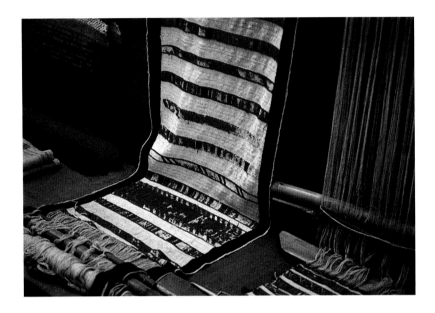

Insect damage to a cotton textile as seen on the red bands of this loom. Some insects will be particularly attracted to specific materials and/or colorants and consume parts of a textile discriminately. Much insect activity in museum collections can be alleviated by a maintenance program that eliminates accumulations of dust, on which insects thrive. Regional Museum of Oaxaca, June 1993. Photo by K. Klein.

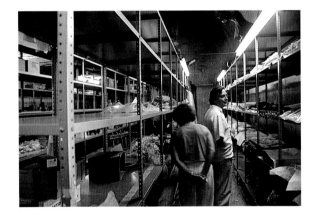

The former storage area consisting of one large room in which all the collections of the museum were stored. Textiles were folded and stacked on open metal shelving units under fluorescent lights. Regional Museum of Oaxaca, May 1993. Photo by M. A. Corzo.

specific objects—a process that can include their partial or complete reconstruction to improve their appearance. In contrast, preventive conservation mitigates the source of the problems and deals with the objects collectively. Moreover, it maintains the integrity of the objects without trying to imitate their original appearances. Even though preventive conservation may not be a glamorous component of conservation, it is an effective approach to preserving collections. In *Conservation: The GCI Newsletter* (1992: vol. 7[1]:5), Jeffrey Levin describes preventive conservation as

> any measure that prevents damage or reduces the potential for it. It focuses on collections [each as a whole] rather than individual objects, nontreatment rather than treatment. In practical terms, the handling, storage, and management of collections (including emergency planning) are critical elements in a preventive conservation methodology.
>
> In the long term, it is the most efficient form of conservation, not only for museums, but particularly for libraries, and collections of ethnographic, natural history, and geologic materials. With comprehensive preventive conservation, the need for individual treatments can be reduced to more manageable levels, putting personnel and financial resources to more effective use.

The challenge of the GCI textile conservation project at the Regional Museum of Oaxaca was to apply a preventive conservation methodology within the setting of a Latin American museum while, at the same time, locating and using available local materials for the conservation of the collection.

When the project began, the general expectation at the museum was that individual textiles were going to be immediately washed and repaired. Instead, preventive conservation methods were discussed at great length with museum staff members and with outside scholars involved with the textile collection (there is no textile curator on staff). Through the demonstration and application of preventive conservation, which included the creation of a new and separate storage room for the textiles, the systematic organization of the textile collection began to make sense to everyone.

The criteria for making conservation decisions were also considered. For example, one practice—the replacement of faded rayon ribbons on a museum textile—was discussed as an intervention that goes beyond the scope of conservation stabilization to become an aesthetic "correction" to the textile's appearance. The replacement of various components of textiles is an ethnological

issue as well. Within indigenous communities, it may be a common practice for the lace and ribbons of traditional costumes to be periodically replaced for religious or festive occasions; nevertheless, it is not considered appropriate for conservators to replace these components, since the practice belies the character of museum objects as documents of history. If a textile is altered—even if it is only twenty years old and the same types of materials (rayon ribbons, for example) are available in local markets—important historical information will be lost. If an object is damaged to the extent that it cannot be exhibited, then, when it is possible, the entire garment may be copied by a weaver from the original community. At the same time, the damaged textile that served as the source for the copy should remain in the collection and be conserved and stored for its informational value.

Preparation of a New Textile Storage Room

With the permission of the director of the museum, a small room on the second floor was designated as the new storage room for the textile collection. The second-floor location, coupled with the high ceilings and thick stone walls, helped create and maintain a cooler and drier atmosphere than that of the first floor storage room. By a simple change in the location of the textile storage area from one part of the museum to another, the ambient conditions for the textiles were greatly improved. The new storage room also served as a workspace where textiles were examined and treated. A door and sawhorses were set up as a large table and covered with polyethylene sheeting for a clean, flat work surface.

After investigating various sources in Mexico and the United States for new storage cabinets, the team decided to utilize as prototypes, and expand upon, the textile storage units that had been designed by Alejandro de Avila B. and fabricated at the museum in Oaxaca. These storage units are quite impressive and practical. Each one consists of four vertical aluminum posts (measuring 190 cm in length) and ten aluminum rectangular frames (198 × 117 cm). The frames were attached with screws to the inside of the four posts to form the horizontal shelving of the unit. Heavy-duty nylon screening was stretched across the horizontal aluminum frames and attached with a polyvinyl acetate (PVA) emulsion adhesive, sold in Mexico under the commercial name Resistol. The nylon screening was later sewn with a lash stitch to the aluminum frames for a stronger attachment. Textiles lie flat on the spacious shelves. Each unit is covered with a form-fitted muslin tent, with hemmed flaps in the front serving as the "door." The muslin tent keeps out

dust, while the nylon screening allows air circulation around the textiles. Velcro tabs were sewn onto the muslin flaps of the "door" to secure it.

The museum director pointed out that the unassembled components of a number of these units were in storage. It made much more sense to use these innovative shelving units than to ship shelving from Mexico City or from the United States.

Preventive Conservation Materials

Many of the conservation materials that were needed were purchased in Oaxaca City. Some of the materials brought from the United States included pH neutral tissue and boxes, humidity cards, light meters, and UV light filters; while these materials are available in Mexico City, they are more expensive than in the United States. Other materials that were also eventually brought from the United States were a Cole-Palmer pocket pH meter, Pigma fadeproof pens, foil-back labels for boxes, fine entomology pins, and various sewing materials (see the list of primary conservation materials in the proposal outline for the project).

With a little ingenuity, many materials available in Mexico can be adapted for use in preventive conservation. The project used goods found in fabric stores, hardware stores, plastic stores, department stores, open air markets, pharmacies, and even an aquarium store. Cotton muslin, various fabrics for consolidation purposes, vacuum cleaners, nylon screening, Velcro, sewing materials, measuring tape in meters, plastic bags and sheeting, plastic containers, plastic and cotton gloves, soft brushes, tweezers, magnifying glasses, thermometers, electric lamps, flashlights, materials to construct the shelving units and an aluminum textile bath, and pH neutral water were all found in Mexico. Fumigants such as mothballs (1,4 dichlorobenzene) and Shell pest strips (2,2 dichlorovinyl dimethyl phosphate) are also available (although there was a minimal use of fumigants during the project). The beauty of preventive conservation is that it does not require special, high-tech equipment in order to greatly benefit the condition of collections.

Moving the Textile Collection to the New Storage Room

The textile collection was moved during an extensive renovation of the former convent of Santo Domingo. While dodging workers, power tools, painters, scaffolding, and all the general chaos of major construction, the team members carried boxes of textiles up a huge

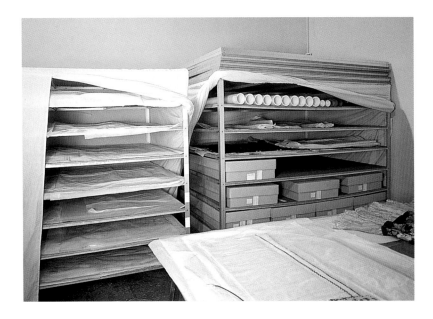

A clean, dry room on the second floor of the museum was designated as the new textile storage area. Through the enthusiasm and hard work of the museum staff, as well as the joint support of the GCI and INAH, solutions to many of the conservation problems of the textile collection were found. Regional Museum of Oaxaca, September 1993. Photo by G. Aldana.

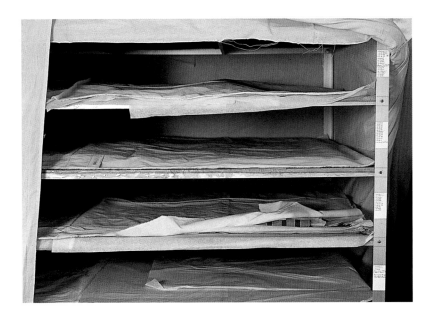

Large, priority textiles placed flat on the spacious shelves of the new aluminum storage units. Each unit is covered with a formfitted muslin tent to prevent the entry of dust. In addition, pH-neutral tissue is interleaved between textiles and padded within folds to prevent creases. Other textiles were packed into pH-neutral boxes and stored on the shelving units. Regional Museum of Oaxaca, September 1993. Photo by G. Aldana.

stone staircase to the new storage room on the second floor. Since the museum does not have an elevator, moving the textile collection was a tremendous amount of work.

Most of the museum staff who became involved with the project are security guards for the museum who had told the museum director about their interest in learning about textile conservation. These people were diligent and enthusiastic, and because of their hard work and the willingness and support of the museum director, the goals of the project were accomplished.

Ninety-three priority textiles that had been designated the rarest were the first to be packed into pH neutral boxes and moved. At this point, the conservation training consisted of handling and packing procedures for textiles. Staff participants wore cotton gloves and packed the textiles as flat as possible. They padded the inside of folds with pH neutral tissue rolled into lengths. Inventory numbers were recorded as the textiles were packed.

Once the priority textiles had been moved, they were unpacked and laid flat on the shelving units. Tissue was interleaved between the items, and a large piece of washed muslin covered the top of each stack of textiles. Most of the nonpriority pieces were moved into the new storage room, where they were stored in boxes—with the exception of wool textiles that showed evidence of insect activity. Altogether, over forty boxes of textiles were packed and moved. Boxes and shelves were labeled with accession numbers so that specific textiles could be easily located. Examination and vacuuming procedures were discussed and demonstrated. At the end of two weeks in Oaxaca, much had been accomplished, but much work had yet to be completed.

In July 1994, the reconstruction of the convent building accelerated as the entire roof was being replaced. Massive amounts of particulate dust from the construction became an imminent threat to the textile collection. Since the supply of pH-neutral boxes had been exhausted, there was little choice but to use local materials to protect the textiles. From out of this urgent situation, what was to be named "the textile tamale" was developed.

This packing procedure consisted of covering a plain cardboard pallet (approximately 100×50 cm) with washed cotton muslin and carefully laying one textile flat upon another on the pallet. (It may be useful to cover the cardboard pallets first with aluminum foil, which may help keep the acids of the cardboard from penetrating the textiles.) The entire stack of textiles, including the pallet, was then wrapped inside another large piece of muslin and

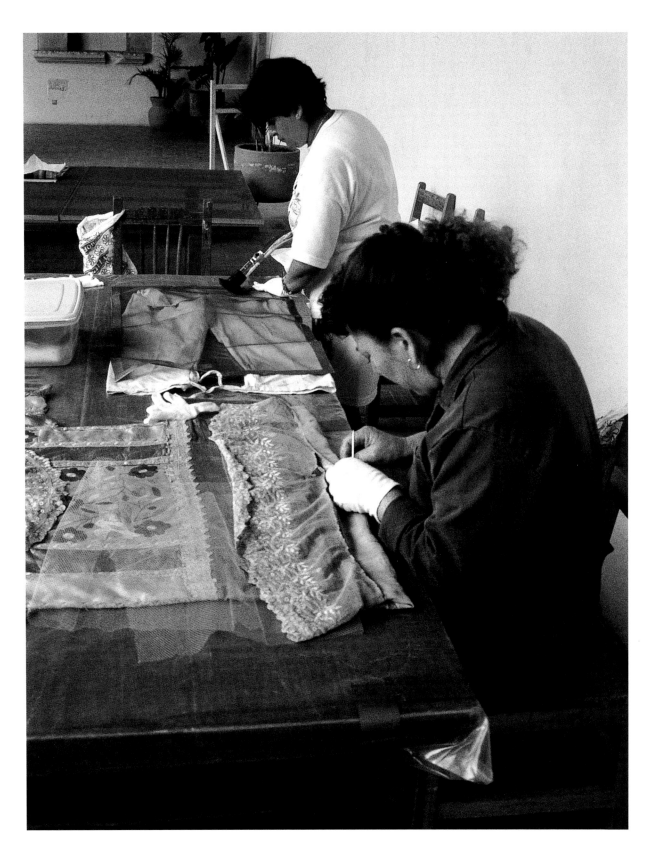

Museum staff members Rosalba Sánchez Nuñez and Angeles Velasco Crespo, working on the textile collection. Vacuuming each textile through nylon screening was one of the highest conservation priorities of the project. The best method is to use a low level of suction and to slowly vacuum the textile in sections. Photo by K. Klein.

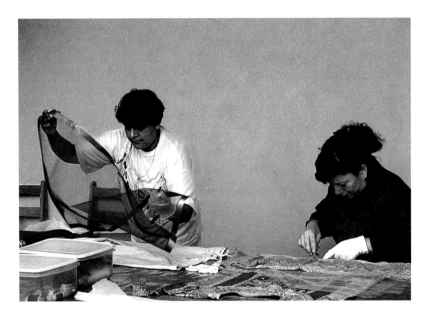

Nylon screening being placed over a textile in preparation for vacuuming. When done properly, vacuuming through a screen greatly improves the condition and appearence of textiles without damaging them. The preventive maintenance program at the Regional Museum of Oaxaca includes vacuuming exhibited textiles of a frequency of six months to a year. Photo by K. Klein.

secured with two wide straps of muslin around each end, making the unit look like a large tamale. The straps were sewn shut and/or wrapped so that there were no heavy knots to press into the textiles. Each unit was next placed inside a large plastic bag, taped, and labeled.

While it is preferable to use pH-neutral materials, this packing method may be useful even when such materials are unavailable. The plastic bags were utilized only because the dust problem outweighed the risk of containing textiles within plastic. Because humidity and moisture can be trapped inside—thereby increasing the chance of mold growth—wrapping textiles in plastic is not recommended in damp, tropical climates. However, washed cotton muslin is a neutral material that allows for some passage of air and is available in most Latin American countries—factors that make it a very useful packing material.

Preventive Conservation Treatments

One of the highest conservation priorities was to vacuum each textile through nylon screening. A one-meter-square section of screening was washed in plain water to remove any trace of dirt or grease residue. It was then dried in the sun. Duct tape was folded and adhered around the sides of the nylon to ensure against rough edges that can catch and snag a textile. The nylon screening protects the textile from the hand-held vacuum attachment to prevent abrasion.

It is preferable that vacuum brush attachments be made of synthetic rather than natural, proteinaceous fibers to prevent insects from thriving on the brush, then being transferred to textiles. Flat vacuum attachments without brushes may also be used. All vacuum attachments should be washed periodically, and vacuum cleaner bags should be changed often. If there is a problem of infestation, the vacuum cleaner bags need to be carefully disposed of in plastic bags every day to prevent the spread of insect eggs from one object to another. Cotton gloves must be worn, and they should be washed often.

During the work with museum staff, vacuuming techniques were discussed and utilized. Textiles were vacuumed on top of a clean table surface covered with plastic (polyethylene). The first step in the vacuuming procedure is to place the nylon screening over the textile on the area that is to be vacuumed. The best method is to use a low level of suction and to slowly go over the textile in sections. If a textile is large, it usually takes two people: one to hold

the nylon screening, the other to vacuum. The two people are then able to turn the textile over in unison while keeping it as flat as possible without overmanipulation. Even though textiles seem to be resilient, every time a textile is folded, creased, or bunched into a pile, the tiny fibers that make up the threads can split and break, adding to the object's degradation.

Vacuuming textiles is a common conservation procedure and the best method for keeping textiles clean. In this case, six months after the textiles had been vacuumed and stored properly, their condition and appearance had improved.

While it is tempting to immerse textiles into water to wash them, water swells the fibers of the threads, making them very susceptible to breakage. Washing museum textiles should be done only under the guidance of a trained textile conservator—and, even then, few textile conservators will wash a textile unless absolutely necessary.

Treatment of insect-infested textiles (which, most commonly, were wool) consisted of packing them into boxes along with mothballs (1,2 dichlorobenzene) for three weeks, then thoroughly vacuuming them as described above. Through these procedures much of the insect activity was eliminated. It will be necessary for the museum staff to continue to monitor the textiles for insect activity.

If mothballs are placed inside boxes, they should not be permitted to touch the textiles. Three to four mothballs were wrapped in a small muslin bundle and taped to the inside of a box lid. The entire box was placed inside a large plastic bag. Plastic gloves were worn, as is necessary whenever any type of chemical fumigant is handled. Other insect mitigation methods, such as freezing or creation of low-oxygen environments, are preferable but not always possible because of limited access to the proper equipment.

Another conservation procedure was demonstrated through the examination and documentation of ninety-three priority textiles. A Spanish-language textile condition report form was developed for use in the project. On the form, simple line drawings were made for each textile and symbols were used to designate problem areas; a checklist of common textile conservation problems was filled out; the type of garment was described; materials were listed; measurements and accession numbers were recorded; and the place of origin was obtained from records of the textiles, including the catalogue for the collection. The forms were filled out in pencil, since ink should not be used near textiles.

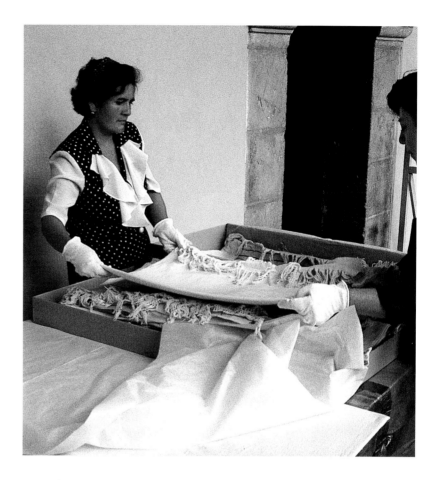

Regional Museum of Oaxaca staff members Auria Jiménez Chávez and Angeles Velasco Crespo packing textiles, using pH-neutral tissue and boxes. Two people keep the textiles as flat as possible during handling by turning them in unison. Cotton gloves are worn to keep textiles away from the acids produced by hands. Photo by K. Klein.

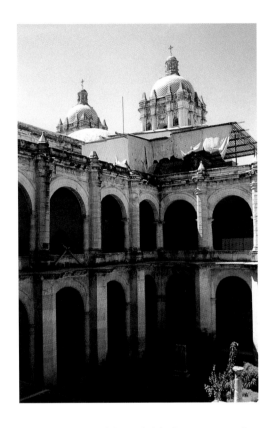

The reconstruction of the roof of the former convent of Santo Domingo. As the museum reconstruction accelerated, massive amounts of particulate dust became an imminent threat to the textile collection. In this urgent situation, all of the textiles were packed in boxes, wrapped in plastic sheeting, and moved to a temporary holding area to protect them from dust while the roof was removed overhead. Photo by K. Klein.

The examination and documentation of the textiles yielded a thorough understanding of the condition of the priority textiles, along with useful and accessible information for future conservation treatments. It was found that documentation of the textiles was also useful to other staff members, especially the director of the museum; to the exhibition designers of INAH, enabling them to easily find the location and dimensions of specific textiles without having to handle them; and to scholars of textiles, to provide overview of the rare pieces. Measurements and descriptions were particularly useful in documenting the collection for this publication.

Conservation and the Staff at the Regional Museum of Oaxaca

After July 1994, the museum staff members continued with the documentation, vacuuming, and proper packing of each textile. The museum staff members who worked on the GCI project were designated to carry on with the procedures for the preventive conservation of the textile collection, as well as to take a comprehensive textile inventory for INAH. The textile conservation training they received through the GCI project enabled them to organize the inventory systematically while handling the textiles properly.

The process of vacuuming, documenting, and packing an entire collection of textiles is time consuming. If a textile is large, for example, it may take an hour to vacuum. Even so, perhaps half the collection was vacuumed within eight weeks. Once all the objects are vacuumed and either stored or exhibited, it will become easier to maintain the collection if small portions of the exhibited textiles are vacuumed every six months or at least once a year. Maintenance records will note when textiles were last vacuumed and when they will need it again. Since staff often changes, these records will help future staff members maintain the collections.

An additional benefit of the conservation training these staff members received was that it enabled them to embark on new, part-time careers at the museum as preventive conservation technicians for textiles. This training has greatly benefited the collection, and it has also given these individuals increased confidence, a sense of accomplishment, and the satisfaction that they are making a contribution to the museum and its cultural goals.

Proposal Outline for the Textile Conservation Project

September 1993

PHASE I

Preparation of a new storage room
(Designated to be a small, dry, and clean room on the second floor)

 A. **Obtain textile storage units, such as:**
 1. Large metal cabinets with drawers
 2. Custom-constructed cedar cabinets with drawers and doors
 3. Metal shelving
 4. Aluminum shelving with nylon screening

 B. **Obtain primary conservation materials, such as:**
 1. One or two vacuum cleaners
 2. pH-neutral tissue and boxes
 3. pH-neutral cardboard tubes (to roll large textiles)
 4. Visible and UV light meters
 5. UV light filters
 6. Hygrometers or standard humidity cards
 7. Nylon screening for use as a barrier for vacuuming textile
 8. Washed muslin cloth
 9. Electric fans
 10. Sewing materials: needles, thread, scissors, nylon netting, blotting paper, cotton tags, tweezers, etc.
 11. Storage containers for conservation materials
 12. Fumigation materials
 13. Insect and rodent traps
 14. Cotton gloves

 C. **Move textiles to new storage room**
 1. Pack textiles flat in pH-neutral boxes with pH-neutral tissue
 2. Label boxes with contents

January 1994

PHASE II

Preventive conservation treatments

 A. **Vacuum each textile through nylon screening**

 B. **Carry out insect mitigation procedures**

 C. **Conduct examination and documentation using textile condition reports**

 D. **Note pieces that need further treatments**

 E. **Pack and store textiles properly**

July 1994

PHASE III

Further treatment of textiles

 A. **Continue vacuuming and documentation**

 B. **Teach basic sewn-stabilization methods**

 C. **Sew cotton labels with accession numbers onto each textile**

 D. **Demonstrate and wet-clean a textile under the guidance of a textile conservator**

PHASE IV

Conservation recommendations for textile exhibition

 A. **Moderate light levels (60 foot-candles or less)**
 1. UV filters
 2. Partitions in front of doors
 3. Curtains and screens for windows

 B. **Install fans to keep air circulating and to lower humidity**

 C. **Reduce exhibit size**
 1. Rotate all textiles on exhibit
 2. Display priority textiles a few at a time in cases where light and humidity levels are monitored and upheld

 D. **Select appropriate, locally available exhibit materials for mounts and cases**

 E. **Maintain pest and rodent control in galleries**
 1. Set traps
 2. Establish schedule for fumigant use

 F. **Establish and maintain schedule for general maintenance**
 1. Periodic systematic vacuuming of textiles
 2. General housecleaning of galleries

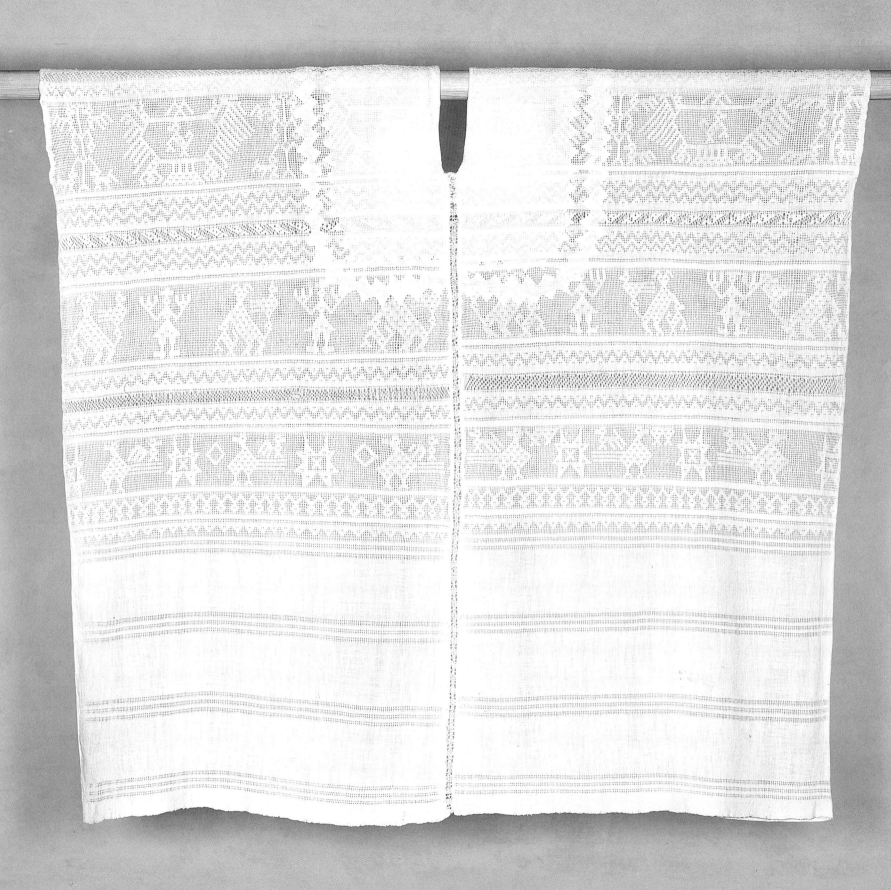

Practicing Textile Conservation in Oaxaca

Sharon K. Shore

IN JANUARY 1994, the author was invited to the Regional Museum of Oaxaca to serve as conservation consultant for phase II of a textile conservation project sponsored by the Getty Conservation Institute. The museum, located in a historic sixteenth-century building, houses a large collection of historically important artifacts, including approximately two thousand regional textiles, without the advantage of funding to support a staff conservator or a conservation laboratory. The administrative staff, which consists of the museum director, the chief of security, and their assistants, must often rely on security personnel to perform some tasks usually carried out by a museum registrar, curatorial assistants, and docents. In addition to guarding artifacts in the exhibition galleries, a security guard can elect to participate in special training sessions for these activities as opportunities arise.

Recent work by security staff included making an inventory of artifacts in the museum collection and conservation treatments for textiles. In phase I of the preventive conservation project, a new textile storage room was established, and preventive textile treatments were carried out by the project team. As part of phase II, the initial task for the visiting conservator was to participate in a textile condition survey; this effort led to subsequent visits by both of the GCI consultants to assist in the continuation of staff training and textile treatments.

The Santiago Choapan huipil after conservation treatment. Only a few examples of this type of huipil exist within museum collections today. Made of hand-spun cotton thread and measuring 88 × 97 cm, this huipil dates from the early 1930s. Delicate animals and costumed figures appear in plain weave against a background of weft openwork. Alternating with the figurative bands are bands with various geometric patterns created with a complex gauze technique. The people of the Choapan area of Oaxaca no longer practice these complicated weaving methods. The conservation of museum textiles preserves the remaining examples of such rare weaving techniques. Regional Museum of Oaxaca (131007). Photo by M. Zabé.

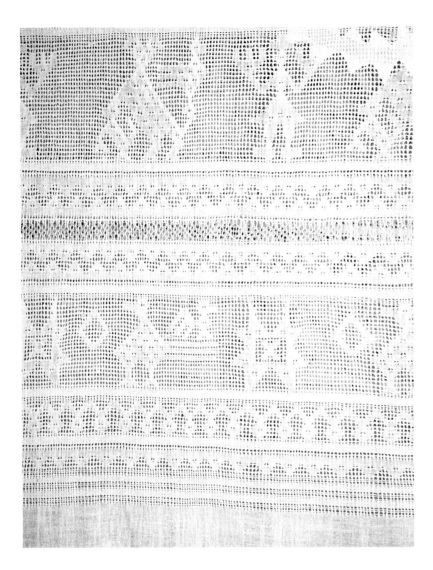

Detail of the Choapan huipil after treatment, revealing the weaving techniques used to achieve the patterning on front and back. Regional Museum of Oaxaca (131007). Photo by M. Zabé.

Almost all work at the Regional Museum is accomplished by cooperative group effort. This fact was immediately apparent in a large-scale project taking place in the long-abandoned sixteenth-century Dominican herb garden adjacent to the museum. A complex arrangement of terraced plots and an underground water system fed by a historical viaduct was unearthed due to the concerted efforts of hundreds of workers. In the same spirit but on a smaller scale, in the first phase of the conservation project, hundreds of textiles had been superficially cleaned, carefully interleaved with pH-neutral tissue paper, and packed in archival storage boxes by museum security staff members and the project coordinator. Understanding and participating in this cooperative work ethic became key to the continued success of textile conservation practiced at the museum.

The relationship between the two GCI consultants and two museum staff members whose early interest in the project carried through every phase was very positive. The museum staff's dedication and intelligent interest in serving the collection earned both appreciation and respect from the GCI consultants. Also, since both museum staff members had spent a great deal of time in the galleries as security guards, they could describe details of prior treatment of the textiles in the collection and recall significant events that had occurred during a long textile-exhibition period. This information proved to be valuable throughout the project.

Continuation of the project required the experience, wits, and organizational abilities of both GCI consultants, and this requirement resulted in a successful collaboration, as goals for phase II and subsequent phases were identified, evaluated, and carried out. Before the Institute's consultants' departure for Oaxaca and after a period of almost daily telephone calls between them, plans for work to be accomplished at the museum typically included a materials and source list and an outline of steps for each goal. In Oaxaca, the plans were inevitably revised (in whole or in part) to fit changing and sometimes surprising situations, but they did provide a reassuring baseline of operation along the way.

The following account of conservation treatments and training sessions carried out at the museum includes detailed descriptions of step-by-step procedures, with explanations of how and why they were devised. Some discussion of their relative success is included as well. This "case study" for textile conservation practiced at a specific site within Mexico is offered to provide information that could be useful to conservators, administrators, researchers, or

other interested participants faced with the challenge of conserving cultural material in similar situations.

Condition Report

The primary objective of the first GCI consultants' visit for phase II of the project was to survey ninety-three textiles designated as priority artifacts by scholar Alejandro de Avila B. For this purpose, a textile condition report form, to be used by both the museum staff and GCI consultants, was developed. A clear, concise, one-page format was chosen for expediency because none of the museum staff members had a background in textile conservation, and they had varying degrees of formal education. After a review of previously developed condition survey forms, it was decided to include date, type of artifact, accession number, provenance, and dimensions at the top of the page. A second section of entries included the primary fiber of the artifact, its location in the museum, and a condition rating, with four categories ranging from "excellent" to "poor." A checklist for structural and superficial aspects was developed for the primary description of condition. The bottom third of the form consisted of blank space for drawing a diagram—a simple outline of the shape of the textile, in which stains, losses, tears, and so on, as indicated in the checklist, could be located. After the consultants edited the English-language form several times to arrive at a format and checklist that seemed acceptable, it was translated into Spanish.

After the consultants arrived at the museum, they developed a one-page symbol key to help standardize the diagrams. Four different categories of condition were listed, with corresponding, easy-to-draw symbols. The symbols were used to indicate common aspects of condition, including losses, breaks, tears, abrasions, discolorations, and written inventory numbers. For example, the location of ink-drawn inventory numbers appeared as a row of three Xs, a discoloration or stain as a line defining an area, which was then filled with parallel slanting lines. All surveyors were given a copy of the symbol key for reference.

The rationale for the survey and the expected benefits to the museum and collection were explained to the staff. After the survey, everyone could begin to assume more control over the situation by making informed decisions about handling, storage, and conservation treatments of the textiles. A further benefit would be that familiarity with the survey forms would lead to their use as a reference and reduce handling of the actual artifacts when future

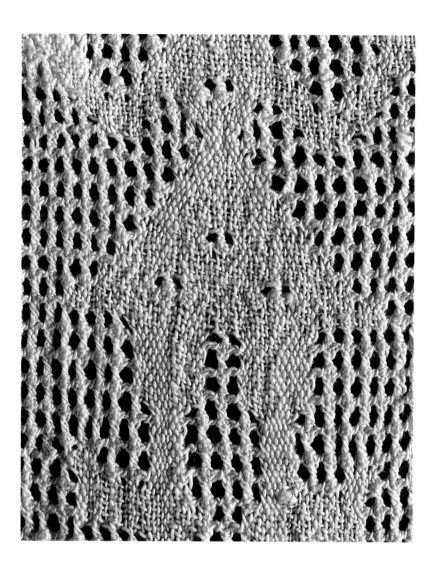

This macro photograph of the Choapan huipil after treatment shows the threads that have been manipulated to achieve weft-wrap openwork; the precise changes to plain weave create the stylized figure shown. Regional Museum of Oaxaca (131007). Photo by M. Zabé.

Instituto Nacional de Antropología e Historia (INAH)
Regional Museum of Oaxaca, Santo Domingo

TEXTILE CONDITION REPORT Date _8/1/94_

Type of object _Huipil_ Number of object _131007_

Location in museum _Textile storeroom_ Place of origin _Santiago Choapan_

Primary fiber _Cotton_ Dimensions L _88 cm_ W _97 cm_

CONDITION Excellent_____ Good_____ Fair_____ Poor__x__

Losses_____x_____		Soils_____	
Tears_____x_____		Dust_____x_____	
Embrittlement_____		Accretions_____	
Abrasion_____x_____		Adhesives_____	
Degradation of fiber_____		Adhesive tape_____	
Distortion of weave_____		Wrinkles and creases_____x_____	
Presence of insects_____		Fading_____	
Damage from insects_____		Discolorations (stains)_____x_____	
Presence of microorganisms_____		Loss of color_____	
Prior repairs, mending_____x_____		Other_____damage from rodents_____	
Alterations_____			
Fragile areas_____x_____			

COMMENTS
Some repairs are crocheted.
Several repairs to tears in gauze weave and weft-wrap areas.
Large brown stain at shoulder reputedly caused by rodents.

DIAGRAM

BACK FRONT

Key to Symbols

Losses
Damage from
insects

Tears

Abrasion

Discolorations
Stains
Accretions

Adhesive tape
Adhesives

Inventory number

exhibitions were planned. Finally, while concentrating on detailed examinations of the textiles, the museum staff could appreciate the unique makeup and often dire condition of each, and become skilled in recognizing conservation problems.

A training session was conducted to familiarize the staff with the meaning of terms in the checklist and their identification on actual textiles. This also included certain rules: no food, drink, or ink pens were allowed on the worktable or near the textiles. As part of the training, each staff member was asked to fill out a condition form and draw a diagram so everyone would arrive at an understanding of the terminology and symbols.

While at first the staff members were reticent about filling out the form because they were afraid of making mistakes, they became more confident as they learned to connect the checklist terms with examples on actual textiles and understood that the diagrams did not have to be beautiful—only clear. Carrying out the survey took two weeks and involved the efforts of both GCI consultants and the museum staff members. All ninety-three priority textiles were surveyed for condition, and the survey sheets were consolidated in notebook form. The process seemed to move the staff members from an emotional to a more conceptual understanding of the status of the collection.

The overall condition of the ninety-three priority textiles reflected twenty years of uncovered display on mannequins, where they were exposed to insects, rodents, handling by staff, and the touch of interested visitors. Some textiles had not yet been vacuumed by the staff and were in desperate need of superficial cleaning to remove heavy deposits of dust, various particulate matter, occasional bits of plant material, hair, and vestiges of insect carcasses. Many were stained and faded, both from original use and from long-term display. Catalogue numbers in various kinds of permanent ink were often found written directly on lower edges of textiles, and those written on the inside often showed through to the front. Curious dark-violet, symmetrical, linear markings appeared on many of the textiles. These were found to be caused by large black moths that appear in July and August throughout Oaxaca, occasionally flying into people as well as into gallery spaces. A few of these moths, with wingspans of up to 15 cm, were seen resting in crevices of the vaulted ceiling on the second-floor arcade of the museum.

Many of the textiles had small holes and tears, but most of the seams, aspects of embellishment, and weave structure were intact.

At the Regional Museum of Oaxaca, textile conservator Sharon Shore and staff members, shown discussing basic principles of textile conservation sewing in the stitch seminar workshop. Because the museum does not have a workroom with adequate light for sewing, the seminar was held outside, on a second-level arcade, to take advantage of natural light. Photo by K. Klein.

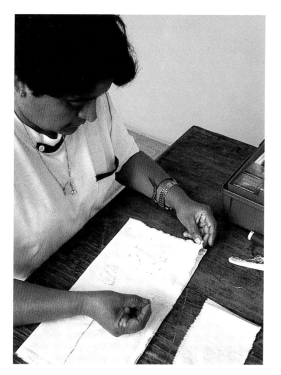

The stitch seminar taking place at the Regional Museum of Oaxaca. Practice samplers were prepared with tears and losses and used for teaching basic sewn stabilization techniques for textiles. Rosalba Sánchez Nuñez practices the difficult technique of using a curved needle for the first time, as she stabilizes a loss in her sampler. Photo by K. Klein.

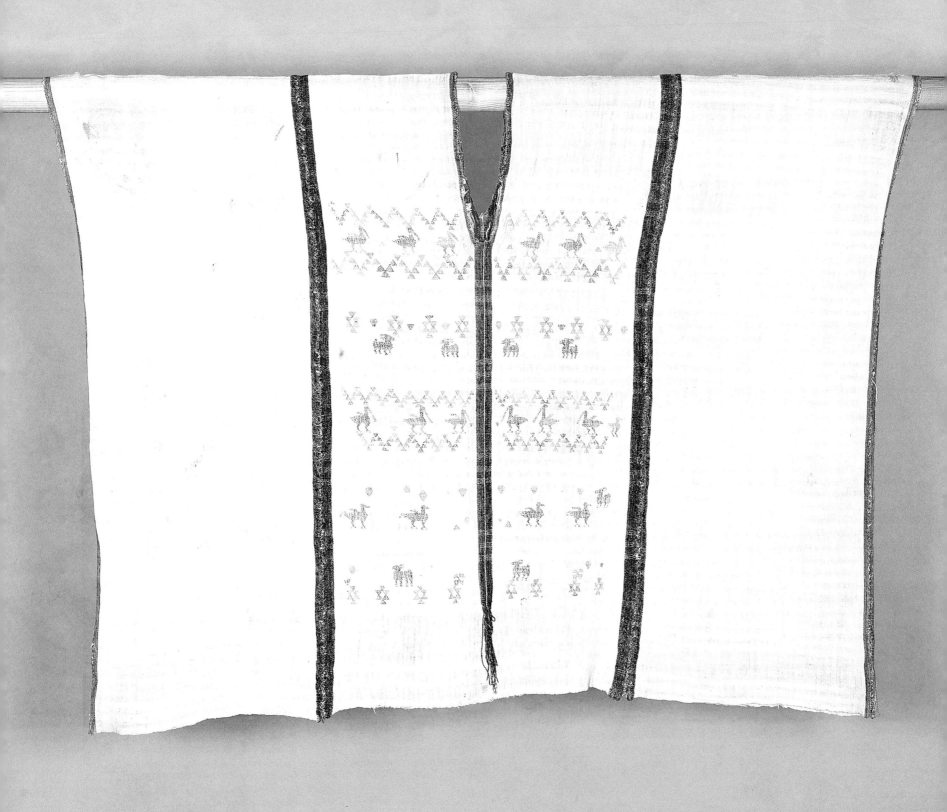

Relatively recent tears and sewn mends frequently appeared at the neck openings of huipils and *camisas* (shirts). The staff explained the probable cause: The museum's only set of mannequins have disproportionately large heads. In order to dress the mannequins, neck openings were forced over the heads. The mends of the resulting tears displayed a wide range of skill and sewing techniques.

Stitch Seminar

Prior to phase III of the project, the Institute's consultants addressed the inevitable question of whether to train the staff to make sewn stabilization repairs on textiles in the museum collection. The most difficult aspect of the decision concerned ethical considerations. Although little has been formally reported by textile conservators, short-term instruction for sewn stabilization in "how-to-do-it" form for staff who have had little or no conservation background sometimes has questionable results and serious repercussions. All too often, conservators are available for only one training session; therefore, they cannot provide continued instruction for trainees and cannot follow up on the results of their efforts. Information is easily misconstrued under the best of circumstances—even more so with the addition of language differences and a cross-cultural setting. Conservators who have worked with auxiliary support groups and eager volunteers at museums and historical sites, within and without the United States, are increasingly aware of their indirect responsibility for what happens after they leave.

After the above considerations were taken into account, several factors present at the Regional Museum led to the decision to proceed with a training session for staff members. In this case, the staff had occasionally made emergency mends in the past and might be called upon to do so in the future. Their ability to comprehend the rationale and carry out procedures for packing and superficial cleaning was very good, their participation in the condition survey had sharpened their attention to detail, and they were very interested in continuing to work on textiles. Moreover, there

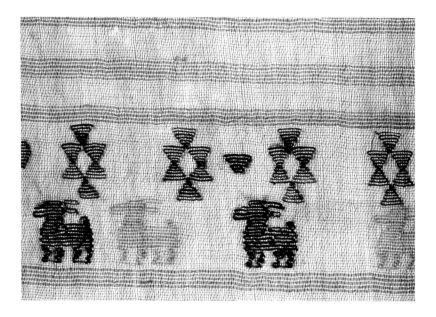

Detail of the finely woven brocaded patterning of the San Mateo del Mar huipil. All of the white brocaded patterns are clearly visible when lit from the back. Regional Museum of Oaxaca (131095). Photo by M. Zabé.

Angeles Velasco Crespo proudly holding up her practice sampler, on which simple stabilization techniques have been completed. At the top edge is an example of a white cotton twill tape marked with her initials in indelible ink, similar to the catalogue tags that were later sewn to textiles in the museum's collection. Photo by K. Klein.

A huipil from San Mateo del Mar, Oaxaca, measuring 84 × 65 cm. This piece is one of the rare priority textiles in the Regional Museum of Oaxaca collection. There is an old repair at the lower proper right of the huipil, and a stain is apparent on the upper corner. The violet stripes and brocaded patterning were dyed with an unidentified colorant that is fugitive in water. With limited equipment and resources on site, this textile could not be wet-cleaned without the risk of irreversible discoloration. However, superficial dust and soils were removed by a thorough vacuuming of the textile through a nylon screen, a treatment that improved its appearance and condition. Regional Museum of Oaxaca (131095). Photo by M. Zabé.

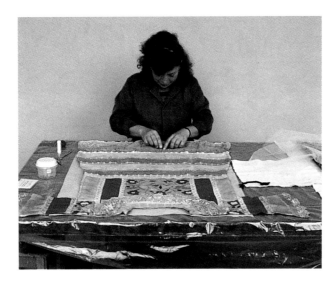

Angeles Velasco Crespo, a participant in the stitch seminar, using techniques learned there to repair a tear in a rayon ribbon on an embroidered blouse. A large number of nonpriority museum textiles designated by INAH for return to a regional costume exhibition were in need of minor sewn stabilizations. Under the supervision of GCI consultants, Regional Museum staff members made sewn stabilization repairs to these textiles. Photo by K. Klein.

An example of a sewn stabilization made by a Regional Museum staff member after the stitch seminar. This technique uses minimal stitching to attach a small piece of net around a torn area in the ruffle of a Tehuantepec skirt slated for exhibition. The net is placed at the front and back of the tear. It provides a temporary encasement to protect the ruffle from further damage; there is little structural intervention to the artifact. Photo by K. Klein.

was a strong possibility that one or both consultants would return for follow-up instruction. Also, the staff clearly understood that more-complicated sewn stabilization procedures were to be carried out only with supervision by a trained conservator. With all of these factors considered, a modest form of training was outlined, thereafter referred to as the "stitch seminar." It was to include instructions for making four different types of sewn stabilizations and for sewing onto textile artifacts cloth tape on which catalogue numbers had been written. The vehicle chosen for demonstration and practice was a sampler format.

On the day appointed for the seminar, the two staff members consistently interested in working on the textile project were present, as was a third staff member who decided to join at the last moment. The teaching method followed one often used for training conservation interns. A sampler consisting of a 30.5 × 35.5 cm washed muslin panel of plain-weave fabric was given to each participant. Each sampler had been prepared with a tear at one edge, a hole with abraded edges in the interior, and a 2.5 cm wide area of abrasion with missing weft, created by scraping the muslin with a fingernail file. A 12 cm length of braid, made of yarn and representing a type of hair ornament found in the collection, was stitched at one end to the sampler; several yarns in the braid were intentionally broken. Finally, a simple line drawing symbolizing the front, back, and neck opening of a huipil was made on one side of the sampler to use for locating and positioning the catalogue number tag.

To introduce the seminar, the conservator presented some basic premises for conservation sewing. The most difficult one to explain convincingly was the idea that conservators do not use knots at the end of sewing thread. The consequences of knotted stabilization sewing were demonstrated by making a sewn mend with knotted thread, then reversing the technique. If conservation sewing is reversed, knots are difficult to see. When clipped threads from reversed stitches are pulled out, unseen knotted ends can tear the textile weave and embellishment materials. The alternative, "safer" way to begin and end sewing is to make two small stitches close together to anchor the thread. Reversing this procedure was also demonstrated by clipping each stitch and easily pulling out the threads with tweezers without damaging the sampler.

Each type of stabilization to be practiced on the samplers was introduced with an explanation, in conservation terms, of the rationale for when to use it. From the notebook of the completed textile condition reports, examples of similar damage on textiles

in the museum collection were pointed out. The four stabilization techniques demonstrated in the seminar are within standard conservation practice, are fairly simple to execute, and do not require special materials or equipment.

The first technique demonstrated was stabilization of a loss, in this case a hole in the sampler. The edges of the loss were stitched to a small fabric support placed behind the hole. The technique for stabilizing a tear followed the same principle: the edges of the tear were aligned and stitched to a support fabric. In both cases the support fabric, which resembles a patch, was anchored to the sampler by stitches made in each corner and side of the patch. For the abraded area of the sampler, an encasement technique using fine nylon net was demonstrated: a square of net slightly larger than the abraded area was positioned over the abrasion; very small stitches were made just beyond the edges of the area to secure the net in place, and the excess net was then cut away just outside the stitches. Nylon net was wrapped around a faux hair ornament for stabililization; it was used to encase broken yarn ends after they were placed in their original positions.

The use of fine nylon net to encase or stabilize damaged textile materials has been practiced in textile conservation in the United States for more than fifteen years. As with all stabilization techniques, some drawbacks have been reported. The nylon net degrades over time more quickly than cotton or some proteinaceous fibers. However, because the net is inexpensive and available in Oaxaca, and because conservation techniques require stitching through textile artifacts in a relatively unobtrusive manner with few stitches, it seemed the best choice for use in this locale. For the last step of the stitch seminar, the entire sampler was folded in half according to the preliminary drawing, to form the components of a huipil. After the participants wrote ersatz catalogue numbers on 2.5 cm wide white cotton twill tape in permanent marking pens, they cut the tape, allowing for a 3 cm plain margin at each end. The ends were then folded under, and the numbered tags were sewn to the sampler using the huipil format. As a final, personal touch, participants embroidered their initials on the samplers to signify their achievement. These samplers are now part of the museum material associated with the proper care of the textile collection.

Although the stitch seminar was planned for just one morning, it continued through one and a half days. The additional time was required because the only suitable work space was outdoors, on the second-floor arcade of the museum, where the best and vir-

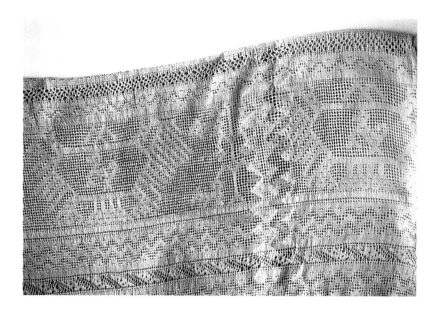

Detail of the Choapan huipil before treatment, showing a large, dark, yellow-brown stain, distortion of weave, and overall yellow discoloration. Regional Museum of Oaxaca (131007). Photo by K. Klein.

Choapan huipil, before treatment. In several of the gauze bands of the Choapan huipil, weft threads had been torn and abraded; this damage created fragile areas with unsupported broken warp threads. In this view before treatment, a polyester thread had been used in a previous attempt to mend the area. Unfortunately, the tight stitches caused further damage by breaking original threads. Regional Museum of Oaxaca (131007). Photo by K. Klein.

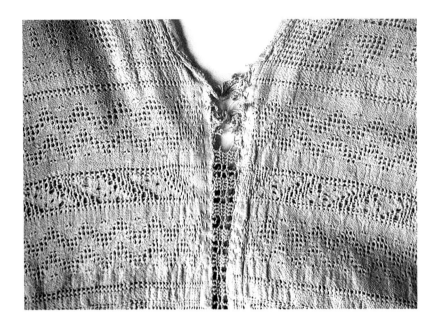

Detail of the Choapan huipil, showing its condition before treatment. A complicated tear at the front crocheted band of the huipil had been previously mended many times; the result was irreversible damage to the crochet work. Regional Museum of Oaxaca 131007. Photo by K. Klein.

tually only light was available. Because this location was also used as a popular thoroughfare, the sessions were sometimes interrupted by curious patrons and staff at the museum passing by on their way to the galleries. In their desire to do perfect work, each of the staff members worked slowly in the beginning and used twice as many stitches as desirable for conservation sewing. Their skill as needleworkers ranged from quite adequate to excellent. The importance of making only the minimal number of stitches had to be explained repeatedly. Stitching through a historic textile, although theoretically reversible, is also intrusive, because holes caused by a needle and tension from thread can be damaging to an old woven structure and aging fiber. The conservator attempted to impress upon the staff that there are important differences between conservation sewing, mending, and needlework. They were told that domestic-style mending strengthens an area of damage by building up a foundation of many stitches—and that the result can be disfiguring and damaging. Since all staff members were familiar with embroidery techniques, which can require hundreds of carefully placed stitches to make a beautiful pattern, the contrast between embroidery and the few but carefully placed stitches needed in conservation sewing was emphasized.

As anticipated, the staff who participated in the stitch seminar were excited to learn some conservation sewing techniques and wanted to use this information on real artifacts from the collection in the museum. By using the survey notebook of textile condition reports as a reference, the consultants selected a small number of nonpriority textiles with uncomplicated holes and tears. All of these textiles were destined to return to mannequins for exhibition and would benefit from some stabilization. Using the techniques learned in the stitch seminar and shown on their samplers as handy references, the staff members began to make simple sewn stabilization repairs under supervision by both consultants. To the surprise of the staff, white cotton gloves, always used during handling of textiles in the collection, were not to be worn for this treatment because they would impede sewing. Instead, everyone trekked to the lavatory for periodic hand washing to remove acidic oils that can be transferred to textiles.

Many of the materials required for this treatment—including support fabrics, needles, scissors, and threads—had been purchased in Oaxaca, where the current fabric of choice for home sewing is a rather stiff but dye-fast cotton-polyester blend found in abundant, printed and solid-color varieties. Yet, since most of the textiles in the collection are cotton, a selection of fabrics made of dye-fast, plain-weave cotton fiber in solid colors was ideal for use as support fabric. Although the selection of cotton fabric was limited, 1 m squares of appropriate solid colors in plain weave were purchased. Unfortunately, when the support fabrics were tested for dye stability by wet cleaning in water, most of the cotton fabric dyes were found to be fugitive. A few 1 m squares of cotton proved to be dye fast, but some colors of cotton-polyester blend were necessary additions. Although cotton is softer and would be a more desirable fiber match for use on the textiles, polyester is neutral and an acceptable fiber. All the colorfast support fabrics were wet-cleaned in a bucket of water without surfactant. Each section of wet-cleaned fabric was spread out on a storage-room shelf screen and dried in ambient air outdoors.

The selection of cotton sewing thread available in Oaxaca was limited to size 50, and the stabilization treatments were carried out using this slightly larger-than-desirable gauge in cotton. Although only a few textile-stabilization treatments could be completed because of time limitations, the results were effective and outweighed the drawbacks of off-color support fabrics and the heavy-gauge thread.

The Choapan Huipil

Among those textiles designated as highest priority were two cotton huipils that were in need of wet cleaning to flush out soiling and damaging organic material. One of the huipils considered for wet cleaning was embellished with violet stripes of an unidentified colorant that is fugitive in water. Without the use of special conservation equipment, such as a cold-suction vacuum table, this huipil could not be wet-cleaned without the risk of permanent discolorations from dye bleeding.

The second huipil, all white in color, originating from the area of Santiago Choapan, Oaxaca, had been woven by a member of the Zapotec linguistic group during the 1930s. This huipil is made in two loom widths of beautiful handwoven cotton in a plain balanced weave, and all edges are woven selvages. The two loom widths are folded in half to form a shoulder line and joined together at center front and back by a band of crochet needlework. The huipil is constructed in a traditional manner, with sewn side seams open at the top for armholes. The crocheted center bands end below the shoulder fold to form a neck opening. Most extraordinary is the embellishment of delicately patterned bands woven in two different techniques across the huipil and featured on the front and back. One type of band embellishment depicts animals and costumed figures in plain weave against a background of weft-wrap openwork. This alternates with a second type, made of a complicated gauze technique to form various geometric patterns.

Both of these weaving techniques are described in an article by Irmgard Johnson published in the *Textile Museum Journal* in 1976. Only a few examples of this type of Choapan huipil are known to remain within textile collections. Sadly, weavers in the Choapan area of Oaxaca either do not remember or do not now practice these complicated weaving techniques; therefore, this traditional huipil is no longer made.

The technical analysis of this huipil found in the collection at the Regional Museum of Oaxaca closely follows the description given by Johnson for a similar huipil of the Choapan area. The overall dimensions of the huipil before treatment were 100.50 cm wide and 89.50 cm long (at the widest points). The warp yarn count was 111.76 cm to 127 cm and the weft between 101.6 cm and 111.76 cm. Both warp and weft are single-ply yarns spun in a Z direction. The yarn counts, taken in several plain-weave areas of the front and back of the huipil, changed at selvages, where yarns were packed more tightly and appeared almost warp-faced. The neck area was

The author taking pH readings with a Cole-Palmer pocket meter. Complete treatment of the Choapan huipil included wet cleaning. In order to identify an appropriate wet-cleaning solution, pH readings were taken of locally available bottled waters. A bottled water with a consistent pH reading of 6.9 was selected. Photo by K. Klein.

INAH staff member Rosalba Sánchez Nuñez, observing the Choapan huipil being prepared for conservation treatment by the author. To protect the textile during the wet-cleaning process, nylon net was sewn over weak and fragile areas. Photo by K. Klein.

faced at the inside with a decoratively shaped plain-weave cotton fabric. Facing edges were folded to the front and over the edges of the neck opening to form a narrow binding at the obverse.

Considered by scholars to be one of the most beautiful and historically important costume artifacts in the museum collection, the Choapan huipil was unfortunately one of the textiles exhibited on a mannequin for twenty years. Staff reported having seen rodents nesting in the shoulder folds of the huipil as it was draped on its mannequin form, and a large, dark yellow-brown stain now appeared in this area. The huipil was a uniform yellow-gray color, and small brown and gray stains appeared throughout the weave. A catalogue number written directly on the huipil in indelible ball-point ink appeared at the back hem edge. Although the overall construction and weave were generally intact, three small mends and a complicated tear appeared at the top of the front crocheted band. This area had been mended several times with heavy cotton thread. Bands of gauze weave at both front and back of the huipil had areas of torn and abraded damage, with losses to weft threads, which resulted in fragile areas with unsupported and broken warps.

After considerable deliberation about the feasibility of carrying out elaborate treatments at the museum, the Choapan huipil was selected for a comprehensive textile conservation treatment to include wet cleaning, blocking, and stabilization.

Santa Maria water

The wet-cleaning treatment for the Choapan huipil was planned to utilize a wash solution of plain water without soap, because of the scarcity of water for rinsing. Several kinds of surfactants (or soaps) have a long history of use by textile conservators for this type of treatment because they aid in soil removal. Over the past fifteen years, however, concern has grown among conservators over evidence of soap residue remaining in textiles after wet-cleaning treatments, even in situations where there is a sufficient amount of rinse water. Soap residue left in textiles that have been wet-cleaned attracts soil and can cause other problems.

Because the large quantity of pH-neutral clean water required for the wet-cleaning treatment was not available at the museum site, it was necessary to purchase a predetermined quantity of commercially available bottled water. In keeping with one of the primary objectives of the project—that is, to use locally available materials whenever possible—a search for suitable water for washing textiles was launched at one of the largest general stores in

Oaxaca. Nine different types of bottled drinking water were purchased at prices ranging from Mex$5.10 to Mex$2.50 pesos per liter.

A simple test procedure for determining the pH of these samples was carried out. Since available equipment was limited, precise record keeping and consistent duplication of all procedures were necessary to maximize the reliability of test readings. The water samples were numbered from one through nine. With a Cole-Palmer pocket pH meter designed for determining pH of solutions, three sets of readings were taken for each sample in the same sample-number order for each set. Each pH reading was taken after immersion of the meter in water for 35 seconds (timed by a wristwatch).

Label information varied between the samples, and the range of pH did not necessarily correspond to the pH listed on labels. Readings varied from 9.4 for a water advertised for use in steam irons to 5.8 for a nonspecific drinking water. The sample selected for the wet-cleaning treatment step was a drinking water with the commercial name of Santa Maria. The selection was made primarily on the basis of consistent readings of pH 6.9, indicating a slight alkalinity suitable for the naturally alkaline cotton fiber of the huipil. At a cost of Mex$3.60 pesos, it was in the median price range of the samples. The label gave a mineral analysis listing seven minerals with amounts in milligrams per liter, determined by a laboratory in Paris. Although this information was encouraging, since there was no equipment to confirm the existing mineral analysis, the label information did not enter into decision making. As preparation for wet cleaning of the Choapan huipil, 57 liters of Santa Maria water were purchased and taken to the museum.

Washing the Choapan huipil

Complete treatment for the Choapan huipil included pretests, superficial cleaning, wet cleaning, blocking, and stabilization. Documentation consisted of color slides taken of the condition before and after treatment, as well as a conservation report describing treatment and results. The first step consisted of prewash tests. Because a pH meter was not available for measuring the pH of solid material, the Cole-Palmer pocket meter was used for a general indication of the pH of the Choapan huipil. This type of meter is intended for measuring pH of solutions only, with a manufacturer-specified range of 0.0–14.0 pH and accuracy to +/- 0.2 pH. One corner of the huipil was placed in a plastic beaker of the Santa Maria drinking water (pH of 6.9–7.1) for 1 minute. The corner of the huipil was removed from the beaker, and the

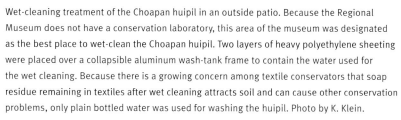

Wet-cleaning treatment of the Choapan huipil in an outside patio. Because the Regional Museum does not have a conservation laboratory, this area of the museum was designated as the best place to wet-clean the Choapan huipil. Two layers of heavy polyethylene sheeting were placed over a collapsible aluminum wash-tank frame to contain the water used for the wet cleaning. Because there is a growing concern among textile conservators that soap residue remaining in textiles after wet cleaning attracts soil and can cause other conservation problems, only plain bottled water was used for washing the huipil. Photo by K. Klein.

A technique of the wet-cleaning treatment. Small sponges were used to gently and systematically tamp the entire front of the huipil; it was then soaked for ten minutes. After the huipil was carefully turned from front to back, the process was repeated. The water was drained from the tank, and it was refilled with clean rinse water. The entire procedure was repeated. By the end of the wet-cleaning treatment, the huipil had remained in the tank for a total of one hour. Photo by K. Klein.

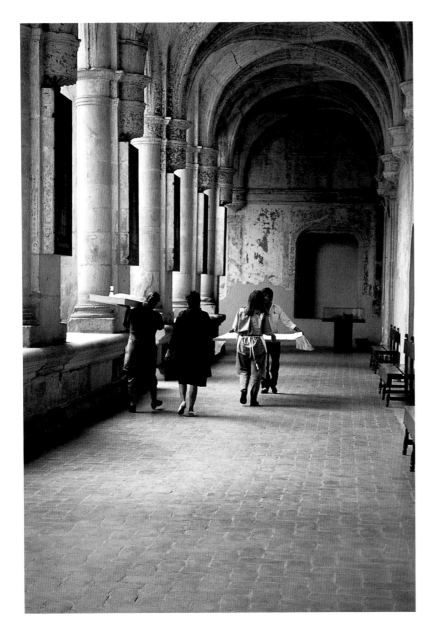

Carrying the cleaned Choapan huipil through the museum to the storage room for further treatment. After the wet-cleaning process was completed, the Choapan huipil was laid flat onto a portable shelving screen layered with clean cotton toweling and then used to transport the textile. Photo by K. Klein.

meter was immersed in the resultant solution. The huipil fiber was assumed to be somewhat acidic, because the reading had changed from the range of 6.9–7.1, a more alkaline indication, to 6.8, a slightly less alkaline indication.

Inked catalogue numbers written on the hem of the huipil were tested for solvency in three solutions: (1) water, (2) 50% water and 50% alcohol, and (3) alcohol only. None of the solutions acted as a solvent to remove the ink. However, this test was an important indication that ink would not disperse during the wet-cleaning process and cause further disfiguration.

Since the huipil had been vacuumed very carefully as part of the ongoing maintenance program at the museum, this usual step of the treatment was not repeated. In preparation for wet cleaning, weak areas of weave and embellishment were encased between two layers of net with basting stitches to prevent damage from mechanical action and handling.

Wet-cleaning the huipil was by far the most elaborate part of the treatment to organize and carry out. Considerable improvisation and organization were required to ensure the success of the treatment and safety of the huipil. Because textile fibers are vulnerable when wet, the plan for wet cleaning would require the coordinated efforts of several people to lift the huipil safely out of a wash tank, turn it from front to back, and return it to the tank. Many museum textile conservation labs have customized steel washbasins with elaborate controls for spray, soak, and water temperatures, and hoses for filling and draining, which are usually connected to systems that use specific types of water (e.g., deionized). The only washbasins with running water at the Regional Museum are in the lavatories, and the water source is unreliable and unfiltered. An alternative for carrying out emergency or single-event, wet-cleaning treatments has been used by conservators for many years. This method involves building a temporary wash-tank framework covered with heavy plastic sheeting to contain the wash solution. The tank is usually set up outside on the ground to facilitate filling and draining. A version of this alternative method was followed for wet-cleaning the Choapan huipil.

A collapsible aluminum wash-tank framework fabricated by a conservation carpenter, Robert Espinoza of Los Angeles, had been carried to Oaxaca by the consultants. It was made of 0.33 cm thick aluminum sheeting, and each side consisted of two sections, each 56 cm long. The overall dimensions of the tank were 112 cm^2, an ample size to accommodate the fully extended huipil. The sides were 7.5 cm high, with an equal flange extending out for stability.

In cross section, the side members were L-shaped. Since the framework was designed to be taken apart and stored compactly for travel, corner braces and center braces to join side sections were included. The braces were held in place with screws threaded from the inside of the tank to the outside to prevent puncture damage to the tank lining or textile. The overall weight of the tank when disassembled for travel was slightly less than 4.5 kg. All other required equipment consisted, for the most part, of items searched out at pharmacies, general merchandise, and hardware stores in Oaxaca. These included cotton towels, a thermometer for temperature readings in solution, polyethylene plastic sheeting for lining the framework and for containment of water, sponges, and a spray bottle. The thermometer was most difficult to locate; it was eventually purchased at an aquarium store.

A small, inside courtyard at the back of the museum was selected as the best location in which to carry out the process. The courtyard consisted of a wide, stone walkway enclosing a garden with rosebushes. It had ample sun and shade areas in the morning and afternoon and little foot traffic throughout the day. After the entire wet-cleaning process was planned in step-by-step detail, all procedures were reviewed for the staff assistants and presented to the museum director for approval.

On the day scheduled for treatment, all equipment and materials, including 57 liters of water, were carried to the courtyard and organized before the huipil was carried from the workroom to the wash site. The wash-tank framework was assembled and placed on heavy plastic sheeting on the stone walkway. A second layer of the sheeting was placed over the wash-tank framework to contain the water. The process was to include soaking periods and two separate rinse periods, each requiring a clean solution of water. All wastewater was to be drained toward the rosebushes.

In order to demonstrate the washing process, a trial run was conducted. Some of the bottled water was sacrificed as a wash solution, while a small piece of muslin representing the huipil was immersed in the bath. For practice, the staff tamped the muslin to flush out soiling, turned it from front to back, lifted the top layer of plastic sheeting supporting the muslin, and drained the water from the tank into the rosebush area.

With everything assembled and the trial run completed, everyone was aware of the careful attention necessary for carrying out this potentially awkward process. The huipil was ceremoniously carried to the courtyard on white cotton towels and humidified front and back with a spray bottle filled with Santa Maria

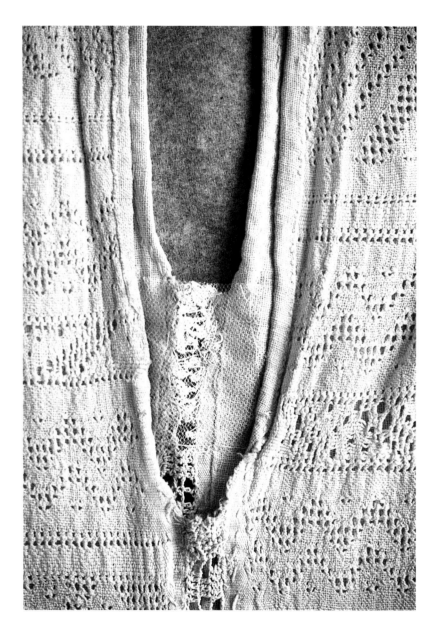

A sewn stabilizaton treatment to the Choapan huipil. After the huipil was blocked dry, stabilization treatments were carried out. Small detached parts of the original crochet embellishment were stabilized onto a section of nylon net with a hand-sewn couching technique. With the net as a support, the detached crochet section was reinserted into the crochet band at the inside of the neck. Photo by K. Klein.

Stabilization of the Choapan huipil using small pieces of nylon net to encase fragile areas. The barely visible netting will provide fairly long-term stability during handling, storage, and exhibition yet maintain the appearance of the open-weave work. Photo by K. Klein.

water. After the tank was filled with a small amount of water, the fully extended huipil was lowered into the tank; the remaining water was slowly poured around it. Small sponges were used to gently and systematically tamp the entire front of the huipil; a soak period of 10 minutes followed. After the huipil was turned from front to back, the process was repeated. Stained areas were given extra sponging on both sides. The water was then drained and the tank refilled with clean water for the rinse. The entire procedure was repeated. By the end of the wet-cleaning treatment, the huipil had remained in the tank for a total of 60 minutes — 30 minutes for the wash and 30 minutes for the rinse. A shelving screen, once again borrowed from the storage room, was covered with clean white towels and used to support the huipil for its trip back to the storage area.

The entire process lasted from midmorning until the end of the workday, even though the actual wet cleaning lasted just 60 minutes. Because all staff, including the consultants, must vacate the museum at the end of the day, the huipil was left to dry overnight. To prevent mold formation, the shelving screen was elevated 15 cm so there would be airflow below as well as above the textile. Wet towels were replaced by clean, dry, pH-neutral blotters. The next morning the huipil was almost dry, and the visible results were encouraging: the largest stains were very light, the overall color was less yellow-gray, and no structural damage had occurred.

The process called blocking was the next step. The object of this process is to reestablish the original size and shape of the textile and to relax creases and wrinkles resulting from cleaning and from prior use. After rehumidification to "relax" the fibers, the huipil was blocked according to the original construction and loom width as guides. Size 0 entomology pins were inserted through the huipil and blotters and into the screen below. When the huipil was again dry, the pins were removed, and the newly established size and shape remained stable. The blotter-covered screen served quite well as a pinning board in lieu of any other neutral, porous surface.

The final treatment step — stabilization of damaged weave, tears, and embellishment — was carried out while the huipil rested on the worktable. Since available light from one small window and a single incandescent bulb at ceiling height was inadequate for detailed work, an extension lamp was borrowed from the museum director's office. As noted in the condition report, one small area of crochet just below the front neck opening of the huipil had been mended at least twice. The jumbled mending stitches were tightly executed, causing damage to crochet embellishment and weave in

this area. The white mending thread was a heavier gauge, softer spin, and lighter color than the crochet thread; therefore, it was possible to identify and remove the heavy mass of mending thread before stabilization of this fragile area.

Small detached bits of the original crochet embellishment were arranged in their approximate original pattern, then stabilized onto a section of nylon net with a hand-sewn couching technique. Since the net served as a support, the crochet bits could be reinserted into the crochet band. Finally, net edges extending under left and right loom widths by about 2 cm were secured by a few carefully placed stitches. Small pieces of nylon net were also used to encase fragile areas of open weave on the front and back of the huipil. The net-supported stabilizations are barely visible when viewed from the front but appear slightly reflective from an acute angle. They provide fairly long-term stability for fragile areas and maintain the appearance of open-weave work.

Although the Choapan huipil is in relatively stable condition as a result of the entire conservation treatment, the wet-cleaning process and complicated stabilizations described here must be regarded as extraordinary measures that should be carried out under the supervision of a trained textile conservator. Because of the limitations of this site, certain aspects of the wet-cleaning treatment were problematic. Every step of the process required considerable effort and careful planning. The quantity of 57 liters of filtered water, although available in Oaxaca, was unwieldy, and its cost could be a significant expense for some museums. The portable, aluminum wash-tank framework proved to be stable, well made, and adequate for its purpose. Although an aluminum frame tank such as this one can be made in Mexico, it was designed and made in the United States for expediency. A simple wash-tank framework made of sealed wooden planks could also be used instead of the collapsible aluminum version described here.

Future Benefits

The most successful aspects of the textile conservation project at the Regional Museum of Oaxaca are the preventive care programs. Their success can be measured by the fact that these programs are ongoing and effective without requiring the continued presence of GCI consultants. Setting up procedures for textile storage; providing training for carrying out maintenance treatments, specifically periodic superficial cleaning by vacuum pressure; and completing a textile survey have proved to be useful and viable programs for

A macro photograph taken after conservation treatment showing the nylon net encasement used to stabilize fragile areas of the Choapan huipil. Photo by M. Zabé.

the museum. Their viability can be credited in large part to the manner in which they were developed. By participating in the way work is organized and accomplished at the museum, the consultants were able to assist in developing programs that can be carried out by existing museum staff.

Support from the Getty Conservation Institute made return visits to the museum possible. Staff training could be continued, reinforced, and developed, and more work on the textile collection accomplished. Having the continued participation of the same security staff members at the museum was a blessing bestowed by the goddess of textiles. Without their willingness to learn and carry out sometimes tedious procedures, the project would have been significantly diminished. A great deal of time might have been spent repeating the same training to many different staff members, and the scope of training provided by the GCI consultants would have been limited. The efforts of these staff members to perform many aspects of preventive treatment—especially superficial cleaning by vacuuming and organizing the collection—can only be described as excellent.

Although it is often difficult for textile conservators to convince museum administrators and staff in charge of textile collections of the far-reaching and desirable consequences of vacuuming, the benefits are documented by textile conservators at museums around the world. Not only does it improve the appearance of the textile, but a simple and careful vacuuming makes textile material less attractive to insects and rodents, decreases the possibility of mold formation, and reduces the accumulation of soils. These benefits have positive, long-term effects for textile collections.

At this time at the Regional Museum of Oaxaca, the feasibility of carrying out comprehensive textile treatments such as wet cleaning and elaborate stabilizations is doubtful because work space and equipment are limited, permanent textile conservation staff are not present, and funding is uncertain. Despite these limitations, a preventive conservation program has been successfully established through the support and encouragement offered by the GCI and the INAH Regional Museum of Oaxaca administration. Because of the dedication and enthusiasm of the museum staff and the importance of this textile collection among the people of Oaxaca, it is hopeful that continued efforts will eventually lead to appropriate maintenance for the entire collection of more than two thousand textile artifacts.

Bibliography for Textile Conservation

Ballard, Mary W. "Climate and conservation." In *The Textile Specialty Group Postprints*, vol. 2. Washington, D.C.: Textile Specialty Group, American Institute for Conservation of Historic and Artistic Works (AIC), 1992.

Burnham, Dorothy K. *Warp and Weft: A Textile Terminology.* Toronto: Royal Ontario Museum, 1980.

Castelló Yturbide, Teresa. *Colorantes naturales de Mexico.* Mexico City: Industrias Resistol, 1988.

Cortes Moreno, Emilia. "Modelo de depósito para material textil: Diseño y ejecución del depósito para material textil del Museo Nacional." *Restauración hoy* (Bogotá) 2(1991):39–45.

Emery, Irene. *The Primary Structures of Fabrics: An Illustrated Classification.* Washington, D.C.: Textile Museum, 1966.

Encuentro regional de expertos sobre conservación de textiles precolombinos. [Marina del Rey, Calif., and Lima]: Getty Conservation Institute and El Proyecto Regional de Patrimonio Cultural, Urbano y Natural-Ambiental, PNUD/Unesco, 1992.

Finch, Karen, and Greta Putnam. *The Care and Preservation of Textiles.* London: B. T. Batsford, 1985.

Ford, Bruce L. "Monitoring colour change in textiles on display." *Studies in Conservation* 37, no. 1(1992):1–11.

Garcia Valencia, E. Hugo. "Textiles: Vocabulario sobre materias primas, instrumentos de trabajo y técnicas de manufactura." *Cuadernos de trabajo* (Mexico City) 3(1975).

Hansen, Eric, and Carol Sussman. *The Deterioration of Silk: A Selected Bibliography.* Marina del Rey, Calif.: Getty Conservation Institute, 1992.

Harpers Ferry Regional Textile Group. *Textile Treatments Revisited.* Eighth symposium, November 1986, National Museum of American History. Harpers Ferry, W.Va.: Harpers Ferry Regional Textile Group,1986.
———. *Textiles and Museum Lighting.* Sixth symposium, November 1980, Anderson House Museum. Harpers Ferry, W.Va.: Harpers Ferry Regional Textile Group, 1988.
———. *Twentieth Century Materials, Testing, and Textile Conservation.* Ninth symposium, November 1988, National Museum of American History. Harpers Ferry, W.Va.: Harpers Ferry Regional Textile Group, 1988.
———. *Textiles on Parade: Exhibition Successes and Disasters.* Tenth symposium, November 1990, National Museum of American History. Harpers Ferry, W.Va.: Harpers Ferry Regional Textile Group, 1990.
———. *Silk.* Eleventh symposium, November 1992, National Museum of American History. Harpers Ferry, W.Va.: Harpers Ferry Regional Textile Group, 1992.

Johnson, Irmgard W. "Weft-wrap openwork techniques in archaeological and contemporary textiles of Mexico." *Textile Museum Journal* 4, no. 3(1976):63–72.

Kajitani, Nobuko. "Cuidado de los tejidos en el museo." *Apoyo* 4, no. 1(1993):3–10.

Lambert, Anne M. *Storage of Textiles and Costumes: Guidelines for Decision Making.* Vancouver: University of British Columbia Museum of Anthropology, with the Special Activities Programme of the National Museums of Canada, 1983.

Leene, Jentine E., ed. *Textile Conservation.* Washington, D.C.: Smithsonian Institution Press, 1972.

McLean, Catherine C., and Patricia Connell, eds. *Textile Conservation Symposium in Honor of Pat Reeves.* Los Angeles: Conservation Center, Los Angeles County Museum of Art, 1986.

Mailand, Harold F. *Considerations for the Care of Textiles and Costumes: A Handbook for the Non-Specialist.* Indianapolis: Indianapolis Museum of Art, 1980.

Odegaard, Nancy. *A Guide to Handling Anthropological Museum Collections.* Published in English and in Spanish. Los Angeles: Western Association for Art Conservation, 1992.

Shore, Sharon. "Review of loss compensation techniques used in textile conservation." In *Loss Compensation Symposium Postprints.* Los Angeles: Western Association for Art Conservation, 1994.

Thomson, Garry. *The Museum Environment.* London: Butterworths, 1986.

Varnell, Cara. "A survey of wet cleaning equipment used in textile conservation." In The *Textile Specialty Group Postprints,* vol. 5. Washington, D.C.: Textile Specialty Group, AIC, 1994.

Ward, Philip R. *The Nature of Conservation: A Race against Time.* Marina del Rey, Calif.: Getty Conservation Institute, 1986.

Zycherman, Lynda A., and Richard J. Schrock, eds. *A Guide to Museum Pest Control.* Washington, D.C.: Foundation of the AIC and the Association of Systematics Collections, 1988.

The Analysis of Dyestuffs on Historical Textiles from Mexico

Arie Wallert

MOST OF THE textiles in the collection at the Regional Museum in Oaxaca were made in the first half of the twentieth century. At that time, both modern synthetic colorants and traditional natural dyestuffs were used. In many areas of the world, where textile dyeing and weaving are of importance, the twentieth century has been a period of change. For example, within Turkish kilims, Indonesian sits and sarongs, Persian carpets, Navajo textiles, and Peruvian weavings, evidence of a gradual replacement of traditional materials and techniques by more modern methods can be found (Saltzman 1986). In contrast to the cumbersome methods of the past, these modern methods allowed craftspeople to produce textiles with often brighter colors, in larger quantities, and in much shorter time.

The techniques commonly used for dyestuff analysis are based on a principle that seeks to find the spectral, or chromatographic, characteristics of an unknown dyestuff. These characteristics are compared with reliable standards. The standards are based on dyestuffs of known composition that are known to have been used in the areas and periods under investigation. Therefore, the greatest concern for the analyst is to obtain dependable standards. Standards can come from the producers of synthetic colorants or from traditionally used plant materials; once the original plant materials of traditional dyes are identified, the dyes can be extracted from

A shellfish (*Purpura pansa*) produces an organic colorant used to dye textiles. The extracts from the glands of these animals are at first yellow, but when exposed to air and sunlight, they change from green to blue and then to a reddish purple. This reaction became readily evident as a skein of hand-spun white cotton thread was stained a dark purple from the secretions of shellfish gathered along the Pacific coast of Oaxaca. Photo by J. Lopez.

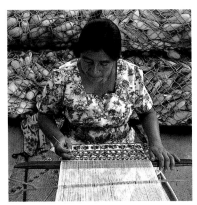

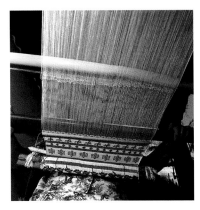

Elvira Martínez López of San Bartolo Yautepec demonstrating backstrap loom weaving using a single-heddle loom. With a pickup stick as a tool, she manipulates the tiny threads and weaves from the reverse side of the textile — an unusual weaving technique. The use of silk thread has all but disappeared in Yautepec; instead, she uses mercerized cotton thread to create the brocaded patterns. Photos by J. López.

those plants and used as standards for scientific analyses (Saltzman 1986:28). Collection of these standard materials, often by specialized ethnobotanists, should also be based on reliable historical documentary evidence. Historical sources — such as recipe books, technical treatises, guild ordinances, or tax agreements — can provide useful information. A great wealth of such historical information for European dye technology is available to conservation scientists (Bischof 1971; Ploss 1962; Frencken 1934; Rosetti 1969).

Much less historical and technical information exists for the dyestuffs of early Mesoamerican cultures. Dyestuffs of precolumbian Mesoamerica, however, were of great economical, social, religious, and cultural importance. It is known that colorful textiles were demanded by Aztec rulers from workers in their subject regions, such as from the Huastec people. In many cases the rulers required the textiles to be "richly worked, embroidered, decorated" and "striped red, blue, and yellow mantles." Textiles from the Huastec culture, in Aztec territory, were called *centzuntilmatli* or *centzunquachtli,* mantles of "a thousand different colors" (McJunkin 1991:34–36).

One of the most important sources on early Mexican crafts and techniques is the famous Florentine Codex. This codex is a treatise with the full title of *Historia General de las Cosas de Nueva España,* written in the sixteenth century. The author of the Florentine Codex, Friar Bernardino de Sahagún, interviewed indigenous people of New Spain about various aspects of their lives and recorded their descriptions in Náhuatl. Illustrations and Spanish translations were also added (Sahagún 1950–81).

Another important source that gives useful clues on historical textile technology is the *Historia Natural de Nueva España,* written in 1570 by Francisco Hernández for Philip II, king of Spain (Hernández 1959). These valuable sources give the names and descriptions of dyestuffs traditionally used by Mexican weavers. From these descriptions, it may be inferred that madder-type reds (so prominent in other cultures) were not used by the Mexican dyers during the sixteenth century. The reason for this may not have been the scarcity of the source material, since madder-type plants seem to have been rather abundant in Mexico (Dempster 1978; Ruiz 1976). Also, the various *Galium* and *Relbunium* species occurred fairly abundantly in Central America (Greenman 1898). In contrast, colorants from these plants were used quite frequently by the indigenous people both further north and in South America.

Another aspect that comes to attention from the historical records is the considerable specialization and division of labor

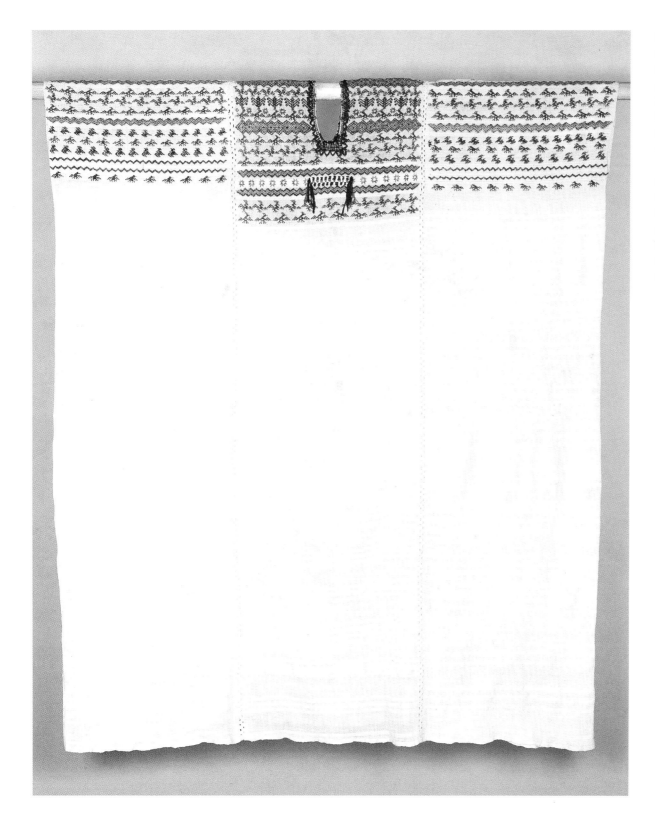

A huipil originating from the Zapotec community of San Bartolo Yautepec, woven on a backstrap loom around 1930. The white primary weave is of hand-spun cotton. Delicate embellishments of pink and purple hand-spun silk were woven into the garment using brocaded patterning. To determine the types of colorants used to dye the silk threads, small fiber samples were removed from the garment and analyzed at the Getty Conservation Institute using thin-layer chromatography. Some of the colorants from the older museum textiles from Yautepec were found to be early twentieth-century synthetic dyes. Regional Museum of Oaxaca (131064). Photo by M. Zabé.

The Coyotepec Ranch, just outside Oaxaca City, where cochineal, a natural organic dyestuff, is produced. The cochineal insect of the Coccidae family lives on the opuntia cactus. It produces a bright red liquid that has been used as a colorant in Mesoamerica since precolumbian times. Indigenous people of the Americas used it as a pigment for body painting and perhaps for painting stucco. In its dry form, cochineal was a highly prized commodity serving as a medium of exchange and tribute demanded by the indigenous Aztec rulers of central Mexico. Under Spanish rule during the sixteenth to eighteenth century, the production of cochineal in Oaxaca increased until it became one of the most lucrative commodities of New Spain for exportation to Europe. Photo by K. Klein.

within textile production. The person who traded in textiles also dyed them: "The seller of rabbit-hair (material) is a dyer, a user of dyes, a dyer (of material) in many colors. . . . He sells it in red, yellow, sky blue, light green, dark blue, tawny, dark green, flower yellow, blue-green, (carmine), rose, brown. (With these) he dyes." This person, however, obtained his wares from a specialized color-man: "a seller of colors, of various colors, of dyes; a man who piles (small baskets of color) on a large basket. He sells dried pigment, bars of cochineal pigment, cochineal mixed with chalk or flour, (pure) cochineal; light yellow, sky blue pigment, . . . alum, . . . small herbs, small roots, . . . a blue coloring made from blossoms; sulphate of copper, iron pyrites." (Sahagún 1950–81, 10:77).[1] From their prominence in the descriptions, it appears that the red colorants, and especially the cochineal reds, were of great importance.

Ancient Natural Dyestuffs

The red dyes

The most important natural organic red dyestuff of Mexico was—and still is—cochineal. This insect dyestuff was one of the most profitable colonial wares that the Spanish empire imported into Europe. Soon after its introduction on the European markets, it almost completely replaced kermes dyes. It was this dye that Hernando Cortés had especially in mind when he wrote to the king

of Spain, "they have colors for painting of as good quality as any in Spain, and of as pure shades as may be found anywhere" (Cortés 1929). The Spanish king had inquired in 1523 about the production of cochineal, and as early as 1540, it was one of the major articles of commerce in Antwerp, Belgium's major port. In Mexico it was known under the Náhuatl name of *nocheztli*— a compound word made up of *nochtli* (the opuntia cactus on which the insect lives); and *eztli* (blood), indicating its color.

In his discussion on the Aztec articles of trade, Sahagún gave a lengthy description of the cochineal insect, its appearance, its life cycle, and its color: "It fattens, it increases much in size . . . When the worms are distended, they come to rest like blood blisters. . . . It is of quite dark surface, still like dried blood . . . It is a coloring medium, a chili-red coloring medium . . ." (Sahagún 1950–81, 11:239). It also appears to have been a dye specifically used for the makeup of courtesans.

The coloring agent in the cochineal insects is a hydroxyanthraquinone : carminic acid. This colorant is closely related to that of the other insect dyes of kermes, Polish cochineal, Armenian cochineal, and lac dye (Born 1938). Its use and trade after the Spanish conquest have found excellent and elaborate description in the works of Donkin, Wouters and Verhecken, and Roosen-Runge and Schweppe (Donkin 1977; Verhecken and Wouters 1988; Schweppe and Roosen-Runge 1986).

Another important red colorant was taken from a tree, which is one of the species of the *Caesalpinia* genus. Long before the first contact of Europeans with South America, a wood called brazilwood was already known in Europe. The South American brazilwood got its name from the Spanish word for live coals, *braza* (blaze). When in the early sixteenth century the Portuguese explorer Cabral reached the east coast of South America, he named it Terra de Brazil, or Land of Brazil, because, within the Pernambuco area, large forests of brazilwood trees were found. The color obtained from these trees was the same one that Europeans had used since the early Middle Ages for dyeing textiles and for making red and purple lake pigments (McJunkin 1991; Wallert 1986). According to Sahagún, *Caesalpinia* (in Náhuatl, *uitzquauitl* or *huitzcuahuitl*) was used in Mexico only for textile dyeing: "Its name comes from *uitztli* [(h)uitztli] (thorn) and *quauitl* (tree). . . . a color is made from its wood, its trunk, with which to dye. . . . It becomes chili-red, very chili-red. . . . It is a dyeing, not a painting medium" (Sahagún 1950–81, 11:241).

The color obtained from this brazilwood may vary, depending on mordant and pH, from bright orange to a deep bluish purple. The substance that produces the color can be extracted from the wood by breaking, chopping, and rasping it into fine particles. The colorless precursor brazilin is then oxidized by losing hydrogen atoms to form the brownish red brasilein ($C_{16}H_{12}O_5$). Brasilein readily dissolves in water and in weaker alkaline solutions. In such alkaline solutions, it takes on a deep purple color. In its chemical constitution, brasilein shows a close similarity to hematein, the coloring substance of logwood, *Haematoxylon campechianum* (Robinson 1962).

Purple dyes

One of the most remarkable purple dyes in the history of textile dyeing is an animal dye obtained from the glands of certain shellfish. In the Roman empire, this purple was exclusively reserved for the highest ranking members of the imperial court. In the Byzantine empire, the royal heir to the throne was called *porphyrogenetos*, "born in purple." The source of this classical purple is a liquid from the hypobranchial glands of various shellfish *Murex* species, in particular *Murex brandaris* and *Trunculariopsis trunculus*. Also, *Ocenebra craticulata*, *Thais hemastoma*, and *Nucella lapillus* produce this colorant (Grasse 1968:58–60). The extracts from the glands of these animals are at first yellowish but when exposed to air and sunlight change from green to blue and then to reddish

Domestic cochineal insects thriving on a cactus at the Coyotepec Ranch. During the early nineteenth century, a Spanish law forbade the importation of cochineal from independent Mexico. This law was made to protect the newly established production of cochineal in Spain, and it greatly decreased cochineal production and thereby strongly affected the economy of Oaxaca. Today there are a few cochineal ranches in Oaxaca, and the organic cochineal colorant is used by local weavers to dye many of their wool textiles. Much of the cochineal produced at Coyotepec Ranch is exported to Japan, where it is used as a colorant for food products—a commercial demand that helps to keep its use as a colorant for textiles alive. Photo by G. Aldana.

A macro photograph of cochineal insects. In Sahagún's sixteenth-century accounts of New Spain, cochineal insects are described as coming "to rest like blood blisters. . . . It is of quite dark surface, still like dried blood. . . . a chili-red coloring medium" (Sahagún 1950–81, 11:239). Photo by G. Aldana.

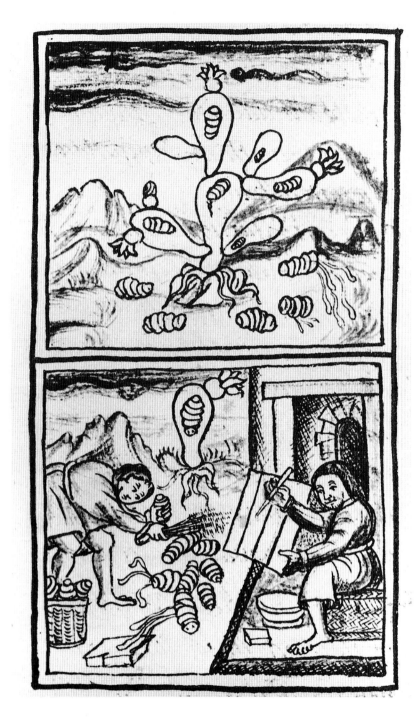

A facsimile of the Florentine Codex. The manuscript with drawings was originally transcribed and translated from the Aztec Náhuatl language to colonial Spanish by Fray Bernardino de Sahagún during the sixteenth century (1558–70). The Aztec transcription describes the cochineal insect and how it is processed to become a coloring medium. The drawings show cochineal insects living on a nopal cactus and falling to the ground when they die; the man on the left sweeps them into a pile, and the man on the right is demonstrating the application of the color with a brush — or maybe he is recording the description with pen and ink (Sahagún 1979, 3:367).

purple. The chemical nature of these colorants has been the subject of intensive research. Two closely related coloring components of shellfish purple have been established. Both precursors are of indigoid type, an indigo-blue and the purplish red 6,6'-dibromoindigo. The shellfish purple found in Mexican textiles is usually obtained from *Purpura pansa.* These shellfish are found especially along the Pacific coast of Oaxaca (Turok 1988:73–78).

Another strong purple colorant, called *cuauhayohuachtli* in Náhautl, was obtained from *Jatropha curcas.* This shrub, with three or five lobate, long petiolate leaves and greenish yellow flowers, is widely distributed in tropical America. Because of the strong purgative properties of its seeds, which are encapsulated in large, three-celled drupaceous capsules, this *piñon de Indias* or *sangregado,* was cultivated. On cold-pressing, the seeds produce up to 40% oil, making it a plant of such commercial value that it also was grown in the Dutch East Indies (Greshoff 1900:315–16, 320). Sometimes its color was also called *sangre de dragón* (dragon's blood), creating some confusion with the red resinous substance obtained from the *Calamus draco* plant. In the Hernández treatise, several different plants were referred to as *sangre de dragó* and are described as sources for colorants (Hernández 1959, 1:213, CLVI; thesaurus 8788, 1651).

The dark purple color that can be found in oil extracts of trunks, branches, and roots of many of the *Jatropha* species is a naphtaquinone colorant (Ballantine 1969). As such, it is related to the shikonin as is found in *Lithospermum erythrorizon* and in *Arnebia (Macrotomia) ugamensis,* as well as to alkannin in the roots of *Alkanna lehmanni* (*A. tinctoria*). The colorant alkanna found extensive use in European antiquity. It comes as a bit of a surprise that chemically similar colorants from different plants apparently were independently utilized in such different cultures as the Aztec and the Ptolemaic empires.

Orange dyes

A more orange-red was obtained from *Bixa orellana* L. This tree, which grows as tall as 9 m and occurs from Sinaloa to Veracruz, Yucatán, and Chiapas, is known as achiote (from Náhuatl *achiotl*). It is one of the best known of tropical American plants because of the yellow-red dye obtained from the fruit. The fruits of this tree are 3-cm-long ovoid capsules covered with long, spinelike bristles. In it are numerous seeds with fleshy, bright orange coverings. To obtain the coloring matter, the seedpods are crushed and put in water. The coloring matter then settles to the bottom, where it can

be collected. When the colorant is dried in the sun, it is pressed into cakes. Hernández describes this part of the preparation as similar to the processing of indigo: "Lo dejan después asentarse y le dan forma de panecillos, como los del añil o *mohuitli* que se saca del *xiuhquílitl,* para usarlos en su oportunidad" (Hernández 1959, 1:27, XCVIII) [They then let it settle and shape it into bread buns, like those of the *añil* or *mohuitli* that is taken from the *xiuhquílitl,* to use them (as needed)].[2] The colorant is not soluble in neutral water but can be dissolved in mild alkaline solutions. The colorant of achiote consists of the carotenoids bixin (i.e., the labile 14-cis-bixin and the more stable β-bixin, or transbixin) and bixein, as well as the water-soluble crocetin and other carotenoids. Wool can be directly dyed orange-red with it. And silk treated in a dye bath of achiote mixed with sodium carbonate receives a deep golden yellow color.

Yellow dyes

A strong carotenoid yellow called *zacatlaxcalli* was obtained from various dodder species (*Cuscuta*). A clue to the identification of this plant is given by its description in the Florentine Codex as a slender climbing plant: "Its name comes from *çacatl* (grass) and *tlaxcalli* (tortilla), because (the plant) climbs like grass. Yellow comes from it. It is long, it is slender." The comparison with the tortilla may be explained by the flat, pancake-like manner in which it envelops the branches of the host plant. This nonchlorophylose vine lives parasitically on host plants, from which it takes nourishing juices by squeezing the tendrils. A yellow color, sometimes shifting to orange, can be extracted from the stems of *Cuscuta tinctoria, C. americana,* and *C. odontolepis.* Judging from the description in the Florentine Codex, the plant must have been the source for one of the strongest colors: "It is yellow . . . very yellow, extremely yellow" (Sahagún 1950–81, 11:240).

All these species are widespread in North and Central America (Yuncker 1921). The plants' taxonomies do not always seem to be completely clear, and there is some confusion in the historical literature concerning the differentiation between the *Cuscuta* and *Cassytha* species (Desmoulins 1952). The coloring activity of *Cuscuta* extracts, however, is fairly well recognized, having been discussed in several publications by the end of the nineteenth century (Balestrier 1890–91, 1897). It had previously been elaborately described in Hernández's herbal treatise (Hernández 1959, 1:124, XCIX), where the origin of the plants' names (e.g., *Torta herbácea* and its use) are explained:

A sample being taken of wild cochineal growing in San Bartolo Yautepec. Wild cochineal insects produce weaker webs than do the domestic insects; the wild insect webs are more susceptible to damage caused by wind and rain. Photo by J. López.

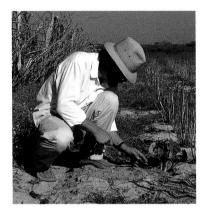

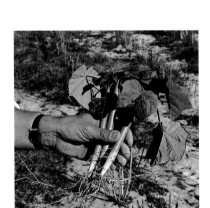

The author gathering a sample of a dark red colorant from the piñon plant (*Jatropha curcas*), which is widely distributed in tropical America. The colorant is found in the oil extracts of trunks, branches, and roots of the *Jatropha* species. Even though it grows in many areas of Oaxaca, there is little evidence to support its continued use as a colorant for dyeing textiles. Photos by J. López.

Al nacer es verde, se vuelve después amarillo, y adquiere por último color rojo. Cuando se está maduro se arranca de los árboles en que se nace, se machaca y se le da forma de tortas, de donde toma el nombre. Maceradas éstas con agua (a la que se agregan alumbre y nitro) y modeladas en forma de conchas, sirven a los pintores para dar a sus pinturas el color amarillo; los tintoreros las usan para teñir de amarillo las lanas o los hilos de seda, mezclándoles yeso cuando quieren dar un color más claro [When sprouting it is green, it then turns yellow, and finally it becomes red. Once ripe it is taken from the trees on which it grows, crushed and given a flat cake shape, from which its name is derived. Once macerated in water (to which is added alum and saltpeter) and shaped like shells, these can be used by painters to give their paintings the color yellow; dyemasters use them to dye wool or silk thread yellow, mixing them with plaster when they want to give a lighter color].

Cuscuta species show, especially in comparison to other parasitic plants such as *Orobanche* and *Lathraea*, large amounts of carotenoid substances in the stems. The carotene contents and their compositions change with the age of the plant. The younger stems appear as greenish yellow, the older stems are an orangy yellow, and the oldest stems have a bright and strong orange color. These differences in color correspond with differences in composition during the life cycle of the plant. The younger stems contain, besides xanthophyls and α-carotene, primarily esterified and free lutein. In time, the amounts of lutein decrease while the amounts of β-carotene and γ-carotene gradually increase. Also the amounts of the green chlorophyll (alpha and beta) appear to decrease in time within the stems of the *Cuscuta* species, leaving the almost pure β- and γ-carotenes to dominate the plants. The carotenoid content of *Cuscuta* species appears to be relatively independent of the carotene content of the host plant; it is, instead, caused by a specific carotenoid metabolism in the parasite itself (Neamtu and Bodea 1969). This metabolism seems to be related to the plants' capacity for photosynthesis (Dinelli et al. 1933).

Another bright and powerful yellow colorant was known as *xochipalli*, its name being a compound word made up of *xochitl* (flower) and *tlapalli* (color). The colorant, used to give luster and make a fine yellow, is also described in Hernández's treatise (Hernández 1959, 2:212, XX). He discusses the plant's appearance and its medicinal use: "Se usa sobre todo para teñir lanas y pintar figuras de color amarillo tirando a rojo, para lo cual se cuece

A carotenoid yellow colorant, obtained from the extracts of a parasitic plant called *chiva de barba* (*Cuscuta tinctoria, C. americana, C. odontolepis*), shown here in San Mateo del Mar, Oaxaca, completely covering the host plant. In the sixteenth century, Sahagún described this plant: "Its name comes from *çacatl* (grass) and *tlaxcalli* (tortilla), because (the plant) climbs like grass. Yellow comes from it. It is long, it is slender" (Sahagún 1950–81, 11:240). Photo by J. López.

agregándole nitro, y después se le exprime el jugo, que se cuela, y sirve asi de colorante a pintores y bataneros. Nace en diversos lugares cálidos, y es una hierba muy común" [It is mostly used to dye wools and to paint figures yellow with a hint of (going on) red, which is done by boiling it and adding saltpeter to it, and then squeezing the juice from it, which is strained, and thus can be used as coloring for painters and fullers (of cloth). It grows in sundry warm places, and is a very common type of plant]. The illustration in Hernández's treatise and the plant's description in the texts justify its identification as *Cosmos sulphureus*. This "flower which dyes" was described as having a similar appearance to the artemisia and is, indeed, quite common in Mexico (Rose 1895; Safford 1918).

Due to its strongly colored flowers, *Cosmos* has gained popularity as a garden plant. The coloring principle in the leaves of these flowers is primarily based on flavonoid colorants. Chmiel, Sütfeld, and Wiermann have found *Cosmos sulphureus* petals to contain 5-deoxy- and 5-hydroxyflavonoids, which were produced by specific enzymatic action. This enzyme, chalcone isomerase, has the ability to convert chalcones into their corresponding flavanones (Chmiel et al. 1983). The main coloring components of *Cosmos*, however, are chalcone and aurone glycosides, which seem to be the plants' metabolic end products. These colorants give the petals a strong orange-yellow color. Chromatography of various strains of *Cosmos* flowers has shown that the color is caused by these chalcones and aurones and by an unidentified (carotenoid?) orange colorant (Samata et al. 1977). Some of the redder color of the petals may also partially be due to the presence of anthocyanin (cyanidin 3-diglucoside) colorants (Hayashi 1941).

Organic blue colorant obtained from the plant (*Justicia spicigera*) known in Spanish as Palo de tinta and in Náhuatl as *mohuitli*. Although this plant grows in Oaxaca, there is little evidence of it being used as a colorant today. At one time it was used to dye the weft threads of wraparound skirts from Jamiltepec, Oaxaca. It was also formerly grown outside of Oaxaca City for the dyeing of rebozos. Photo by J. López.

A branch of an *añil* plant growing near Oaxaca City. While other indigoid plant species are found in Asia and Europe, in Mexico an indigoid blue colorant is obtained from the *añil* plant (*Indigofera suffructicosa*) indigenous to the Americas. The production of blue indigoid colorants for textiles and for painting is an ancient technology that may have developed independently in both the eastern and western hemispheres; a process of fermentation yields a rich coloring matter that is pressed and dried into cakes. Photo by J. López.

Blue dyes

The blue dyes that were reportedly used in precolumbian Meso-america are also highly interesting. As in Europe, the most important blue was an indigoid. The indigo most commonly used in Europe was made of woad (*Isatis tinctoria*) and indigenous to Europe. An imported indigo from Asia (*Indigofera tinctoria*) was also used in Europe. The most important blue colorant of Mexico was made from an indigoid plant indigenous to the Americas called *Indigofera suffructicosa*.

A blue colorant could also be obtained from a plant called *mohuitli* in Náhuatl, or *hierba purpurea* in Spanish. From its Náhuatl name this plant received its original Latin name, *Jacobinia mohintli* (Thomas 1866); it was also known as *J. tinctoria*. The plant is now known as *Justicia spicigera* (Schlectend) (Acanthaceae). It was reported to grow in the low and high plains of Hoaxtepec and seems to occur quite abundantly. Hernández stated that it cured dysentery and excessive menstrual flow and that "tomando cuantas veces sea necesario el agua donde se haya remojado, machacada, por algún tiempo; cura la sarna, y tiñe las lanas de color púrpura" (Hernández 1959, 1:78, C) [taking the water in which it has been soaked as often as necessary, crushed, for some time; it cures the itch (mange) and dyes wool the color of (shellfish) púrpura]. In the second volume, Hernández, describing a plant called *xiuhquilitpitzáhoac*, or *añil tenuifolio*, writes:

[H]acen de ellas un colorante azul llamado por los indios *tlacehoili* o *mohuitli*, y tiñen también de negro los cabellos . . . se echan las hojas despedazadas en un perol o caldera de agua hervida, pero ya quitada del fuego y tibia, o mejor fría y sin haber pasado por el fuego; se agitan fuertemente con una pala de madera, y se vacía poco a poco el agua ya teñida en una vasija de barro o tinaja, dejando después que se derrame el líquido por unos agujeros que tiene a cierta altura, y que se asiente lo que salió de las hojas. Este sedimento es el colorante; se seca al sol, se cuela en una bolsa de cáñamo, se le da luego la forma de ruedecillas que se endurecen poniéndolas en platos sobre las brasas, y se guarda por último para usarse durante el año (Hernández 1959, 2:112, XIX) [They make them into a blue colorant named *tlacehoili* or *mohuitli* by the Indians, and (it) also dyes hair black . . . the torn leaves are thrown into a cauldron or pot of boiling water, already off the fire and lukewarm, or better still cold and not boiled; they are stirred energetically with a wooden ladle, and slowly the already

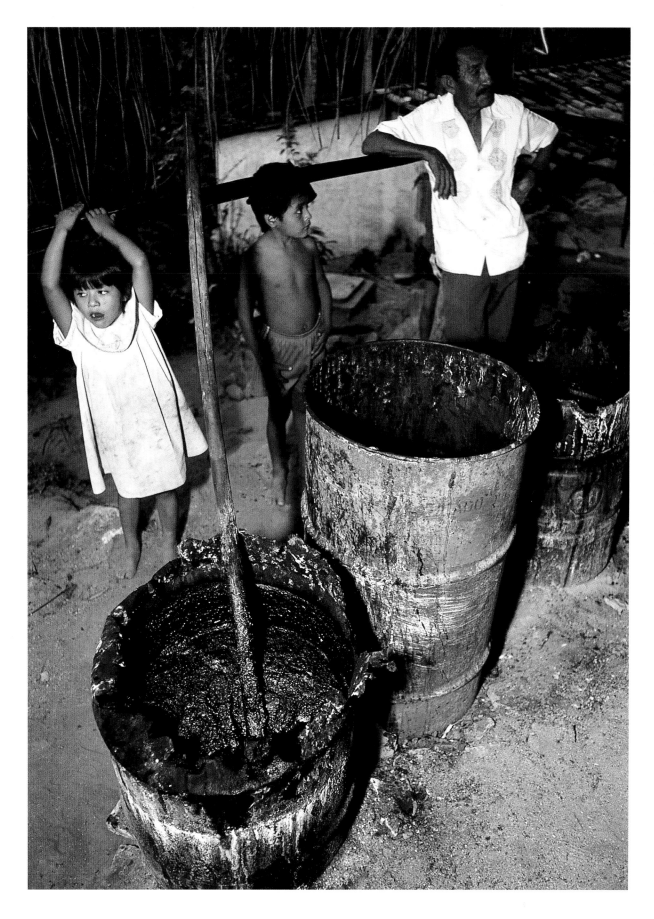

A mestizo family of indigo dyers from Pinotepa de Don Luis, Oaxaca, standing near tanks full of indigo. For several decades, this family has used indigo colorants to dye commercial cotton thread to be sold to local indigenous weavers. The thread is dipped repeatedly to achieve the dark blue required by weavers. According to these dyers, the plant (*Justicia spicigera*) was formerly mixed with indigo to achieve a blue color superior to the current dye. Today their indigo is purchased in Oaxaca City and may be imported from Asia. Photo by J. López.

dyed water is emptied into an earthenware container or large jar, then the liquid is left to drain through holes made at a certain level, and the residue from the leaves is left to settle. This sediment is the colorant; it is dried in the sun, strained off into a hemp net bag, then shaped into small wheel-shaped forms then hardened by placing them on plates on live coal fires, and lastly saved for use during the rest of the year].

Hernández also describes a *xiuhquilitpatláhac*, or *añil latifolio*, as producing the same colorant but of lesser quality. An unidentified shrub yielding a blue color, described in 1923 by Cuevas, in Yucatec Maya language, as *yich-caan* (sky blue) may describe this *Jacobinia mohintli* (Cuevas 1923). In 1905, Perkin discussed the blue colorants of various *Justicia* species and was more explicit in his descriptions (Perkin 1905).

There were also a number of other blue colorants. One of them may have been obtained from the fruits of *Cissus sicioydes* L. (or *Cissus elliptica*). This is a sometimes very long, slender vine of very variable leaf form—which has led to the proposal of many segregates and varieties and to incorrect determinations. Widely distributed in tropical America, it is known under a variety of names: *temecatl* (in Náhuatl), *tabkanil* (in Yucatec Maya), *tripa de zopilote* (in Spanish, as used in Sinaloa), or *tripas de Judas* (Spanish, as used in Morelos, Oaxaca). The colorant was obtained from its globose, ovoid, one-seeded black fruit (Standley 1923:731). Toledo et al. have found the berries of this plant to contain the anthocyanins cyanidin 3-rhamnosylarabinoside and delphinidin 3-rutinoside, 3-rhamnoside (Toledo et al. 1983). The berries contain these colorants in such large amounts that Toledo even suggested their use for a commercial food colorant. We can find the plant, described by Hernández for its medicinal purposes, as *tlacamazatcazqui* (Hernández 1959: thesaurus 414, 1651), and its leaves are still employed externally as a treatment for rheumatism and for healing of wounds.

Another blue colorant may have been obtained from a plant called *matlalitztic*. Hernández described the purgative properties of this plant but also said that "tiñe de color azul el agua donde se

Detail of the reverse side of a Usila huipil, showing a red synthetic dye generically called fuchsin that was used to overpaint the textile after it was woven. The red colorant can be seen on the white vertical lines of the huipil. Synthetic dyes became available to weavers in Oaxaca during the late nineteenth century. Because of the labor-intensive demands of making organic colorants—in combination with the artistic endeavors of weavers to experiment with new materials—the use of synthetic colorants for dyeing textiles is prevalent throughout the twentieth century and can be considered part of a continuing tradition. Regional Museum of Oaxaca (8–1746). Photo by M. Zabé.

The weave of a wool wraparound skirt from Mitla, Oaxaca, woven on a backstrap loom around 1930. A scientific analysis performed at the Getty Conservation Institute confirmed that the bright red wefts and the dark and light red warps of this skirt had been dyed with cochineal colorants. Chromatographic separation showed the presence of carminic acids, an indicator of scale-insect dyestuffs. Regional Museum of Oaxaca (132222). Photo by M. Zabé.

Partial view of a wool wraparound skirt from Mitla, Oaxaca. The presence of cochineal colorants used to dye the light and dark red warps of this skirt was confirmed through chromatographic separation. Various shades of red — ranging from orange to purplish reds — can be obtained by adjusting the pH of the cochineal solution. The dyers add an acid (such as lime juice) to obtain orange-red, or an alkali (such as calcium hydroxide — "lime" or *cal*) to obtain a purplish red. Regional Museum of Oaxaca (131032). Photo by M. Zabé.

remoja por algún tiempo, de donde le viene el nombre, y suaviza y provoca la orina. Se vende esta raíz en los mercados mexicanos" (Hernández 1959:I, 423, CXII) [it dyes the water blue where it has been soaked for some time, from which the name comes, and softens and induces urinating. This root is sold in Mexican markets]. In the Florentine Codex the Aztecs say of this *matlali:* "Its name comes from nowhere. It is the blossom of an herb, a blossom. This matlali is blue and a little herb-green. It is very sound, firm, good, of good appearance, fresh green." (Sahagún 1950–81, 11:240). The coloring components in these blossoms are most likely based on anthocyanin substances.

Modern Synthetic Dyestuffs

Many of the textiles that are now being produced in Mexico, are not dyed with natural, organic colorants but, rather, with modern synthetic dyes. A red dyestuff known under the name *fuchina* is rather commonly sold on the market. This name derived from Fuchsin, a synthetic dye discovered in Lyon in 1859 by the French chemist Verguin. This purplish red dye gained such a popularity that "fuchina" became a generic name for any red dye, even if it did not contain any Fuchsin.

The use of synthetic dyes is a late nineteenth- and twentieth-century phenomenon. It started in 1856 when the chemist William Henry Perkin tried to synthesize the malaria medicine quinine. His attempts were based on the use of toluidine, which he obtained from coal tar. He found that the base material could produce an intense bluish purple solution with methanol and that this solution could dye silk in a beautifully rich color. His patent of 26 August 1856, marks the beginning of a new era in the history of dye technology (Travis 1993:47). His dye, named Mauve or Mauveine, produced by Poirrier of Saint-Denis, France, was the first of several thousand new dyes to follow.

The discovery of diazo compounds by P. Griess in 1859 laid the foundation for what is currently the largest class of synthetic dyes, the azo dyes. The first true azo dyes became commercially available in 1861 (Aniline Yellow) and 1863 (Bismarck Brown). In 1863, Verguin heated some aniline with stannic chloride and obtained a brilliant red dye, magenta. This redder magenta had even greater commercial success than Perkin's mauve. Because the newly discovered dyes were much easier to apply and less labor intensive than natural colorants, synthetic dyes gained tremendous popularity in the textile industry. Within thirteen years after Perkin's

discovery, it was possible to dye textile fibers in a wider variety of shades with the aniline dyes than with natural dyes. Many of these early synthetic dyes, however, were not very lightfast. After the synthesis in 1868 by Heinrich Caro of alizarin, the main coloring component of madder, and the synthesis of indigo blue in 1897 by chemists at the German firm BASF, many more lightfast dyes appeared on the market (McLaren 1983:15). To date, the total number of synthetic dyes and pigments marketed is about ten thousand. It cannot come as a surprise that some of these dyes can be found in Mexican textiles of the early twentieth century.

Chemical Compositions of the Dyes

Quinones

All the coloring quinones contain the same chromophore, that of benzoquinone. It consists of two carbonyl groups in conjugation with two carbon-carbon double bonds. The most important natural organic quinone colorant in Mexico is cochineal. The coloring principle of this scale insect dye is carminic acid. This colorant, a rather complex antharquinone, is formulated as a 1,3,4,6-tetrahydroxy-2-d-gluco-3-pyranosyl-8-methyl-anthraquinone-7-carbonic acid. The coloring principle of *Jatropha curcas* is a naphtaquinone. Both quinones are hydroxylated, with phenolic properties, and occur in vivo in a combined form with sugars as glycosides (Harborne 1991:89).

Carotenoids

The carotenoids are an extremely widely distributed group of lipid-soluble plant pigments. The name *carotenoid* comes from the mixture of unsaturated hydrocarbons, isolated from carrots by Wackenroder in 1831. This carotene could later be separated by chromatography into its three isomers α-, β-, and γ-carotene. There are now more than three hundred known carotenoids, most of which are rare. They occur either as unsaturated hydrocarbons based on lycopene or as oxygenated lycopene derivatives, known as xanthophylls. Lycopene consists of a chain of linked isoprene units. These combined units give a completely conjugated system of alternate double bonds, which give the carotenoids their strong color. Cyclization at one end of the chain gives γ-carotene; cyclization at both ends gives β-carotene. Its isomers, α- and η-carotenes, differ only in the positions of the double bonds in the cyclic end units (Harborne 1991:129). In most cases the major component of a mixture of carotenoid colorants extracted from plant material is β-carotene.

Partial view of a wraparound skirt from Jamiltepec, Oaxaca, made of hand-spun cotton and hand-spun silk woven on the backstrap loom, perhaps before 1950. The pinkish magenta and the wine-red silk warps show the characteristic absorption maxima for cochineal. Scientific analysis confirmed the violet cotton warps to have been dyed with shellfish Purpura. The dye used for the dark blue cotton warps was analyzed as *Indigo tinctoria*—the indigo imported from Asia. Regional Museum of Oaxaca (132362). Photo by M. Zabé.

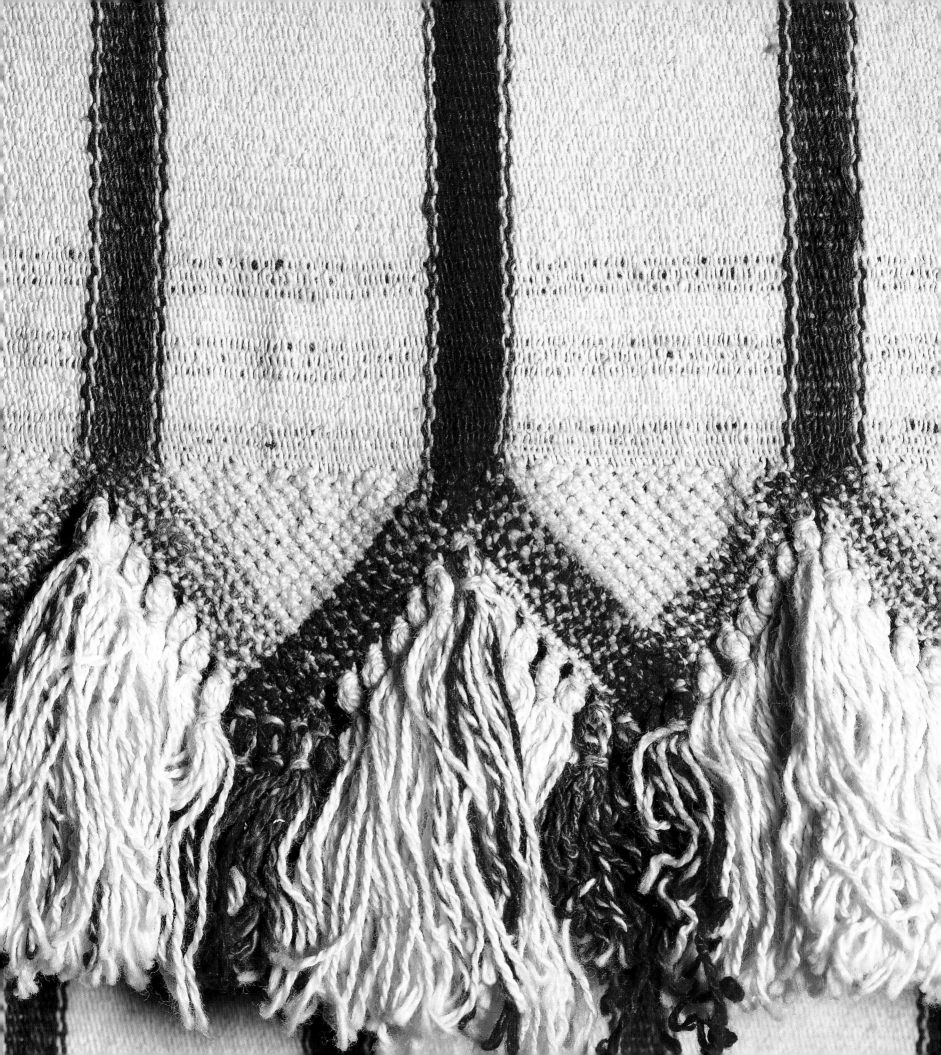

Flavonoids

Excellent descriptions of the chemistry of the flavonoid dyestuffs and of their (mainly European) history of use are given by Hofenk-de Graaff and by Schweppe (Hofenk-de Graaff 1969; Schweppe 1992). All flavonoids contain the C6-C3-C6 unit. Subgroups providing important colorants are the flavones, the flavonols, the chalcones, and the aurones. The flavonoids are mainly water-soluble plant compounds. Flavonoid compounds are to be distinguished from one another by the number and orientation of their hydroxyl and methoxyl groups. All flavonoid and anthocyanin colorants originate from one biosynthetic pathway, as one source describes: "Modification by hydroxylation of the A- and, in particular, the B-ring, methylation of hydroxyl groups as well as glycosylation and acylation reactions result in the immense diversity of the flavonoids found in nature" (Heller and Forkmann 1988).

The flavonoids are generally present in plants bound to sugar as glycosides. Any one flavonoid aglycone may occur in several glycosidic combinations, in which one or more hydroxyl groups is connected with a sugar by a semi-acetal link. In the dyeing process, these sugar bonds are broken and replaced with a flavonoid–metalsalt–textile chelate complex.

Indigoids

Among the most ancient dyes is the blue obtained from indigo. Indigo blue in Mexico was obtained by fermentation of the leaves of *Indigofera suffructicosa*. This fermentation caused the dye precursor indoxyl, contained in the plant as the glucose indican, to form the pale yellow leuco-indigo. This substance is readily oxidized by air into the deep blue of indigo.

The chemistry of the other indigoid dye, the shellfish purple, is quite complex. It is generally believed to be a 6,6'-dibromoindigo, which was applied to the fiber as a colorless leuco-dibromoindigo. From this leuco form, it would oxidize into a purple color. Shellfish purple is the only one of the many hundreds of indigoid dyes that requires exposure to light to obtain a development of color. It has been suggested that the precursor is a quinhydrone-type complex

Detail of two sets of *tlacoyales* (hair cords) from the Valley of Oaxaca, made before 1950. They are of braided hand-spun wool yarn decorated with wrappings of magenta and orange silk fibers. The magenta color of the silk wrapped around the green hair cords was identified as an early synthetic dye, Magenta (c.i. 42510), because its absorption maxima matched that of a known standard for this dye. The silk wrapped around the black hair cords was identified as a different synthetic dye, Rhodamine B (c.i. 45170). Regional Museum of Oaxaca, green (154634.2/2); black (154634.1/2). Photo by M. Zabé.

Detail of a rebozo from San Pedro Quiatoni, Oaxaca, made of hand-spun cotton and hand-spun silk woven on the backstrap loom before 1930. The red silk warp was confirmed to have been dyed with cochineal colorants. The purple silk warps were confirmed to have been dyed with shellfish *Purpura* colorants. Microchemical tests and ultraviolet and visible spectroscopy were used. Regional Museum of Oaxaca (131021). Photo by M. Zabé.

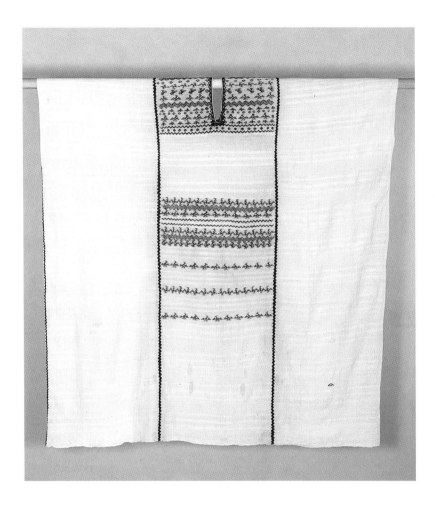

A huipil from San Bartolo Yautepec, woven on a backstrap loom before 1950. The white ground weave is of hand-spun cotton, and the pink and dark purple embellishments are of hand-spun silk. The dark purple silk colorant was identified as an early synthetic dye, Magenta (c.i. 42510). The white cotton ground has been discolored by the fugitive purple dye. Regional Museum of Oaxaca (131086.1). Photo by M. Zabé.

containing sulfur (Baker and Duke 1973). This complex, called tyriverdin, yields, on exposure to light at 400 nm, dibromoindigo and a mercaptan. It is this mercaptan that makes it yield, according to Cole's 1685 report, "a very strong and foetid smell, as if Garlick and Assa Foetida were mixed together" (Cole 1685).

Synthetic dyes

Most of the yellow, orange, and red synthetic colorants are azo dyes. These are compounds containing azo groups (−N=N−) linked to carbon atoms, mainly benzene or naphtalene rings. Almost all azo dyes are made by coupling—that is, by the reaction of an aromatic diazo compound with a coupling agent. Azo colorants are the world's most successful commercial dyes because of the relative simplicity of their synthesis by diazotation and azo coupling and because of the countless possibilities for different shades obtained by variation of diazo compounds and the coupling agents. Azo dyes have strong molar extinction and are relatively lightfast. The chemistry of the different possible azo dyes is too diverse to be treated within this paper. The reader is referred to the extensive monograph by Zollinger (1958).

Analysis of Dyes in the Textile Collection of the Regional Museum of Oaxaca

Many deep red samples among the museum textiles show in solution in concentrated sulfuric acid the bright reddish fluorescence that is characteristic of scale-insect dyestuffs. This diagnostic already distinguishes these colorants to some extent from other natural red dyestuffs (e.g., madder-type anthraquinones and the redwoods). Usually, for each museum textile, a small droplet of the red dye is then brought on the spot plate for microchemical tests. When a grain of boric acid is added to the solution, the presence of carminic acids is confirmed by the appearance of a blue color (Rosenthaler 1923:896). Ultraviolet-visible (UV-vis) absorption spectrometry in the acid of red yarns showed characteristic curve shapes and maxima at 285 nm, 505 nm, 540 nm and often a shoulder at 480 nm. Such a spectrum can usually be taken as conclusive evidence for the presence of cochineal red dye. This absorbance was found on the dark red hand-spun woolen weft of an *enredo* (wraparound skirt) from the Valley of Tlacolula (cat. 132220) and on another *enredo* from the same area (cat. 154627.2/3). The absorbance at 506 nm, 540 nm, and 320 nm and a shoulder around 480 nm

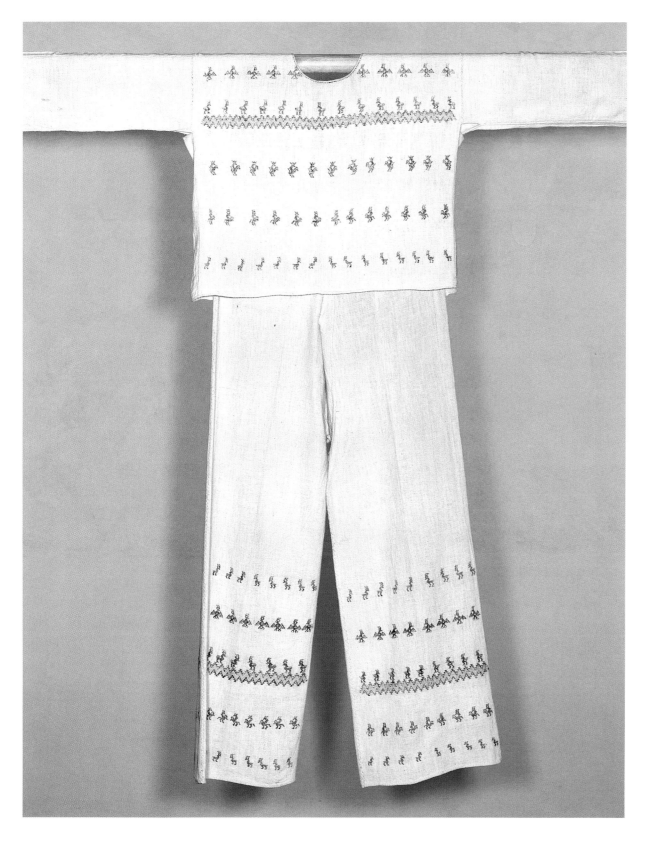

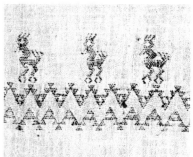

Full view and detail of a *camisa* (man's shirt) and *calzón* (man's trousers) from San Bartolo Yautepec. They are made of hand-spun cotton and hand-spun silk woven on the backstrap loom, perhaps before 1930. The dark purple and magenta colorants were identified as a synthetic dye, Magenta (c.i. 42510). The yellow colorant of the silk embellishment was found to contain a flavonoid organic colorant mixed with a synthetic colorant, Amido Black (c.i. 20470). Another synthetic colorant was found but could not be identified. Regional Museum of Oaxaca (131034.1-2.). Photos by M. Zabé.

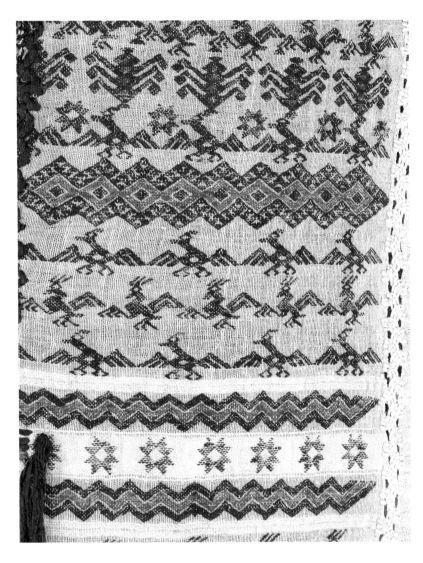

Detail of a huipil from San Bartolo Yautepec. The purple and pink colorants of the silk brocaded patterns match an unidentified synthetic colorant found on the man's shirt and trousers from the same community. Regional Museum of Oaxaca (131064). Photo by M. Zabé.

was also found in the dark red wool of the *ruedo de enredo* (embroidered band) at the bottom of a skirt from Huautla de Jiménez (cat. 154629.3/3).

In some cases the cochineal red dyestuffs of the Oaxacan textiles were prepared for analysis by thin-layer chromatography (TLC). The sulfuric acid solution in which the dyestuff is hydrolyzed for spectrometry was diluted with water. Then the diluted acid solution was shaken out with ethyl acetate and a few drops of amyl alcohol. The colorant, dissolved in the organic phase, was then separated in a small separating funnel, or a liquid/liquid extractor, and repeatedly shaken out with demineralized water in a separating funnel to neutral pH. The dye solution was then applied with a micropipette to Schleicher & Schüll F 1700 Mikropolyamid TLC plates. The chromatograms were developed in a saturated chamber with a butanone-2 : formic acid (7 : 3) mixture. The spots were observed under ultraviolet and ambient light and then sprayed with a uranyl acetate reagent. The retention (*Rf*) values of the spots allowed for an unambiguous identification of the scale-insect dyestuffs.

The bright red wefts and the dark and light red warps of an *enredo* from Mitla (cat. 132222) were clearly dyed with cochineal. Another woolen, hand-spun *enredo* from Mitla (cat. 131032) also had light and dark red warps dyed with cochineal. The wine-red silk warp of the rebozo (shawl) from San Pedro Quiatoni (cat. 131021) and the pinkish magenta silk fiber and the wine-red silk warps of the *enredo* from Jamiltepec (cat. 132362) showed the characteristic absorption maxima for cochineal. The suspicion that differences in these dark and light red dyes in the rebozo and *enredos* might have been caused by the additional use of other natural dyes could not be confirmed. Chromatographic separation showed only the presence of carminic acid (cochineal) as the sole colorant for these yarns.

Several small samples of dark red wool fibers from the embroidery applied to a cotton *enredo* made in Huautla de Jiménez (cat. 154629.3/3) were examined. This red was suspected to be a synthetic dye, as it had bled heavily onto the cotton. But analysis showed that the wool fibers were dyed with cochineal. This suggests that the bleeding could have been caused by the presence of another dye. TLC (Merck 60 F45 silicagel nano plates, methyl ethyl ketone : methanol : formic acid = 65 : 30 : 5) of this colorant did indeed suggest that there may be a small admixture of Fuchsin (C.I. 42685).

Quite a few red colors turned out to have been dyed with synthetic colorants. Some of these were fairly readily identifiable.

A magenta-colored dye on silk from a set of *tlacoyales* (hair cords) from the Valley of Oaxaca (cat. 154634.2/2) was indeed an early synthetic dye known as Magenta (C.I. 42510). Its curve shape and absorption maxima at 406 nm, 314 nm, 288 nm and a shoulder around 260 nm nicely matched that of the Magenta standard, 262 nm, 317 nm, and 409 nm. A perfectly identical spectrum (407 nm, 288 nm, and shoulders at 315 nm and 260 nm) was obtained from the dark purple of the hand-spun silk of a *huipil* from San Bartolo Yautepec (cat. 131086.1). This came as a bit of a surprise, as scholars had assumed that, because of its early date, the fibers of this garment were dyed with cochineal. A nice match with Magenta was also found in the dark purple (409 nm, 319 nm, shoulder at 260 nm) and Magenta (407 nm, 318 nm, 261 nm) hand-spun silks of a *calzón* (man's trousers) from San Bartolo Yautepec (cat. 131034). A violet dye on the silk fibers of the *calzón* (291 nm) also appeared to be of synthetic nature but could not be identified. The colorant, however, was identical to the purple and pink in the silk of another *huipil* from San Bartolo Yautepec (cat. 131064). These colors, too, were previously assumed to have been dyed with cochineal. The green dye on the *tlacoyales* had absorptions at 292 nm and 424 nm. It appeared to be synthetic, but no matching spectrum for it could be found.

A cotton *faja* (sash) from Jalietza (cat. 131058) showed quite interesting features. The rich, variegated red resembled similar woolen *fajas* dyed with cochineal. There are, however, no confirmed examples of cotton dyed with cochineal in the area. Absorption spectra with maxima at 327 nm, 264 nm, and 452 nm showed the dye to be a synthetic. The red of the cotton in another *faja* (cat. 131045) from the same place showed a similar spectrum, with peaks at 323 nm, and 263 nm (and a smallish peak at 391 nm). Spectrometry and chromatography indicated that the red on the cotton in these *fajas* is a synthetic dye, Fuchsin (C.I. 42685), which was purposefully used in an irregular manner to imitate the cochineal hues. The dark red wool of the warp from the second *faja* (cat. 131045), however, did show peaks (503 nm and 540 nm) that strongly suggested the presence of cochineal. Fuchsin was also found in the pink silk warp of the *pozahuanque* (wraparound skirt) from the Pinotepa de Don Luis (cat. 132706).

There were other synthetic colorants for which the GCI did not have a reference spectrum in its library. This is not a surprise, since there are now several thousand different synthetic dyes. It could, therefore, be reported that the magenta and pink dyes in the silk of the *huipil* from San Bartolo Yautepec (cat. 131086) were of

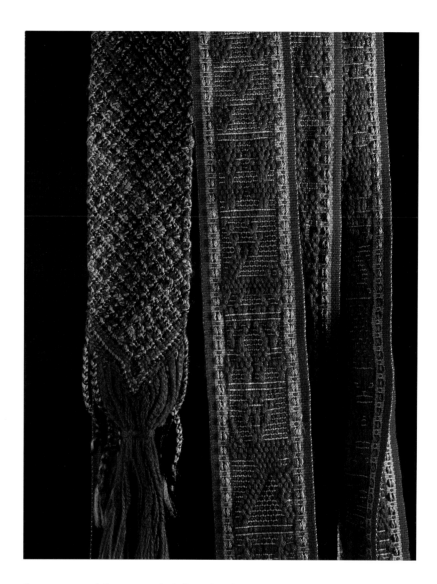

Spectrometry and chromotography indicate that the red colorant of the cotton in this *faja* (sash) from Jalietza is a synthetic dye, Fuchsin (c.i. 42685). The cotton thread may have been dyed in an irregular manner to imitate the varied hues of cochineal colorants. Although cochineal is often used to dye wool and silk fibers, there are no confirmed examples of historical cotton textiles dyed with cochineal in the Oaxaca area. Because cochineal adheres more readily to proteinaceous materials such as wool and silk—as opposed to the cellulosic material of cotton—the use of cochineal as a colorant for woven cloth may not have been exploited until the introduction of sheep into the Americas. In ancient Mesoamerica, feathers and rabbit fur may have been dyed with cochineal and applied to or woven into textiles. Regional Museum of Oaxaca (131058). Photo by M. Zabé.

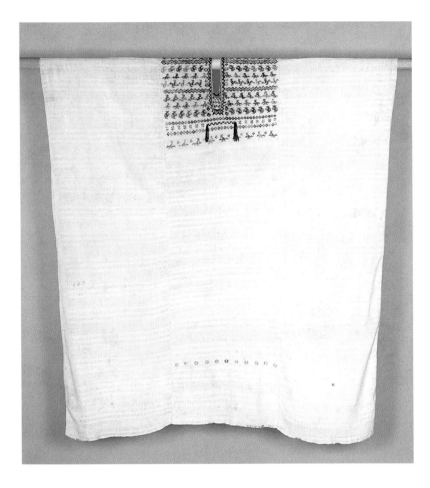

The magenta and pink colorants of the silk brocaded patterns in this huipil from San Bartolo Yautepec were indentified as synthetic. Although the colors appear the same as those in other textiles from this area, the spectral characteristics for the samples of this huipil are different from the known synthetic Magenta dye identified in other examples. Regional Museum of Oaxaca (131086.2). Photo by M. Zabé.

synthetic nature, but they could not be further identified. The spectral characteristics of these dyes, however, were clearly different from those of other pieces from that region that were dyed with Magenta. Finding this difference is significant in that it seems to confirm that the *huipil* is older than the other pieces from San Bartolo Yautepec.

Analysis of natural yellow and orange dyes should initially be based on the distinction and separation of the two major types of possible dyes: the carotenoids and the flavonoids. The sample is first extracted with chloroform or petroleum ether.

Carotenoids can be readily identified by their characteristic absorption spectra in chloroform. Carotenoids, dependent on the length of their lycopin chains, have their maximum absorption between 400 nm and 500 nm. The major peak, around 450 nm, usually has smaller peaks or shoulders at either side. The wavelengths of the absorption maxima are very much dependent on the length of the absorbing chromophore, that is, on the number of conjugated double bonds. Bixin, the main coloring component of achiote has, in solution in chloroform, absorption bands at 503 nm, 470 nm, and 440 nm. The identification of carotenoids can also be confirmed by a simple microchemical test. The carotene colorants from both *Cuscuta* and *Bixa orellana* immediately show a blue coloration when they are touched with a drop of water-free concentrated sulfuric acid. Strongly colored complexes are also formed in reaction with antimony trichloride (Nuhn 1990:490–93). None of the yellow or green fibers of the samples submitted gave evidence of being dyed with a carotenoid substance; therefore, an attempt was undertaken to establish the presence of flavonoid colorants.

The search for flavonoid colorants was accomplished by hydrolysis with hydrochloric acid for 30–40 minutes at ambient temperature. The hydrochloric acid solution was then diluted with methanol. The methanol and acid were next warmed to boil and evaporate. The dry extract was then redissolved in methanol, which was again heated and evaporated. The dilution with methanol and evaporation were repeated until the yellow extract in methanol had a pH of at least 5. Then it was ready for absorption and fluorescence spectrometry.

Detail of a San Bartolo Yautepec huipil shows magenta and pink silk thread, which was dyed with a synthetic colorant having no known reference. The presence of an unreferenced synthetic dye may confirm the assumption that this huipil is older than the other examples from San Bartolo Yautepec. The red figures, made with cotton thread, were not analyzed for dye content. Regional Museum of Oaxaca (131086.2). Photo by M. Zabé.

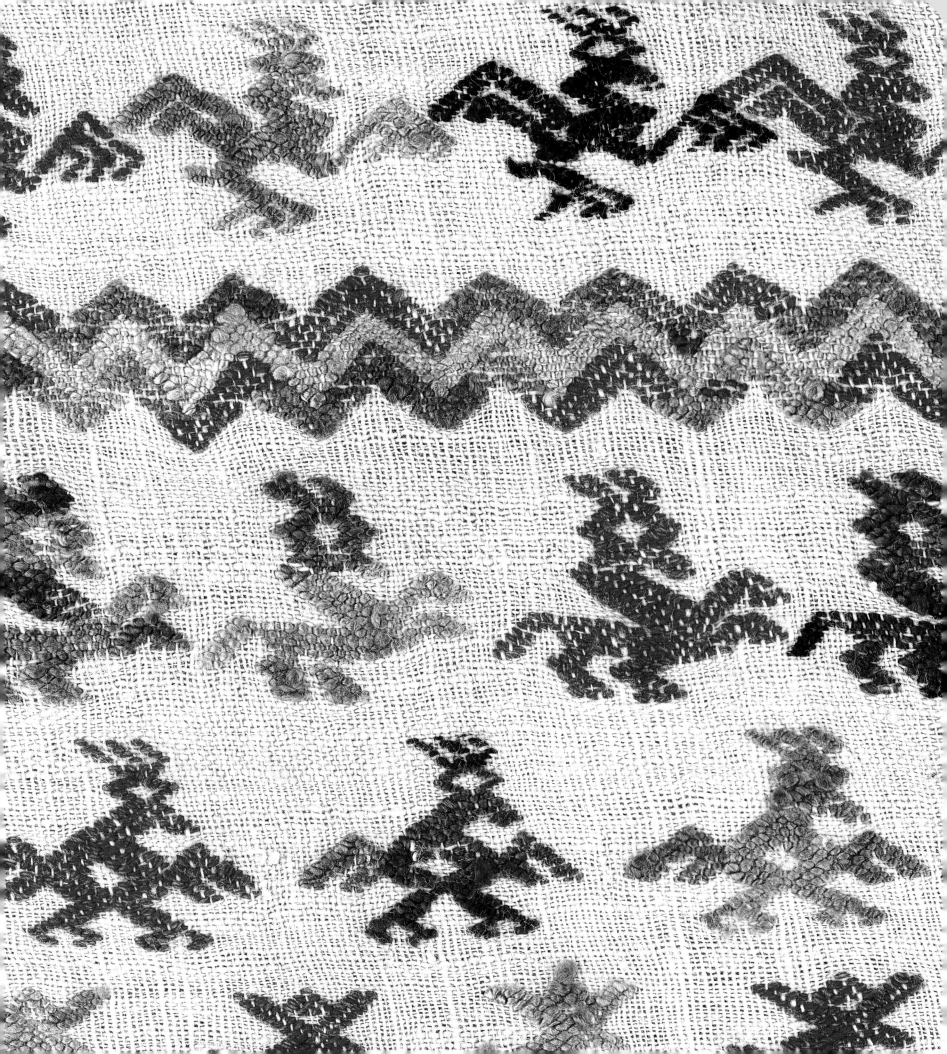

A rebozo from San Juan Mixtepec made of industrially spun cotton and hand-spun silk woven on the backstrap loom before 1950. The bright pink silk stripes, the strongest feature of the overall pattern, were found to be from a synthetic dye called Rhodamine B (c.i. 45170). Regional Museum of Oaxaca (131089). Photo by M. Zabé.

Flavonoid substances contain conjugated aromatic systems and thus show intense absorption bands and fluorescence in the ultraviolet and visible regions of the spectrum. This characteristic makes them particularly suitable for spectrometric identification. It is generally accepted that UV-vis spectroscopy is the most useful technique for identification of flavonoid type, for defining the oxygenation pattern, and for determining the positions of phenolic substitutions (Mabry et al. 1970; Wollenweber and Jay 1988).

Since the flavonoid-type plant dyes usually consist of different coloring components, they may show different spectral characteristics. This also makes them good candidates for identification by fluorescence spectrophotometry (Jatkar and Mattoo 1956a, 1956b; Wallert 1995). The changes in absorption and fluorescence of the sample—directly measured or on treatment with reagents such as aluminum chloride, sodium methoxide, and 2-amino ethyl diphenyl borate—make it possible to detect the presence of flavonoid substances, even in extremely small quantities.

From all the samples that were examined, it was only possible to identify the presence of flavonoid-type colorants in two items—in the dark green of another set of *tlacoyales* from the Valley of Oaxaca (no cat. no.) and, together with a synthetic Amido Black (C.I. 20470), in the yellow silk of a *calzón* from San Bartolo Yautepec (cat. 131034). This came as a surprise, as all the other colorants of that object appeared to be of modern, synthetic nature. Sixteenth-century chronicles describe a "natural" yellow colorant (perhaps a flavonoid) combined with a "natural" blue colorant (perhaps indigo) to make a green colorant. Weavers may have experimented with mixing organic colorants with synthetic colorants to achieve similar results.

The identification of indigoid colorants like the indigo blue and the shellfish purple can be done by microchemical test and by UV-vis spectroscopy. The microchemical test is described by Hofenk-de Graaff (1974). A few threads of the samples are placed in test tubes and treated with a mixture of 5% sodium hydroxide and 5% sodium dithionite solution. The blue components in the samples are thus reduced off from the fibers into their colorless leuco forms. When the chemically reduced sample in the solution with ethyl acetate is shaken, the indigoid component oxidizes again and dissolves in the separate organic phase. Absorption spectrometry of this organic phase for the *Indigofera tinctoria* blue standard shows distinct spectra with maxima at 260 nm and 600 nm and a shoulder at 275 nm. This reaction was also found with the blue of the Jamiltepec *pozahuanque* (cat. 132362), in the bluish black of

the *ruedo de enredo* from Huautla de Jimenez (cat. 154629.3/3), and in the dark blue warps and wefts of the *enredo* from San Pedro Quiatoni (cat. 131045).

Direct extraction in pyridine followed by absorption spectrometry results in a maximum at 611 nm for indigotin and 606 nm for dibromoindigo (Daniels 1987). The blue from the *enredo* from San Pedro Quiatoni (cat. 131045) showed, when dissolved in pyridine, the characteristic absorption at 610 nm. This was demonstrated by the analysis of a light bluish purple from the rebozo from San Pedro Quiatoni (cat. 131021) and the *pozahuanque* from Jamiltepec (cat. 132362). It has already been mentioned that the deep reds in these two textiles were made of cochineal. The purple colors are made of shellfish dye. Absorption spectrometry of these purples in pyridine consistently showed absorptions (602 nm and 330 nm) and curve shapes that matched those of the laboratory's standard for shellfish purple (*Thais melones* and *Purpura patula pansa*). Since the shellfish purple is a 6,6'-dibromoindigo, the finding of large quantities of bromine may confirm our identification. We were able to find very high peaks for bromine by energy dispersive X-ray fluorescence (XRF, Ba/Sr secondary target, 50 kV, 3.3 mA, 240 seconds). The finding of high peaks for bromine alone, however, may not in itself be taken as an unambiguous identification of shellfish dye. The dyestuff of the black wool of *tlacoyales* (cat. 131100) showed very high peaks for bromine. Its absorption spectrum in pyridine with maxima at 585 nm, 329 nm, and 351 nm did not sufficiently match the standard for shellfish purple. Later chromatographic examination made it possible to identify the dye as Amido Black (C.I. 20470). The presence of large amounts of bromine in the textile remains unexplained. The *tlacoyal* was decorated with bits of pink, turquoise, and yellow threads. There is a possibility that some of this decorative material may be responsible for the high reading of bromine.

Many of the red dyes of the textiles in the Oaxaca Museum were described as cochineal. In some cases this was true. In other cases, the UV-vis spectrum of the colorant in sulfuric acid did not show the characteristic absorptions at 285 nm, 505 nm, and 540 nm, nor did they match the spectra of the other well-known natural red dyes. But they did produce spectra that matched those of the GCI laboratory's synthetic standards fairly well.

A magenta-colored silk sample from a *tlacoyal* from the Valley of Oaxaca (cat. 154634.1/2), which scholars thought was dyed with cochineal, had absorption maxima at 366 nm, 287 nm, and 264 nm, with shoulders at 327 nm and 437 nm. Therefore, the dyestuff could

not have been cochineal. Another sample of the same magenta-colored threads readily dissolved its dyes in water that was brought to pH 12 with ammonia. A striking feature of this dye was its strong fluorescence. Fluorescence spectrometry showed the highest excitation wavelength at 336 nm, with an emission maximum at 434 nm. The dye produced a dramatic three-dimensional fluorescence spectrum that perfectly matched that of the laboratory's standard for Rhodamine B (C.I. 45170). The UV-vis absorption spectrum of the Rhodamine standard showed maxima at 366 nm, 262 nm, and 288 nm and thus confirmed this result. This identification was further confirmed by TLC. Chromatography was done on Merck silica gel 60 F254 nano plates, with a methyl ethyl ketone : methanol : formic acid (65 : 30 : 5) mixture as eluent. This technique was also very instrumental in finding an admixture of this Rhodamine B in the Fuchsin red for the *pozahuanque* from the Pinotepa de Don Luis (cat. 132706). In the literature, it was reported that the Pinotepa de Don Luis weavers traditionally used cochineal. It was now known that, at least for this 1970 piece, this was not the case. The same bright luminescent dye was found in the pink silk warp of a Mixtepec rebozo from the Miahuatlán district (cat. 131089). The absorptions at 262 nm, 290 nm, and 365 nm matched nicely with the 262 nm, 288 nm, and 366 nm absorptions of the laboratory's Rhodamine standard. This colorant seems to have gained some popularity in the Valley of Oaxaca, since a similar curve shape and maxima was also found at 365 nm, 289 nm, and 262 nm in the silk of another *tlacoyal* (no number) from this area. The orangy red dye in the silk of the *tlacoyal* from the Valley of Oaxaca (cat. 154634.1/2) showed absorptions at 533 nm, 318 nm, and 277 nm, and a small but characteristic absorption at 351 nm. TLC confirmed the identification of the dye as Congo Red (C.I. 22120).

The braided hand-spun green wool on the *tlacoyal* from the Valley of Oaxaca (cat. 154634.2/2) was analyzed in a similar manner. The *Rf* value of the dye from the sample nicely matched that of the laboratory's standard of Diamond Green B (C.I. 42000). This was confirmed by the absorptions at 271 nm, 315 nm, and 428 nm of our sample. The black dye of the wool on the same *tlacoyal* (cat. 154634.1/2) easily dissolved with a bluish color in ammonia water and clearly was a synthetic acid dye. Chromatography showed that the dye was Amido Black (C.I. 20470).

Based on historical documentary evidence, the original plant sources that were used for textile dyeings have been identified. Once the plant sources are identified, more can be learned about the chemical constitutions of the quinone, carotenoid, flavonoid, and indigoid substances that yielded specific colors. With this knowledge, spectrophotometric and chromatographic techniques can be used to identify the historical and modern dyes used for textiles in museum collections. Such knowledge adds depth to the understanding of the uses and meanings of textiles in the cultural life of Mesoamerica.

Notes

1. The Florentine Codex was originally transcribed and translated from the Aztec Náhuatl language to colonial Spanish by Fray Bernardino de Sahagún during the sixteenth century (1558–70). In his chapter, Arie Wallert quotes a modern translation of the Florentine Codex by Anderson and Dibble (1950–81) that was translated directly from Náhuatl to English. The quotes were then translated into modern Spanish for the Spanish version of the GCI publication, since it gives a more accurate translation of the original Náhuatl found in the Florentine Codex. (Ed.)

2. José Rojo Navarro's (1959) Spanish translation of the sixteenth century document, *Historia Natural de Nueva España*, was translated by Sabine Harl for use in this chapter. [Ed.]

References

Baker, J. T., and C. C. Duke
1973 *Australian Journal of Chemistry* 26:2153.

Balestrier, L. de
1890–91 El zacatlaxcale. *Boletín de la Sociedad Agrícola Mexicana* 15:80.
1897 Plantas nocivas. *Progreso de México* 4:783–84.

Ballantine, J. A.
1969 The isolation of two esters of the naphtaquinone alcohol, shikonin, from the shrub *Jatropha glandulifera*. Phytochemistry 8:1587–90.

Bischof, B.
1971 Die Überlieferung der technischen Literatur. In *Artigianato e tecnica nella società dell'alto medioevo occidentale*, 227–69. Settimane di Studio, vol. 18. Spoleto: Centro Italiano di Studio sull' Alto Medioevo.

Born, W.
1938 Scarlet. *Ciba Review* 7:206–27.

Chmiel, E., R. Sütfeld, and R. Wiermann
1983 Conversion of phloroglucinyl-type chalcones by purified chalcone isomerase from tulip anthers and from cosmos petals. *Biochemie und Physiologie* der Pflanzen 178:139–46.

Cole, W.
1685 *Philosophical Transactions of the Royal Society* 15:1278.

Cortés, Hernando
1929 Cortés's second letter to Charles V. *In Five Letters—1519–1526*, 88. Trans. and ed. J. B. Morris. New York: McBride.

Cuevas, G. R.
1923 Breves consideraciones sobre plantas útiles de Yucatán. *Agricultor* (Mérida) 10(6):19–20.

Daniels, V.
1987 Further work on the dye analysis of textile fragments from Enkomi. In *Dyes on Historical and Archaeological Textiles*. York: York Archaeological Trust.

Dempster, L. T.
1978 *The Genus* Galium (Rubiaceae) *in Mexico and Central America*. Berkeley: University of California Press.

Desmoulins, C.
1852 Etudes organiques sur les Cuscutes. *Comptes Rendus, 19e session du Congrès Scientifique (Toulouse, France)* 2:243–320.

Dinelli, G., A. Bonetti, and E. Tibiletti
1993 Photosynthetic and accessory pigments in Cuscuta campestris Yuncker and some host species. *Weed Research* 33:253–60.

Donkin, R. A.
1977 Spanish red: An ethnogeographical study of cochineal and the opuntia cactus. *Transactions of the American Philosophical Society* 67(5):1–84.

Frencken, H. G. T.
1934 *T Bouck va wondre 1513*. Roermond: H. Timmermans.

Grasse, P. P.
1968 *Traité de zoologie*. Vol. 5, *Mollusques, gastropodes, et scaphopodes*. Paris: Masson.

Greenman, J. M.
1898 Revision of the Mexican and Central American species of *Galium* and *Relbunium*. *Proceedings of the American Academy of Arts and Sciences* 33:455–70.

Harborne, J. B.
1991 *Phytochemical Methods: A Guide to Modern Techniques of Plant Analysis*. London: Chapman and Hall.

Hayashi, K.
1941 Studien über Anthocyane, no. 7: Über das Anthocyanin der roten Kosmosblüten I. *Acta Phytochimica* 12:83–95.

Heller, W., and G. Forkmann
1988 Biosynthesis. In *The Flavonoids: Advances in Research Since 1980*, ed. J. B. Harborne, 399–422. London: Chapman and Hall.

Hernández, F.
1959 *Historia Natural de Nueva España*. Trans. José Rojo Navarro. Mexico City: Universidad Nacional de México.

Hofenk-de Graaff, J. H.
1969 Natural dyestuffs: Origin, chemical constitution, identification. In *ICOM Committee for Conservation Plenary Meeting*. Amsterdam: Amsterdam Central Laboratory.

Jatkar, S. K. K., and B. N. Mattoo
1956a Absorption and fluorescence spectra of flavones. *Journal of the Indian Chemical Society* 33:623–29.
1956b Absorption and fluorescence spectra of flavonols. *Journal of the Indian Chemical Society* 33:641–46.

Mabry, T. J., K. R. Markham, and M. B. Thomas
1970 *The Systematic Identification of Flavonoids.* Berlin: Springer Verlag.

McJunkin, D. M.
1991 Logwood: An inquiry into the historical biogeography of *Haematoxylum campechianum* L. and related dyewoods of the neotropics. Ph.D. diss., University of California, Los Angeles.

McLaren, K.
1983 *The Colour Science of Dyes and Pigments.* Bristol: Adam Hilger.

Neamtu, G. and C. Bodea
1969 Chemotaxonometrische Untersuchungen an höheren Pflanzen, no 2: Uber die Carotinoidfarbstoffe parasitärer Pflanzen. *Revue roumaine de biochimie* 6:227–31.

Nuhn, P.
1990 *Naturstoffchemie: Mikrobielle, Pflanzliche, und tierische Naturstoffe.* Stuttgart: S. Hirzel Wissenschaftliche Verlagsgesellschaft.

Perkin, J.
1905 On a brilliant pigment in species of *Jacobinia. Annals of Botany* (London) 19:167–68.

Ploss, E. E.
1962 *Ein Buch von alten Farben: Technologie der Textilfarben im Mittelalter mit einem Ausblick auf die festen Farben.* Munich: Heinz Moos.

Robinson, R.
1962 Synthesis in the brazilin group. In *Chemistry of Natural and Synthetic Colouring Matters,* 1–11. New York: Academic Press.

Rose, J. N.
1895 New or little-known plants: A yellow-flowered Cosmos. *Garden and Forest* 8:484.

Rosenthaler, L.
1923 *Der Nachweis organischer Verbindungen Ausgewählte Reaktionen und Verfahren.* Stuttgart: Verlag von Ferdinand Enke.

Rosetti, G.
1969 *The Plictho, Instructions in the Art of the Dyers which teaches the Dyeing*
[1548] *of Woolen Cloths, Linens, Cottons, and Silk by the Great Art, as well as by the Common.* Trans. S. M. Edelstein and H. C. Borgetty. Cambridge, Mass.: M.I.T. Press.

Ruiz, R.
1876 Rubia mexicana. *Cultivador* 2(2):51–53.

Safford, W. E.
1918 Cosmos sulphureus. *Journal of the Washington Academy of Science* 8:613–20.

Sahagún, Bernardino de
1950–81 *The Florentine Codex: A General History of the Things of New Spain, Books 1–12.* Trans. Arthur J. O. Anderson and Charles E. Dibble. Santa Fe, N.M.: School of American Research; Salt Lake City: University of Utah.
1979 *Codice Florentino: Historia general de los cosas de Nueva España.* Mexico City: La Secretaría de Gobernación.

Saltzman, M.
1986 Analysis of dyes in museum textiles or, you cannot tell a dye by its color. In *Textile Conservation Symposium in Honor of Pat Reeves,* ed. C. C. Maclean and P. Connell, 27–39. Los Angeles: Los Angeles County Museum of Art.

Samata, Y., K. Inazu, and K. Takahashi
1977 Studies on the interspecific hybrid between *Cosmos sulphureus* and *C. caudatus* with special reference to flower color and pigments. *Ikushu-gaku zasshi/Japanese Journal of Breeding* 27(3):223–36.

Schweppe, H.
1992 *Handbuch der Naturfarbstoffe.* Landsberg/Lech: Ecomed Verlagsgesellschaft.

Schweppe, H. and H. Roosen-Runge
1986 Carmine: Cochineal carmine and kermes carmine. In *Artists' Pigments,* vol. 1, ed. R. Feller, 255–83. Cambridge: Cambridge University Press.

Standley, P. C.
1923 *Trees and Shrubs of Mexico (Oxalidaceae–Turneraceae).* Contributions from the United States National Herbarium. Vol. 23, pt. 3. Washington, D.C.: U.S. National Herbarium.

Thomas, A. M.
1866 Sur le séricographis mohitli et sur la matière colorante fournie par cette plante. *Recueil de mémoires de medecine, de chirurgie, et de pharmacie militaires* 3(17):62–78.

Toledo, M. C. F., F. G. R. Reyes, M. Iaderoza, F. J. Francis, and I. S. Draetta
1983 Anthocyanins from Anil Trepador (*Cissus sicyoides* Linn.). *Journal of
 Food Science* 48:1368–69.

Travis, A. S.
1993 *The Rainbow Makers: The Origin of the Synthetic Dyestuffs Industry in
 Western Europe.* Cranbury, N.J.: Lehigh University Press.

Turok, Marta
1988 *El Carocol Purpura: Una Tradición Milenaria en Oaxaca.* Mexico
 City: Secretaria de Educación Pública/Dirección General de
 Culturas Populares.

Verhecken, A., and J. Wouters
1988 The coccid insect dyes: Historical, geographical, and technical data.
 *Bulletin de l'Institut Royal du Patrimoine Artistique/Koninklijk Instituut voor
 het Kunstpatrimonium* 22:207–39.

Wallert, A.
1986 Verzino and Roseta colours in 15th-century Italian manuscripts.
 Maltechnik/Restauro 92:52–70.
1995 Identification of flavonoid type yellows in small paint samples by
 solution absorption and fluorescence spectrophotometry. *Dyes in
 History and Archaeology* 13:46–58.

Wollenweber, E., and M. Jay
1988 Flavones and flavonols. In *The Flavonoids: Advances in Research since
 1980*, ed. J. B. Harborne, 233–96. London: Chapman and Hall.

Yuncker, T. G.
1921 A revision of the North American and West Indian species of *Cuscuta.
 University of Illinois Biological Monographs* 6:1–141.

Zollinger, H.
1958 *Chemie der Azofarbstoffe.* Basel: Birkhäuser Verlag.

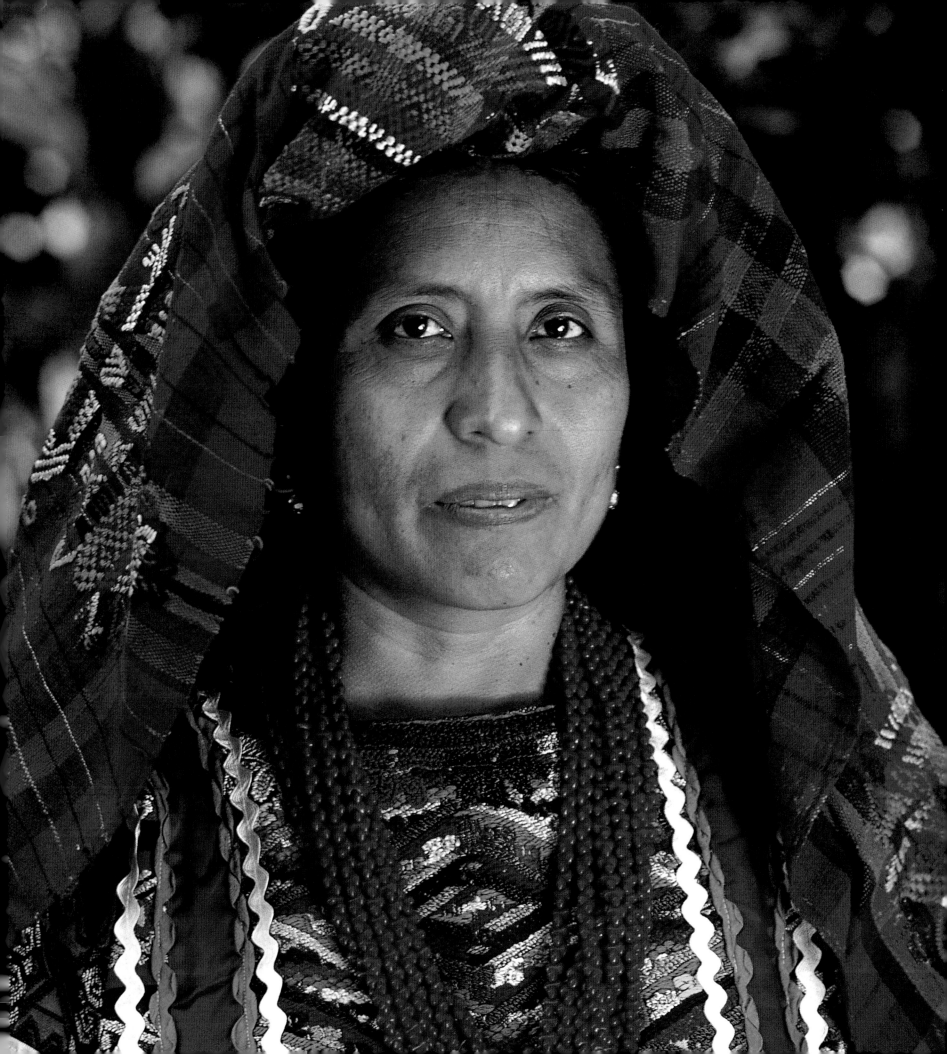

Threads of Diversity:
Oaxacan Textiles in Context

Alejandro de Avila B.

THE TEXTILES of Oaxaca meet the eyes with a flourish of colors, textures, and designs. In an area as varied in weaving traditions as Mesoamerica, Oaxacan textiles stand out for their richness of form and style. The ecological contrasts of the land and its remarkable biodiversity are reflected in the variety of fibers and dyes employed in their manufacture. The inventory of weaving techniques known from Oaxaca is more extensive than that of any other part of Mexico or Guatemala. Motifs and styles of decoration, garment construction, manners of clothing, and other features bespeak a complex history, from the divergent evolution of the Zapotec, Mixtec, and other indigenous civilizations to Spanish colonization, the development of the Mexican nationality, modernity, and economic globalization. Quite unlike the static markers of ethnic identity that "regional costumes" are portrayed to be, Oaxacan textiles document social change. Colonial records evidence shifting trends in the production and trade of textiles in southern Mesoamerica, while old paintings

Salías del templo un día, Llorona,

cuando al pasar yo te vi;

hermoso huipil llevabas, Llorona,

que la Virgen te creí.

You were coming out of the church one day, Llorona,

when in passing I saw you;

so beautiful a huipil you wore, Llorona,

that I thought you were the Virgin

"La Llorona," song from
the Isthmus of Tehuantepec

Josefina Jacinto Toribio, weaver and president of a women's artisan organization of Usila, wearing a headcloth and huipil that she wove herself. She weaves delicately brocaded textiles, using industrially spun cotton and rayon thread dyed with synthetic colorants in bright hues. Rayon ribbons are used to join the woven webs at the selvages to form the structure of the garment. The ribbons are also sewn together into wide horizontal strips, to form short, bell-shaped sleeves. In Usila, headcloths were once worn by both women and men during ceremonial occasions; they are rarely used today. Photo by J. López.

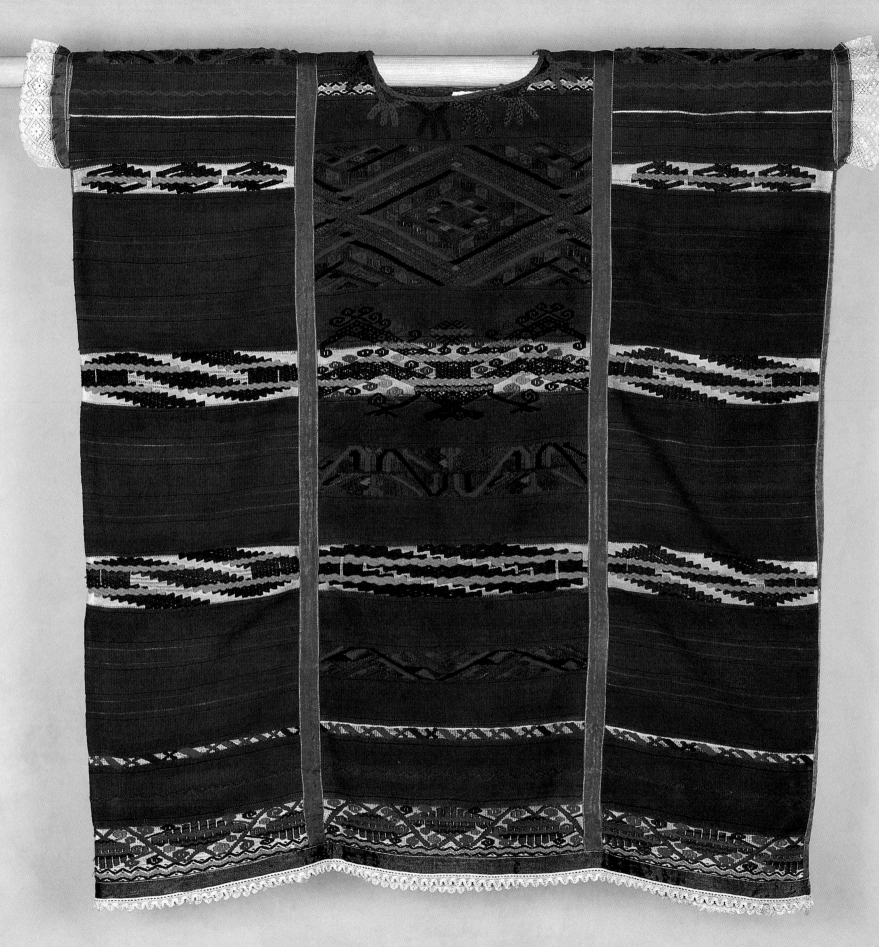

and early photographs bear witness to innovations in indigenous attire. In the past fifty years the rate of change has accelerated, and the economy and aesthetics of clothing have been transformed radically. Weaving has died out in many communities. Where the art is alive, weavers are creating new kinds of textiles, often in response to the folk art trade. The work of women in rural households becomes a commodity, as subsistence agriculture and local networks of trade are subsumed in an industrial economy. Time and effort formerly devoted to textile manufacture for family use are now invested in the production of exchange goods, cash crops, or wage labor. Paradoxically, while daily use of traditional dress is waning, indigenous textiles, as prominent signs of ethnicity, have gained symbolic power in the politics of cultural pluralism and social inequity in Mexico. In the 1990s, a woman wearing a beautiful huipil at a demonstration on the main square of the capital city evokes strong feelings. Her presence sums up five hundred years of resistance—she is no less compelling an image than the allusion to the Virgin in an old love song.[1]

This chapter approaches Oaxacan textiles in their ethnohistoric context, describing some of their technical features and sketching their evolution. A salient theme of this overview is the relationship between environmental complexity and cultural history as a frame of reference for understanding how weaving developed and diversified in Oaxaca. The variety of native plant and animal species providing fibers, dyes, and other materials useful to the weaver is highlighted, and the parallels between ancient and contemporary textiles are described in detail. Many of the notes at the end of this chapter document these linkages. However, the intent is not to overstate cultural continuity—and much less to present Oaxacan weaving as a timeless form of art rooted in nature. The view that defines the survival of precolumbian forms as the essence of indigenous textiles and that values designs of pre-Hispanic

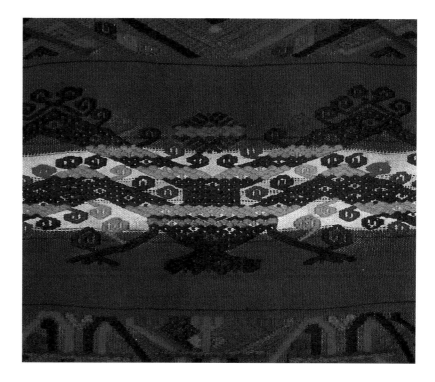

Detail of the central web of the Usila huipil, showing a white weft area overpainted with a natural blue colorant (indigo) and red areas overpainted with fuchsin. The double-headed eagle design was woven simultaneously into the alternating plain and gauze weave ground by use of brocaded patterning (supplementary weft patterning). In some communities of Oaxaca and Guerrero, the double-headed eagle relates symbolically to a traditional myth in which a monster is slain by twins who then become the sun and the moon. Since double-headed creatures were often depicted in ancient Mesoamerican art, the current design may represent a combination of precolumbian and Spanish colonial iconography, as double-headed eagles were also depicted on the heraldic Habsburg coat of arms. Regional Museum of Oaxaca (8-1746). Photo by M. Zabé.

A huipil from the Chinantec community of San Felipe Usila, located in northern Oaxaca. Dating from the 1930s or the 1940s, this garment is wider and its colors more somber than the huipils being woven in Usila today. It was woven on the backstrap loom in industrially spun cotton thread, with industrial wool yarn added to make the brocaded patterns. After it was woven, all of the sections of red colored weft were overpainted with a synthetic red colorant (fuchsin), which saturated the textile and made its color richer and more vibrant. The overpainting also helped to reduce discoloration from the sun and washing. Rayon ribbons and lace were added to finish the huipil. The diamond-shape design below the neck is symbolically linked to the sun as the source of vital force and considered to be a door that protects the soul of the woman who wears it. When she dies, it is believed that the door opens and her spirit leaves the body. Regional Museum of Oaxaca (8-1746). Photo by M. Zabé.

On the road to Usila, a bridge crossing the Santo Domingo River, which runs through the Rift Valley Chinantla. The Sierra Mazateca limestone massif rises above the river valley. This mountain, called Cerro Rabón, is considered to be sacred, as gods and ancestors are believed to reside on its lofty peak. Covered with tropical vegetation and cloud forest mixed with stands of pine and cypress, this mountain range is rich in biological diversity and is an important area for ecological conservation. Photo by J. López.

style as inherently more interesting or more beautiful than motifs of European "folk" origin or modern inspiration is not espoused in this chapter. As far as it can be documented, weaving in Oaxaca has changed steadily in its estimated three thousand years of history, and it continues to change today. Much of this change has involved appropriation, experimentation, and reinterpretation of new materials, techniques, and designs from outside the local community, both from other indigenous traditions and from colonial Hispanic and modern Mexican culture.

Another theme of this chapter has to do with documenting and understanding innovations. It is in the context of rapid change and loss that the conservation of extant textiles gains its proper perspective. Some of the most important textiles in museum collections have not received adequate care partly because they have been felt to be easily replaceable, given the notion that indigenous weaving is timeless. The custody of this artistic legacy may benefit from a better appreciation of the dynamics of cultural change in Oaxaca.

The study of Mesoamerican textiles has largely focused on the Maya area. Museum collections and publications devoted to the indigenous textiles of Guatemala and Chiapas are extensive and well documented. Contemporary Maya weaving is characterized by extraordinary vitality, yet Oaxacan textiles, which are less prominent than Maya textiles in museums outside of Mexico, are comparatively more diverse. Some of the fibers, dyes, and techniques used in making them are unique to this region. The delicateness of cotton spinning and weaving in some huipils from Oaxaca has no parallel in other areas of Mesoamerica and compares well with fine precolumbian cloth from the Andean region. This chapter explores the cultural context in which such exceptional textiles have been created.

Furthermore, this chapter attempts to show how the links between ethnic history, myth, and symbolic representation in weaving are a fertile field of inquiry, given the vast archaeological, colonial, and ethnographic records on Oaxaca. Names and etymologies of textile forms and designs, together with the explanations and stories of weavers, lend insight on the nature of images woven into cloth. The symbolism of textile motifs—some of which relate to indigenous cosmology—has been studied by indigenous scholars in Oaxaca, who have grounded their work in the discourse of the weavers. Made explicit in the artists' own words, the mythical referents of various designs add a literary, often poetic sense to the visual appreciation of the textiles and underline their cultural value as objects worthy of preservation. Indeed, Oaxaca weavings constitute a high

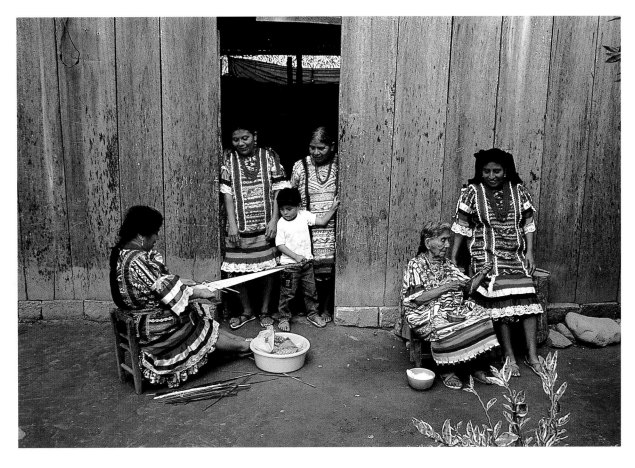

The huipils worn by the Chinantecan women of Usila illustrate the range of variation in weaving that can characterize a single community in Oaxaca. Weavers develop individual styles that are subtly distinct, while they share a repertoire of techniques, designs, and color combinations that identify them as members of the community. Photo by J. López.

priority for conservation because of their symbolic significance as much as for their technical interest and aesthetic qualities. Exemplified by the work of Chinantec researchers cited in this chapter, the study and preservation of these fragile works of art benefits from the participation of indigenous scholars and conservators.

Natural History and Cultural Geography

The state of Oaxaca in southern Mexico covers an area of 95,000 square kilometers, comparable to the median size of Central American countries. Its boundaries to the east (the Isthmus of Tehuantepec, where Oaxaca borders the state of Chiapas) and northeast (the lowlands along the coast of the Gulf of Mexico, along the Oaxaca-Veracruz border) coincide roughly with breaks in the landscape, where mountains give way to coastal plains. The borders to the northwest (state of Puebla) and west (Guerrero), in contrast, are not marked by geographical discontinuities, and the limits of Oaxaca as a cultural-linguistic area would extend well beyond its political boundaries in these directions.[2]

The terrain in Oaxaca is characterized by its ruggedness. Situated at the confluence of three tectonic plates, the southern Mexican highlands are an area of high geological activity. Earthquakes are frequent. Complex faulting and uplifting have shaped an extremely mountainous region with a pronounced diversity of rock formations and soil types. There are few areas of level terrain except for the broad alluvial plains of the Oaxaca Valley, a fact that underlies the salience of Central Oaxaca in the cultural history of the region. The broken topography gives rise to a complex mosaic of climates and vegetation types (Lorence and García 1989; Rzedowski 1978). Moist tropical forests extend over the lowlands toward the Gulf coast to the north, whereas the drier Pacific coast to the south is covered by thorn forests and tropical deciduous forests. Estuaries, lagoons, and mangrove swamps are interspersed with reefs, sandy beaches, and rocky shores along the Pacific. Mountains facing both coasts harbor cloud forests and humid pine-oak forests, giving way to drier forests and grassy woodlands on the leeward side. Rain shadows are cast by the

Surrounding Oaxaca City, the broad alluvial plains of the Oaxaca Valley. This area supports agriculture and wild scrubby thickets that harbor a large variety of cacti and *Agave*. The original vegetation of the Oaxaca Valley has been significantly altered by human impact over millennia. Photos by J. López.

mountains on the interior valleys and canyons, resulting in tropical desert conditions that foster a rich thorn scrub vegetation with the largest variety of cacti and *Agave* plants on the planet. In view of its environmental complexity, it is not surprising that Oaxaca boasts the greatest diversity of plants and animals in Mexico, as well as the highest incidence of endemism—a large number of its native species are not found anywhere else (Flores and Gerez 1988; Rzedowski 1993).

The indigenous civilizations of Oaxaca have developed in this context of marked ecological diversity. The cultural sequence of the region, and particularly the shifting patterns of subsistence and use of natural resources over millennia, are known in great detail through the efforts of archaeologists working over several decades in the Valley of Oaxaca in the center of the region, the Mixteca Alta to the west, and the Tehuacán-Cuicatlán Valley to the north (Byers 1967; Flannery and Marcus 1983; Flannery 1986). Research in these areas has yielded information on the transition from hunting and gathering in the archaic period to the incipient domestication of crops and the subsequent development of full-fledged agriculture, permanent settlements, social stratification, and state societies. Excavation of dry caves in these interior valleys has produced a few samples of fiber, netting, and cloth fragments at various phases along the cultural sequence from the lithic period (before 1500 B.C.E.) to the village stage (1500–500 B.C.E.), urban stage (500 B.C.E.–750 C.E.; the latter part of this period, from about 200 C.E., is known as the Classic period), and city-state stage, or Postclassic (750–1521 C.E.) (Winter 1989). Although extremely fragmentary, this record allows us to reconstruct part of the textile history of Oaxaca during the precolumbian period.

The indigenous population of Oaxaca is an ethnically and linguistically complex group of peoples, mirroring the geographical diversity of the land. A major phase of cultural and linguistic divergence is thought to have taken place as the rise of agriculture limited the mobility of hunter-gatherers and led to the development of crop varieties and cultivation techniques adapted to specific environments. Comparative study of the languages spoken in Oaxaca today provides insights into the early periods of ethnic history. Linguistic relationships point to repeated episodes of fragmentation, isolation, divergence, contact, and exchange between groups. Most languages spoken in Oaxaca are part of the Otomanguean family, which is the linguistic stock in Mesoamerica with the widest geographical distribution and the greatest degree of internal

differentiation—indicative of a long period of local development. The core area of Otomanguean speech, which includes central, northern, and western Oaxaca, as well as the Central Mexican highlands, coincides closely with the distribution of the Tehuacán tradition, an archaeological assemblage characterized by distinctive stone tools that are associated with the oldest remains of domesticated plants in Mexico (Winter et al. 1984). The people whose material culture is designated as the Tehuacán tradition are thought to have spoken proto-Otomanguean; they are viewed as the precursors of Mesoamerican civilization.

The Pacific coast of Oaxaca at Zipolite. The rocky shores provide a habitat for shellfish, crabs, and other animals of the intertidal life zone. One species of shellfish found here (*Purpura pansa*) has been a source for a colorant used to dye textiles since precolumbian times. Photo by J. López.

Weaver Nicolasa Reyes Marín of Pinotepa de Don Luis displaying her painted spindle whorls used to make cotton thread. These spindles, made of mangrove wood with clay whorls, are from the nearby town of Jamiltepec and were once traded widely in Oaxaca and Guerrero. Today women rarely spin their own cotton thread. Nicolasa Reyes Marín wears a *pozahuanque*, a striped wraparound skirt of patterned weave worn traditionally in Mixtec communities of southwestern Oaxaca. While everyday skirts continue to be made on the backstrap loom, weavers mainly use industrially made and dyed thread in combination with a cotton dyed with indigo. Today, only ceremonial skirts are made with hand-spun cotton dyed with *Purpura* shellfish colorants and hand-spun silk dyed with synthetic red colorants. Most of these types of skirts are made exclusively for the folk art trade. Photo by J. López.

Contemporary Otomanguean languages are grouped into seven branches, six of which are represented in Oaxaca and adjacent states (Suárez 1983). The Popolocan branch includes Popoloca, Chocho, Ixcatec, and the various Mazatec dialects. These languages are spoken in northern and northwestern Oaxaca and adjacent southern Puebla. The Mixtecan branch is composed of Trique[3] and Cuicatec, in addition to the several dialect groups of Mixtec. Mixtecan languages are spoken in western, southwestern, and northern Oaxaca and neighboring areas of eastern Guerrero and southern Puebla. Chatino and the diverse Zapotec dialect clusters make up the Zapotecan branch. Zapotecan languages are spoken in central, northeastern, eastern, and southern Oaxaca. The Chinantec branch is composed of a number of widely divergent dialects spoken in northern Oaxaca. Amuzgo, spoken in a small area of southwestern Oaxaca and southeastern Guerrero, constitutes its own separate branch. A sixth branch includes Tlapanec, spoken in eastern Guerrero.

In addition to the Otomanguean languages, four other linguistic stocks are represented in Oaxaca (Suárez 1983).[4] These are Mixe-Zoquean, Chontal, or Tequistlatec,[5] Uto-Aztecan (a family that includes Náhuatl, spoken in northern Oaxaca, southern Puebla, and eastern Guerrero, as well as other areas in Mexico), and Huave, a language with no close relatives that is restricted to a small area on the coast in the Isthmus of Tehuantepec.

Most of these languages comprise several dialects, with varying degrees of mutual intelligibility. In some cases, linguists have distinguished separate languages within a group, as in coastal and highland Chontal. In other instances, as in Mixtec, continuous dialect variation from village to village makes for a highly differentiated complex with few clearly defined subgroups. It is for this reason that estimates of the number of indigenous languages spoken in Oaxaca vary between fifteen and over a hundred. The distribution and dialectal variation of the languages of Oaxaca reflect a complicated history of population flux, with the expansion of some linguistic groups (and the retraction of other groups) followed by internal diversification. These processes are exemplified by the evolution of Zapotec and Mixtec, the two largest language groups in Oaxaca. Apparently originating in the highland valleys of the interior, proto-Zapotec and proto-Mixtec spread steadily over the surrounding areas, splitting into numerous dialect groups (Winter et al. 1984). Internal differentiation of these languages has been correlated with specific events that have been documented archaeologically, such as the appearance of new settlements on the periphery

of the sphere of influence of the ancient city of Monte Albán during the Classic period and the development of warring city-states in the Mixtec region during the Postclassic (Winter 1989). Linguistic, ethnic, and political boundaries shifted and overlapped at various times, and early colonial records point to the existence of pre-Hispanic states that crossed language lines (Acuña 1984, 2:185), as well as communities where more than one language or dialect was spoken (Acuña 1984, 2:220, 281–85).

After the Spanish conquest, cultural and linguistic fragmentation was exacerbated. The huge loss of life from the devastating diseases introduced from the Old World reduced densely populated areas to small, increasingly isolated communities. Spanish settlers and African slaves, as well as Náhuatl speakers from Central Mexico, formed enclaves in a few areas of Oaxaca that came to constitute cultural wedges between indigenous peoples.[6] Colonial policies, paired with an economic system based on the exploitation of indigenous labor rather than the control of land, worked to suppress indigenous social superstructures, weakening intercommunal links and promoting allegiance to the village of one's birth (Taylor 1979:158–70). In contemporary Oaxaca, ethnic identity varies widely from situations in which kinship and ritual ties between communities are strong, dialectal differences are minimal, and people of different communities have a clear sense of forming a distinct group to cases in which primary loyalty is to the local community, dialectal differences are significant (in some cases even exaggerated by rival villages), and the townspeople have only a weak sense of belonging to a larger people (Barabas and Bartolomé 1986:77–84). It is mainly in recent decades—in a movement correlated with extensive migration of indigenous families for work in northern Mexico and the United States—that a sense of ethnic affiliation beyond the local community has begun to strengthen among larger groups, such as the Mixtec and Zapotec. This renewal of ethnic identity is largely a response to economic exploitation and discrimination faced by indigenous migrants (Nagengast and Kearney 1990).

Enmeshed in the complex dynamics of group identity in Oaxaca are the shifting definitions of indigenous versus nonindigenous, "mestizo" ethnicity. The ambiguities and contradictions inherent in categorizing who is indigenous in Mexico account partly for the large disparities in population estimates of the ethnic groups of Oaxaca today. The national census counts as *indígenas* only individuals above five years of age who speak an indigenous language.[7] Yet the reliance on language as a marker of ethnicity has

been called into question—after all, there are large areas where indigenous languages have disappeared only recently and where people nevertheless maintain various expressions of traditional culture and a sense of indigenous identity. The inclusion of such communities in the official census would raise the number of *indígenas* considerably, making them by far the majority of the population of the state (Barabas and Bartolomé 1986:19–24).

Traditional clothing reflects the complexity of ethnic history in Oaxaca. Distinctions in costume correlate closely with local community and dialect rather than with larger regional or ethnic divisions. Adjacent communities speaking closely related variants of the same language often differ markedly in clothing;[8] in some cases, the differences were accentuated dramatically in the nineteenth and twentieth centuries, as some communities adopted garments and styles of nonindigenous Mexican dress of different periods,[9] while neighboring communities retained earlier forms of clothing. Even among the smaller ethnic groups, where costume tends to be more uniform, subtle differences usually distinguish individual communities.[10] Similarities of dress within geographically defined regions often cross language lines, and the textiles of a given community are often much more similar in both technique and design with the weaving of its linguistically unrelated neighbors than with the textiles of a more distant community speaking the same language.[11] As in other areas of Mesoamerica, it is more productive to study the historical development of costume in Oaxaca locally and regionally rather than by ethnic group.

Ethnographic study, including textile research, has focused on the indigenous groups of Oaxaca (as defined by language) to the neglect of the mestizo population. Until quite recently, however, weaving and distinctive clothing were not restricted to indigenous villages. Interesting textiles were produced in Spanish-speaking communities, including the city of Oaxaca itself, where some traditional cotton fabrics continue to be woven on treadle looms, and the African-Mexican communities on the Pacific coast in southwestern Oaxaca. Except for a pioneering monograph on the town of Cuajinicuilapa in Guerrero (Aguirre Beltrán 1958), the culture of the *morenos* (dark-skinned people—a term that is not derogatory) of southern Mexico is poorly documented. Their cultural history, modes of subsistence, technology, and arts, among other aspects, call for further study. As late as the 1960s, African-Mexican women on the coast of Oaxaca made beautiful, distinctive textiles of handspun cotton woven on the backstrap loom.

Weaver Elvira Martínez López of San Bartolo Yautepec demonstrating backstrap loom weaving on the front porch of her home. This Zapotecan community is located in the mountains of southeastern Oaxaca. The pine tree on the porch is decorated for Christmas celebrations. Bean plants hang to dry from the rafters above. The women of this community no longer wear traditional huipils and skirts but like to wear Western flower-print dresses. Through a project sponsored by the Mexican government, a group of women learned to weave from an elderly woman who was the only backstrap loom weaver left in their community. Elvira Martínez López sells her handwoven textiles in Oaxaca City, although the money she makes does not compensate for the time required to make them. She explains that her love of weaving motivates her to maintain this ancient art. Photo by J. López.

A Regional History of Cloth

The complex dynamics of interethnic relations and cultural change in Oaxaca are reflected diachronically in the archaeological and historical record of weaving and apparel, as they are reflected synchronically in the large diversity of contemporary textiles. Very few fabrics, mostly minute precolumbian fragments and some colonial *lienzos*—manuscripts painted on cotton cloth—have survived from periods earlier than the late nineteenth century, but there is considerable information on clothing and adornment in the precolumbian and early colonial codices from Oaxaca, as well as in the vast colonial literature and archives. Garments depicted on murals, ceramics, and stone sculptures and engravings from the precolumbian period, as well as in colonial and nineteenth-century paintings, add to the information from the documents. Combined, these sources show textile arts developing early in Oaxaca and sharing the basic traits of Mesoamerican weaving technology and design. Local and regional variation in attire, though less clear in the precolumbian record, has been attested since the earliest colonial accounts.

The precolumbian record

Pieces of cordage from Guilá Naquitz Cave in the Valley of Oaxaca antedating 7000 B.C.E. appear to be the oldest radiocarbon-dated fiber samples in Mesoamerica. A knotted netting fragment excavated at the same site is dated between 6910 and 6670 B.C.E. The fibers utilized in preceramic fragments from Guilá Naquitz appear to have been obtained from the leaves of *Agave* or *Yucca* plants; no cotton samples were found (King 1986). Flannery (1986:iv) suggests that *Hechtia* (a terrestrial bromeliad) fiber was probably used by early hunters and gatherers in the Valley of Oaxaca. The most extensive evidence of early use of plant fibers in Mesoamerica comes from archaeological excavations in the Tehuacán-Cuicatlán Valley in southern Puebla and northern Oaxaca. The Tehuacán-Cuicatlán Valley is the driest area in southern Mexico, as the high mountains to the east block moist air flowing inland from the Gulf of Mexico. The dry climate of this region has allowed the preservation of organic materials, including textile fragments, in caves and rock shelters. Smith (1967) reports on the presence of leaf or stem fragments of different species of *Agave, Beaucarnea gracilis* (a treelike succulent related to the lily family), *Brahea dulcis* (a palm), a species of *Cissus* (vines in the grape family), a species of *Hechtia*, some species of *Tillandsia* (epiphytic bromeliads), and *Yucca periculosa* in preceramic levels in the dry caves of the Tehuacán Valley;

these species, characteristic of dry, midaltitude areas of southern Mexico, appear to have furnished useful fibers. The earliest remains of cotton, a genus found mostly in low altitudes, appear to be two boll segments uncovered in Coxcatlán Cave Valley at a level dating to about 5500 B.C.E.,[12] but it is possible that these materials are intrusive from a more recent period. The second-oldest cotton remains in the archaeological record of this area are two samples from San Marcos Cave, dating to about 3500 B.C.E. (Stephens 1967). The early cotton remains from the Tehuacán Valley, identified as *Gossypium hirsutum* (Smith 1967), are markedly different from wild specimens, indicating that the species had already undergone genetic selection and was probably being cultivated.

Some fragments of both knotted and knotless (looped) noncotton netting dating from the El Riego phase (ca. 6500–4800 B.C.E.) were found in Coxcatlán Cave. The earliest remnant of a loom-woven textile in southern Mexico is a fragment of plain-weave cotton cloth from the Santa María phase (ca. 900–200 B.C.E.), also from Coxcatlán Cave, although there is earlier evidence of weaving in the form of a piece of pottery with the impression of a fabric dating from the Ajalpan phase (1500–900 B.C.E.) (Johnson 1967b:217). Only occasional fragments of weavings from later periods have been found in the excavations in the Tehuacán-Cuicatlán Valley. Even fewer textiles, mostly minute fragments, have been excavated outside that arid area.

Among the few archaeological finds are two striped noncotton fabrics,[13] apparently the largest archaeological textiles known from the region, found as mummy-bundle wrappings in Coxcatlán Cave; they date from the Palo Blanco phase (200–700 C.E., corresponding to the Classic period). Both are described as blanket-sized cloths composed of two webs of warp-faced plain weave with warp stripes of several colors (Johnson 1967b:192–200, 215–16). The outer wrapping shows a curious weft-twined decoration with a loop-fringed end; a number of contemporary textiles from Oaxaca and southern Puebla show similar border reinforcements.[14]

Other techniques attested by archaeological textiles from the Tehuacán Valley include corded wefts and warps, two-and-two twill, and plain and brocaded gauze, all of which are still used in Oaxaca.[15] The diameter of thread and degree of twist in spinning, as well as the density of warps and wefts and quality of weave, vary widely in these pieces from coarse, strong cloth to extremely fine, delicate weaving. Most cotton threads, both warp and weft, are single ply, as in most contemporary Oaxaca textiles in which hand-spun thread is used. Warp counts range between 15 and 78

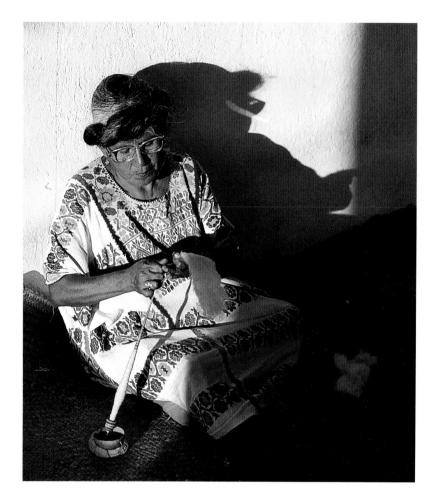

Florentina López de Jesús, a weaver and the president of the House of the Artisans of Xochistlahuaca, located in a large Amuzgo community of Guerrero, demonstrating her spinning technique. Her textiles have won prizes for their superb quality of execution. Photo by J. López.

per 2.5 cm, with weft counts between 12 and 37 per 2.5 cm; the majority of the fragments are warp-faced, and most appear to have been monochromatic. The color of some threads suggests the use of natural-brown cotton (Johnson 1967b:195). Various features of these textiles, such as the preserved side and end selvages, as well as a possible join section (the last portion to be woven in a four-selvage web) present in one fragment, indicate that they were woven on backstrap looms, ubiquitous in Mesoamerica and apparently the only type of loom used in Oaxaca before the Spanish conquest.

Two fragments of cotton gauze weave from Coxcatlán Cave are of particular interest in relation to contemporary Oaxacan textiles. They date from the Venta Salada phase (700–1540 C.E., corresponding to the Postclassic period). One is a corner of a cloth that preserves a portion of the end selvage (to which is sewn a separately woven weft fringe) and a portion of the side selvage. This fragment, which could have been part of a ceremonial cloth, has been compared to an archaeological textile found at Tenancingo (south of the Toluca Valley in Central Mexico) which consists of a square fabric with a separately woven weft fringe sewn around the four sides. Square or rectangular webs decorated with separately made fringes, used as tortilla napkins or ritual cloths, are still woven in a number of communities in Oaxaca and Guerrero.[16] A second fragment, which may have been part of a huipil, alternates bands of gauze with plain weave and includes designs woven in weft brocading (supplementary-weft weave) in one of the gauze sections (Johnson 1967b:211–14). Contemporary Chinantec, Cuicatec, Mazatec, and Amuzgo huipils exhibit weft brocading on gauze.[17]

A fragment of a huipil from Chilapa in eastern Guerrero, radiocarbon-dated between 1200 and 1400 C.E., shows a complex design where the motifs are worked in plain weave against a gauze background (Johnson 1967a; Franco 1967); the red color of the textile is due to an iron oxide. Mineral pigments do not appear to be used in contemporary textiles from Oaxaca; gauze weaves, however, are common and quite diverse. Zapotec huipils from Choapan in northern Oaxaca were formerly decorated with plain-weave designs against a background of weft-wrap openwork, a technique which, like gauze, achieves a netlike effect by the twisting together of sets of two or more warps between one weft and the next. The density of the designs and the contrast in texture between motif and background in the Choapan textiles are reminiscent of the Chilapa huipil.

The only other archaeological textile of comparable complexity of design known from this area is a remarkable fragment discovered in the Ejutla Cave, south of Cuicatlán in Oaxaca, from a Postclassic burial that had been looted (Moser 1975, 1983; King 1979). It was woven in double cloth worked in an elaborate design; both sets of warp and weft are cotton. Patterned double cloth, which involves a complicated loom setup, requires considerable technical sophistication on the part of the weaver. This complex fragment is perhaps the most significant piece of evidence of the high level of development of the textile arts in precolumbian Oaxaca. The technique is known today in central and western Mexico but is no longer used in Oaxaca or any other area of southern Mesoamerica.[18] The Ejutla Cave double cloth shows a positive design—that is, the motifs are dark and the background is light. The designs on the Chilapa fragment and the brocaded Coxcatlán Cave gauze, as well as the weft-wrap openwork Choapan motifs and the majority of brocaded designs on contemporary Oaxaca textiles, are also positive. Contemporary double-cloth designs from central and western Mexico, in contrast, are mostly negative.

Perhaps the most interesting archaeological pieces from Oaxaca, in relation to contemporary textiles, are a number of miniature garments that appear to have been deposited as ritual offerings in a dry cave of the Cuicatlán Canyon; they may date from the Postclassic period (Johnson 1966–67).[19] They include several small huipils and a *quechquemitl*, a garment commonly depicted in Mixtec codices that appears to have disappeared from Oaxaca since the time of the Spanish conquest or perhaps even earlier (Anawalt 1981:212–16).[20] The miniature huipils are particularly interesting: made in one web, the neck openings are woven as kilim slits, with a twined reinforcement added at the beginning and end of each slit to prevent the cloth from tearing, as if it were to be pulled over the head like a full-sized huipil.[21] The weft-twined reinforcements in these pieces are of the same white cotton thread as the warp and weft of the huipils, and the ends of the twining thread dangle only from one end—both traits appearing to indicate that this was a functional, nondecorative feature. The twined reinforcement evolved into a purely decorative element seen in many contemporary huipils from Oaxaca.

Very few archaeological textiles have been found in Oaxaca outside the Cuicatlán Canyon. The only examples known from the Valley of Oaxaca, besides the early remnants from Guilá Naquitz, appear to be a few small fragments uncovered at Yagul,

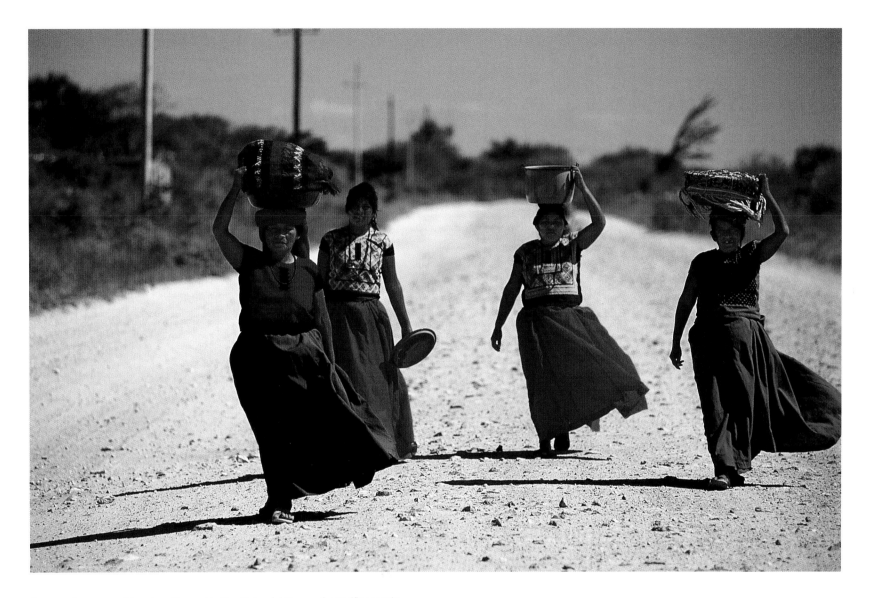

A group of women walking along the road to San Mateo del Mar, on the Pacific coast in southeastern Oaxaca. They wear long skirts and short huipils made of commercial fabric with applied machine-sewn decorative designs. Throughout the Isthmus of Tehuantepec, this everyday outfit is worn by many women of culturally different backgrounds. In San Mateo del Mar, the backstrap loom is used mainly for weaving textile samplers, napkins, and table-cloths sold in markets throughout Oaxaca. Photo by J. López.

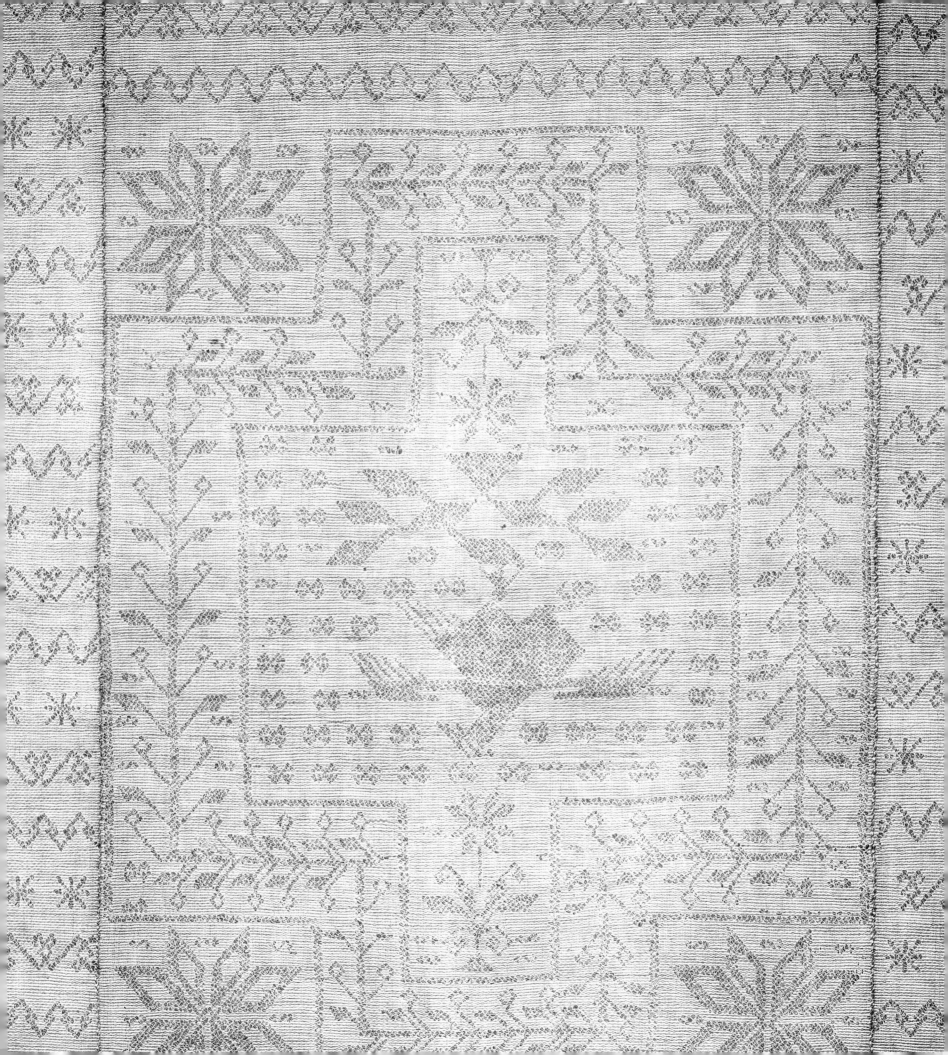

a major site during the Late Classic and early Postclassic periods. Two of the fragments were woven in warp-faced, one-three twill (Johnson 1957a:80–82). Diverse twill weaves are common in contemporary woolen textiles from the valley and surrounding areas in central Oaxaca.

Beyond the limited information provided by archaeological textiles, the diversity and richness of pre-Hispanic Oaxacan attire is evidenced by ceramic and stone sculptures, by murals and engravings, and by the magnificent Mixtec codices. The contemporary huipil and wraparound skirt held by a sash appear to find their earliest precedents in Oaxaca in ceramics of the urban phase. Zapotec urns of the Classic period also depict elaborate women's coiffures that appear to be constructed in a similar manner to some contemporary hairstyles, worn with hair cords known as *tlacoyales* (Cordry and Cordry 1968:127). Equally rich and elaborate in precolumbian sculptures and manuscripts are the man's loincloth; *tilma* (in Náhuatl, *tilmahtli*), a cloak; *xicolli*, a sleeveless, jacketlike garment, and other elements of attire. These garments disappeared early in the colonial period. In the geographical accounts written in the late 1500s, there are no references to either the loincloth or the *xicolli* in the description of men's clothing in different communities of Oaxaca (Acuña 1984).[22] By the late 1700s, there are only occasional references to a *tilma* (Esparza 1994:403, 454), a term that by that time seems to have referred generically to a woolen blanket. Contemporary men's garments in Oaxaca that seem to have precolumbian antecedents are a reduced *tilma*-like cape called a *gavilán*, formerly worn in the Chontal area (Lechuga, 1982a:69), and the elaborately fringed and tasseled sashes worn on ritual occasions by Mixtec elders in a number of towns in the district of Jamiltepec. The latter are reminiscent of the heavily decorated loincloth ends depicted in precolumbian sculptures and paintings.[23] Undecorated loincloths were worn by Huave fishermen at the turn of the century (Starr 1899:113, 115). A curious hip cloth—probably derived from a similar garment frequently depicted in Mixtec codices, as well as in Postclassic murals, sculptures, and manuscripts from other areas of Mesoamerica—was formerly worn by men in the Náhuatl-speaking village of Altepexi, in southern Puebla (Cook de Leonard 1966; Cordry and Cordry 1968:239–43).[24]

Mixtec manuscripts from the early colonial period, such as Codex Tulane (Smith and Parmenter 1991), may document a change in women's huipils and skirts toward the end of the Postclassic period. Whereas precolumbian codices such as the Zouche-Nuttall depict mostly multicolored, uniformly decorated garments, often

Partial views (opposite page and above) of a large cotton tablecloth or bedspread from the African-Mexican area on the Pacific coast of western Oaxaca and eastern Guerrero. This textile, made on the backstrap loom during the early twentieth century, is of hand-spun cotton in a pile weave. Thick supplementary wefts were pulled up in loops to create the pattern, a technique called *confite* in Spanish. Three webs were sewn together, and an elaborately twined and knotted fringe was added around the four sides, as shown in the detail. The central element of the design is the Mexican national emblem: an eagle perched on a nopal cactus devouring a serpent. During the last few decades, the art of spinning and weaving has been lost within these African-Mexican communities, and this type of textile is no longer being made anywhere in Mexico. Regional Museum of Oaxaca (131081). Photos by M. Zabé.

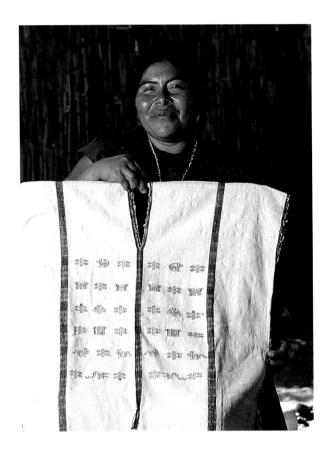

Teófila Palafox from San Mateo del Mar, a weaver, video artist, and the president of the Association of Artisans. She recently helped organize and videotaped a workshop on plant dyes held in San Mateo del Mar. Her video training was through a federal government program of the Instituto Nacional Indigenista of Mexico. Here she holds a new huipil woven in an older style of her community. At one time, weavers of this community used shellfish *Purpura* colorants to dye the threads used to make the brocaded patterning of textiles. Today, San Mateo weavers use mostly synthetic colorants, but interest in local dyestuffs—such as brazilwood and mangrove bark—is growing. Photo by J. López.

with fringes on the bottom borders, the postconquest manuscripts show mainly white, unfringed huipils and skirts, where the decoration is concentrated on the bottom edges and on a rectangle below the neck of the huipil, in the same style as in the Codex Mendoza (Berdan and Anawalt 1992) and other manuscripts from Central Mexico. Codex Tulane also depicts the reinforcement below the neck, with the ends hanging loose, that appears frequently in manuscripts from the Valley of Mexico of the same period. These features appear to indicate that Oaxaca—or at least the Mixtec elite—shared or became influenced by clothing styles of Central Mexico, as is suggested by seventeenth-century inventories documenting large-scale textile trade between the two areas (Romero Frizzi n.d.). Among contemporary Oaxaca textiles, the emphasis of decoration on the border in an otherwise white garment distinguishes highland Mazatec wraparound skirts,[25] preserving, perhaps, sixteenth-century fashion (Cordry and Cordry 1968:110–11).

The communities listed in the Codex Mendoza that paid tribute to the Aztecs in the form of cloth include a number of towns in Oaxaca. The weaving of large quantities of textiles for tribute, both before and after the Spanish conquest, must have had an effect on clothing styles, distributing over long distances the fabrics produced in diverse areas. In early colonial Mexico, the quantity of tribute was equal to or greater than that given to the Aztecs, and cloth continued to represent the largest share in terms of value. Tribute weaving was simplified after the conquest: whereas a major part of the textiles delivered to the Aztecs had consisted of finished garments and decorated mantles, the Spaniards required mostly plain white cotton cloth (Brumfiel forthcoming). Given the amount of labor exacted from weavers, textile production for local use in the tribute-paying areas must have been compromised; it is conceivable that the coercion to produce large quantities of plain cloth discouraged the use of laborious techniques of decoration in textiles for the weavers' households. It is interesting to note in this regard that areas that were densely settled in the early sixteenth century, where taxation would appear to have been enforced most effectively, and where weaving for tribute would later evolve into weaving for trade—as in the Valley of Oaxaca, the northern part of the Mixteca, the Cuicatlán Canyon, and the Ixtlán and Villa Alta areas[26]—today maintain relatively fewer textile techniques and more uniformity in costume. Notoriously absent in these areas are the more laborious techniques of decoration, such as weft brocading, that characterize the textiles of peoples on the periphery, such as the Chinantec and Mazatec, the eastern Mixe, and the groups

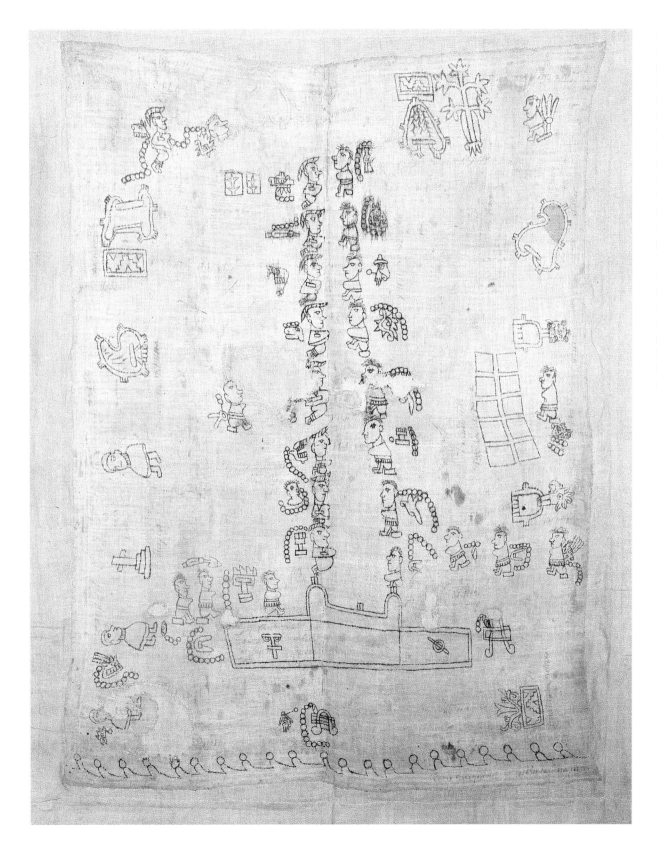

A *lienzo,* a colonial pictorial document from Oaxaca painted on handwoven cloth, dating perhaps to as early as the sixteenth century. Precolumbian manuscripts were painted on bark paper and animal hides. After the Spanish conquest, the indigenous people of Oaxaca continued to record their history by mapping out their ancestoral territories and genealogies on cloth. These documents were recognized by colonial authorities as well as by indigenous rulers during land disputes and inheritance claims. *Lienzos* show a system of pictorial place and name glyphs painted on unsized cotton fabric. This piece is made of hand-spun cotton woven on a backstrap loom; two webs were sewn together. At one time it was treated at the conservation facility of INAH in Mexico City. As shown, it was mounted onto a linen ground with carefully placed hand stitches to help reduce further damage caused by handling. Regional Museum of Oaxaca. Photo by M. Zabé.

A Postclassic cotton textile excavated in Coxcatlán Cave, located in the Tehuacán Valley of southern Puebla. This fragment is assigned to the Venta Salada phase and dated to 700–1500 C.E. Bands of gauze weave alternate with plain weave. Brocaded patterns of flower motifs were woven into the gauze. Brocaded gauze is found in some present-day textiles from Oaxaca and Guerrero. In Mixtec, Chinantec, and other indigenous languages of the region, brocaded patterns are often generically referred to as flowers. Reproduced courtesy of the Robert S. Peabody Museum of Archaeology, Phillips Academy, Andover, Massachusetts.

inhabiting the mountainous area inland from the Pacific coast, from the Tlapanec to the Chontal. In the absence of detailed historical evidence, however, it is difficult to distinguish the impact of tribute weaving from the effects of contact and acculturation in the more accessible areas of Oaxaca.

The colonial record

Early colonial documents, such as the Relaciones Geográficas — cultural and economic records of various communities written by Spanish administrators around 1580 (Acuña 1984) — and the indigenous vocabularies prepared by Dominican friars (de Córdova 1578, on Zapotec; de Alvarado 1593, on Mixtec) provide a wealth of detail on indigenous weaving and clothing. The Relaciones Geográficas reveal regional and local differences in precolumbian costume (as existed between different Mixtec communities in the Juxtlahuaca area [Acuña 1984, 1:287–321]), and distinctive clothing that appears in some cases to have characterized entire ethnic groups (such as the Chontal and the Mixe [1:348, 351]). They describe costumes both prior to and after the Spanish conquest and often stress the differences in clothing between *macehuales* (the commoners) and *principales* or *caciques* (the indigenous elite). Some Relaciones from Oaxaca specify that the commoners wore garments woven of *Agave* fiber (Relaciones from Atlatlauca, Guaxilotitlan, Nexapavol, Tecuicuilco, and Miquitla), cotton being reserved for the elite (Acuña 1984, 1:53, 216, 351; 2:96–97, 260).[27] The specific Relaciones of Tanatepec, Itztepexic, Macuilsúchil, Peñoles, Mitlantongo, and Tamazola also mention that the people wore *Agave* garments before the conquest, but they do not indicate any distinctions between *principales* and commoners, while the Relación of Mixtepec states that the *caciques* wore *Agave* mantles dyed or painted with *almagre* (iron oxide) and the *macehuales* wore "white" (probably referring to the natural, undyed color) mantles of the same fiber (Acuña 1984, 1:295). The Relaciones of Miahuatlán, Tututepetongo, Macuilsúchil, and Papaloticpac mention the continued manufacture of *Agave* clothing at the time of writing.[28] Other Relaciones describe the use of cotton garments by both commoners and members of the indigenous aristocracy before the Spanish conquest. The Relación of Ixcatlán mentions mantles woven with feathers and rabbit hair worn by the priests during festivities, as well as canopies woven of the same materials used in the local temple prior to the arrival of the Spaniards.[29] The Relación of Atlatlauca describes the use of textiles decorated with feathers that were reserved for the elite; the garments were woven locally, and

the feathers were obtained from ducks bred for that purpose, a practice that was also mentioned in the Relación of Tecuicuilco and other Zapotec communities of the Sierra Juárez (Acuña 1984, 1:53; Johnson 1989:164–65). These documents confirm that weavers in Oaxaca used a variety of materials before the Spanish conquest; some of the fibers, such as rabbit hair, appear to have been abandoned early in the colonial period.

Many of the sixteenth-century Relaciones comment that the indigenous men, especially *principales*, wore Spanish-style clothes at the time, in some cases mentioning felt hats, silk stockings, and leather shoes. No mention is made of the continued use of the loincloth, and references to European-style capes and *jubones* (jerkins) are about as frequent as mentions of the indigenous men's mantles. The Relaciones often refer to fabrics imported from Europe that were used by men and women *caciques* and even by commoners, commenting in some cases that rank distinctions in dress were being erased (Acuña 1984, 2:95–97). *Camisas* (shirts) and *zaragüelles* (wide breeches) of white cotton cloth are most often described as the basic dress of indigenous men, and sometimes it is specified that the cloth was woven locally by women. Female dress, when it is mentioned, included a huipil and a wraparound skirt, but little detail is given; an interesting exception was the Mixtec-Amuzgo community of Xicayán de Tovar, where women wore a colorful, robe-like *sicoli* (*xicolli*?), called *zunu* in Mixtec (Acuña 1984, 1:308).

The sixteenth-century vocabularies provide abundant information on fiber preparation, spinning, dyeing, and weaving, as well as references to specific textile techniques, designs, and garments. The Mixtec vocabulary of Friar Francisco de Alvarado (1593) is particularly rich in textile terminology. Numerous entries that refer to wool and silk—as well as glosses for a thistle-like carding implement (possibly the same plant still used for that purpose in the Náhuatl-speaking community of Hueyapan, Morelos [Cordry and Cordry 1968]), the spinning wheel, and the treadle loom—indicate that European textile technology had been adopted in some areas of Oaxaca by that date.

Parallel to the adoption of European techniques, indigenous weaving continued to be an important activity both for local use and for interregional trade, in spite of the vast population decline after the Spanish conquest. Seventeenth-century documents from the judiciary archive at Teposcolula, an important highland Mixtec town, include detailed inventories of commerce. They list cargoes of indigenous textiles traveling over long distances from the Mixtec region (Romero Frizzi n.d.). Large shipments of *ropa mixteca*

(Mixtec clothing), including huipils decorated with silk (most probably silk raised locally) and other garments, were sent to the city of Puebla and to Guatemala.[30] One of the records lists several loads of *huipiles de pluma* (featherwork huipils) and other textiles that were sent in a mule train to Guatemala; it is not clear in this case whether the weavings were of local manufacture.[31] An earlier document, the 1581 Relación of Teutitlan (a town known today as Teotitlán del Camino), describes how a number of communities in the Tehuacán-Cuicatlán Valley produced huipils and skirts for trade in the provinces that are now Chiapas, Guatemala, and El Salvador; luxurious textiles figure prominently in the tribute paid by these communities before the Spanish conquest (Acuña 1984, 5.2:196–204). These historical references provide clear evidence for the exchange of textiles among Oaxaca, Central Mexico, and the Maya region. It seems probable that early colonial commerce in indigenous weavings was based on precolumbian trade systems.[32] Mixtec clothes woven for export must have influenced the designs and styles of local textiles in the areas where they were marketed.

The colonial link with Guatemala is interesting in view of the recent trade in Oaxacan textiles to the town of Mixco, where sashes and *tlacoyales* from the Valley of Oaxaca were worn by Pokomam Maya women earlier in this century (Morgadanes 1940; Osborne 1965).[33] The reference to featherwork huipils brings to mind contemporary wedding huipils from the Tzotzil community of Zinacantan in Chiapas, brocaded along the bottom border and in a rectangle below the neck, a unique design among contemporary Maya garments that is strongly reminiscent of huipils depicted in early colonial manuscripts from Oaxaca and Central Mexico (Johnson 1957b; Morris 1984; Martínez Hernández 1990).[34] The brocading on these huipils incorporates chicken feathers. The *huipiles de pluma* that were traded south from Oaxaca, as attested by the seventeenth-century Teposcolula document, may have provided a model for the Zinacantan huipil.[35] Fragmentary as it is, the early colonial record provides evidence that Oaxaca played an important role in the economy of cloth in Mesoamerica both before and after the Spanish conquest, and that it influenced, and was in turn influenced by, other indigenous weaving traditions.

The Relaciones Geográficas of the 1770s are a major source of information on Oaxacan textiles during the late colonial period. In their descriptions of clothing worn in indigenous communities at that time, the chroniclers do not lay as much stress on rank differences as did the earlier writers, and the distinction between *macehuales* and *principales* is no longer made. Some of the accounts

A Chinantec man's sash from northern Oaxaca, dating from the 1930s or 1940s. The warp and weft threads are of industrially spun cotton dyed with a synthetic red colorant. The stripes and brocaded patterns (supplementary weft patterning) are woven with industrial wool yarn. The alternation of plain weave with simple and complex gauze weave produces a rich variation in texture. The brocaded patterns are woven into the gauze. This combination of plain weave, gauze weave, and supplementary weft patterning on gauze is reminiscent of the archaeological textile fragment from Coxcatlán Cave. Regional Museum of Oaxaca (132735). Photo by M. Zabé.

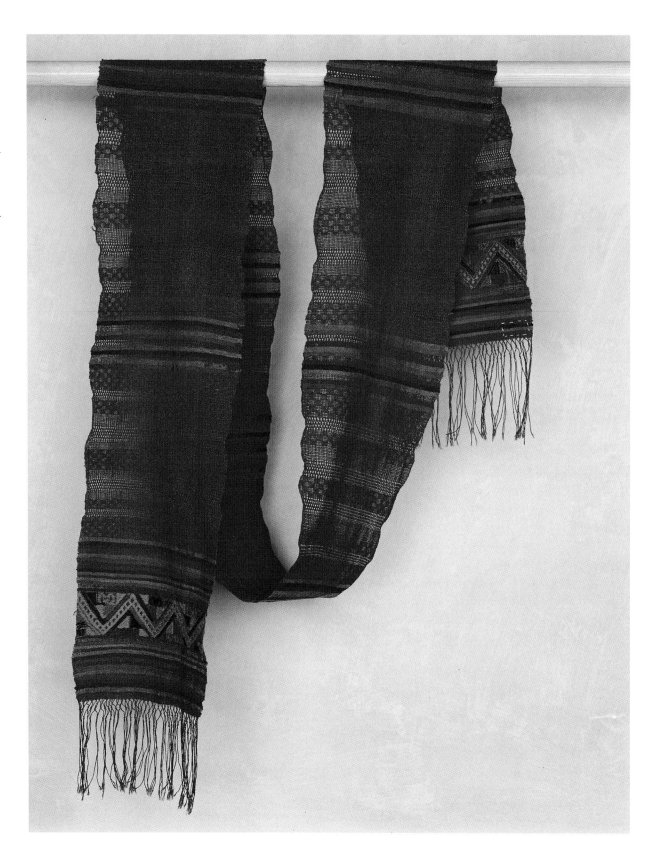

stress that rich and poor Indians of a given community dressed
alike (Esparza 1994:226). The most salient status differences in
clothing seem to have involved men holding office in communal
government, who are mentioned in one case to have worn "españoles
anticuados" [old-fashioned Spanish] attire (Esparza 1994:424).
Women still wore huipils and *tlacoyales* throughout Oaxaca; only
one Relación (Jalatlaco, a suburb of the city of Oaxaca established
in the sixteenth century by Náhuatl speakers from Central Mexico)
mentions that some women wore blouses, while others continued
to wear huipils (Esparza 1994:400). Men in most areas wore shirts
and trousers of white cotton cloth, either woven locally or made
with trade cloth, and overtrousers of buckskin or woolen material.[36]
The accounts also provide a clear picture of regional differences in
dress, describing some costumes that match present-day textiles.[37]
As in most of the sixteenth-century sources, they do not give clear
indications of ethnic and linguistic distinctions in clothing beyond
the local community or region. In some cases, they emphasize
that there was considerable variation in the dress of a given town
(Esparza 1994:105, 345).

The geographical accounts of 1777–78 also stress the impor-
tance of cochineal in large areas of Oaxaca. It seems that the
insertion of indigenous communities of this region into a monetary
economy through the production of this insect dye was correlated
with a growing reliance on regional and extraregional trade.
Most of the Relaciones refer to the use of commercial fabrics, pro-
duced both in the city of Oaxaca and in other weaving centers in
New Spain as well as in Europe and Asia. The *chapaneco*, a cotton
fabric woven on treadle looms in the city of Oaxaca, is the skirt
material cited most commonly; together with sashes and *tlacoyales*
made in the valley, it was traded to areas as distant as the eastern
Mixe lowlands (Esparza 1994:37). Woolen fabrics woven in Puebla
and Querétaro are cited in some of the accounts (Esparza 1994:251,
258, 275, 400); imported textiles are mentioned frequently, including
velvet, linen, "paño de Castilla" (woolen material), "seda de pelo"
(Spanish silk floss), cloth from Bretagne and Rouen, and skirt
material from China, probably made of silk. The Relación of Jalapa
del Marqués (a Zapotec town on the Isthmus of Tehuantepec)
describes how people in the communities that produced cochineal
wore luxurious textiles and jewelry during festivities, mentioning
the use of lace, sequins, ribbons, and fillets of gold and silver
(Esparza 1994:173). Such profusion of imported materials must have
influenced the design and style of indigenous weaving.

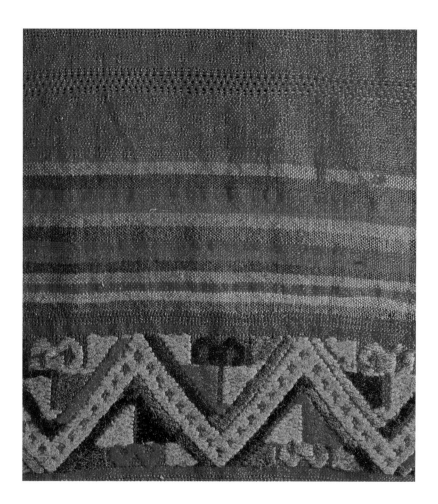

Detail of the Chinantec man's sash shown on the opposite page. Photo by M. Zabé.

Fragment of an archaeological textile from the area of Chilapa in eastern Guerrero, radiocarbon dated to between 1200 and 1400 c.e. The cotton warp and red threads are impregnated with a red pigment, iron oxide. The supplementary wefts incorporate rabbit hair. The designs are woven in a plain weave against a gauze background and feature S-shaped motifs, as well as two-headed humanlike figures with bent limbs, referred to as "hockers." Photo by Jose Luis Franco, 1967.

The nineteenth- and twentieth-century record

There appear to be no surviving colonial or early nineteenth-century textiles from Oaxaca except for the *lienzo* maps. Besides these and the archaeological pieces, the oldest textiles extant that are reliably attributed to Oaxaca seem to be the *dechados* (embroidery samplers) in the collection of the Regional Museum of Oaxaca. These extraordinary pieces, embroidered in techniques and designs that are common in mid-nineteenth-century samplers from Mexico, appear to be the work of indigenous women, in spite of their overwhelmingly European style (Sayer 1985:74–75, 85). The feature that warrants this hypothesis is the fact that hand-spun cotton dyed with *Purpura* (shellfish) is the predominant thread used in the embroidery, along with dark blue cotton thread (probably dyed with indigo).[38] The cloth, furthermore, is of hand-spun cotton, apparently woven on the backstrap loom. These samplers seem to be the earliest examples of a succession of Western needlework styles, as well as other decorative techniques, that were adopted by indigenous women in Oaxaca. These include distinctive types of running-stitch embroidery, cross-stitch, smocking, drawnwork, embroidery with *chaquira* (minute glass beads), floral embroidery (a semirealistic style, usually depicting flowers and leaves worked in satin stitch, French knots, and other stitches), sewing-machine embroidery, and crochet.[39] Most of these techniques were used to decorate the chemises and blouses that supplanted the huipil in many areas during the nineteenth and early twentieth centuries. They are executed on fabrics of industrial manufacture (mainly *manta*, a white cotton muslin), but some have been applied to cloth woven on the backstrap loom. During this period, the adoption and elaboration of new garments and decorative techniques often came to differentiate the dress of neighboring communities more markedly than was evident earlier.[40]

Lithographs and drawings are the main source of information on Oaxacan textiles for most of the nineteenth century. The most noteworthy are Linati's engraving of a Zapotec woman from the Isthmus of Tehuantepec (Linati 1828), García Cubas's depiction of a number of indigenous costumes of Oaxaca and other parts of Mexico (García Cubas 1876), and, most important, Martínez Gracida's unpublished paintings of indigenous dress and folk art of Oaxaca (Martínez Gracida 1986; Esparza 1980), preserved in the Biblioteca Pública in the city of Oaxaca. Together with the earliest photographs portraying indigenous subjects, notably those taken in various parts of the state by Frederick Starr (1899, 1900–1902, 1908), they document major changes in indigenous dress and textile

production during the Porfirio Díaz regime (1877–1910). Some of Starr's photographs (as well as his collections, conserved at the Chicago Field Museum) and Martínez Gracida's illustrations, some of which were based on photographs, reflect the impact of economic transformations in Mexico at that time. Industrially manufactured clothing is amply evident in the photographs, especially in the *manta* garments worn by men in most of the communities Starr visited. In most photographs, the clothing worn by men, and in some cases even women's dress, is indistinguishable from that of nonindigenous Mexican peasants of the period.[41] The short, everyday huipils and ceremonial head huipils made of lace that are worn by Isthmus Zapotec women in these photographs and paintings were made with industrial fabrics, probably imported from Europe.

Most interestingly, some of Starr's photographs capture the transition between handwoven and industrially manufactured clothing: a Mixe woman from Quetzaltepec is shown weaving on the backstrap loom, yet her skirt and blouse are of industrial cloth (Starr 1899:96). Similarly, older Mixe women of Coatlán are shown wearing a handwoven huipil and *tlacoyales* on their hair, whereas the younger women in the photograph wear huipils of industrial cloth in the style of the Isthmus of Tehuantepec (Starr 1899:pl. 95). A group portrait of Mixtec women in San Bartolo Yucuañe shows women with huipils and wraparound skirts, but one of the younger women wears a long-sleeved blouse, apparently of manta (pl. 64). Contemporary "traditional" clothing of women in Yucuañe consists of a plain long-sleeved blouse and pleated skirt, all of *manta*. A Zapotec woman from Mitla in the Valley of Oaxaca photographed by Starr wears a *manta* huipil (pl. 90); other photographs from the same period show young Mitla women wearing crocheted blouses combined with wraparound skirts. Discussions on modernity and the transformation of traditions such as indigenous costume in Mexico have focused on the Mexican Revolution of 1910 and the industrialization of the country after 1940 as periods of major change. Yet the comparison of Starr's photographs with earlier documents suggests that a drastic reduction in backstrap weaving in Oaxaca began well before the Mexican Revolution.

Starr's photographs and collections also attest to significant changes in textiles from areas where women continue to weave today. One salient example is the huipils he photographed in San Andrés Chicahuaxtla, a Trique village nested on a high ridge where the Mixteca Alta drops down to the Pacific lowlands. The huipils of the 1890s had very little brocading, and the design was centered on the section below the neck and a few widely spaced lines of

Detail of a Zapotec huipil from Santiago Choapan in northeastern Oaxaca showing figures worked in plain weave against a background of weft-wrap openwork, a laborious technique that achieves a netlike effect. The huipil, dating from the 1930s or earlier, is composed of two webs woven on the backstrap loom. Warp and weft threads are of hand-spun cotton. The contrast in texture between the positive motifs and the sheer background, the organization of the designs into horizontal bands, and the overall density of the patterning recall the archaeological textile from Chilapa, shown on the opposite page. Regional Museum of Oaxaca (131007). Photo by M. Zabé.

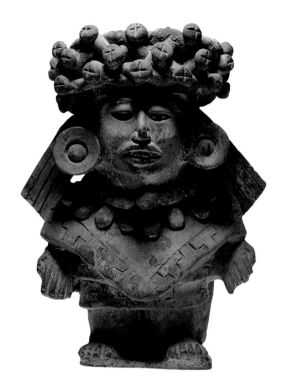

A ceramic urn from the Late Classic Zapotec period, depicting an elite woman wearing a *quechquemitl* over a huipil and a wraparound skirt. The hair is styled into an elaborate coiffure, created by tying it into *tlacoyales* (hair cords) and wrapping or braiding these around the top of the head. This figure wears jewelry: earspools and a necklace. Today women of some indigenous communities of Oaxaca continue to wear *tlacoyales*, but the use of the *quechquemitl* has disappeared. Regional Museum of Oaxaca. Photo by M. Zabé.

colored weft and rows of small brocaded motifs through the rest of the garment (Starr 1899:71, 75, 80; Basauri 1940, 2:291). Photographs taken by the Cordrys in the 1940s show more closely spaced bands of brocading, yet the white background weave continued to predominate (Cordry and Cordry 1968:132, 311). Today huipils are woven with wider and more densely packed stripes of red weft and brocaded motifs, and little of the white background is visible. Similarly, contemporary huipils of the neighboring community of San Juan Copala are almost solidly red, whereas the garments photographed by the Cordrys in 1941 were mostly white (1968:313–14).

The same tendency is documented in the collection of the Regional Museum, in huipils from other communities in the vicinity of Chicahuaxtla, such as Santa María Yucunicoco (Mixtec) and San Martín Itunyoso (Trique), dating from around 1950; they can be compared to recent pieces from the same towns, in which the brocaded motifs have become more diverse and complex. This is not a case of borrowing patterns from outside, as has occurred in other areas; the designs are based on the same repertoire of simple geometric forms brocaded in the older textiles. Because of this elaboration, contemporary huipils from the different communities in this area appear more readily distinguishable. To a naive observer, they appear more traditional than nineteenth-century pieces. Part of this development has to do with the wider availability and cheaper price of industrially manufactured threads for brocading in recent decades. However, it also seems to reflect an interest of the weavers to assert womanhood and ethnic identity more vividly, as well as to mark communal affiliation more clearly.[42]

Textile Fibers

Ixtle

Ixtle — (in Náhuatl, *ichtli*; in Zapotec, *quèeche* (de Córdova 1578); and in Mixtec, *(n)daa* (de Alvarado 1593) — the fiber obtained from various species of *Agave*, is used in Oaxaca to manufacture nets, hammocks, and tumplines, as well as rope, cordage, and bridles. De Córdova gives separate Zapotec glosses for *nequen cañamo delos magueyes* (*henequen*, hemp of the *Agave*): *quèeche tòba* and *quèeche yàa*; and for *nequenblando* (soft *henequen*): *quèeche pecuèça* and *quèeche làchi* (de Córdova 1578); *tòba* refers to *Agave*-like plants generically. De Alvarado gives three Mixtec glosses for *maguei la ebra que sacandel* (*Agave*, the fiber they get from it): *(n)daayavui*, *(n)daa cuiñe*, and *(n)daa yata* (de Alvarado 1593); *yavui* refers to the *Agave* and similar plants. This group of plants is found in southern Mexico, mainly in

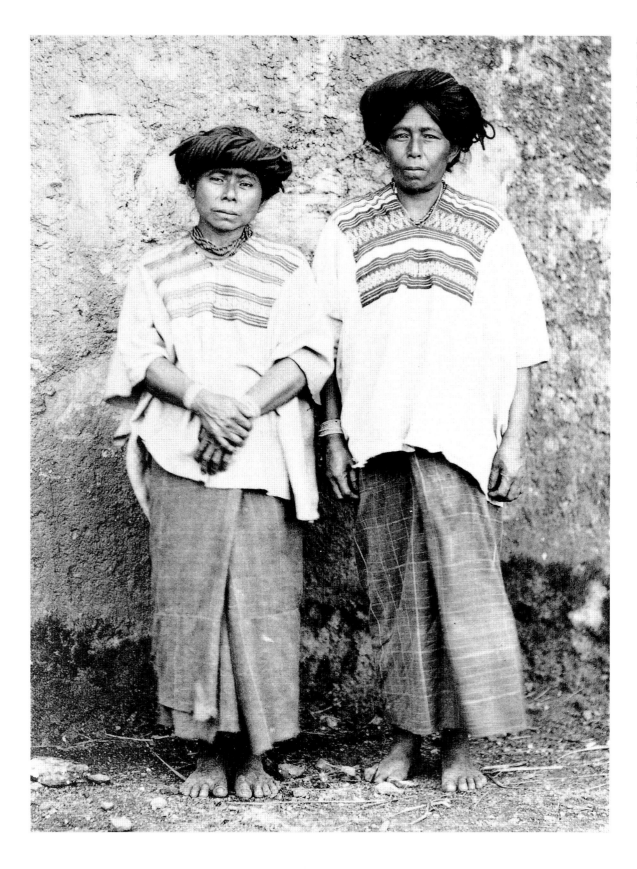

A turn-of-the century photograph by Frederick Starr, showing Mixe women from Santa María Coatlán in eastern Oaxaca wearing their hair in wool *tlacoyales* wrapped around their heads—the same style depicted in precolumbian sculptures and paintings. Women from Coatlán no longer wear traditional clothing, but many Mixe, Zapotec, and Mixtec women retain this distinctive coiffure (Starr 1899:pl. 97).

Zapotec men from San Bartolo Yautepec shown at the turn of the century wearing shirts and trousers of hand-spun cotton and handwoven cloth. The brocaded patterning is barely visible in this photograph by Frederick Starr (1899:pl. 104). Not long after Starr's visit, men stopped wearing this type of clothing. Garments such as these — untapered and without pleats — appear to have originated early in the colonial period. Sixteenth-century documents describe indigenous men wearing shirts and drawers of handwoven cloth. Their low-top felt hats seem to follow a style popular in Mexico during the early nineteenth century. The collection at the Regional Museum of Oaxaca includes a man's shirt and trousers from San Bartolo Yautepec with brocaded patterns in hand-spun silk (see page 75).

areas of dry climate at middle to high altitude. The species used in Oaxaca and the process of extraction and preparation of the fiber have been studied as part of a research project on *Agave* taxonomy, phytochemistry, and industrial applications by a team of researchers at the Instituto Tecnológico de Oaxaca (Palma Cruz 1991; Sánchez 1989); most of the reports from this project remain unpublished. The main center for *ixtle* manufacture in Oaxaca is the Cajonos area, where distinctive netted bags, worked in colored bands with a patterned base, are made; these are sold widely in the state. Warp-twined tumplines are the specialty of Yahuío in the Ixtlán district. Fine, undecorated netted bags are made in Zenzontepec (Chatino) and Ixtayutla (Mixtec). Coarser nets with colored stripes are made in Chatino villages in the district of Juquila. Utility nets and rope are made in the Zoque town of San Miguel Chimalapa in the Isthmus region. Small nets carried on the shoulder were formerly made in some Mixtec villages; knotted nets from Peñoles were distinctive.

Beautiful sandals made of *ixtle* were formerly worn by women in Yalalag and probably other towns in the area of Cajonos and Villa Alta. The soles of these sandals were made of compressed *ixtle*, stitched tightly with cord of the same fiber. A finely woven heelpiece, made of fine *ixtle* or *pita*, was sewn to the sole. More coarsely made *ixtle* sandals, called *ixcacles* (in Náhuatl, *ichcactli*) come from southwestern Puebla. Strikingly similar sandals of *Agave* fiber have been excavated in dry caves of the Tehuacán Valley (MacNeish et al. 1967:185). The Relaciones of Miahuatlán (Zapotec), Tututepetongo (Cuicatec), and Nochixtlán (Mixtec), of around 1580 (Acuña 1984), mention the use of *cacles* made of *Agave* fiber. *Ixtle* clothing, still worn at that time according to the Relación of Papaloticpac (Cuicatec), seems to have fallen into disuse by the eighteenth century, as none of the Relaciones Geográficas of the 1780s refer to it. Contemporary textiles made of *Agave* fiber are poorly represented in museum collections. It is important to document these textiles, as the extraction of *ixtle* and the manufacture of various items are dying out in many communities.

Pita

Pita —in Zapotec, *quèechehuij* (de Córdova 1578); and in Mixtec, *(n)daa yusi* (de Alvarado 1593) —the fiber of *Aechmea magdalenae*, a terrestrial bromeliad that is native to moist tropical forests of the Gulf of Mexico slope, is used traditionally in northern Oaxaca for the manufacture of cords and fishing nets. The plant is cultivated in small scale in some Chinantec communities, such as Santiago

A photograph by Frederick Starr taken in the late 1890s, showing men from San Mateo del Mar wearing undecorated loincloths with what appear to be capelike garments (*tilmas*) tied around their shoulders (Starr 1899:pl. 115). Both of these items of clothing hark back to precolumbian apparel. Zapotec men in nearby communities wore the loincloth as underwear until the 1940s.

Detail of the dense band of wool embroidery along the bottom border of a Mazatec wraparound skirt from Huautla de Jiménez in northern Oaxaca, dating from the 1930s or earlier. Among contemporary Oaxacan textiles, the emphasis of the border decoration in an otherwise white garment distinguishes highland Mazatec wraparound skirts and perhaps preserves a sixteenth-century fashion. Early colonial documents depict huipils and skirts heavily decorated along the bottom border. Photo by J. López.

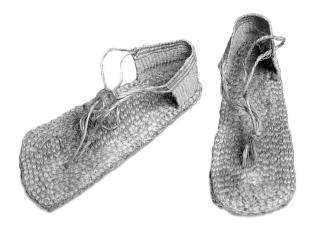

A pair of sandals made of *ixtle*, the fiber obtained from various *Agave* plants. Sandals such as these were formerly worn by Zapotec women in the Villa Alta district of Oaxaca. The soles were made of compressed *ixtle* stitched tightly with a cord of the same fiber. The rectangular piece for the back of the foot was woven with finely spun *ixtle*. Similar sandals of the same material dating from the precolumbian period have been excavated from dry caves in the Tehuacán Valley and in the Cuicatlán Canyon. Regional Museum of Oaxaca. Photo by J. López.

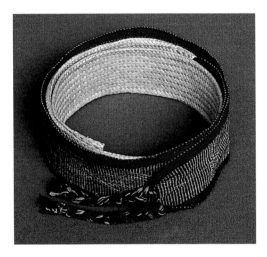

A long strip of plaited palm, called a *soyate*, sewn to the end of a wool sash and worn wrapped around the waist. This *soyate* and sash, dating from the 1960s, is from Pinotepa Nacional in southwestern Oaxaca. The use of a *soyate* to bind the belly is believed to prevent illness and infertility. Today, some women who no longer wear indigenous clothing continue to wear the *soyate* and sash underneath their Western-style clothes. Regional Museum of Oaxaca (131110). Photo by J. López.

Tlatepusco. Currently, large quantities of *pita* are being extracted from wild populations of the plant in the Chimalapa area for export. The 1777 Relación of Quiechapa, a Zapotec community in the Yautepec district, mentions the use of *pita* (possibly referring to *Agave* fiber) combined with wool to weave wraparound skirts (Esparza 1994:275); no contemporary textiles from Oaxaca are documented to combine wool or cotton with *Agave* or *Aechmea* fiber.

Palm

Palm raincoats were formerly made in some communities and used widely before the advent of polyethylene; de Córdova and de Alvarado list Zapotec and Mixtec terms for them, as well as a Náhuatl-derived name. *Brahea* leaves are the same material used to plait hats, *tenates* (pliable baskets), and *petates* (mats)—as well as to thatch houses—in several Mixtec, Chocho, Ixcatec, Tlapanec, and Náhuatl-speaking communities of western Oaxaca, southern Puebla, and eastern Guerrero; as well as in mestizo and Zapotec villages in the areas of Albarradas and Amatlán, northeast and south of the Valley of Oaxaca. The leaves of *Sabal*, a group of palms that grow mostly in the tropical lowlands, are used similarly in the Isthmus of Tehuantepec; the Huave twist the leaves into cord to make netted food hangers. Palm plaiting in southern Mexico, particularly the development of large-scale hat manufacture in the Mixteca, has a complex history that has not been documented adequately. Nineteenth-century photographs seem to indicate that felt hats were more prevalent than palm hats in Oaxaca.

The leaves of *Brahea dulcis* and other species in the same genus of palms that are widespread in dry midaltitude highlands of Oaxaca, southern Puebla, and Guerrero are used to manufacture the *soyate*—in Náhuatl, *soyatl*—(*Brahea* palm) a long tubular strip worn around the waist underneath the sash in a number of communities in Oaxaca, Puebla, and Guerrero, especially in the Mixtec region. One end of the woolen or cotton sash is sewn to an end of the *soyate* to hold it tight around the waist. Women in Oaxaca and other areas in Mesoamerica bind their bellies tightly to prevent illness and infertility, especially after childbirth. De Alvarado (1593) provides a Mixtec term *tnani* (*cinta o cincho que se ponen las indias recien paridas*) for the girdle or sash worn by women after giving birth; this is distinct from *huatu*, the generic term for sash or band. Women who give up indigenous dress often continue to use a *soyate* and/or sash underneath Western clothes. Similarly, in some areas men still wear a tight, handwoven sash underneath industrially manufactured pants and leather belts.

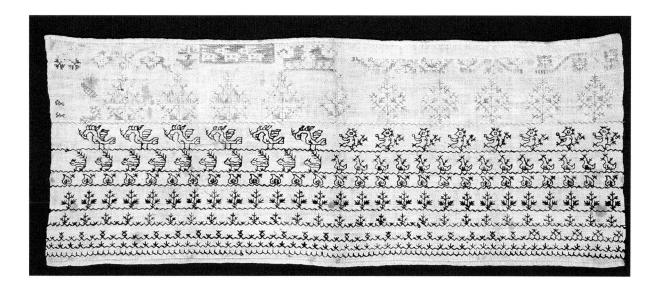

Chichicaztle

Chichicaztle fiber (in Náhuatl, *chichicaztli*; designating a number of urticating plants), obtained from the inner bark of *Urera caracasana*, a small tree in the nettle family, is unique to Oaxaca. Although the species is common in midaltitude areas in the state and is widespread in Mexico, textiles from its fiber were made only in a restricted area of the Sierra Sur, centered in the Zapotec village of San Juan Guivini and neighboring Chontal communities (MacDougall and Johnson 1966). The use of this fiber appears to have been long confined to this area. The 1579 Relación of Nexapa, at that time the administrative center for this region, mentions a "hemp . . . they call *chichicastle*," which was abundant and much used (Acuña 1984:355). The geographical accounts of the 1770s describe the use of nettle fiber in the towns of Santiago Lapaguía and Santa María Quiegolani, in the close vicinity of Guivini (Esparza 1994:191, 291). However, none of the eighteenth-century accounts from other Zapotec towns in the same general area, such as San Pablo Coatlán, San Andrés Miahuatlán, and San Pedro Apóstol Quiechapa—nor from any other region in Oaxaca—mentions this fiber. The authors of the Lapaguía and Quiegolani Relaciones stressed that the fiber was used for skirts by poor women who could not afford wool. The Relación de Lapaguía indicates that the "nettle or *chichicasle*" was propagated purposefully, suggesting that this species was under incipient domestication: it was planted in the summer and was mature enough for use four years later, without receiving any further care. Naturalist Thomas MacDougall and textile scholar Irmgard W. Johnson visited Guivini in the 1950s and documented how the fiber was

An embroidered sampler dating from perhaps the middle of the nineteenth century. The cloth is a single web of hand-spun cotton woven in plain weave on the backstrap loom. The embroidery thread is of hand-spun cotton, dyed with *Purpura* shellfish and indigo colorants. A couple of small sections were embroidered with imported silk floss. The embroidery techniques, as well as several of the designs on this piece, can be seen on samplers from central Mexico dated to around 1850. The curly tipped, leaf motif appears to be unique to this sampler and may reflect Moorish influence on colonial Spanish embroidery; or it may have been inspired by paisley prints imported from England into Mexico during the early nineteenth century. Through either channel, it would seem that this design derived from the *boteh* motif of the Middle East and India. This sampler and two others were kept as heirlooms by a woman from Santiago Tamazola, a Mixtec community south of the Nochixtlán Valley in central Oaxaca. Regional Museum of Oaxaca (131074.2). Photo by M. Zabé.

processed, spun, and woven. Handsome fringeless ponchos, with warp stripes of cochineal-red and dark brown wool, were woven of this fiber in Guivini, as were simple carrying cloths (MacDougall and Johnson 1966). The weaving of *chichicaztle* appears to have died out since the 1960s, and very few textiles of this fiber have been conserved in museum collections.

Other bast fibers are still used occasionally to manufacture cordage in some areas of Oaxaca and Guerrero. The author has documented the use of the fibers of *Cochlospermum vitifolium* and *Pseudobombax ellipticum* to manufacture cords and small netted bags in the Mixtec town of Jicayán de Tovar, Guerrero (de Avila B. 1987, Field Notes). Both trees are common in the tropical dry forests of southern Mexico and may have been used similarly in other areas. The bark of *pochote* (probably *Ceiba pentandra*) and *ita yata* (*Pseudobombax*) is used in San Pedro Amuzgos, Oaxaca, to make

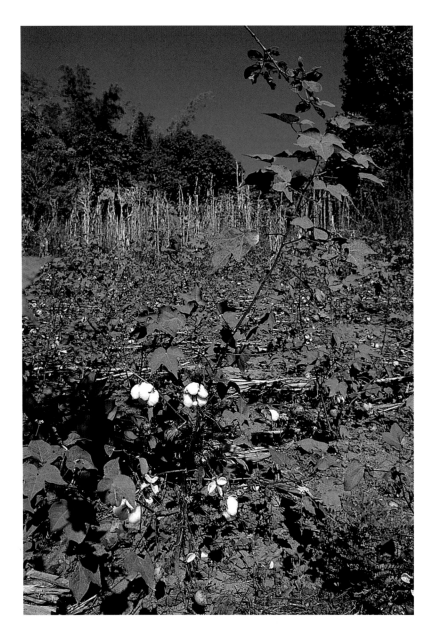

A cotton field in Xochistlahuaca, Guerrero, photographed in January 1995. Cotton boll fragments excavated in Coxcatlán Cave in the Tehuacán Valley appear to indicate that at least one species of cotton (*Gossypium hirsutum*) was domesticated in southern Mexico as early as 5500 B.C.E., long before the development of intensive agriculture. Photo by J. López.

nets for the maize harvest (Cruz Hernández 1993). De Córdova recorded the Zapotec name of a "tree with bark with which they make ropes" as *yàga nàca làça* (de Córdova 1578).

Cotton

Cotton—in Zapotec, *xilla* (de Córdova 1578); and in Mixtec, *cachi* (de Alvarado 1593)—is the most important fiber in Oaxaca. A number of wild species of cotton (genus *Gossypium*, in the mallow family) are known from the state, including *G. gossypioides*, an arborescent species that is endemic to the area of Yautepec (Fryxell 1988). *G. gossypioides* appears to be the wild cotton that is genetically closest to the two cultivated species native to the Americas (Wendel et al. 1995). Both species are traditionally cultivated in Oaxaca: *G. barbadense*, or *algodón de árbol* (tree cotton), reported only from indigenous home gardens (this species appears to have been introduced into southern Mexico from South America during precolumbian times); and, most important, *G. hirsutum*, cultivated widely and apparently domesticated on the Yucatán Peninsula (Brubaker and Wendel 1994). The cotton boll fragments that were excavated in Coxcatlán Cave appear to indicate that *G. hirsutum* was already being cultivated in the Tehuacán Valley in 5500 B.C.E., if the date attributed to these specimens is reliable (Stephens 1967). At present, this species dominates world cotton commerce (Wendel et al. 1992).

A number of varieties of *G. hirsutum* are cultivated in indigenous communities in Oaxaca, including *G. hirsutum* or *palmeri* (*G. lanceolatum*), endemic to southern Mexico and known only from traditional home gardens (Brubaker and Wendel 1993), and the short-stapled, naturally brown forms that have been designated *G. mexicanum* in the past and are known as *coyuche* in Oaxaca. The etymology of *coyuche*, and of the cognate term *cuyuscate* in Guatemala, is "coyote-colored cotton," from the Náhuatl *coyoichcatl* (Cordry and Cordry 1968:7). The former importance of brown cotton seems to be attested by the widespread use of *coyuche* in Oaxaca Spanish to refer to any tawny color, especially the light brown hair of children. Also grown in other areas in Mexico, Guatemala, and northern Peru, naturally colored cotton varies in Oaxaca from a light tan to a rich cinnamon. At present it is cultivated and used mainly in Mixtec communities in the district of Jamiltepec and Amuzgo villages in Guerrero, but it was more widespread until recently, including in some Mixe and Chinantec communities in northern Oaxaca. *Coyuche* textiles in the collection

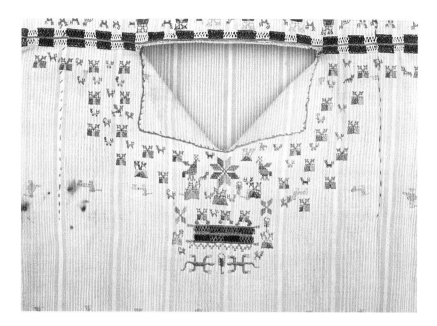

Embroidery on the handwoven cloth of a man's shirt from Santa María Zacatepec, Oaxaca, dating from the 1930s to 1940s. The stripes of the cloth were woven by an alternation of warp threads between hand-spun white cotton and naturally brown-colored cotton (*coyuche*). The embroidery thread is industrially spun cotton, dyed with indigo and various synthetic colorants. Regional Museum of Oaxaca (132887.1). Photo by M. Zabé.

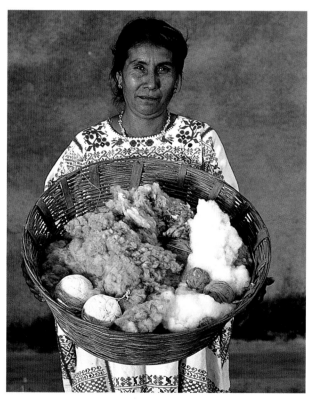

Adela García de Jesús, a weaver from Xochistlahuaca, displays a basket of naturally colored cotton. Three species and several varieties of cotton are cultivated by indigenous people in Oaxaca and Guerrero, including a short-stapled, naturally brown cotton known as *coyuche*. Also grown in other areas of Mexico and Guatemala, *coyuche* varies in color from light tan to rich cinnamon, as shown in the close-up image. A naturally green colored cotton was recently reintroduced into this area, and weavers are incorporating it into some of their textiles. Photos by J. López.

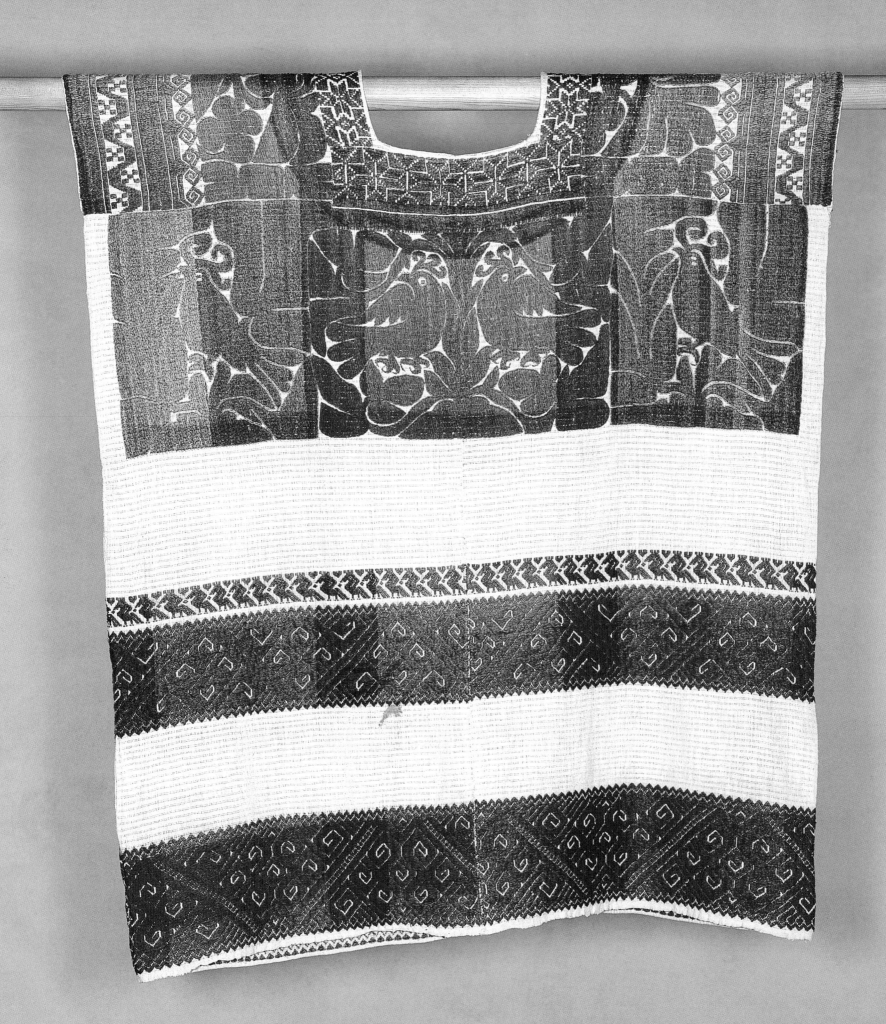

of the Regional Museum of Oaxaca include women's headcloths from the Mixe town of San Juan Cotzocón and Mixtec men's shirts from Santa Catarina Mechoacán (district of Jamiltepec) and Santa María Zacatepec, as well as two huipils from the latter community. *Coyuche* huipils are also known from the Trique area of San Juan Copala and from the Amuzgo communities of Guerrero. An old pair of trousers in the collection, apparently from San José Chiltepec (Chontal), shows wide warp stripes of *coyuche* cotton (perhaps white cotton dyed a light brown to simulate it); it is accompanied by a *gavilán* of more recent manufacture that also shows light brown stripes.

The Codex Mendoza (Berdan and Anawalt 1992, 3:83, 111) depicts large mantles with yellowish brown stripes that were paid in tribute to the Aztecs by some communities on the Pacific and Gulf coasts. Other tribute records describe these textiles in Náhuatl as *cozhuahuanqui* (yellow striped). The stripes in the manuscript appear to be the same color as the illustration of a boll of *coyuche* cotton. Cihuatlan province, on the coast of what is today the state of Guerrero, was the only area to send *coyuche* in tribute, according to the codex; it was also the region that sent in the largest quantity of *cozhuahuanqui* mantles. The 1580 Relación of Juxtlahuaca mentions that the women of Ayusuchiquilasala and Xicayán de Tovar, communities on the Guerrero-Oaxaca boundary, wore thick, striped skirts called *cozohuahuanqui* (Acuña 1984:302, 309). The 1778 description of San Pedro Atoyac, a Mixtec community in the Pinotepa district of Oaxaca bordering Guerrero, refers to the women's skirt as *posaguán*. Today, striped wraparound skirts from the Pinotepa area are called *pozahuanques* or *pozahuancos*, even though they do not include yellow stripes or *coyuche*.

Cozhuahuanqui fabric depicted in the Codex Mendoza is similar to a large three-web cloth, with wide warp stripes of *coyuche*, traditionally woven in the Chinantec community of Ojitlán, where it was used as a blanket (illustrated on the cover of Williams 1964, described erroneously as a Mixe wraparound). *Coyuche* seems to have been highly regarded in most areas of Oaxaca and may have had ritual significance. The 1777 Relación de Santa María Puxmetacán, a Mixe village in the lowlands toward the Gulf Coast, mentions that men wore everyday shirts of white cotton, spun and woven locally, and shirts of white and *coyuche* cotton for festive occasions: "this *cuyuche* is a kind of cotton they grow of cinnamon color" (Esparza 1994:37). Similarly, the Relación of Huazolotitlán, a Mixtec community close to the Pacific coast, mentions *algodón collete,* used in stripes on men's shirts (Esparza 1994:145).

Full view (opposite) and detail (above) of a cotton huipil from San Bartolomé Ayautla from the 1940s or earlier. The two bottom bands of geometric design and the row of birds were brocaded into a gauze weave. The rest of the huipil is of plain weave alternating with gauze weave. After the cloth was woven on the backstrap loom, parts of the upper portion of the huipil were embroidered with large curvilinear designs consisting of vertical stitches. The section around the neck was embroidered to simulate brocaded patterns. Ribbons were once sewn around the neck and in two vertical and two horizontal bands. Sections not covered by ribbon faded from exposure to ultraviolet light. This discoloration may have been caused from previous use, when the garment was worn outdoors in sunlight, and later from being displayed under fluorescent lighting in the museum. Regional Museum of Oaxaca (131027). Photos by M. Zabé.

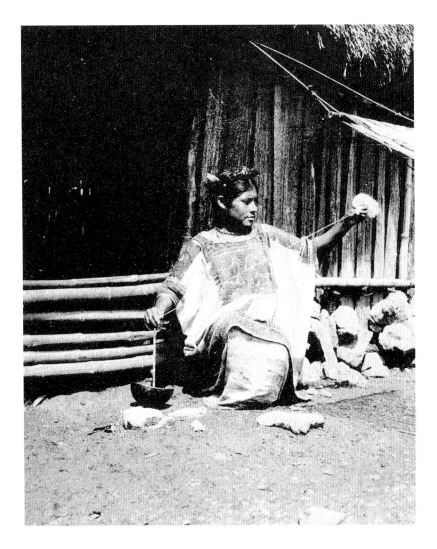

A Mazatec woman from San Bartolomé Ayautla, photographed by James Cooper Clark early in the twentieth century (Clark 1938:pl. 12b), shown spinning cotton with an indigenous spindle (*malacate*). Cotton is first cleaned by hand to remove seeds and debris, then beaten on a large pillow to align the fibers in preparation for spinning. The cotton fibers are spun on the spindle to make a single-ply thread. Most indigenous textiles from Oaxaca use warp and weft threads composed of a single ply. In some areas, two and three threads are plied together with the spindle. The woman in this photograph wears a huipil of handwoven cotton cloth with a wraparound skirt of striped industrial fabric. Reproduced courtesy of the Bancroft Library.

A number of plants are used in different areas today to dye cotton beige or brown, simulating *coyuche*. Communities where brown-dyed cotton that resembles *coyuche* is used traditionally—usually in warp stripes combined with white cotton—include the Zapotec villages of San Juan Yaeé, Yalalag, and Quiatoni (for wraparound skirts); Guiloxi (for wide sashes worn by women, stripes dyed with alder bark of the *Alnus* species); and San Juan Mixtepec, Miahuatlán (for striped rebozos, apparently dyed with oak bark). *Nanche* (*Byrsonima crassifolia*), mangrove, and other plants are used to dye cotton a light brown that resembles *coyuche* in textiles woven for the folk art trade in Pinotepa de Don Luis (Mixtec) and San Mateo del Mar (Huave). The use of these dyes may relate to the special status that brown cotton seems to have held. Even so, Johnson found that huipils of *coyuche* were considered less desirable in the Mixtec community of Santa María Zacatepec in the 1950s (Johnson n.d.). Agapito Valtierra, an Amuzgo artisan who cultivates *coyuche* and white cotton, recalls elders in Xochistlahuaca, Guerrero, describing a greenish cotton that was formerly grown (de Avila B. 1995, Field Notes). The seed was lost, and no textiles woven with this cotton appear to have survived. Valtierra recently received seeds of a greenish cotton bred in the United States by Sally Fox, a geneticist who specializes in colored cotton; he is now growing it in Xochistlahuaca.

The loss of seed, which often means the extinction of an entire genetic strain of a crop that was carefully selected over generations to adapt to particular ecological conditions and cultural preferences, is not restricted to colored cotton. The traditional cultivation of white cotton has disappeared in large areas of Oaxaca. The sixteenth- and eighteenth-century Relaciones refer to cotton being grown along both coasts, as well as in some low-altitude areas of the interior—as in the Nejapa Valley, according to the Relación of Macuilsúchil, 1580 (Acuña 1984:332)—from where it was traded throughout Oaxaca. The Relaciones consistently

A huipil from one of the Chinantec communities of western Chinantla in northern Oaxaca, dating from the 1930s or 1940s. Three webs were woven on the backstrap loom. Warp and weft threads are of industrial cotton in a plain weave alternating with a gauze weave; the technique produces a checkered effect. Supplementary wefts of industrial wool yarn make the brocaded patterns. Because wool can be easily dyed and became more available over time, it eventually replaced supplementary wefts of cotton spun with rabbit hair and duck feathers, both of which are mentioned in sixteenth-century colonial documents of Oaxaca. Regional Museum of Oaxaca (132760). Photo by M. Zabé.

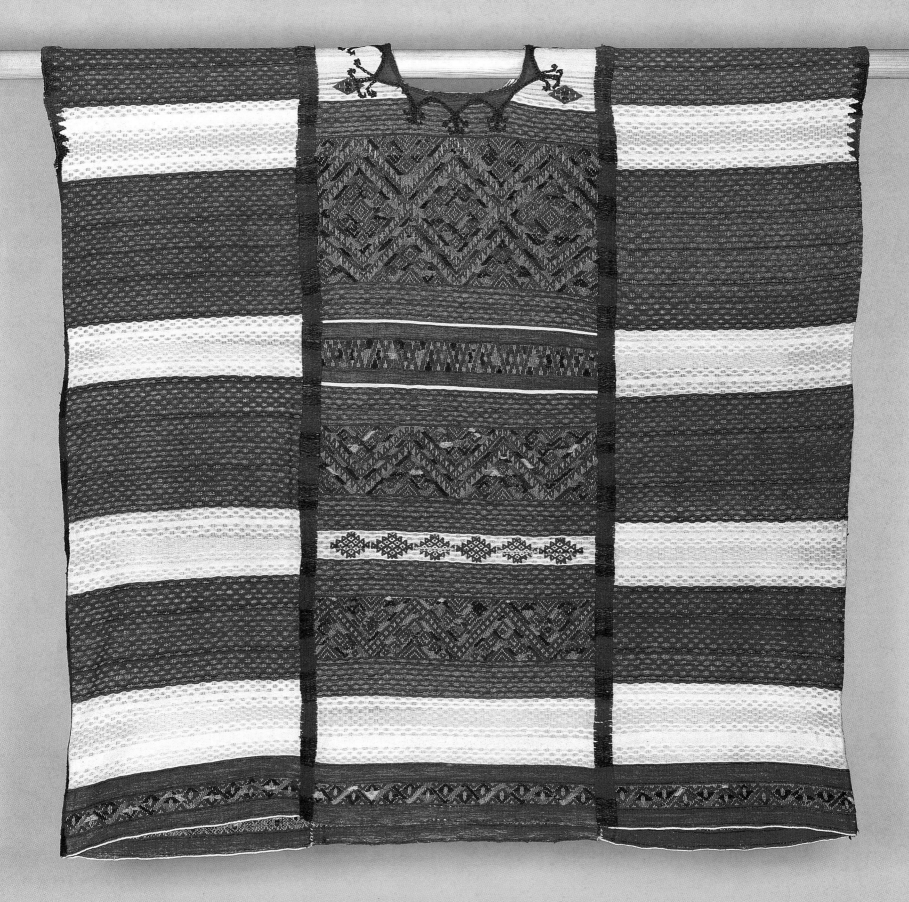

Juan Sánchez Rodríguez demonstrating wool tapestry weaving on the treadle loom at the Shan-Dany Community Museum of Santa Ana del Valle. In this Zapotec community, wool thread is either spun with a manually turned wheel or is spun by machine. Sheep, spinning wheels, and treadle looms were introduced into Mesoamerica from Europe during the sixteenth century. Today, the designs of wool tapestries range from traditional to modern, including copies of designs from paintings by Joan Miró and lithographs by M. C. Escher. Wool tapestry weaving on the treadle loom is the basis of the economies of both Santa Ana del Valle and Teotitlán del Valle, a neighboring Zapotec community in the Valley of Oaxaca. Photo by J. López.

mention cotton grown in indigenous communities as one of the most important articles of commerce. The Gulf Coast and the Pochutla and Tehuantepec areas on the Pacific appear to have been the most important producers; traditional cultivation of cotton has disappeared long since in all three areas. At present, the only area where cotton continues to be cultivated, spun, and woven manually to any significant extent in Mexico is the Mixtec and Amuzgo region of southwestern Oaxaca and southeastern Guerrero, and even there its use is waning. In other areas, industrial thread has supplanted the hand-spun fiber, and cotton plants are only occasionally maintained in home gardens. In some areas where spinning and weaving were abandoned long ago, cotton is kept in gardens because of its medicinal uses—as in Zapotitlán Salinas, Puebla, where Popoloca was formerly spoken (de Avila B. 1992, Field Notes). Among the indigenous crops of Mesoamerica, cotton seems to be losing genetic diversity most rapidly. The conservation of local varieties in situ is important and urgent.

Wool

Wool—in Zapotec, *quícha pecoxilla* or *quíchaxílla* (de Córdova 1578); and, in Mixtec, *idzi* (de Alvarado 1593)—was introduced into Oaxaca soon after the Spanish conquest. Early colonial documents record the establishment of *estancias de ganado menor* (sheep and goat ranches) in the Mixteca Alta and in the Valley of Oaxaca, both by Spaniards and by *caciques*. The history of wool in Oaxaca is poorly documented. The early vocabularies include terms for cleaning and carding wool, as well as for *merino* wool, coarse wool, and dirty wool. The reference to *merino* wool may reflect the introduction of specific breeds of sheep in the interest of producing fiber of a certain quality. In both the Zapotec and Mixtec vocabularies, the gloss for *merino* translates as "soft wool." There are other parallels in the words that both languages coined to refer to the introduced fiber and to the animal itself: the roots *quícha* and *idzi* both refer to hair, and the terms *pecoxilla* (Zapotec for cotton dog) and *ticachi* (Mixtec for cotton animal) both make reference to the most important native fiber. The 1580 Relación de Macuilsúchil mentions that one of the trades of the town was the sale of *mantas de lana* (woolen mantles), but it does not indicate the same in the detailed list of products of nearby Teotitlán del Valle (Acuña 1984:332, 337). Similarly, the 1777 Relación de Teotitlán fails to mention the weaving of wool, recording only the use of woolen mantles (possibly sarapes) by the men, woolen skirts and wool or cotton huipils by the women (Esparza 1994:338). The lack of references to weaving in this town is significant, given the present importance of Teotitlán and nearby Santa Ana del Valle as the major wool-weaving towns in Oaxaca. Perhaps other towns in the valley were producing woolen textiles for trade; the Relación de Atatlahuca (a Cuicatec-Chinantec community) of 1777 mentions that the woolen blankets used locally were purchased in the city of Oaxaca (Esparza 1994:220). Multicolored woolen mantles worn by men, textiles that fit the description of sarapes, are mentioned in the account of Tlalixtac, a Zapotec community in the Valley of Oaxaca; blue and white woolen *"tilmas* worn as capes" are reported for the Mixtec town of Juxtlahuaca (Esparza 1994:300, 454).

At present, the Zapotec weavers of Teotitlán and Santa Ana del Valle use the treadle loom to weave woolen tapestries. The wool is spun with a manually turned wheel. Thick, stiff rugs for the folk art trade are the main product now, but softer tapestries that were used as sarapes and blankets were formerly made for the regional market. Very few old woolen textiles from this area have survived to document the evolution of design that has taken place in this distinctive weaving tradition, which appears to be the finest and most dynamic form of tapestry art in contemporary Latin America. The nineteenth-century sarapes that have been attributed to Oaxaca do not show a number of technical features that distinguish Teotitlán and Santa Ana weavings from other Mexican tapestries (Taylor 1995). These features include the woolen warp, the two bundled warps at each selvage, the warp ends twisted together in groups, and the warp ends left uncut at one end of the web. Sarapes that have been attributed to Oaxaca that do not show these features include a piece at the American Museum of Natural History illustrated in Fisher (1979:96, fig. 6) and seven examples in the collection of the Hearst Museum of Anthropology at the University of California, Berkeley. Other sarapes of this style are illustrated in Sayers (1990:pl. 3) and in Jeter and Juelke (1978:83). In contrast, old wraparound skirts, woven on the treadle loom in a weft-faced twill and worn by Zapotec women in Teotitlán and Tlacolula for festive occasions, do share some of the technical peculiarities of Oaxacan sarapes; three examples are conserved in the collection of the Regional Museum. The weave of these skirts resembles the highly esteemed, cochineal-dyed, diamond-twill woolen skirts that were woven in a single web on the backstrap loom. These textiles are kept as heirlooms in many Zapotec communities of the Valley of Oaxaca.

Wool is spun with the indigenous spindle and woven on the backstrap loom in a number of highland communities in Oaxaca to make wraparound skirts, ponchos, rebozos, sashes, and some huipils. *Tlacoyales* are also made of wool. Prominent skirt-weaving communities represented in the Regional Museum collection are Magdalena Peñasco and Santa María Peñoles (Mixtec) and San Pedro Mixtepec, Mitla, and the unknown Oaxaca Valley community where the extraordinary cochineal-dyed diamond-twill skirts discussed above were woven (Zapotec). Salient blankets and ponchos in the collection come from Peñoles (Mixtec), Tlahuitoltepec (Mixe), Santa María Quiegolani (Zapotec), and other communities. Woolen sashes are woven in San Agustín Tlacotepec (Mixtec) and formerly in Jalieza in the Valley of Oaxaca (Zapotec), where commercial cotton is now mostly used. The Regional Museum collection includes three beautifully woven woolen huipils from Santa María Cuquila, a Mixtec community in the Mixteca Alta. As in the case of cotton spinning and weaving, the traditional processing of wool is dying out in most areas; in some cases the hand-spun fiber is being replaced by acrylic yarns. Given the susceptibility of wool to insect damage, few old woolen textiles have been conserved in Oaxaca.

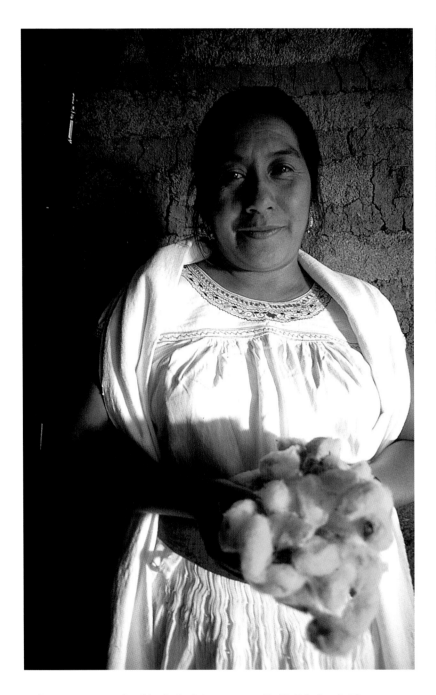

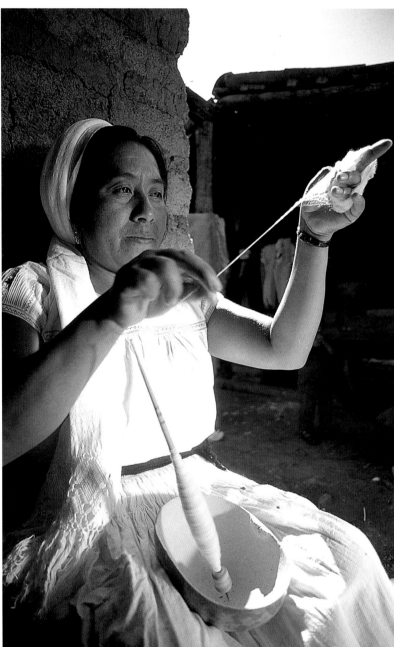

In the Zapotec community of San Pedro Cajonos, weaver Giselda F. Jiménez holding empty silkworm cocoons. Traditional processing of silk in Oaxaca treats the cocoons as a source of short fibers. Rather than killing the pupa and unreeling the entire filament of the cocoon, silk raisers allow the adult moth to emerge from the cocoon, which breaks the continuity of the filament. The empty cocoons are boiled in water with ash and then spun with a spindle in the same manner as are cotton and wool. Photo by G. Aldana.

Giselda F. Jiménez demonstrating silk spinning using a spindle. Oaxaca silk thread lacks the gloss of unreeled *Bombyx* silks but has a beautiful, subdued sheen. Giselda F. Jiménez wears the woman's traditional clothing of her highland community: a white cotton huipil and gathered skirt held in place with a bright magenta handwoven silk sash. Traditional clothing is no longer worn daily in San Pedro Cajonos but is reserved for special occasions. Photo by G. Aldana.

Woolen felt hats were formerly made in Oaxaca City, Jamiltepec, and possibly in other communities; they are still made in the Zapotec town of Yalalag, in the Villa Alta district. The 1578 Zapotec vocabulary of de Córdova includes references to hatters and felt making. Large-brimmed, high-crowned felt hats popular at the turn of the century in the Valley of Oaxaca were richly embroidered with silver thread (Cook de Leonard et al. 1966:134). A smaller, dark red felt hat with a silver, ropelike *toquilla* (a decorative band that encircles the base of the crown) appears to have been distinctive of the Isthmus Zapotec. The Regional Museum collection includes some outstanding examples of both types.

Silk

Wild silk was used until recently in some areas of Oaxaca. The species that produced it appear to be *Gloveria psidii*, a moth, and *Eucheira socialis*, a butterfly, both of which are found in midaltitude, relatively dry forests (Peigler 1993:156–57; Peigler et al. 1993). In Santa Catarina Estetla, a Mixtec community in the mountains west of the Valley of Oaxaca, a wild silk called, in Mixtec, *doko tachi* was gathered from oak trees and spun and woven into very durable sashes (de Avila B. 1985, Field Notes). Wild silk was also used to weave sashes in Santo Tomás Quierí and other communities in the Zapotec area of Yautepec; two types of wild silk were known in this area—one found on oaks, the other on madrona trees (*Arbutus*) (Johnson n.d.). A silk gathered from oaks is also remembered in San Miguel Cajonos, a Zapotec community in the Villa Alta district (de Avila B. 1986, Field Notes). The use of wild silk in precolumbian times in Oaxaca and other areas of Mesoamerica has been debated; Borah (1943:102–14) proposed that indigenous weavers began to use wild silk only after sericulture, brought from Europe, began to wane. However, a document dating from 1777 describes the excavation of a precolumbian burial in which textiles of wild silk, cotton, and feathers were found; this took place in the area of Teotitlán, in the dry Tehuacán-Cuicatlán Valley (Esparza 1994:59).

Bombyx silk and the mulberry to feed it were introduced to Oaxaca by the Spaniards in the 1530s (Borah 1943). By the 1550s the Mixteca Alta in western Oaxaca had become the most important center of sericulture in the continent, and Mixtec silk is said to have compared favorably with Asian silk in quality. Late sixteenth-century documents attest to the prosperity of indigenous communities in Oaxaca that produced it. Silk-raising in Mexico thrived for less than a hundred years; in the early seventeenth century,

Silkworms thriving on a leaf of a mulberry tree. *Bombyx* silkworms and the mulberry trees on which they feed were introduced from Europe soon after the Spanish conquest. By the middle of the sixteenth century, the Mixteca Alta in western Oaxaca had become the most important center of silk raising on the continent. Photo by G. Aldana.

A woman's hand-spun silk sash from the Cajonos area. The sash was woven on the backstrap loom in a plain weave; the warp ends were knotted into an elaborate fringe. Wide sashes of either silk or wool are worn today in a number of Zapotec communities. The popularity of this type of sash may have developed during the mid-twentieth century; prior to that, narrow belts with woven patterns were worn. Photo by G. Aldana.

it was interdicted by the king to protect Spain's own silk industry. Although production dwindled and export was halted by the decree, locally raised silk continued to be used in Oaxaca until the present, mostly for ceremonial textiles. It is still raised in two areas: the Mixtec community of San Mateo Peñasco in the Mixteca Alta, where it is spun and dyed for sale in Pinotepa de Don Luis and Santiago Ixtayutla, two Mixtec communities in the coastal district of Jamiltepec (the dark red Peñasco silk is known locally as *hiladillo*); and in a number of Zapotec communities in the Villa Alta and Ixtlán districts, including San Pedro Cajonos, San Pablo Yaganiza, and Santiago Laxopa, where it is woven into pink-red sashes worn locally and natural-color shawls for the folk art trade. In the early part of this century, silk was also raised in the Mazatec town of Huautla de Jiménez (Johnson n.d.), and it was produced in the Mixtec area of Santa María Peñoles as late as the 1960s (Cordry and Cordry 1968:286–87). Small quantities are still raised by Zapotec families in Macuilxóchitl in the Valley of Oaxaca, who send it to the Cajonos area to be spun and woven into sashes (Aquino 1987).

The processing of silk in Oaxaca uses the fiber in the same way that cotton and wool are spun: rather than unreeling the entire filament of the cocoon (which is only possible if the chrysalis is killed), indigenous silk raisers allow the adult moths to emerge, dissolving their way out of the cocoon and thereby breaking the continuity of the filament. The empty cocoons are boiled in ashes and then spun with light spindles like those used for spinning cotton. The result is a thread that lacks the gloss of other *Bombyx* silks but has a beautiful, subdued sheen and confers an extremely handsome irregular texture to textiles woven with it. Current regional development projects that seek to revive sericulture in Oaxaca by promoting Asian and European strains of silkworms and the adoption of reeling techniques fail to appreciate the unique aesthetic qualities of traditional Oaxacan silk textiles.

Besides its use in the aforementioned sashes and shawls woven in the Cajonos area, silk is used in Pinotepa de Don Luis to weave *pozahuanque* wraparound skirts that combine silk warp stripes with cotton warp and weft. Peñasco silk is used in Ixtayutla as supplementary weft in cotton textiles decorated with brocading. Hand-spun silk was formerly used in supplementary weft weaves in other areas as well; the most notable examples were the extremely fine Zapotec textiles from San Bartolo Yautepec. Warp stripes of hand-spun silk were present in the rebozos woven in the Zapotec communities of San Pedro Quiatoni and San Pedro Mixtepec.

A woman's rebozo (shawl) from San Pedro Quiatoni, a Zapotec community located in the mountains east of the Oaxaca Valley, dating from the 1930s or earlier. A rich variety of materials from ecologically and culturally distinct sources is found in Quiatoni textiles. This rebozo epitomizes the diversity of textiles found in Oaxaca. Some of the cotton threads were dyed with *Purpura* shellfish colorants, perhaps by Chontal specialists on the Pacific coast; silk threads dyed with cochineal are from a highland region, possibly the Cajonos area; while the white thread was spun locally from cotton imported from the lowlands. Because the art of weaving has not been practiced in Quiatoni for at least fifty years, the few surviving textiles are found only in collections. Regional Museum of Oaxaca (131021). Photo by M. Zabé.

Local silk decorated the black and dark green *tlacoyales* formerly made in the Valley of Oaxaca and worn in many areas. An old Trique huipil from San Juan Copala in the Regional Museum collection includes some hand-spun silk in the brocaded patterns. Old ceremonial textiles from other communities in Oaxaca also included hand-spun silk, such as a huipil brocaded with *hiladillo* from San Pedro Amuzgos in the collection of the National Museum of Popular Arts and Crafts in Mexico City, and the magnificent silk sashes formerly worn by Mazatec elders, decorated with gauze weave and brocaded designs, of which there appear to be only two examples known, one in the Chicago Field Museum (in the Frederick Starr collection) and another in the Franz Mayer Museum in Mexico City (Johnson n.d.). Both the warp and weft of these sashes are of hand-spun silk, as are two old square pieces (probably headcloths) in the collection of the National Museum of Anthropology in Mexico City. The wine-red background and dark-blue and gold stripes on one of these cloths match the colors of the Mazatec sashes and may indicate that it came from the same area and was possibly worn as a ceremonial headcloth by members of the council of elders. The most outstanding textile from Oaxaca, and possibly the oldest piece that shows local hand-spun silk, is a large, old huipil, conserved at the National Museum of Anthropology, woven of extraordinarily fine hand-spun cotton thread. The gossamer-thin cotton warp and weft of this piece appear as delicate as the finest precolumbian Andean cotton threads. The top portion of the central web of the huipil was woven with a wine-red silk weft. After weaving, a red dye appears to have been applied on this section of the textile, which brings to mind the use of indigo and fuchsin to overdye the Chinantec huipils of Usila. No information has been preserved on the origin, date, or history of this and other remarkable old pieces in museum collections. These superb textiles attest to the virtuosity of indigenous weavers in Oaxaca.

Myth and Motif

The diversity of fibers and dyes and weaving techniques used in Oaxaca has propitiated the development of an extremely rich inventory of design. Specific materials and thread manipulations allow for certain effects of texture and vividness of design. Some techniques, such as 1/1 weft brocading and cross-stitch embroidery, lend themselves to elaborate small-scale motifs, while other techniques, such as 5/3 brocading, are less suited to minutely detailed elements. Design repertories vary markedly from area to area of

Full view (opposite) and detail (above) of a Mixe huipil from San Juan Cotzocón in northeastern Oaxaca. Woven in the 1940s or earlier, this huipil shows white brocaded patterns (supplementary weft patterning) woven into a white plain weave ground. Warp and weft threads are of hand-spun cotton. While older women of this community continue to wear handwoven huipils, white-on-white brocaded patterning is no longer being woven in Cotzocón. The detail shows human figures alternating with stylized double-headed eagles—a predominant motif found on present-day huipils from Oaxaca and Guatemala, as well as on colonial huipils from Central Mexico. Regional Museum of Oaxaca (130989). Photos by M. Zabé.

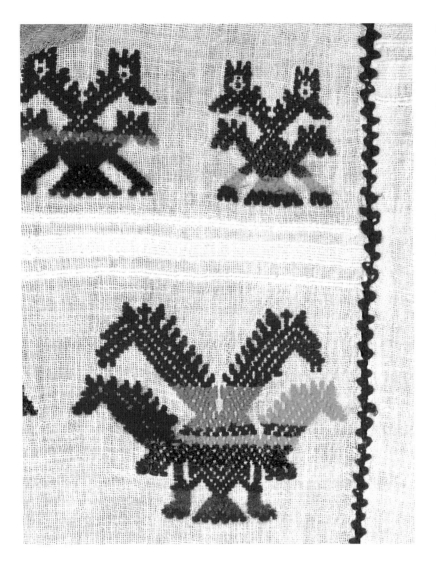

A huipil (opposite) from a Mixtec community in the Metlatónoc area of eastern Guerrero, dating from the 1950s or earlier. As shown in the detail (above), the long-floating wefts of the brocaded patterns create fantastic winged birds that sprout four heads—called *titia'a* in the Mixtec language. Linguistically these birds are related to the mythical double-headed eagle and symbolically play a transcendental role in Mixtec cosmogony: they refer to the story of a monstrous creature, the hero twins, and the creation of the sun and moon. Regional Museum of Oaxaca (154599). Photos by M. Zabé.

Oaxaca, partly as a response to the limitations imposed by the techniques customarily employed. Among present-day textiles, especially elaborate designs are brocaded and embroidered in the area of Metlatónoc in eastern Guerrero and in the western Chinantec area of northern Oaxaca. This section will focus on these two areas to illustrate some remarkably imaginative designs woven by Mixtec and Chinantec women. Certain motifs relate explicitly to local myths and beliefs, as has been documented by Chinantec scholars in their native language.

Beautifully conceived, spread-winged fantastic birds sprouting two, four, and even six heads figure prominently in the huipils of Citlaltepec, Chilixtlahuaca, Buenavista, and other Mixtec communities in the area of Metlatónoc.[43] Brocaded with floating wefts, they are often the largest motifs on the huipil and frequently occupy the most salient area of design in three-web huipils from Oaxaca, as in other areas of Mesoamerica—the rectangular section below the neck on both sides of the central web. Several other elaborate motifs distinguish these finely spun and woven textiles; they are referred to generically as *ita* (flower). Weavers know specific designs by names that other women may not recognize or that other weavers may apply to different motifs: *ita nda ina* (dog-hand flower, i.e., dog's footprint design), *ita se'e* (*Tigridia pavonia* flower), and so on. Yet the multiheaded creatures seem to be recognized by all as *titia'a* or *ticha'a*. This name appears to be a cognate of the term for eagle, recorded by de Alvarado (1593) in Tamazulapan Mixtec as *ya'a* (*yaha,* in his spelling), preceded by the semantic marker *ti-* in duplication.[44] The etymological linkage between *titia'a* and the eagle is paralleled by the iconographical relationship of this design with the coat of arms of the Habsburgs. The double-headed eagle was a ubiquitous motif in early colonial Mexico, when the Spanish empire was ruled by members of that lineage, and again in the 1860s, under the imposed rule of Maximilian of Austria after the French invasion.

Oblivious to the frustrated pretensions of the imperialistic eagle, *titia'a* plays quite a transcendental role in twentieth-century Mixtec cosmogony. The gist of the sun and moon story, as narrated by women in Chilixtlahuaca,[45] is the following: the monstrous *titia'a* devoured people until the twins arrived and dug seven holes. In the holes, they made fire; when *titia'a* tried to kill the twins, the eagle fell into the successive holes. It burnt to death at the seventh hole. The twins took out its eyes. A fly had bitten the eye of one of the heads, and hence it shone less brightly. The twin with the fly-bitten eye desired the brighter eye, but the other twin would not trade it.

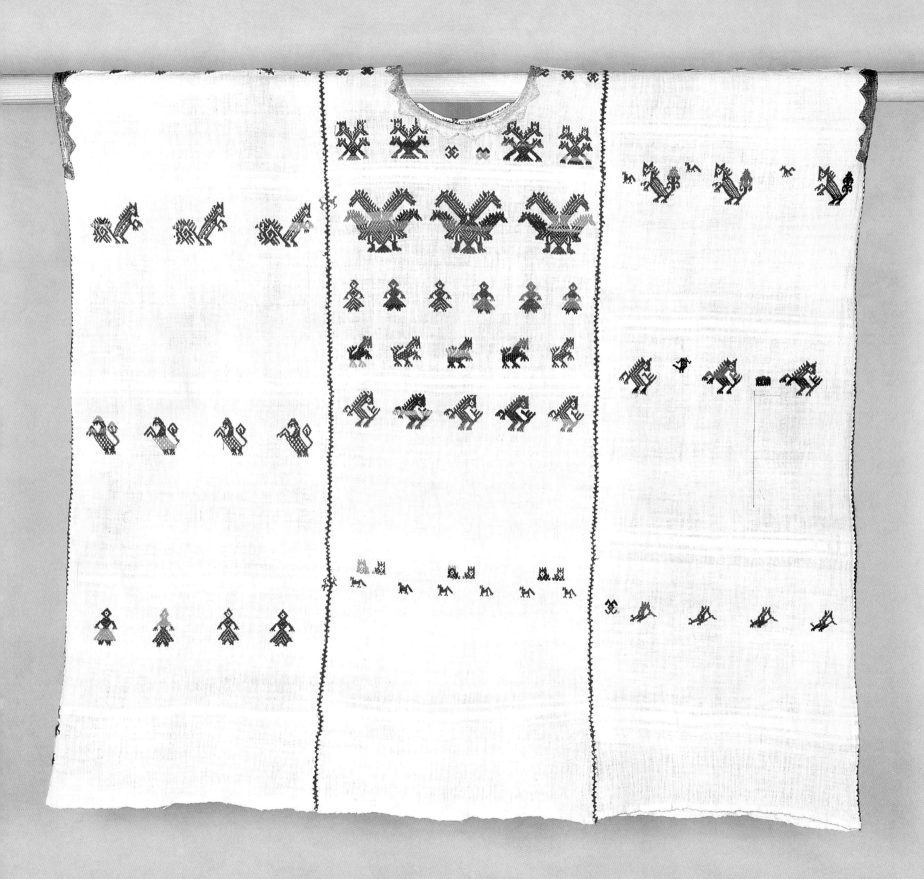

Every time the stubborn twin attempted to drink water, however, the water would dry up. The thirsty twin then agreed to exchange the eyes for water. The twins met a woman wearing a beautiful cloth who was headed for a contest. One of the twins challenged the other to have sex with her. They gave her a fruit that caused drowsiness. When she fell asleep, the challenged twin attempted to rape her but found that her vagina had teeth. He broke the teeth off with a rock and then raped her. The twins ran away and became the sun and the moon. When the woman woke up and realized what had happened, she cast the bloodied cloth over the land in anger; because of that curse, women have their menses.

The double-headed eagle is not unique to the huipils of the area of Metlatónoc; it is actually one of the most widespread motifs in Oaxaca, eastern Guerrero, and other areas of Mexico and Guatemala, appearing in numerous forms and techniques and often occupying the most prominent place in the design schemes of various textiles. The Chilixtlahuaca myth is not exceptional, either: its basic plot recurs again and again in the elaborate cycle of monster-and-twins/sun-and-moon sagas that have been recorded throughout Oaxaca (Bartolomé 1984), various themes of which have close parallels in the myths from other areas of Mesoamerica (most notably in the Popol Vuh of the Quiché Maya) and beyond. Furthermore, the explicit identification of the double-headed design with the mythical monster has been documented in at least one other area of Oaxaca, the Chinantec community of Ojitlán. Bartola Morales García, an ethnolinguist from Ojitlán, has carefully recorded the Chinantec names and mythical correlates of the unusually complex and ornate designs that are embroidered on huipils and that use stitches closely resembling the brocading technique employed in other Chinantec communities (Morales García 1987). The large double-headed eagle embroidered in the huipils has a two- or seven-headed counterpart in Ojitlán myths that is analogous to the Mixtec *titia'a*: it devours people and is vanquished by the twins, who take out its eyes to become the sun and moon (Bartolomé and Barabas 1983).

In some areas of Oaxaca where the full sun and moon myth appears to have been forgotten, bits and pieces of the story are still remembered, especially the episode of the eagle that devoured people. In the Zapotec village of Santiago Laxopa and in the Amuzgo community of Xochistlahuaca, a story is told of how, long ago, people had to move about with large baskets over their heads: when the huge eagle would swoop down to catch them, the people would let go of the baskets and thus be spared (de Avila B. 1987, 1995,

Field Notes). Benítez (1970) recorded the same passage in the Mazatec town of Huautla de Jiménez. In other versions of the full myth, recorded in the Chatino area (Bartolomé and Barabas 1982) and in the Mixe town of Camotlán (Miller 1956), the twins kill a huge snake. In the Chatino story, the twins take out its glimmering eyes to become the sun and the moon; no mention is made of the eyes in the Mixe version, but there is a subsequent encounter with a monster, an episode structured in much the same way as the Ojitlán story. A double-headed eagle intervenes in the elaborate Cuicatec version reported by Weitlaner (1977), but in this case the theme of the twins taking out the eyes fuses with the killing of a deer, which is the husband of the old woman who raised the twins.

These examples illustrate how the multiheaded monster is one of a series of elements that are rearranged and transformed in various ways in different versions of the myth. The eagle only occurs in some of the stories, but where it is absent, it usually has a counterpart, such as the Chatino serpent-monster. This suggests that the eagle may not have been the original form of this motif: it raises the possibility that the Habsburg eagle fused with a creature, or a complex of creatures that played the man-eating/shiny-eyed role in earlier versions, including perhaps a two-headed snake—a fascinating instance of syncretism (and perhaps resistance to cultural domination) with iconological as well as etymological implications, as suggested by the Mixtec *titia'a*.[46] Precolumbian representations of two-headed creatures come to mind, such as the sky monster of the Classic Maya (Schele and Miller 1986:45). There is perhaps also a link between the Habsburg eagle, the double-headed mythical creature, and a motif that decorates the Chilapa and Ejutla Cave fragments described earlier. José Luis Franco comments on the double-headed "hockers," vaguely anthropomorphic designs with flexed legs that figure prominently in the Chilapa textile. He relates them to similar motifs on archaeological pottery stamps from Guerrero and Oaxaca; in two examples illustrated, the hocker is flanked in one instance by two-headed snakelike figures and in another case by solar designs (Johnson 1967a:168).[47]

The Ejutla Cave fragment also shows a hocker-type motif, in this case as the dominant element of the design. In the Chilapa textile, the two heads are oriented vertically in opposite directions, fused into one motif that fills triangular spaces inside a larger design that resembles a double-headed serpent. In the Ejutla Cave piece, the two heads are independent but similarly oriented in opposite directions, forming two mirror copies of the same motif. It may not be a coincidence that the only two elaborately patterned

textiles known from Oaxaca and adjacent regions show a similar motif, suggesting that it held special significance. The possibility that this design relates to a hypothetical precursor of the double-headed monster in the Oaxacan sun-moon myths is open to speculation. From the point of view of design, however, it is evident that there is a series of parallels between the hocker-type motifs of the archaeological textiles and the contemporary double-headed eagles: both are bilateral-symmetric figures in which the axis of symmetry is vertical; both are "flexible" figures suited to fill square shapes but adaptable enough to fit in rectangular or even triangular spaces. The Chilapa motif, viewed with the vertex pointing up, is strikingly similar to contemporary eagle designs, with projections from the head resembling spread wings, and long arms resembling stretched-out legs. If iconographic syncretism did indeed take place, as suggested between the Habsburg eagle and the hocker, it must have been facilitated by these common features of design, which weavers would have easily noticed. It is interesting to note in this regard that there seems to be a complementary distribution of the two motifs at present: hocker-type designs are common in Tzotzil and Tzeltal textiles from highland Chiapas, where double-headed eagles are notoriously absent. In contrast, in Oaxaca, Guatemala, and other areas of Mesoamerica, double-headed eagle motifs are common, and hocker-like motifs are rare or altogether absent.[48]

Figurative motifs are not the only type of designs that relate explicitly to origin stories. Bartola Morales García (1987) reports that weavers associate the geometric motif that decorates the rectangular area below the neck in two of the three types of Ojitlán huipils, a design called *tú juo* (large stomach) with the beginning of the world. This embroidered design, consisting of concentric lozenges, was probably brocaded formerly on gauze weave, as are similar designs in the huipils of other communities in the western Chinantla. Unlike most other designs on Ojitlán textiles, this section of the huipil is embroidered, mostly in red, with stitches that cover the white warp and weft completely. Weavers associate this design with the primordial darkness before Tepezcuinte (the paca, a large rodent of the moist tropical forests) found two eggs that hatched to produce the twins that become the sun and the moon. A more elaborate design, also composed of concentric lozenges, decorates the area below the neck in the huipils from Usila, another Chinantec community. María del Socorro Agustín, a member of the weavers' cooperative of Usila, does not hesitate to comment on this bold, beautiful motif that covers the chest and the heart, as well as the back. The design is a doorway: in life, it is closed, protecting

Detail of a double-headed eagle motif woven into a huipil from the Zapotec community of Choapan. The depiction of this creature is widespread and found on many textiles from Oaxaca, eastern Guerrero, and other areas of Mexico and Guatemala. It appears in numerous forms and techniques and often occupies the most prominent place in the design schemes of various textiles. In this huipil, the double-headed eagle alternates with treelike motifs surrounded by birds. Because the art of weaving has disappeared in Choapan since the 1940s, there are no records of the Zapotec names and specific meanings of these remarkable designs. Motifs of double-headed eagles with tree-and-birds are prominent in textiles from Chinantec communities west of the Choapan district. The Ojitlán Chinantec weavers associate double-headed eagles with the story of the sun-and-moon twins. They also link the tree-and-birds motif with the sacred ceiba tree that reaches to the sky; the birds act as messengers for ancient deities—a frequent role of birds in indigenous myths throughout Mesoamerica. Regional Museum of Oaxaca (131007). Photo by M. Zabé.

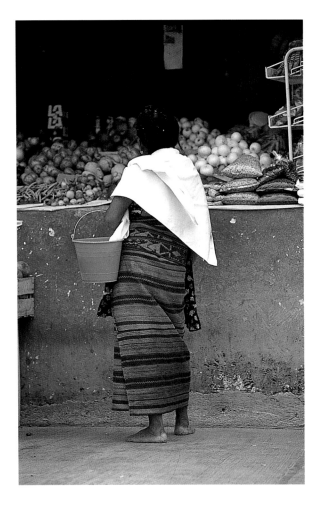

A local women at the market in Pinotepa de Don Luis. Photo by J. López.

the soul. When the woman dies, the doorway opens, allowing the soul to pass on (de Avila B. 1995, Field Notes). The perils of the soul, prone to abandon the body if frightened or startled, have long concerned Mesoamerican peoples (McKeever Furst 1995).

As if to underline the links between textile designs and creation myths, spinning and weaving also figure prominently in the sun-and-moon cycle in Oaxaca. Other forms of women's work, such as grinding maize, making pottery, and weaving baskets, are not mentioned in the stories; textiles appear to be the key symbol of womanhood in mythical thought. In the Camotlán Mixe version, a girl named María is weaving cloth for trousers when a little bird perches on her loom (Miller 1956).[49] The girl shoos it away, but the bird keeps coming back and finally defecates on the thread. Angered, the girl takes the batten and hits the bird, which rolls down the warp and apparently dies. Feeling sorry for having killed it, the girl takes the bird into her bosom, where it revives and pecks her nipple. From this, she becomes pregnant—a theme reminiscent of the Aztec myth in which Coatlicue is impregnated by a ball of feathers and gives birth to Huitzilopochtli, "the hummingbird on the left," the tutelary deity of the Aztecs. Later in the Mixe story, María is tricked by the squirrel and falls from a swing and dies. When the vulture is about to feed on her corpse, it hears the voices of the unborn twins inside her; they ask the vulture to remove the flesh carefully so they may emerge unharmed. Several episodes later, after encountering a two-headed snake, they become the sun and the moon.

In a Chinantec version of the myth, the twins' mother is chastised for getting pregnant before marriage. Her punishment is to weave the seven layers of the sky, in preparation for the forthcoming sunrise (Boege 1988:109). In other stories, the weaver is busy trying to finish making huipils for all the animals before the first dawn. She does not complete the armadillo's garment in time for him to greet the sun. Because he wears the unfinished cloth along with the wooden loom sticks, the armadillo has a tough shell. In the Chatino and Ojitlán Chinantec versions cited earlier, the twins are reared by an old woman whose spindle they play with, tangling the thread. The Chatino story specifies that the twins burn up the old woman in the *temazcal* sweat bath and thus convert her into the goddess who receives sacrifices at childbirth to protect the newborn. The grown-up twins keep a skein of her thread, with which they strangle the large snake to take out its eyes. Later, the twins throw the skein up to the sky and climb up the dangling thread to become sun and moon.

Sus Ley is the Zapotec name of the first spinner and weaver of Mitla. According to Parsons (1936:222), the story was the only widely known myth at the time in that important weaving town. Sus Ley pursues the twins after they kill her husband, a frequent theme in many versions of the sun and moon story. As they flee, the twins throw behind them various weaving implements belonging to the old woman, which become geographical landmarks. In one of the Trique versions (Bartolomé 1984), the twins rape the old woman after killing the deer that is her husband. When she wakes from her sleep, induced by the fruit the twins have given her, she realizes what has happened and throws her seven warping stakes, or weaving sticks, at the sun and moon. The sticks become the Pleiades.

The salience of spinning and weaving in contemporary Oaxacan myths parallels the prominence of spindles, cotton puffs, and battens in the attire of precolumbian deities depicted in the Mixtec codices, as well as in the Borgia group codices and the early Central Mexican manuscripts. Delicate objects related to spinning and weaving found in high-status Postclassic burials at Monte Albán, Zaachila, Lambityeco, and other sites in Oaxaca, such as spinning cups,[50] spindle whorls, weaving picks, and elaborately carved bone battens, bespeak the ritual significance of thread and cloth as women's symbols. Furthermore, the use of textile designs in fine ritual pottery and jewelry,[51] as well as in decorative mosaics on monumental architecture such as the buildings and tombs at Mitla, may be interpreted as displays of women's status in pre-Hispanic Oaxaca (McCafferty, McCafferty, and Hamann 1994).[52] Women are frequently depicted as rulers in the Mixtec codices. When couples are represented, the iconography indicates that wives and husbands shared the same status in this region, in contrast to Central Mexico. The power of women in indigenous Oaxaca is also attested by historical records of the colonial period, which refer frequently to *cacicas*, their property, and their privileges (Terraciano 1996). Contemporary ethnographies emphasize the central role of women in production, politics, and ritual in Oaxaca (Stephen 1991a, b; Chiñas 1973). The weavers of Teotitlán del Valle interviewed by Stephen, as well as the Isthmus Zapotec merchants studied by Chiñas, express womanhood, ethnicity, and creativity through textiles.[53] Cloth remains a powerful symbol of identity in Oaxaca, as local politicians have realized.

Cultural Politics and the Conservation of Textiles

During a recent campaign for state governor elections, a novel poster appeared in the streets of Oaxaca. Depicting an idealized, elaborately decorated textile, the poster read: "[name of the candidate], de auténtica urdimbre oaxaqueña" [of authentic Oaxacan warp]. The candidate, representing the dominant party, boasted of his indigenous identity in the propaganda and in his speeches—even though he would not be considered *indígena* by the definition of the national census, since the indigenous language is dying out in his native village. To his discredit, there is no record of traditional textiles from his community; weaving appears to have died out in that area of Oaxaca early in the 1800s. The poster illustrates the appropriation of textiles as symbols of ethnicity for political purposes. Indigenous clothing, usually simplified and worn by young, urban, middle-class women, has become part of the protocol at state functions and political rallies in Oaxaca. It is meant to convey a message of legitimacy and cultural pride.

That message is exalted in the Guelaguetza, a yearly festival sponsored and presided over by the state government. Named after a traditional system of reciprocal exchange of goods and labor practiced in Zapotec communities in the Valley of Oaxaca, the Guelaguetza developed in the 1950s as an event to attract tourism. It was superimposed on the Lunes del Cerro (Monday of the Mountain), a traditional celebration in the city of Oaxaca, during which families climb the hill just west of the center of town to relax and enjoy traditional foods and drinks sold there for the occasion (González Ríos 1993). A massive amphitheater was built on the hillside for the Guelaguetza. Groups of dancers and musicians, dressed in traditional garb, are brought in to perform. Few, if any, of the young people who participate wear indigenous clothing, except during the festival. Many of the dances are specially rehearsed for the event, as they are no longer performed traditionally. Some, in fact, were devised by the organizers of the festival.[54] Spectators are invited to enjoy the "authentic" music and dance of the indigenous people of the "seven regions" of the state.[55] In spite of the rhetoric, the Guelaguetza is viewed resentfully by some Oaxacan intellectuals as a masquerade. Indigenous rights activists have voiced strong criticism of the festival.

The debate over the Guelaguetza reflects a deep contradiction in the relationship of the Mexican state to indigenous peoples (Nagengast and Kearney 1990). Nationalistic ideology after the

revolution of 1910 glorified the precolumbian past and the folkloristic expressions of contemporary indigenous cultures. This ideology led to the creation of a system of institutions funded by the state that study, conserve, and promote indigenous and popular culture. At the same time, the state continues to implement policies that compromise the viability of communal forms of organization of indigenous peoples and promote migration from the countryside to the cities, facilitating cultural breakdown. Substantial resources are invested in the development of commercial farming and cattle raising, most of which take place in areas where indigenous population is minimal. Comparatively meager resources are devoted to the economic development of indigenous areas, characterized by subsistence agriculture. Legislative reform, designed to facilitate the privatization of *ejidos* (a system of collective land tenure that was instituted after the revolution of 1910), threatens the integrity of land and natural resources held by numerous indigenous communities.

In response to that threat, some indigenous *ejidos* have sought to obtain the legal status of *comunidades agrarias indígenas*, agrarian communities whose lands are inalienable. As they press their claims, they find that the federal land-certification program defines indigenous status on the basis of the retention of certain cultural traits, including language and traditional costume (PROCEDE 1994:3–4). The diverse and complex evolution of indigenous clothing in Oaxaca, however, would seem to challenge any definition of what constitutes traditional dress. Furthermore, this policy fails to acknowledge the active role that the state has played promoting cultural change in indigenous communities. Until recently, public education programs sought to erase cultural differences. In many communities of Oaxaca, as elsewhere in Mexico, state-sponsored schools actively suppressed the use of indigenous language and clothing. Huipils and wraparound skirts were discouraged, and in some cases, children wearing traditional dress were not accepted into the classroom.

The historical role of the state in undermining cultural pluralism is at odds with official institutions chartered to conserve and promote the cultural legacy of the nation. Since the 1960s, public museums at the national and regional levels have displayed extensive collections of contemporary indigenous material culture. Textiles, generally presented on mannequins, are a prominent part of the exhibits, which often convey a static vision of indigenous culture. Important changes taking place in the indigenous communities in the last three decades are usually not reflected in these displays, and the conservation and renewal of collections has been largely neglected. As a result, some valuable weavings and other fragile materials have deteriorated on exhibition and in storage. The custody of textile collections has also suffered in some cases from a limited recognition of the importance of research and adequate documentation in the context of rapid cultural change.[56]

State policy is not the only factor in the dynamics of cultural change at the community level. Historically, shifting trends in the international economy have been conducive to regional specialization. Overseas markets have affected textile production in Oaxaca since the early colonial period, as exemplified by the raising of silk for export, and the intensification of cochineal production. Global economic pressures have modified local land-use patterns. Environmental deterioration induced by unsustainable agriculture, deforestation, and goat herding has had significant demographic effects in large areas of the state. Soil erosion has forced many communities to migrate. Oaxaca is the state with the highest rate of emigration in Mexico. Within the state, the most heavily eroded areas, notably the Mixteca Baja and the northern Mixteca Alta, are the regions with the highest number of migrants. It is no coincidence that weaving has died out in those areas.

The loom has been abandoned in several communities of Oaxaca only in the last few decades. Certain fibers, such as *chichicaztle* and wild silk, and certain weaving techniques, such as weft-wrap openwork, have been lost. In some cases, even the designs have been forgotten, and no old textiles have survived for documentation. In many communities where the loom persists, women active today may be the last generation to weave. They often state regretfully that their daughters are too busy, feel embarrassed, or simply do not have the interest to learn the art.

During the weddings of the African-Mexican people of the coast of Oaxaca and Guerrero, the families of the bride and the groom traditionally exchanged a chant that played down the abilities of the young woman, as if to make her less desirable and keep her with her parents (Tibón 1961:44):

> Bride's family: "La novia no sabe jilá."
> > [The bride doesn't know how to spin.]
> Groom's family: "Así la queremoj!"
> > [That's how we want her!]
> Bride's: "La novia no sabe cosé."
> > [The bride doesn't know how to sew.]

Groom's: "Así la queremoj!"

 [That's how we want her!]

Bride's: "La novia no sabe molé."

 [The bride doesn't know how to grind maize.]

Groom's: "Así la queremoj!"

 [That's how we want her!]

This once-playful disparagement has now become a reality for most women in Oaxaca. Few girls growing up today have ever felt the twirling of the spindle in their hands to turn the fibers into thread, as do their grandmothers. Conservation of the diverse textile traditions of Oaxaca may allow children of the future to sense the magic of that experience.

Acknowledgments

Irmgard Weitlaner Johnson has generously shared her knowledge of textiles with me for twenty years. I am indebted to numerous persons in Oaxaca and Guerrero who have welcomed me, offering information and friendship. Manuel Sánchez Díaz taught me how to weave and how to speak the language of the loom. Bartola Morales García and Irma García Isidro have opened my eyes to symbolism. I am grateful to Angeles Romero, Manuel Esparza, Priscilla Small, and Javier Urcid, who sent me fascinating data. This chapter is dedicated to the memory of Lucina Cárdenas Ramírez, who died while working with indigenous weavers in the struggle for a dignified life.

Notes

1. Among the *sones* (the foremost genre of traditional Mexican music) from the Zapotec region of Juchitán and Tehuantepec in eastern Oaxaca, there is a beautiful tune known as "La Llorona." The well-known lyrics of this song, including the verses quoted here, were apparently composed earlier in this century by a Zapotec writer. Concha Michel recorded a slightly different version, which alludes to a huipil of lace (*huipil con blondas*, referring to the *bidaani ro'* [large huipil], of white lace worn as a head covering for ceremonial occasions) (Toor 1947: 443). In the repertory of the *son jarocho*, from Veracruz, there is also a *son de la Llorona*, with quite different lyrics, older in style and closer to the verses included in Covarrubias, also from the Isthmus (1946:329–30). The title and original theme of these *sones*, if not of the contemporary verses, is the Crying Woman, who haunts the night wailing for her dead children. La Llorona harkens to Cihuacóatl, the Serpent Woman goddess of the Aztecs who howled into the wind at night. Cihuacóatl is depicted in Aztec manuscripts holding a weaving batten in her hand. La Llorona also merges in legend with the cursed Malinche, Cortés's interpreter and mistress. Bartra (1992) dwells on the fusion of the Llorona/Malinche/La Chingada with the Virgin of Guadalupe, which he sees reflected in the verses quoted above: a subversion of the central icon of Catholicism and nationalism in Mexico that implies deeper nuances in the political symbolism of the huipil.

2. Mixtec, one of the two major language groups of Oaxaca, extends into Guerrero and Puebla. The Amuzgo people, a small group, are settled on both sides of the Oaxaca-Guerrero border in an area south of the Mixtec, close to the Pacific coast. As the state line does not represent an ethnic boundary, Mixtec and Amuzgo textiles from eastern Guerrero, which are well represented in the collection of the Regional Museum of Oaxaca, are included in this discussion.

3. Trique and Triqui are the conventional names by which both this language and the people who speak it are known. However, Trique scholars from San Andrés Chicahuaxtla, who have developed an orthography for their language, consider Drike to be a more appropriate term to refer to their people. Likewise, indigenous intellectuals in Oaxaca advocate the use of the self-designations Ayuuk and Ikood to refer to the people known respectively as Mixe and Huave. The name Huave, in particular, has negative connotations in Isthmus Zapotec. The Ikood are also known locally as Mareños.

4. Greenberg (1987), following earlier proposals by Freeland and Radin, considers Huave and Mixe-Zoque to be affiliated with Mayan and Totonacan as a Mexican branch of the Penutian stock, and he links Tequistlatec with Hokan, as proposed by Kroeber. Hokan and Penutian are the major language stocks of the native peoples of California. Greenberg also follows Lehmann's and Sapir's placement of Tlapanec-Subtiaba in Hokan, but Suárez's affiliation of Tlapanec with Otomanguean seems to be generally accepted.

5. The term *Tequistlatec*, widely cited in the anthropological and linguistic literature, is not used in Oaxaca. It appears to have been misderived from the name of the town of Tequisistlán. (Following the Náhuatl pattern for deriving designations for people from place names, the expected term would be *Teccisteco* or *Tequisisteco*.) The term seems to have been devised to avoid confusion with the Mayan Chontal of Tabasco and other peoples of southern Mexico and Central America, who were referred to as *chontalli* (stranger) in Náhuatl.

6. Important enclaves included the city of Oaxaca, the towns of Villa Alta and Nejapa to the east, the major towns in the Mixteca to the west, and the cattle-raising area on the coast to the southwest. As early as 1580 (Relación de Chichicapa, in Acuña 1984:69), a chronicler noted that people in the villages closer to the city of Oaxaca were the most "benefited," referring evidently to the cultural influence that the Spaniards exerted on them, an influence that must have affected indigenous clothing. A Spanish-speaking colonial enclave appears to be the origin of the *cuerudos*, leather-clad mestizo ranchers of Miahuatlán and Zoquitlán (Rojas 1958).

7. Following that criterion, the indigenous population reported for Oaxaca in 1990 was 1,018,106 persons, representing 39 percent of the total population of the state (INEGI 1991). To this figure would have to be added the large numbers (estimated at hundreds of thousands) of speakers of languages indigenous to Oaxaca who have migrated to Mexico City and other urban areas, as well as to the agribusiness centers of northwestern

Mexico and the United States. Furthermore, anthropologists doing field-work in Oaxaca have cast doubt on the reliability of the official census figures, estimating that the number of speakers of various languages is considerably higher.

8. A salient example of this is the differences in women's costumes of the neighboring Mixe communities of Ayutla, Tamazulapan, Tlahuitoltepec, Mixistlán, Yacochi, Chichicaxtepec, Totontepec, Tiltepec, Zacatepec, and Cotzocón, described by Kuroda (1993). Similarly divergent are the costumes of the Mixtec communities of San Juan Piñas, Santos Reyes Xochiquilazala, Coicoyán de las Flores, Tilapa, Jicayán de Tovar, and Yucucani, all situated in proximity (de Avila B. 1986–90).

9. In the Mixe example cited previously, Ayutla adopted Victorian skirts and long-sleeved, ruffed blouses of colored fabrics, and Tlahuitoltepec developed a distinctive long-sleeved blouse of *manta* (a white cotton muslin) embroidered with a sewing machine, which also seems to follow a Victorian model; Totontepec, like Camotlán and other Mixe villages to the southeast, adopted a short-sleeved chemise (also of *manta* embroidered with a sewing machine) of a style popular in Mexico earlier in the nineteenth century. Tamazulapan, Mixistlán, Yacochi, Chichicaxtepec, Tiltepec, Zacatepec, and Cotzocón, in contrast, retained the huipil; in Chichicaxtepec, *manta* substituted handwoven cloth for the huipil, while in Mixistlán and Yacochi a long-sleeved shirt later displaced the huipil. A similar series of changes took place in the area of Coicoyán: Tilapa and other communities to the west retained the huipil, while San Juan Piñas, Coicoyán, and Jicayán adopted the short-sleeved *manta* chemise embroidered by hand. Xochiquilazala developed a long-sleeved embroidered blouse of manta. Yucucani adopted Victorian-style blouses and skirts of colored fabrics. A long-sleeved Victorian blouse of printed cotton also became popular in Coicoyán, worn over the older embroidered short-sleeved chemise. These examples illustrate the complexity of cultural dynamics in Oaxaca, as reflected in costume. In no other area of Meso-america do the coexistence and mixture of styles associated with different historical periods, and the development of new forms, seem so diverse.

10. Community distinctions are well marked in the clothing of Trique (as between Chicahuaxtla, Copala, and Itunyoso) and Amuzgo (as between San Pedro Amuzgos, Xochistlahuaca, and Zacualpan), two small ethnic enclaves in Oaxaca and Guerrero. Among the Chatino, a relatively small group that maintains distinctive dress, the textiles from the different communities in the Juquila area do not appear to be distinguishable, but the linguistically divergent communities of Zenzontepec and Tatltepec appear to have worn distinctive costumes. Unfortunately, textiles from this area have not been well documented.

11. An example of this is the huipils of the Mixtec communities of San Miguel Progreso and Santa María Yucunicoco, which have more design and technical features in common with the huipils of their Trique neighbors of Chicahuaxtla and Itunyoso, respectively, than with those of other Mixtec villages. Other illustrative cases are the weavings of the Cuicatec community of San Andrés Teotilalpan and the Mixtec village of San Juan Coatzospan, which resemble closely the textiles of their Chinantec and Mazatec neighbors respectively. The adoption of new clothing styles orig-inating among the Isthmus Zapotec by the surrounding Huave, Chontal, Mixe, Chimalapa Zoque, and Sierra Sur Zapotec communities has been

well documented (Cordry and Cordry 1968:273). Even before the devel-opment of the sewing-machine-embroidered short huipil and the *rabona* (a long ruffled skirt), the Isthmus Zapotec shared with the Huamelula Chontal, the Huave, and the Chiapas Zoque the use of a finely woven huipil as a head or shoulder covering (Linati 1828; Martínez Gracida 1986:31; Cordry and Cordry 1968:327, 332–34); the armholes of this huipil were not used. The contemporary *biðaani ro'* of lace evolved from this earlier garment, which relates further to the huipil, formerly used as a head cover in San Bartolo Yautepec. It also relates to the *xiko ka'nu* (large huipil) — in contrast to the *xiko unda* (two-hand, i.e., two-web) huipil, worn as a shoulder wrap and designated *tralla* in the literature of the Mixtec com-munities of the district of Jamiltepec. The armholes of the *xiko ka'nu* were not used, except, apparently, in the garment's final use, when it was put on a deceased woman for burial. Mapelli-Mozzi and Castelló Yturbide (1965) report that the brocaded huipil formerly employed in the Huave community of San Mateo del Mar as a shoulder cover, with the designs showing on the back, was put on the deceased woman with the arms through the armholes and the brocaded motifs showing on the front. The distribu-tion of the *biðaani ro'-xiko ka'nu*, and the ritual restrictions associated with it, among unrelated linguistic groups along the Pacific coast suggest that it may represent a trait that was formerly more widespread in the region.

12. The reliability of these dates is questionable. Long et al. (1989) have reassessed the age of early maize remains from Coxcatlán Cave and other sites in the Tehuacán Valley using the accelerator mass-spectrometry method of radiocarbon dating. Their oldest dates fall between the second and third millennia B.C.E., thousands of years later than earlier estimates. There appears to be no evidence for agriculture in Mesoamerica until after 4000 B.C.E. (Fritz 1995:5).

13. Noncotton fibers excavated in the Tehuacán Valley caves were not identi-fied; Smith suggested that *Hechtia* or *Tillandsia* leaves, or perhaps very young leaves of *Agave* or *Yucca*, might be their source (letter quoted in Johnson 1967b:192).

14. Johnson (1967b:216) noted that woolen ponchos woven in Los Reyes Mezontla, a Popoloca village close to Coxcatlán in the Tehuacán basin, are finished with a loop-knotted fringe similar to the reinforcement on the archaeological piece; she reports similar finishes on rebozos and napkins from the Zapotec area of Miahuatlán. Warp-faced, striped woolen blan-kets (and formerly also cotton and silk bags and silk sashes) with weft-twined reinforcements at the warp ends are woven in the Mixtec area of Santa María Peñoles; the blankets are woven in two webs in plain weave with warp stripes or in twill weave with both warp and weft stripes. The similarity of the decorative reinforcement on these textiles to that of the mummy wrap from Coxcatlán Cave was noted by Cordry and Cordry (1968:288–89). These authors give the name of the town as San Sebastián Peñoles, an error followed by Lechuga (1982) and Sayer (1985).

15. Corded wefts that embellish the texture of plain weave are very common in the huipils, rebozos, and napkins from many areas of Oaxaca. Corded warps are less frequent; they are found in napkins from the Zapotec com-munity of San Bartolo Yautepec and in Mixtec huipils from Buenavista in Guerrero. The loom setup for weaving two-and-two twill from Teotongo, a Mixtec town in the district of Teposcolula, is described by Johnson (1967b:209); the same type of twill appears to have been used to weave

woolen blankets in Chocho villages of the Coixtlahuaca district and in the Náhuatl-speaking communities in the mountains east of Teotitlán del Camino, bordering the Mazatec area. Other types of twill weave are also known from Oaxaca. Plain gauze is common in various areas of Oaxaca and eastern Guerrero; brocaded gauze is known from northern Oaxaca and the Amuzgo area in Guerrero.

16. The fringe on the gauze fragment from Coxcatlán Cave consists of wefts held together by two sets of warps twined in opposite directions (Johnson 1967b:215). Twined fringes that match this description decorate contemporary napkins from the southwest coast of Oaxaca, apparently made by African-Mexican weavers. Similarly, fringes woven with a rigid heddle are sewn around the four sides of Amuzgo napkins from Xochistlahuaca and Mixtec napkins from Buenavista, both in Guerrero. Tlapanec napkins from Tlacoapa, Guerrero, and ritual cloths from the Zapotec community of San Agustín Loxicha, Oaxaca, also had a separately made fringe around the edges. Outside of this area, delicate gauze napkins with a fine-twined fringe decorating the four sides were formerly woven in central San Luis Potosí (de Avila B. 1980a).

17. Huipils from a number of Chinantec (Usila, Tepetotutla, Valle Nacional, and others) and Cuicatec (San Andrés Teotilalpan) communities include sections of brocaded gauze, most notably in a large rectangular area below the neck. Mazatec huipils from San Bartolomé Ayautla were formerly brocaded and embroidered on gauze. Some Amuzgo huipils from Xochistlahuaca, Guerrero, are woven entirely in gauze weave, with wide bands of brocading throughout the three webs.

18. Double cloth is a technique known by the Cora and Huichol in western Mexico, and the Otomí of the Valle del Mezquital and the central Querétaro area of central Mexico. It is generally used in bags and sashes made of wool or of wool and cotton (Sperlich 1995). Formerly this technique was also used by nonindigenous weavers in a large area of central and northeastern Mexico (de Avila B. 1980a).

19. The original publication (Johnson 1966–67) gives the Mixteca Alta as the provenance of these pieces, but Johnson (1987) considers that they were probably found somewhere in the Cuicatlán Canyon.

20. The *quechquemitl* survives among the indigenous peoples of central and western Mexico, as well as in the Huastec–Totonac–Sierra de Puebla region (Johnson 1953). Curiously, the Náhuatl term survived in Oaxaca in Hispanicized form to designate woolen ponchos worn by men (Esparza 1994:320—*casquemeles* worn in Santiago Tejupan, a Mixtec-Chocho community; Rojas 1958—*casquemes* used in the Miahuatlán District). The quechquemitl is not listed in the 1578 Zapotec vocabulary of the Dominican Friar Juan de Córdova, which gives glosses for various indigenous garments, including the huipil, skirt, loincloth, cloak, and even the *xicolli* (a sleeveless, jacketlike garment). It does not appear either in the 1593 Mixtec vocabulary of the Dominican Friar Francisco de Alvarado, which includes an even richer textile terminology, and it is not mentioned in the sixteenth-century Relaciones Geográficas (Acuña 1984). Throughout this text, the author has maintained the spelling of the original sources for indigenous terms as well as Spanish ones. Most of the Zapotec and Mixtec terms from the sixteenth-century vocabularies have cognates in modern dialects. For most of these terms contemporary forms

are not cited, as these often vary markedly. De Córdova was vicar in the communities of Huitzo, Teitipac, and Tlacochahuaya, all in the vicinity of the city of Oaxaca; his vocabulary represents Valley Zapotec dialects of the sixteenth century. De Alvarado was vicar of Tamazulapan in the Mixteca Alta; the title of the vocabulary specifies that he completed work begun by other Dominican scholars on Mixtec, probably based on the Yanhuitlán and Teposcolula dialects.

21. A similar reinforcement below a kilim-slit neck opening is evident in some Andean textiles: two Aymara huipil-like garments of alpaca wool from Bolivia illustrated in Adelson and Tracht (1983:52–55) show this feature; both are thought to date from the colonial period. Mapuche ponchos from Chile also show this feature.

22. The 1578 Zapotec vocabulary of Friar de Córdova ([1578]1942) does record the names of both the loincloth and the *xicolli;* in the case of the latter, the Spanish gloss appears to imply that it was no longer worn. Interestingly, the Zapotec term he lists for *çaraguelles,* the wide breeches worn at the time, is the same as one of the two words for loincloth, *làna, lati laana* (*lati* is the generic term for cloth). There does not appear to be any reference to the *xicolli* in the 1593 Mixtec vocabulary of Friar de Alvarado, but the loincloth is mentioned in connection with the phrase *ceñirse el mastel el indio* (to tie at the waist).

23. The collection of the Regional Museum of Oaxaca includes a coarse two-web brown and white striped cotton cloth from the Chontal area, apparently woven around 1960; it seems to be a re-creation of the old *gavilán.* There are also some elaborately decorated men's sashes from Jamiltepec and Santa Catarina Mechoacán in the collection.

24. The men's hip cloth had a wide distribution in Mexico until recently. Known as *patío* or *cotense,* it consisted of a square piece of cloth folded diagonally and tied around the waist, either with the knot on the belly or on the hip. It was made of *manta* and was worn over the *calzón* (loose trousers made of *manta*) by mestizos in a large area of central and northern Mexico (de Avila B. 1980a), by the Chichimec in Guanajuato (Rojas González et al. 1957:248, 250), and by the Otomí in southern Querétaro (van de Fliert 1988: photograph between pages 64 and 65). It is still worn by the Rarámuri (Tarahumara) men in Chihuahua and apparently also by the Cora of Santa Teresa, Nayarit. Photographs taken by Lumholtz at the turn of the century document its former use among the northern Tepehuán (in combination with an interesting handwoven, diaperlike loincloth: Vélez Storey 1993:139) and Pima Bajo (Lumholtz 1904). A similar cloth was worn by Seri men (Felger and Moser 1985; Cordry and Cordry 1968). Kiltlike garments worn traditionally by Yucatec and Cakchiquel Maya men may have a common origin with the *patío.* Sayer (1985:194) mentions that "rectangular cloths, worn like kilts over trousers and tied on one hip, appear in several turn-of-the century photographs from Oaxaca." The only example known to this author is the photograph by La Rochester published in Monsiváis (1978:2d pl.), and it is not clear whether the attribution to Oaxaca is reliable. Except for Altepexi, the garment has not been documented in any area of southern Mexico recently, although bandannas worn around the waist in some ritual dances perhaps derive from it. The hip cloth is salient, however, in the Postclassic record of Oaxaca, as in other areas of Mesoamerica. Anawalt (1981:209) found that it is the most widely used male garment in the codices and noted that its Náhuatl

name is unknown. The Relación Geográfica of Ixcatlán of 1579 mentions a textile that may represent this garment under the name *tapatío*, clearly a cognate of *patío*. Furthermore, the Relación provides a clue to interpret its Náhuatl name: the town of Quiotepec, at the confluence of the Tehuacán and Cuicatlán Valleys, paid tribute to the Aztecs in the form of gold and a load of *tapatíos*, which are described as square pieces of cotton cloth of a certain measure, valued at about fifty cacao seeds each (Acuña 1984:236). The mention of the price lends support to the etymology of *tapatío* as derived from the Náhuatl *tlapatiotl* (attested by de Molina 1571 as "precio de lo que se compra" [the price of what is purchased]) and *patío* ("cosa que tiene precio, o que vale tanto" [thing that has a price, or is worth so much]). Karttunen (1983:188) reconstructs a root *pati* that "has to do with worth or price and may also be related to *patla* (to exchange something)." The *tapatíos* of Quiotepec are probably synonymous with the mantillas, square pieces of white cotton cloth widely used as currency, mentioned by several early colonial sources. The Relación Geográfica of Atlatlauca of 1580 (Acuña 1984:49) relates how some of the tribute items paid to the Aztecs, which included cochineal, green stone gems, and precious feathers, were obtained from other areas in exchange for mantillas, "las cuales iban entre lo demás como moneda" [which went among them as coinage]. Coins of a certain denomination were known in New Spain as *tapatíos*, from which evolved the designation for people from Guadalajara, Jalisco (Santamaría 1959:1007). In the Yucatán Peninsula, *patí* designated white cotton cloth woven for tribute or trade (Santamaría 1959:817). Unfortunately, neither Cook de Leonard (1966) nor Cordry and Cordry (1968) recorded the Náhuatl name of the hip cloth formerly worn in Altepexi.

25. Examples in the collection of the Regional Museum of Oaxaca include the skirts from Huautla de Jiménez, with a band of heavy embroidery in wool, and a skirt from San Bartolomé Ayautla (ca. 1960), with a band of weft brocading in red and dark blue cotton thread of industrial manufacture. Old huipils from Ayautla similarly show a band of brocading on the bottom border, the rest of the garment being decorated with embroideries, which appear to have developed later in the textile history of this area.

26. The district of Villa Alta is particularly interesting in this regard. Large quantities of cloth were woven for trade in the eighteenth and nineteenth centuries in this area, which is characterized today by relatively plain, undecorated textiles. The 1777 Relación de Santa María Villa de Oaxaca calls the white cotton cloth for men's shirts "manta Rincona o Caxona" (Rincón and Cajonos are subareas of this region); the Relación de Jalatlaco mentions that great quantities of white cotton cloth for men's shirts and trousers came from the Villa Alta province (Esparza 1994:251, 400). Two nineteenth-century paintings conserved at the National Museum of Anthropology in Mexico City depict costumes from a number of villages in this region; other than stripes, there is no form of patterning on the textiles illustrated (Basauri 1940, 2:362–63).

27. Atlatlauca, a former Cuicatec town where Chinantec is spoken presently, is located upriver from the Cuicatlán Canyon. Guaxilotitlan, known today as Huitzo, is a large town at the northwestern end of the Valley of Oaxaca, where both Mixtec and Zapotec were formerly spoken. Nexapa, a large town where Zapotec was formerly spoken, lies in a broad valley on the upper basin of the Tehuantepec River; the Relaciones indicate that Nexapa was one of the areas where cotton was produced for trade.

Tecuicuilco, present-day Teococuilco, is a Zapotec community in the Sierra Juárez north of the Valley of Oaxaca. Miquitla refers to Mitla, an important Zapotec town at the eastern end of the Valley of Oaxaca.

28. Tanatepec was a Cuicatec village in the mountains south of the Cuicatlán Canyon; Itztepexic, present-day Santa Catarina Ixtepeji, is a Zapotec town in the Sierra Juárez; Macuilxóchitl is a Zapotec town in the Valley of Oaxaca. Peñoles, Mitlantongo, and Tamazola are Mixtec communities in the eastern Mixteca Alta. San Juan Mixtepec is a large Mixtec town on the border between the Mixteca Baja and Mixteca Alta in western Oaxaca; Tututepetongo was a Cuicatec village on the eastern slope of the Cuicatlán Canyon; Papaloticpac, present-day Pápalo, designates a number of Cuicatec communities in the mountains east of the Cuicatlán Canyon.

29. Communities where commoners are reported to have worn cotton garments before the Spanish conquest include Tehuantepec, a Zapotec city on the Isthmus of Tehuantepec; Teotitlán, a Náhuatl-speaking community in the Tehuacán–Cuicatlán Valley; Ayutla, a Tlapanec community on the Guerrero coast; and Juxtlahuaca, a Mixtec town in the Mixteca Baja. Cotton was cultivated in the first three areas. Ixcatlán is an Ixcatec community on the western slope of the Tehuacán–Cuicatlán Valley.

30. A 1676 testimony mentions a load of *ropa mixteca* that was sent to Puebla to be sold there; the muleteer returned to Teposcolula with a silk huipil that was part of the shipment (Romero Frizzi n.d.:*legajo* 35, *expediente* 87). A receipt dated in 1603 stipulates a considerable amount of money received by a merchant to buy clothing "in this Mixteca" and sell it in Guatemala (*rollo* 3, doc. 15–6). A 1649 voucher records an even larger sum (5135 pesos) invested in "Castillian" and indigenous clothing (including huipils) and sold in Guatemala (*leg.* 40, *exp.* 9, f. 18).

31. The incomplete inventory, dated 1628, includes 875 huipils, 200 *ayates* (referring apparently to *tilmas*), and 200 *escapopules*. A large number (665) of the huipils are listed as "huipiles de pluma entera" (huipils of whole feathers), and 210 are listed as "huipiles tachiguales." The *ayates* are quoted as "amarillos con sus çanefas" [yellow with a decorative band at the border]. The terms *tachiguales* and *escapopules* are interesting, as they seem to indicate that the Spanish and Mixtec traders used a commercial vocabulary derived from Náhuatl to refer to textiles of different grades. *Tachigual* is a Hispanicized rendering of *tlachihualli*, designating manufactured objects. The term is still used in some areas in Mexico, such as Tuxpan in Jalisco, to differentiate textiles woven on the backstrap loom from industrial cloth. It is not clear what *escapopules* were, but the name appears to derive from *ichcapopol*; the etymology would be *ichca(tl)* (cotton) and *-popol*, plural of the derogative compounding element *-pol*, which implies large size or great degree (Karttunen 1983:202). The term would seem to apply to some coarse cotton textiles.

32. Evidence for precolumbian economic exchange between Oaxaca and areas to the southeast is provided by the 1579 Relación of Itztepexic, which describes how indigenous men would travel to Tehuantepec, the Soconusco, and Guatemala, where they would hire themselves out as porters (presumably for merchants) and agricultural workers, in order to earn funds to pay tribute to their Aztec and Mixtec overlords (Acuña 1984, 1:255).

33. Osborne (1965) illustrates the Zapotec sash from Jalieza that was worn in Mixco. A *cofradía* headdress composed of woolen cords, which was collected in Mixco early in this century and is conserved at the Middle American Research Institute of Tulane University, includes green wool *tlacoyales* that were made in the Valley of Oaxaca. Morgadanes (1940) noted similarities between the women's costumes of Mixco in Guatemala and the Zapotec town of Yalalag, including the use of heavy *tlacoyal* headdresses; these similarities, however, appear to have developed independently from shared precolumbian antecedents, rather than through contact or influence between the two areas. Schevill (1994) has examined the strong influence of Mexican sarapes on tapestry blankets formerly worn by Quiché religious cargo holders in Totonicapán; Oaxacan sarapes do not appear to have been a source of design in this case.

34. The Zinacantan wedding huipil is also unique among highland Maya three-web huipils in having a V-shaped neck slit rather than a square or round neckhole; below the neck and above the rectangular brocaded design, there is a horizontal bar analogous to the decoration found on various huipils from Oaxaca, derived from a twined reinforcement.

35. In addition to the *huipiles de pluma* that would have been acquired through trade, Maya weavers decorated some of their own textiles with feathers; Landa's account of sixteenth-century Yucatán mentions that one of the duties of Maya women was to raise birds whose feathers were woven into cloth (Tozzer 1941).

36. Overtrousers are described in some of the Relaciones to be of woolen fabric woven in Querétaro or Puebla. Overtrousers were still used in some indigenous communities in Oaxaca at the turn of the century, as illustrated by Starr's photograph of a group of Zapotec men from San Bartolo Yautepec (1899:CIV) and by Martínez Gracida's plates depicting Coixtlahuaca Chocho and Huamelula Chontal men (1986, 5:pls. 99, 110; Esparza 1980). Basauri (1940, 1:50) includes a turn-of-the-century photograph attributed to Petapa, a Zapotec community on the Isthmus of Tehuantepec; the man wears dark split overtrousers. At present this garment is only used in some ritual dances, but it was commonly worn in other parts of Mexico until recently. Zoque men of Tuxtla Gutiérrez, Chiapas, wore decorated overtrousers of leather in the 1930s (Cordry and Cordry 1968:170, 334; Basauri 1940, 3:389). Called *pantaloneras, calzoneras,* or simply *neras,* overtrousers split down the sides, often buttoned, were commonly worn by nonindigenous men in rural areas of San Luis Potosí and other regions of central and northern Mexico earlier in this century (de Avila B. 1980a). Anawalt regards the split overtrousers worn by Mam men in Todos Santos Cuchumatán, Guatemala, as an example of "innovative traits that . . . came into being through the process of internal change. . . . These . . . came about not through direct diffusion from the outside but rather as the result of innovative forms being created within the socio-cultural system" (Anawalt 1977:110). The wide distribution of similar garments in Mexico, however, suggests that the Mam overtrousers are not, after all, a case of innovation.

37. The continuity between eighteenth-century and contemporary costume in the Mixtec communities of the coastal district of Jamiltepec is particularly well documented. The Relación of Santa María Huazolotitlán describes in detail men's and women's garments of hand-spun cotton, mentioning white shirts with *Purpura* and *coyuche* (natural brown cotton) stripes and sashes with decorated fringes, as well as white huipils and striped skirts of blue cotton and red silk, all of which are still worn at present in Huazolotitlán and neighboring villages (Esparza 1994:173).

38. Embroidery samplers appear to have been made by indigenous women in other areas of Mexico in the nineteenth century: a *dechado* in possession of the author, which seems to have originated in the Puebla-Tlaxcala area, was embroidered with silk on linen, both imported from Europe, and signed "Maria Soledad Noma"; *noma* is "my hand" in Náhuatl.

39. Salient examples of these techniques (the asterisks indicate pieces represented in the collection of the Regional Museum of Oaxaca) are the following: (a) *pepenado de hilván* (running stitch)—blouses from a number of Mixtec villages in the Juxtlahuaca district; (b) cross stitch—Zapotec blouses from San Vicente Coatlán,* Santa Lucía Miahuatlán, and San Lorenzo Texmelucan, and Chatino blouses from Santiago Yaitepec* and other villages in the area of Juquila; (c) *pepenado fruncido* (smocking)—blouses from San Pablo Tijaltepec (Mixtec); (d) chaquira bead embroidery—mestizo and African-Mexican blouses from Pinotepa Nacional, Ometepec,* and formerly other communities of the Guerrero coast (Gadow 1908:270), and blouses from Teococuilco (Zapotec)*; (e) drawnwork—blouses from Tlacolula and San Antonino Castillo Velasco* (Zapotec); (f) satin stitch with floral motifs—blouses from San Antonino Castillo Velasco* and other villages in the Valley of Oaxaca, as well as huipils from Santo Tomás Mazaltepec* and elaborate huipils and skirts from the Zapotec of the Isthmus of Tehuantepec* (all Zapotec); (g) sewing-machine embroidery—huipils and skirts from the Isthmus,* huipils and blouses from the area of Zoogocho* (Zapotec), and blouses from Tlahuitoltepec* and other Mixe villages*; (h) crochet—blouses from Mitla* and San Antonino Castillo Velasco* (Zapotec).

40. Examples of this are the elaborate blouses of San Antonino Castillo Velasco in the Valley of Oaxaca and the blouses of the area of Zoogocho in the Sierra Juárez. These blouses differentiate dress conspicuously in areas where neighboring communities traditionally wore a simple white huipil. The earlier use of a plain huipil in San Antonino was documented by Anita Jones (Cordry and Cordry 1968:140–42).

41. Examples are the portraits of a Mixtec woman from Yodocono (Starr 1899:68) and a Cuicatec woman from Pápalo (pl. 138).

42. Similar developments probably occurred in other areas, where documents from the late nineteenth century comparable to Starr's photographs are lacking. Other communities in which contemporary textiles are decorated more profusely than examples dating from the earlier part of this century include Xochistlahuaca and its neighbors (Amuzgo), Ixtayutla, Zacatepec, and the area of Metlatónoc (Mixtec is the language spoken in the last three areas).

43. Cordry and Cordry (1968:137) believed that the huipils woven with floating supplementary wefts, decorated with prancing horses and other animal motifs, which they observed among Mixtec women from the area of Metlatónoc who had recently settled on the Guerrero coast, were a recent innovation that had supplanted an earlier style characterized by geometric motifs woven in 3/1 brocading. The author's research in Chilixtlahuaca, Llano Perdido, Buenavista, Yoloxóchitl, Tlacoapa, Jicayán de Tovar, Santiago Tilapa, Coicoyán, and other communities in this region, does not

support this notion. Both techniques of brocading are attested to in weavings from this area dating from the early part of this century. Floating weft brocading is preferred in the western communities within this area, such as Citlaltepec, Chilixtlahuaca, and Buenavista, and 3/1 brocading is more common in the eastern communities, such as Cochoapa. Weavers in some communities use both techniques, as well as other supplementary weft weaves and gauze.

44. The semantic marker *ti-*, related to the free noun *kiti* (animal), precedes many animal names in various Mixtec languages (de Avila B. 1995); in some variants it has become fossilized and tends to have undergone phonological changes, whereas in Mixteca Baja and Guerrero Mixtec it remains productive as a classifier (de León Pasqual 1980). It is also applied to some supernaturals, such as the devil, in some Mixtec languages. The reduplication of this marker in the term *titia'a* would seem to signal the distinction of a mythical creature from an ordinary eagle, which may have been glossed earlier as *tiya'a*. The phonological change from *titiya'a* to *titia'a* and *ticha'a* is not unusual, as exemplified by the well-documented shift from *tiyaka* (fish) to *tiaka* and *chaka* in some dialects (de León Pasqual 1980).

45. The author heard this myth in Chilixtlahuaca in 1983 from two women of about fifty years of age. Other people in the community were familiar with the story, which was offered spontaneously during a conversation about the names of woven designs.

46. The myth of the twins from San Miguel el Grande, a Mixtec community in the Mixteca Alta, involves a large snake rather than an eagle (Dyk 1959:15). As in the Chatino story, the twins kill it and take out its eyes. Similarly, in an elaborate version recorded by Priscilla Small (1971) in San Juan Coatzospan, a Mixtec enclave in the Mazatec area, the twins kill a seven-headed snake and take out its eyes. The theme of a two-headed eagle that devoured people is also known in Coatzospan, but it is not part of the sun-and-moon story (Cayetano Porras 1989). This suggests that early versions of the myth did not involve the two-headed eagle even among the Mixtec. Codex Baranda, a deerskin manuscript believed to have been painted in western Oaxaca in the seventeenth century, depicts a young man throwing hot stones from an oven into the mouth of a huge rattlesnake; this scene appears to illustrate the killing of the monster in the sun-and-moon myth (Vázquez 1983).

47. Franco notes that hockers are common in western Mexico from the Preclassic on, but they are very rare in other areas of Mesoamerica before the Toltec period, at which time they become frequent, "particularmente en la zona de influencia de la cultura mixteca" [particularly in the area of influence of the Mixtec culture] (Franco 1967:176). He points out that this motif is most prevalent on spindle whorls and on stamps possibly used to print designs on cloth. The most salient archaeological textile from western Mexico is a weft-wrap openwork fabric found in a cave in the area of San José de Animas in Durango. The dominant design on this textile is a "stylized, double-headed bird, animal or serpent" (Johnson 1976b:68).

48. The double-headed eagle tends to co-occur in textiles (both in the area of Metlatónoc and in the western Chinantla, as in other areas of Oaxaca and elsewhere in Mexico and Guatemala) with designs that appear to be derived from the crowned lion, another motif of European heraldry that was prominent in colonial Mexico; this lends support to the hypothesis

that the Habsburg emblem provided the model. Double-headed birds, however, have also been documented in precolumbian pottery (Delgado Pang 1977:394). Colonial illustrations of indigenous textiles featuring the double-headed eagle and the lion include two huipils in a wedding scene in the notorious *Retablo de los sacramentos* (1735) of the church of Santa Cruz in Tlaxcala (Sebastián 1992:37). The motifs occupy the central rectangle below the neck of a wide, vertically striped white and brown huipil, reminiscent of the colonial textile that Miguel Covarrubias (Johnson n.d.) christened "huipil de la Malinche." This huipil, woven with warp stripes of white and *coyuche* cotton and brocaded with feathers, silk, and wool, shows a large double-headed eagle inside a large rectangle below the neck (Johnson 1993:87). Double-headed eagles are prominent on the chest of a white-on-white huipil depicted in an eighteenth-century *castas* painting (García Sáiz 1989:185) and in a red and white huipil with designs that suggest the use of *plangi* (a tie-dye technique used on cloth), in an eighteenth-century portrait of an indigenous aristocrat (Armella de Aspe et al. 1988). The double-headed eagle was evidently one of the most prominent motifs in indigenous textiles of the late colonial period, and probably earlier.

49. One of storytellers interviewed by Miller specified that the bird was a hummingbird. McCafferty and McCafferty (1994) discuss precolumbian depictions of a bird perched on the loom where a woman (sometimes interpreted as a goddess) is weaving; the best-known example is a Jaina terra-cotta illustrated by Cordry and Cordry (1968:46).

50. Spinning cups made of rock crystal and onyx were found in Tomb 7 of Monte Albán, and a beautiful example of fine polychrome pottery with a hummingbird perched on its rim was excavated in the Zaachila tombs. The main personage buried in Tomb 7 may in fact have been a woman (McCafferty and McCafferty 1994).

51. Geometrical patterns inspired by textiles are frequent in polychrome pottery of the Postclassic period from Oaxaca and Central Mexico. Designs composed of hollow circles, strongly reminiscent of the *plangi* technique, decorate some of these archaeological pieces. Tripod vases of the same shape are depicted in wedding scenes in the Mixtec codices and are associated with the bride's lineage (Lind 1995). A precolumbian Mixtec ornament of gold and turquoise mosaic, known as the Yanhuitlán brooch, is decorated with a stepped fret, a common motif in Mesoamerican and Andean textiles.

52. McCafferty, McCafferty, and Hamann (1994) and other scholars have linked the Mitla mosaics to weaving but have not documented the use of those designs in Oaxacan textiles. White-on-white brocaded ceremonial huipils formerly worn in coastal Mixtec communities were decorated with geometric motifs that resemble closely some of the Mitla carvings (Cordry and Cordry 1968:69fig.). Huipils from Nuyoo and other nearby Mixteca Alta communities also show stepped frets and other geometrical patterns reminiscent of the Mitla mosaics (Johnson 1976b). Weavers in Teotitlán del Valle began to copy designs from the Mitla walls early in this century. They produced sarapes with strongly geometric designs that were widely traded in village markets before the 1960s, when most of the production shifted to the tourist market. Teotitlán textiles influenced sarapes woven by men on treadle looms in Chalcatongo and the Tlaxiaco area, as well as blankets woven on the backstrap loom by Mixtec women in

Santiago Tlazoyaltepec, Santa María Peñoles, and a community in the municipality of Metlatónoc. These textiles are produced mostly for local use. The influence of Teotitlán tapestry was especially marked in Tlazoyaltepec, where the warp-faced, plain-weave blankets woven earlier have almost disappeared. Peñoles women continue to weave blankets in a variety of twill weaves and in warp-faced plain weave, in addition to tapestry. Tlazoyaltepec weavers have developed a distinctive style with simple, strongly contrasting geometric patterns in black, gray, and white wool. Their elegant, well-balanced geometric patterns illustrate the rapid evolution of textile design.

53. While the discussion of motifs and symbolism in this paper has focused on the continuity of precolumbian and early colonial patterns, it is important to emphasize the versatility of weavers and embroiderers in Oaxaca. New techniques and styles of design have been adopted and adapted periodically. Motifs inspired by cross-stitch samplers, especially popular in the nineteenth century, have been elaborated and rearranged in a myriad ways in Zapotec blouses from San Vicente Coatlán, San Lorenzo Texmelucan, Santa Lucía Miahuatlán, and other communities, as well as in Chatino blouses from the communities around Juquila. Dazzling curvilinear designs, taken from the embroidery booklets that became popular around 1950, appear in Chinantec huipils from Valle Nacional and other communities, amplified in scale, rotated, and juxtaposed in complex combinations in which the original models are not easily recognizable. Isthmus Zapotec women, working with old sewing machines, have developed an extremely varied repertoire of chain-stitched designs by criss-crossing diagonal lines of different colored threads in complex sequences, a technique of their own invention (Scheinman 1991:63–88). Justina Oviedo, an extraordinary weaver from the Huave community of San Mateo del Mar, has developed ingenious new techniques on the backstrap loom, including two-faced weft brocading and round weavings (Connolly 1985; Lechuga 1982:57). These and other examples attest to the undiminished creativity of textile artists in Oaxaca.

54. The *flor de piña* (pineapple flower), danced by the delegates from Tuxtepec, was choreographed expressly for the Guelaguetza; other dances have been "enriched" with new movements (González Ríos 1993:12–14). G. Johnson (1994:25) illustrates a group of young, nonindigenous women doing the dance, wearing Chinantec huipils from Usila, Ojitlán, and Valle Nacional, as well as Mazatec huipils from Jalapa de Díaz. The caption reads "Mazatecs at the Guelaguetza," an eloquent example of misrepresentation.

55. The division of the state into seven regions is itself problematic, as it does not recognize the large indigenous populations inhabiting the Sierra Sur mountains inland from the Pacific coast.

56. In the case of Oaxaca, museum collections include very few textiles from the 1970s to the present. Furthermore, there has not been a systematic effort to collect materials from all regions and ethnic groups. Large, culturally important regions of the state, such as the eastern Chinantla, the Rincón, the Silacayoapan and Juxtlahuaca districts, the Zenzontepec–Amoltepec–Textitlán–Texmelucan area, and the Coatlán–Loxicha–Ozolotepec communities, among others, are poorly represented.

References

Acuña, René, ed.
1984 *Relaciones geográficas del siglo 16, Antequera.* Serie Antropológica. Mexico City: Instituto de Investigaciones Antropológicas, Universidad Nacional Autónoma de México.

Adelson, Laurie, and Arthur Tracht
1983 *Aymara Weavings: Ceremonial Textiles of Colonial and Nineteenth-Century Bolivia.* Washington, D.C.: Smithsonian Institution Traveling Exhibition Service, Smithsonian Institution.

Aguirre Beltrán, Gonzalo
1958 *Cuijla: Esbozo etnográfico de un pueblo negro.* Mexico City: Fondo de Cultura Económica.

Anawalt, Patricia R.
1977 Suggestions for methodological approaches to the study of costume change in Middle American indigenous dress. In *Ethnographic Textiles of the Western Hemisphere*, ed. Irene Emery and Patricia Fiske. Washington, D.C.: Textile Museum.
1981 *Indian Clothing before Cortés: Mesoamerican Costumes from the Codices.* Norman: University of Oklahoma Press.

Aquino, Víctor Manuel
1987 Communication with the author. Sericulture promotion project, Centro de Graduados e Investigación, Instituto Tecnológico de Oaxaca.

Armella de Aspe, Virginia, Teresa Castelló Yturbide, and I. Borja Martínez
1988 La historia de México a través de la indumentaria. Mexico City: INBURSA.

Barabas, Alicia, and Miguel A. Bartolomé
1986 La pluralidad desigual en Oaxaca. In *Etnicidad y pluralismo cultural: La dinámica étnica en Oaxaca*, ed. A. Barabas and M. Bartolomé. Mexico City: Colección Regiones de México, INAH.

Bartolomé, Miguel A.
1984 *El ciclo mítico de los hermanos gemelos sol y luna en las tradiciones de las culturas oaxaqueñas.* Oaxaca: Centro de las Culturas Oaxaqueñas, Centro Regional de Oaxaca, INAH.

Bartolomé, Miguel A., and Alicia Barabas
1982 *Tierra de la palabra, historia y etnografía de los chatinos de Oaxaca.* Colección Científica, no. 108. Mexico City: INAH.
1983 El ciclo de los gemelos en la Chinantla. *Guchachi' Reza* 17.

Bartra, Roger
1992 *The Cage of Melancholy: Identity and Metamorphosis in the Mexican Character.* New Brunswick, N.J.: Rutgers University Press.

Basauri, Carlos
1940 *La población indígena de México: Etnografía.* Mexico City: Oficina Editora Popular, Secretaría de Educación Pública.

Benítez, Fernando
1970 *Tierra de brujos.* Vol. 3 of *Los Indios de México.* Mexico City: ERA.

Berdan, Frances F., and Patricia R. Anawalt
1992 *Codex Mendoza.* Berkeley: University of California Press.

Boege, Eckart
1988 *Los mazatecos ante la nación: Contradicciones de la identidad étnica en el México actual.* Mexico City: Siglo XXI Editores.

Borah, Woodrow
1943 *Silk Raising in Colonial Mexico.* Ibero-Americana, vol. 20. Berkeley: University of California Press.

Brubaker, Curt L., and Jonathan F. Wendel
1993 On the specific status of *Gossypium lanceolatum* Todaro. *Genetic Resources and Crop Evolution* 40:165–70.
1994 Reevaluating the origin of domesticated cotton (*Gossypium hirsutum, Malvaceae*) using nuclear restriction fragment length polymorphisms (RFLPs). *American Journal of Botany* 81(10):1309–26.

Brumfiel, Elizabeth M.
n.d. Tribute cloth production and compliance in Aztec and colonial Mexico. In *Artisan Production: Tradition Transmitted and Transformed*, ed. June C. Nash and Enid Schildkraut. Forthcoming.

Byers, Douglas S., ed.
1967 *The Prehistory of the Tehuacán Valley.* Austin: University of Texas Press.

Cayetano Porras, Alejo
1989 *Cuentu iña tadun quiti uvi diquii.* Mexico City: Instituto Lingüístico de Verano.

Chiñas, Beverly N.
1973 *The Isthmus Zapotec: Women's Roles in Cultural Context.* New York: Holt, Rinehart and Winston.

A garden in front of a house in San Mateo del Mar. Photo by K. Klein.

Clark, James Cooper, ed.
1938 *Codex Mendoza*. Vol. 1. London: Waterloo and Sons Ltd.

Connolly, Loris
1985 The work of a Huave Indian weaver in Oaxaca, Mexico: Complex weaving structures utilizing one warp set and two complementary weft sets. *Ars Textrina* 3:7–46.

Cook de Leonard, Carmen
1966 Indumentaria mexicana: La indumentaria y el arte textil prehispánico. *Artes de México* 13(77–78):5–7.

Cook de Leonard, Carmen, Donald Cordry, and María Dolores Morales
1966 Indumentaria mexicana. *Artes de México* 13(77–78).

Cordry, Donald, and Dorothy Cordry
1968 *Mexican Indian Costumes*. Austin: University of Texas Press.

Covarrubias, Miguel
1946 *Mexico South: The Isthmus of Tehuantepec*. New York: Alfred A. Knopf.

Cruz Hernández, Modesta
1993 *N'on nan kobïjnd'ue n'an tzjon noan—Los usos de la madera entre los amuzgos*. Mexico City: Centro de Investigaciones y Estudios Superiores en Antropología Social.

de Alvarado, Francisco
1593 *Vocabulario en lengua misteca*. Mexico City: Casa de Pedro Balli.

de Avila B., Alejandro
1976–95 Field Notes on Textiles: Tlahuitoltepec and Tamazulapan Mixe, Oax.; Chilixtlahuaca, Llano Perdido, Buenavista, Yoloxóchil, and Tlacoapa, Guerrero; Pinotepa de Don Luis, San Juan Colorado, San Pedro Atoyac, Tulixtlahuaca, and Santiago Ixtayutla, Oax.; San Mateo del Mar and San Pedro Huamelula, Oax.; Santa María Peñoles, Santa Catarina Estetla, and Santiago Tlazoyaltepec, Oax.; Santa Lucía Miahuatlán, Oax.; San Pedro Quiatoni, Oax.; San Cristóbal Lachirioag, Oax.; San Juan Mixtepec and Santa María Yucunicoco, Oax.; San Pedro Cajonos, Oax.; Santiago Laxopa, Yahuío, and Guiloxi, Oax.; Coicoyán de las Flores and Santiago Tilapa, Oax., and Jicayán de Tovar, Guerrero; Santa María and San Miguel Chimalapa, Oax.; Zapotitlán Salinas, Puebla; Huautla, Chilchotla, and San José Tenango, Oax.; San Felipe Usila and Santiago Tlatepuzco, Oax.; San Pedro Mixtepec, Oax.; San Bartolo Yautepec, Oax.; Xochistlahuaca, Guerrero.
1980a Notes on the Ethnography of Central San Luis Potosí, Mexico. Bachelor's thesis, Tulane University, New Orleans.
1980b *Catalog for an Exhibit of Mexican Textiles*. Miscellaneous Series, no. 14. New Orleans: Middle American Research Institute, Tulane University.
1986–90 Ethnobotanical Field Notes and Herbarium Specimens, Coicoyán de las Flores, Oax., and Jicayán de Tovar, Guerrero. Oaxaca: SERBO, A.C., and Instituto Tecnológico de Oaxaca.
1995 Castilian Maize and Horned Deer: Notes on the history of plant and animal names in Mixtec. University of California, Berkeley.

de Córdova, Juan
1942 *Vocabulario en lengua zapoteca*. Impreso por Pedro Charte y Antonio
[1578] Ricardo en México. Reprint. Facsimile edition with introduction and notes by Wigberto Jiménez Moreno. Mexico City: Biblioteca Lingüística Mexicana, INAH-SEP.

de León Pasquel, Lourdes
1980 La clasificación semántica en mixteco. Tesis de licenciatura, Escuela Nacional de Antropología e Historia, Mexico City.

Delgado Pang, Hilda
1977 Similarities between certain early Spanish, contemporary folk Spanish, and Mesoamerican Indian textile design motifs. In *Ethnographic Textiles of the Western Hemisphere*, ed. Irene Emery and Patricia Fiske. Washington, D.C.: Textile Museum.

Dyk, Anne
1959 *Mixteco Texts*. Linguistic Series, no. 3. Norman: Summer Institute of
 Linguistics, University of Oklahoma.

Emery, Irene, and Patricia Fiske, eds.
1977 *Ethnographic Textiles of the Western Hemisphere*. Irene Emery Round-
 table on Museum Textiles, 1976 Proceedings. Washington, D.C.:
 Textile Museum.

Esparza, Manuel
1980 Fotografías de las acuarelas de la obra de Manuel Martínez Gracida.
 In *Los indios oaxaqueños y sus monumentos arqueológicos*. Estudios
 de Antropología e Historia, no. 23. Oaxaca: Centro Regional de
 Oaxaca, INAH.

Esparza, Manuel, ed.
1994 *Relaciones geográficas de Oaxaca, 1777–1778*. Oaxaca: Centro de
 Investigaciones y Estudios Superiores en Antropología Social and
 Instituto Oaxaqueño de las Culturas.

Felger, Richard S., and Mary B. Moses
1985 *People of the Desert and Sea: Ethnobotany of the Seri Indians*. Tucson:
 University of Arizona Press.

Fisher, Nora
1979 *Spanish Textile Tradition of New Mexico and Colorado*. Santa Fe: Museum
 of New Mexico Press.

Flannery, Kent V., ed.
1986 *Guilá Naquitz: Archaic Foraging and Early Agriculture in Oaxaca, Mexico*.
 Orlando, Fla.: Academic Press.

Flannery, Kent V., and Joyce Marcus, eds.
1983 *The Cloud People: Divergent Evolution of the Zapotec and Mixtec
 Civilizations*. New York: Academic Press.

Flores Villela, Oscar, and Patricia Gerez
1988 *Conservación en México: Síntesis sobre vertebrados terrestres, vegetación y uso
 del suelo*. Mexico City: Instituto Nacional de Investigación sobre los
 Recursos Bióticos and Conservación Internacional.

Franco C., José Luis
1967 La decoración del huipilli de Chilapa. *Revista Mexicana de Estudios
 Antropológicos* 21:173–89.

Fritz, Gayle J.
1995 New dates and data on early agriculture: The legacy of complex
 hunter-gatherers. *Annals of the Missouri Botanical Garden* 82:3–15.

Fryxell, Paul A.
1988 *Malvaceae of Mexico*. Systematic Botany Monographs, vol. 25.
 Ann Arbor, Mich.: American Society of Plant Taxonomists,
 University of Michigan Herbarium.

Gadow, Hans
1908 *Through Southern Mexico: Being an Account of the Travels of a Naturalist*.
 London: Witherby.

García Cubas, Antonio
1876 *The Republic of Mexico in 1876: A Political and Ethnographical Division of the
 Population, Character, Habits, Costumes. . . .* Mexico City: La Enseñanza
 Printing Office.

García Sáiz, María Concepción
1989 *Las castas mexicanas: Un género pictórico americano*. Mexico City: Olivetti
 de México.

González Ríos, Álvaro, ed.
1993 *Oaxaca, tierra de la pluralidad: La guelaguetza, breve semblanza*.
 Oaxaca: Instituto Oaxaqueño de las Culturas.

Greenberg, Joseph H.
1987 *Language in the Americas*. Stanford, Calif.: Stanford University Press.

INEGI (Instituto Nacional de Estadística, Geografía e Informática)
1991 *Oaxaca: Resultados definitivos tabulados básicos, vol. 2. XI censo general
 de población y vivienda, 1990*. Aguascalientes: INEGI.

Jeter, James, and Paula Maria Juelke
1978 *The Saltillo Sarape*. Santa Barbara, Calif.: New World Arts.

Johnson, Grace
1994 Native clothing of Oaxaca: Continuities and transitions. In *Cloth and
 Curing: Continuity and Change in Oaxaca*, ed. Grace Johnson and
 Douglas Sharon. San Diego Museum Papers, no. 32. San Diego:
 San Diego Museum of Man.

Johnson, Irmgard W.

1953 El quechquemitl y el huipil. In *Huastecos, totonacos y sus vecinos,*
 ed. Ignacio Bernal and Eusebio Dávalos Hurtado. Vol. 13, *Revista
 Mexicana de estudios antropológicos.* Mexico City: Sociedad Mexicana
 de Antropológicos.

1957a An analysis of some textile fragments from Yagul. *Mesoamerican
 Notes* 5:77–81.

1957b Survival of feather ornamented huipiles in Chiapas, Mexico. *Extrait
 du Journal de la Société des Americanistes,* n.s., 16:189–96.

1966–67 Miniature garments found in Mixteca Alta caves, Mexico. *Folk*
 (Copenhagen) 8–9:179–90.

1967a Un huipilli precolombino de Chilapa, Guerrero. *Revista mexicana de
 estudios antropológicos* 21:149–72.

1967b Textiles. In *Nonceramic Artifacts.* Vol. 2 of *The Prehistory of the Tehuacán
 Valley,* ed. Douglas S. Byers. Austin: University of Texas Press.

1976a *Design Motifs on Mexican Indian Textiles.* Graz, Austria: Akademische
 Druck- und Verlagsanstalt.

1976b Weft-wrap openwork techniques in archaeological and contemporary
 textiles of Mexico. *Textile Museum Journal* 4(3):63–72.

1989 Antiguo manto de plumón de San Miguel Zinacatepec, Estado de
 México, y otros tejidos emplumados de la época colonial. In *Enquêtes
 sur l'Amérique Moyenne: Mélanges offerts à Guy Stresser-Péan,* ed.
 Dominique Michelet. Mexico City: INAH, Consejo Nacional para la
 Cultura y las Artes, and Centre d'Études Mexicaines et
 Centraméricaines.

1993 Viceregal Feathered Fabrics. In *The Art of Featherwork in Mexico.*
 Mexico City: Fomento Cultural Banamex.

n.d. Communication with the author, Mexico.

Karttunen, Frances
1983 *An Analytical Dictionary of Náhuatl.* Austin: University of Texas Press.

King, Mary Elizabeth
1979 The prehistoric textile industry of Mesoamerica. In *Junius B. Bird
 Pre-Columbian Textile Conference,* 265–78. Washington, D.C.:
 Textile Museum.

1986 Preceramic cordage and basketry. In *Guilá Naquitz: Archaic Foraging
 and Early Agriculture in Oaxaca, Mexico,* ed. Kent V. Flannery. Orlando,
 Fla.: Academic Press.

Kuroda, Etsuko
1993 *Bajo el Zempoaltépetl: La sociedad mixe de las tierras altas y sus rituales.*
 Oaxaca: Centro de Investigaciones y Estudios Superiores en
 Antropología Social and Instituto Oaxaqueño de las Culturas.

Landa, Diego de
1941 *Landa's "Relación de las cosas de Yucatán."* Trans. A. M. Tozzer. Papers
 of the Peabody Museum of Archaeology and Ethnology, vol. 18.
 Cambridge, Mass.: [Peabody Museum].

Lechuga, Ruth D.
1982 *El traje indígena de México: Su evolución, desde la época prehispánica hasta la
 actualidad.* Mexico City: Panorama Editorial.

Linati, Claudio
1956 *Trajes civiles, militares y religiosos de México.* Reprint. Mexico City:
[1828] Imprenta Universitaria.

Lind, Michael
1995 Mixtec polychrome ceramics. Paper presented at the second Mixtec
 Gateway Conference, Las Vegas.

Long, A., B. Benz, J. Donahue, A. Jull, and L. Toolin
1989 First direct AMS dates on early maize from Tehuacán, Mexico.
 Radiocarbon 31:1035–40.

Lorence, David H., and Abisaí García Mendoza
1989 Oaxaca, Mexico. In *Floristic Inventory of Tropical Countries: The Status
 of Plant Systematics, Collections, and Vegetation, Plus Recommendations
 for the Future,* ed. D. G. Campbell and H. D. Hammonds. Bronx:
 New York Botanical Garden.

Lumholtz, Carl
1904 *Unknown Mexico.* New York: Charles Scribner's Sons.

MacDougall, Thomas, and Irmgard W. Johnson
1966 Chichicaztli fiber: The spinning and weaving of it in southern
 Mexico. *Archiv für Völkerkunde* 20:65–73.

MacNeish, Richard S., Antoinette Nelken-Terner, and Irmgard W. Johnson
1967 *Nonceramic Artifacts.* Vol. 2 of *The Prehistory of the Tehuacán Valley,*
 ed. Douglas S. Byers. Austin: University of Texas Press.

Mapelli-Mozzi, Carlotta, and Teresa Castelló Yturbide
1965–68 *El traje indígena en México.* Mexico City: INAH.

Martínez Gracida, Manuel
1986 *Los indios oaxaqueños y sus monumentos arqueológicos.* Index of the
[1910] 1910 manuscript, with a sample of the illustrations, ed. Genaro
 Vásquez Colmenares. Oaxaca: Gobierno del Estado.

Martínez Hernández, Ricardo
1990 *K'uk'umal chilil, el huipil emplumado de Zinacantan, Chiapas.* Tuxtla
 Gutiérrez: Casa de las Artesanías, Gobierno del Estado de Chiapas.

McCafferty, Geoffrey G., and Sharisse D. McCafferty
1994 Engendering Tomb 7 at Monte Albán: Respinning an old yarn.
 Current Anthropology 35(2):143–66.

McCafferty, Geoffrey G., Sharisse D. McCafferty, and Byron Hamann
1994 Powerful women of Pre-Columbian Oaxaca. Paper presented at the
 American Anthropological Association Meeting, Atlanta.

McKeever Furst, Jill L.
1995 *The Natural History of the Soul in Ancient Mexico.* New Haven, Conn.:
 Yale University Press.

Miller, Walter S.
1956 *Cuentos mixes.* Mexico City: Instituto Nacional Indigenista.

Monsiváis, Carlos
1978 *México . . . los de ayer: Colección Juan Manuel Casasola, fotografías
 1900–1928.* Mexico City: Ediciones Larousse.

Morales García, Bartola
1987 La elaboración de la indumentaria femenina chinanteca de Ojitlán,
 Oaxaca. Tesis de licenciatura, Secretaría de Educación
 Pública/Instituto Nacional Indigenista, Apetatitlán, Tlaxcala.

Morgadanes, Dolores
1940 Similarity between the Mixco (Guatemala) and the Yalalag
 (Oaxaca, Mexico) costumes. *American Anthropologist* 42:359–64.

Morris, Walter F., Jr.
1984 *A Millennium of Weaving in Chiapas.* San Cristóbal las Casas, Mexico:
 Sna' Jolobil.

Moser, Christopher L.
1975 Cueva de Ejutla: ¿Una cueva funeraria postclásica? *Boletín del INAH*
 14 (July–Sept.):25–36.
1983 A postclassic burial cave in the southern Cañada. In *The Cloud People:
 Divergent Evolution of the Zapotec and Mixtec Civilizations,* ed. Kent V.
 Flannery and Joyce Marcus. New York: Academic Press.

Nagengast, Carol, and Michael Kearney
1990 Mixtec ethnicity: Social identity, political consciousness, and political
 activism. *Latin American Research Review* 61:88.

Osborne, Lilly de J.
1965 *Indian Crafts of Guatemala and El Salvador.* Norman: University of
 Oklahoma Press.

Palma Cruz, F. J.
1991 El género *Agave* L. y su distribución en el Estado de Oaxaca. Thesis,
 ENEP Iztacala, Universidad Nacional Autónoma de México.

Parsons, Elsie C.
1936 *Mitla: Town of the Souls and Other Zapotec-speaking Pueblos of Oaxaca,
 Mexico.* Chicago: University of Chicago Press.

Past, Ambar, Lucina Cárdenas R., Erasmo Maldonado V.,
and Alejandro de Avila B.
1987 Memoria del curso de colorantes naturales en Santiago Laxopa.
 Oaxaca: GADE, A.C.

Peigler, Richard S.
1993 Wild silks of the world. *American Entomologist* 39(3):151–61.

Peigler, Richard S., Taeko Narumi, and Masahiko Kobayashi
1993 Fiber identification of *Eucheira socialis (Pieridae),* a Wild Silkworm
 from Mexico. In *Wild Silkmoths"92,* ed. H. Akai. Japan: International
 Society for Wild Silkmoths.

PROCEDE
1994 Consideraciones para la regularización de las tierras comunales—
 Propuesta operativa. Documento de trabajo, Dirección de Normas,
 Procedimientos y Evaluación, Dirección General del PROCEDE,
 Mexico City.

Rojas, Basilio
1958 *Miahuatlán, un pueblo de México: Monografía del distrito de Miahuatlán,
 Estado de Oaxaca.* Oaxaca: Papeles de Oaxaca.

Rojas González, Francisco, René Barragán Avilés,
and Roberto de la Cerda Silva
1957 *Etnografía de México: Síntesis monográficas.* Mexico City: Instituto de
 Investigaciones Sociales, Universidad Nacional Autónoma de México.

Romero Frizzi, Maria de los Angeles
n.d. Transcriptions of sixteenth- to eighteenth-century documents from
 the Judiciary Archive of Teposcolula, Oaxaca.

Rzedowski, Jerzy
1978 *Vegetación de México.* Mexico City: Editorial Limusa.
1993 Diversity and origins of the phanerogamic flora of Mexico.
 In *Biological Diversity of Mexico: Origins and Distribution,* ed.
 T. P. Ramamoorthy. New York: Oxford University Press.

Sánchez L., Alberto
1989 *Oaxaca, tierra de maguey y mezcal.* Oaxaca: Instituto Tecnológico
 de Oaxaca.

Santamaría, Francisco J.
1959 *Diccionario de mexicanismos.* Mexico City: Editorial Porrúa.

Sayer, Chloë
1985 *Costumes of Mexico.* Austin: University of Texas Press.
1990 *Mexican Patterns: A Design Source Book.* New York: Portland House.

Scheinman, Pamela
1991 A line at a time: Innovative patterning in the isthmus of Tehuantepec,
 Mexico. In *Textile Traditions of Mesoamerica and the Andes,* ed. Margot
 B. Schevill, 63–88. New York: Garland.

Schele, Linda, and Mary Ellen Miller
1986 *The Blood of Kings: Dynasty and Ritual in Maya Art.* New York: Braziller,
 and Fort Worth, Tex.: Kimbell Art Museum.

Schevill, Margot B.
1994 The communicative nature of indigenous and mestizo dress in
 Mexico and Guatemala. In *Cloth and Curing: Continuity and Change
 in Oaxaca,* ed. Grace Johnson and D. Sharon. San Diego Museum
 Papers, no. 32. San Diego: San Diego Museum of Man.

Sebastián, Santiago
1992 *Iconografía e iconología del arte novohispano.* Mexico City:
 Grupo Azabache.

Small, Priscilla
1971 The legend about the sun and the moon. Transcription and
 translation of a Mixtec myth narrated by Joaquín Mancera,
 San Juan Coatzospan.

Smith, C. Earle
1967 Plant remains. In *Nonceramic Artifacts.* Vol. 2 of *The Prehistory
 of the Tehuacán Valley,* ed. Douglas S. Byers. Austin: University
 of Texas Press.

Smith, Mary Elizabeth, and Ross Parmenter
1991 *The Codex Tulane.* New Orleans: Middle American Research Institute,
 Tulane University.

Sperlich, Norbert
1995 *Mexican Double-Cloth Weaving.* St. Paul, Minn.: Dos Tejedoras.

Starr, Frederick
1899 *Indians of Southern Mexico: An Ethnographic Album.* Chicago:
 Lakeside Press.

Stephen, Lynn
1991a Export markets and their effects on indigenous craft production:
 The case of the weavers of Teotitlán del Valle, Mexico. In *Textile
 Traditions of Mesoamerica and the Andes,* ed. Margot B. Schevill,
 381–402. New York: Garland.
1991b *Zapotec Women.* Austin: University of Texas Press.

Stephens, Stanley G.
1967 A cotton boll segment from Coxcatlán Cave. In *Nonceramic Artifacts.*
 Vol. 2 of *The Prehistory of the Tehuacán Valley,* ed. Douglas S. Byers.
 Austin: University of Texas Press.

Suárez, Jorge
1983 *The Mesoamerican Indian Languages.* Cambridge: Cambridge
 University Press.

Taylor, Anne
1995 Research file on Oaxaca sarapes. Hearst Museum of Anthropology,
 University of California, Berkeley.

Taylor, William B.
1979 *Drinking, Homicide, and Rebellion in Colonial Mexican Villages.* Stanford,
 Calif.: Stanford University Press.

Terraciano, Kevin
1996 Yuhuitayu Ñudzahui: Reading women into Mixtec history.
 Paper presented at the third Mixtec Gateway Conference, Las Vegas.

Tibón, Gutierre
1961 *Pinotepa Nacional: Mixtecos, negros y triques.* Mexico City: Universidad
 Nacional Autónoma de México.

Toor, Frances
1947 *A Treasury of Mexican Folkways*. New York: Crown Publishers.

van de Fliert, Lydia
1988 *Otomí en busca de la vida (ar ñäñho hongar nzaki)*. Querétaro:
 Universidad Autónoma de Querétaro.

Vázquez, Juan Adolfo
1983 The cosmic serpent in the Codex Baranda. *Journal of Latin American
 Lore* 9(1):3–15.

Vélez Storey, Jaime, ed.
1993 *El ojo de vidrio: Cien años de fotografía del México indio*. Mexico City:
 Banco Mexicano de Comercio Exterior.

Weitlaner, Roberto
1977 *Relatos, mitos y leyendas de la Chinantla*. Serie de Antropología Social,
 no. 53. Mexico City: Instituto Nacional Indigenista.

Wendel, Jonathan F., Curt L. Brubaker, and A. Edward Percival
1992 Genetic diversity in *Gossypium hirsutum* and the origin of upland
 cotton. *American Journal of Botany* 79(11):1291–310.

Wendel, Jonathan F., Andrew Schnabel, and Tosak Seelanan
1995 An unusual ribosomal DNA sequence from *Gossypium gossypioides*
 reveals ancient, cryptic, intergenomic introgression. *Molecular
 Phylogenetics and Evolution* 4(3):298–313.

Williams, Gerald
1964 *Textiles of Oaxaca*. Hanover, N.H.: Hopkins Center, Dartmouth College.

Winter, Marcus C.
1989 *Oaxaca: The Archaeological Record*. Mexico City: Editorial
 Minutiae Mexicana.

Winter, Marcus C., Margarita Gaxiola G., and Gilberto Hernández D.
1984 Archaeology of the Otomanguean area. In *Essays in Otomanguean
 Culture History*, ed. J. Kathryn Josserand, Marcus Winter, and
 Nicholas Hopkins. Vanderbilt University Publications in
 Anthropology, no. 31. Nashville: Vanderbilt University.

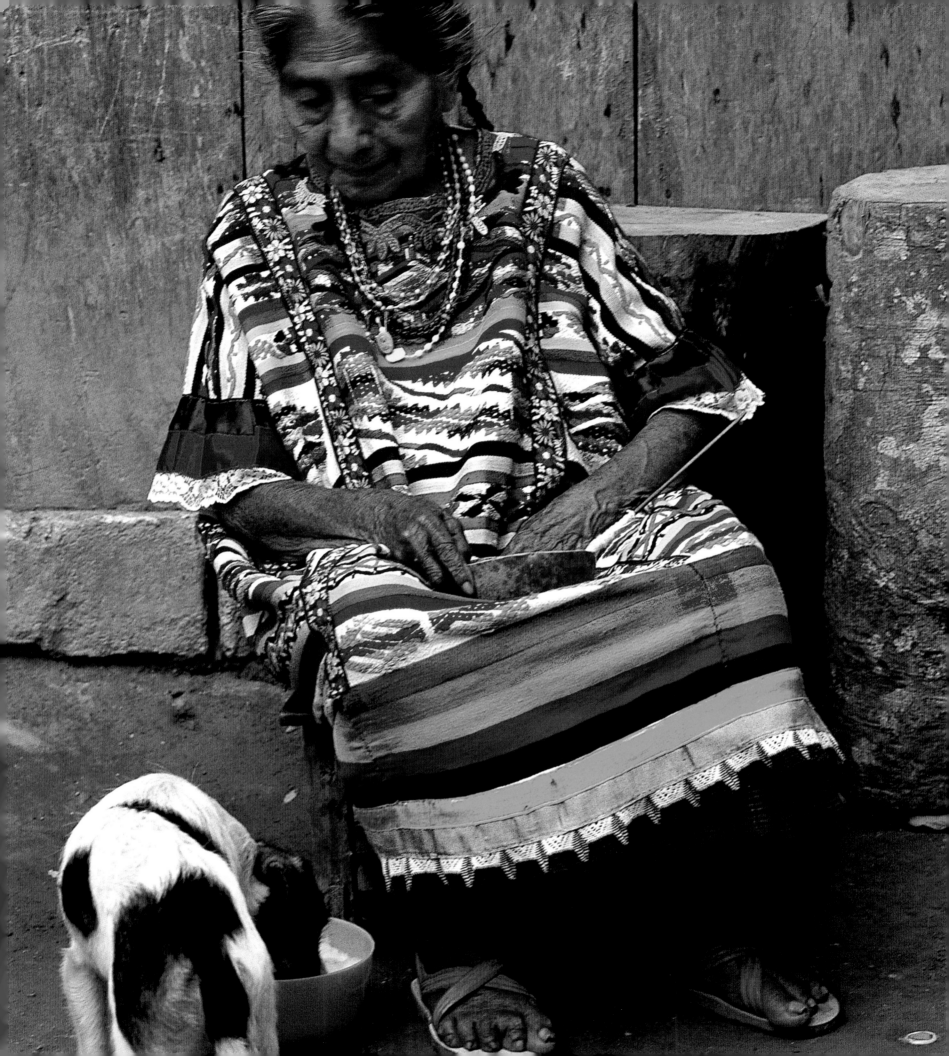

Afterword

Oaxaca Textile Fieldwork

Kathryn Klein

Weaver Guadalupe García and a dog in Usila, Oaxaca. Photo by J. López.

The original intent of this publication was to document the GCI textile conservation project and present practical information for the conservation of textile collections in Latin America. As the concept for the publication began to grow, however, the project expanded to include work in the field with the weavers of Oaxaca. Sometimes it was difficult to differentiate between the project and the publication: As the publication took on a life of its own, it provided further impetus to work directly with the weavers of Oaxaca, and as the project began to include working in the field, more information was found for the publication. At one point, the GCI authors had to stop researching and just write. But seeing that the ultimate goal is to conserve cultural traditions in states of transition, it is necessary to view the project in the same light and to find satisfaction in knowing that our work has only just begun and exists within the same continuum.

Few art conservators have the opportunity to work directly with the original artists. Imagine being able to ask Leonardo da Vinci questions about his materials and

Conservation fieldwork team at the Museum Shan-Dany. From left to right: Jesús López, Marilurdes Navarro, Juan Sánchez Rodriguez (a local weaver), Rosalía Navarro, Arie Wallert, Kathryn Klein. Photo by J. López.

Following pages:
Members of the local weaving cooperative with the author. Photo by J. López.

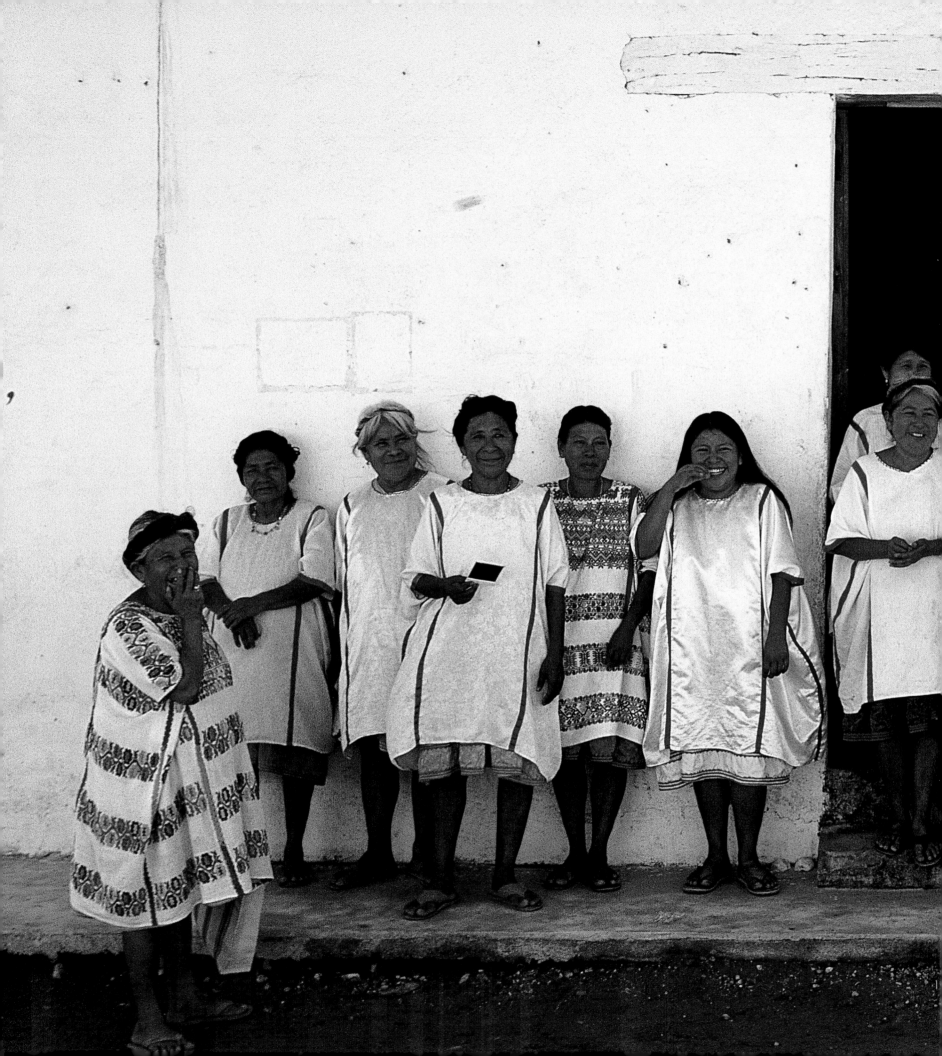

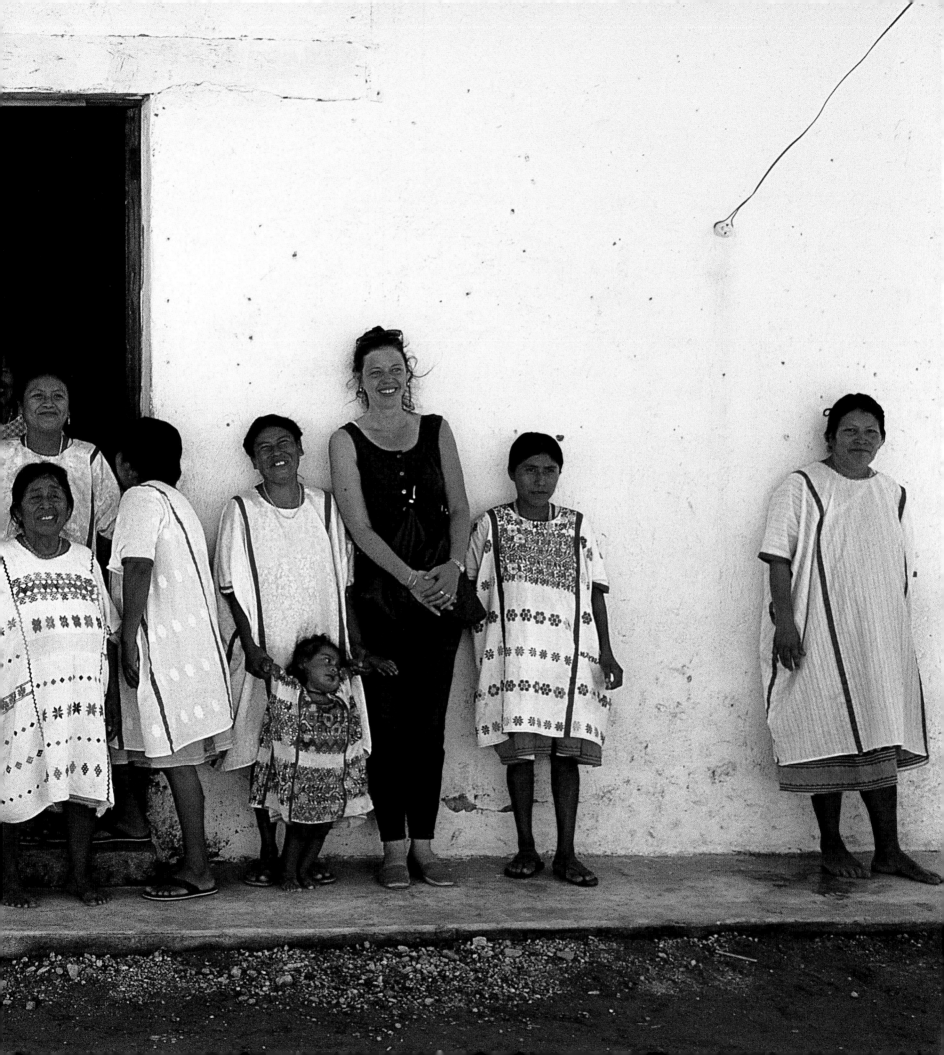

Breakfast in Usila, Oaxaca. From left to right: Alejandro de Avila B., Arie Wallert, Marilurdes Navarro, Kathryn Klein, Rosalía Navarro. Photo by J. López.

The fieldwork team in Pinotepa de Don Luis. Photo by J. López.

techniques. What was important to him? What was he thinking when he made a painting? Did he use specific materials because they appealed to him aesthetically or did he use them because they were the only thing available? Working on the conservation of ethnological materials and of living traditions allows the scholar to emerge from the seclusion of the museum into the world of the original artists. By examining textiles along with their original makers, researchers can explore the cultural contexts in which those objects were made.

With this view of conservation in mind, the goals of the preliminary GCI Oaxaca fieldwork were established. These included comparing textiles that are made today with the museum textiles; gathering pertinent information from weavers about indigenous textile traditions; documenting and photographing current weaving techniques of some of the more remote areas of Oaxaca and Guerrero; and collecting samples of fibers, dyestuffs, and plant and animal materials that are (or have been) used for making textiles. The samples were brought back to the United States and analyzed for their chemical compositions at the laboratories of the GCI.

In 1994 and 1995, two teams of GCI specialists visited six indigenous communities of Oaxaca represented by textiles in the Regional Museum collection. The teams included a textile conservator, a paintings conservator, an anthropologist, an ethnobiologist, an anthropological art conservator, a conservation scientist, and photographers. While traveling throughout the Oaxaca-Guerrero region, the GCI teams logged over 2,000 km, most of which were on treacherously narrow, unmaintained highways and dirt roads. But it was well worth the effort, since we met weavers and saw firsthand how their textiles are made. We also witnessed the ruggedness of the land, the conditions of living—which, for the most part, are in poverty—and the considerable effort the people of Oaxaca expend, no matter how difficult the situation, to make their lives more beautiful.

During the fieldwork, the weavers expressed that indigenous people are greatly interested in conserving their cultural heritage. The weavers of these communities welcome the opportunity to establish projects that bring attention to the importance of their specific textile techniques. And they want to examine closely older textiles in museum collections.

Photographer Jesús López at the site of Mitla, Oaxaca, January 1995. Photo by K. Klein.

Frederick Starr photograph at the site of Mitla, Oaxaca, late nineteenth century (Starr 1899:pl. 83).

Photographer Michel Zabé working at the Regional Museum of Oaxaca. Photo by K. Klein.

Manuel Velasco, director of the Regional Museum of Oaxaca.
Photo by K. Klein .

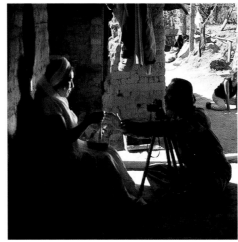

Photographer Guillermo Aldana working in San Pedro Cajonos, Oaxaca. Photo by K. Klein.

From out of this consensus, a future GCI project was developed, in which master weavers will attend a workshop at the Regional Museum of Oaxaca, where they will examine the weaving techniques of the textiles. As a method of conservation, they may make copies or interpretations of the museum textiles using as many of the original techniques and materials as possible. The plans include a traveling textile exhibit that will display the museum textiles and their interpretations. The establishment of a marketing component to this exhibit would help support the weavers.

In June 1995, I was given a glimpse into the possible benefits of the project: While I was

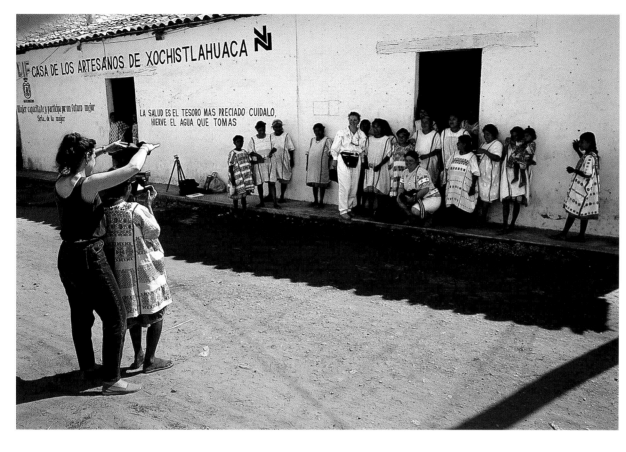

Fieldwork in Xochistlahuaca. Weaver Adela García de Jesús takes a photograph with a Polaroid camera. Photo by J. López.

at the Regional Museum of Oaxaca, a group of visitors from Usila showed up and asked to see the museum's older huipil from Usila. This group was headed by the community leader Francisco Maldonado Lorenzo, whom the GCI team had met during the fieldwork in January of 1995. The museum director, Manuel Velasco, and I brought out the Usila huipil, which was packed flat in its conservation box with tissue. In an almost ceremonial fashion, while wearing cotton gloves, we unpacked the huipil, gently turning it in unison to lay it on the table. The manner in which the huipil had been packed and was being handled clearly demonstrated to the visitors the importance of the Usila textile to the museum and the respect the museum has for them and their community. The visitors wore the cotton gloves as they examined and discussed the techniques found in the older textile. They enjoyed it immensely. And so did I. All the trudging up and down the stairs of the museum, the vacuuming, and the packing of the textile collection had really paid off, in one glorious moment.

Later that day I thought about Maria, a weaver from Usila, and how she had explained the large brocaded diamond pattern that appears on the front of most Usila huipils: it is worn over the heart and is called "the door to the soul." When a person wears it, her soul is protected. And when she dies, that is where the spirit leaves the body.

The textiles of Oaxaca have provided a door into which we are invited to explore the creative spirit of people. Through that door we enter and depart—everyone's heart enriched and transformed.

Photographer Jesús López and conservation scientist Arie Wallert photographing in San Bartolo Yautepec. Photo by K. Klein.

Editor's Acknowledgments

I would like to thank all of the participants of the Oaxaca textile project and the entire staff at the INAH Regional Museum of Oaxaca for their many hours of hard work and dedication to the cultural heritage of Mexico. The time we spent together in Oaxaca will always be remembered.

It would not have been possible to produce this book without the support and guidance of Miguel Angel Corzo, director of the Getty Conservation Institute. I would also like to express my sincere appreciation to Dinah Berland, publications coordinator at the GCI, and all of the GCI consultants who became involved with the book: Sylvia Tidwell for her expertise as the copy editor of the English manuscript; Katy Szucs, who undertook the translation of the text for the Spanish edition of the book; and Marta Turok for copyediting the Spanish edition. I would also like to thank Scott Patrick Wagner for his work on fine-tuning the manuscript and for keeping us "in stitches" while we were at it. In addition, I would like to thank the graphic designer, Vickie Karten, of Getty Trust Publication Services, and consultant Anita Keys, the production coordinator, for their invaluable contributions to the book.

I also wish to thank my professors from the University of New Mexico, Flora Clancy and Mari Lyn Salvador, whose expertise in art history and anthropology shaped the construct on which much of the Oaxaca project was formed. Many thanks to Jill Leslie Furst from the Moore College of Art and Design, Philadelphia, whose research on Mixtec codices helped guide my investigations, and also to Peter T. Furst for providing the color photographs of the Codex Vindobonensis. Deepest gratitude to scholar and writer Kathleen McCormick Price. Her lifelong friendship inspired the direction of my studies and my career.

Kathryn Klein

About the Authors

Alejandro de Avila B. was born in Mexico City and has family roots in Oaxaca. He obtained a B.A. in anthropology and physiological psychology from Tulane University and a master's degree in biological psychology from the University of California, Berkeley. He has held research and teaching positions at the Centro Interdisciplinario de Investigación para el Desarrollo Integral Regional, Oaxaca, the Instituto Tecnológico de Oaxaca, and the Universidad Autónoma Benito Juárez de Oaxaca since 1984. He was also a field representative for the World-Wide Fund for Nature in Mexico from 1990 to 1993 and a cofounder of the Sociedad para el Estudio de los Recursos Bióticos de Oaxaca, a nonprofit research group focused on the study and sustainable management of natural and cultural resources of Oaxaca. He is currently enrolled in the Ph.D. program in anthropology at the University of California, Berkeley, and has been conducting ethnobiological and ethnographic research in Mixtec- and Náhuatl-speaking communities in Mexico since 1974.

Kathryn Klein graduated from the University of California, Irvine, with a B.A. degree in studio arts. She was first employed at the J. Paul Getty Museum as a preparator in 1986, and from 1988 to 1991 served as a conservation assistant in the museum's Decorative Arts and Sculpture Conservation department. At the University of New Mexico, Albuquerque, she completed her M.A. and Ph.D. in Latin American studies, with areas of specialization in art history and anthropology and their application to art conservation. She has lived and traveled extensively in Mexico and Central America since 1980, and has served as a conservation consultant for the Getty Conservation Institute while working with various ethnographic collections at museums and weaving cooperatives in the Mexican states of Chiapas and Oaxaca.

Sharon K. Shore holds a B.F.A. from Illinois Wesleyan University and an M.A. with honors in art education from the University of Oregon, where she also completed two years of graduate work in cultural anthropology and research in art education. Since 1982, after completing an apprenticeship with Pat Reeves, a founding leader in the profession and one of the first textile conservators to practice and teach in South America, she has acted as conservator and consultant for numerous institutions with regard to the organization, surveying, exhibition, and maintenance of textile collections. She has served as a consultant to the Getty Conservation Institute and to the J. Paul Getty Museum since 1988 and is a Professional Associate of the American Institute of Conservation.

Arie Wallert studied at the academies of art in Utrecht and Groningen in the Netherlands and holds an M.A. and a Ph.D. He studied art history at Groningen University, then worked in the Department of Medieval Studies of Groningen University on the study of historical technical sources and on the techniques of manuscript illumination. Formerly an associate scientist at the Getty Conservation Institute, he is now in charge of the technical examination of paintings in the collection at the Rijksmuseum, Amsterdam. His main interests are painting techniques, the study of historical art technology, and the identification of dyestuffs and pigments.

MORELOS

PUEBLA

ORIZABA• •CORDOBA

Gulf of Mexico

TEHUACAN•

VERACRUZ

Huautla de Jiménez•
San Bartolomé Ayautla• •TUXTEPEC

COATZACOALCOS•

TABASCO

San Felipe Usila•

MINATITLAN•

GUERRERO

Valle Nacional•

Santa Cruz Tepetotutla•

Santiago Choapan•

San Pedro Cajonos•

Metlatónoc•

San Juan Cotzocón•

OAXACA•

Santo Tomás Jalieza• •Mitla

Xochistlahuaca• Santa María Zacatepec•

San Pedro Quiatoni•

OAXACA

CHIAPAS

Pinotepa de Don Luis•

San Bartolo Yautepec•

JUCHITAN•

Jamiltepec•

San Juan Mixtepec•

TEHUANTEPEC•

San Pedro Tututepec•

SALINA CRUZ• •San Mateo del Mar

MEXICO

OAXACA

0 25 kilometers

Pacific Ocean